Academies, Museun
Canons of Art

Academies, Museums and Canons of Art

EDITED BY GILL PERRY AND COLIN CUNNINGHAM

Yale University Press, New Haven & London
in association with The Open University

First published 1999 by Yale University Press in association with The Open University

10 9 8 7 6 5 4 3 2

Academies, museums and canons of art / edited by Gill Perry and Colin Cunningham.
 p. cm. -- (Art and its histories : 1)
 ISBN 0-300-07741-6 (h/b). -- ISBN 0-300-07743-2 (p/b)
 1. Art -- Historiography. I. Perry, Gillian. II. Cunningham, Colin. III. Series.
N7480.A27 1998
707'.2 -- dc21 98--23735

Edited, designed and typeset by The Open University.

Printed in Italy

a216b1i1.1

1.1

Contents

Preface

GILL PERRY

This is the first of six books in the series *Art and its Histories*, which form the main texts of an Open University second-level course of the same name. The course has been designed both for students who are new to the discipline of art history and for those who have already undertaken some study in this area. Each book engages with a theme of interest to current art-historical study, and is self-sufficient and accessible to the general reader. This first book seeks to open up some problematic issues which are central to the discipline of art history and to the series as a whole; at the same time it focuses on questions which underpin the study of 'canons' of art. As part of the course *Art and its Histories*, it (along with the rest of the series) also includes important teaching elements. Thus the text contains discursive sections written to encourage reflective discussion and argument, and to contribute to the on-going critical debate which surrounds the study of the developing western canon.

The six books in the series are:

Academies, Museums and Canons of Art, edited by Gill Perry and Colin Cunningham

The Changing Status of the Artist, edited by Emma Barker, Nick Webb and Kim Woods

Gender and Art, edited by Gill Perry

The Challenge of the Avant-Garde, edited by Paul Wood

Views of Difference: Different Views of Art, edited by Catherine King

Contemporary Cultures of Display, edited by Emma Barker

What is art history?

Today many universities and colleges offer degrees in the discipline of art history, although the subject appears under an array of different titles. In addition to plain 'Art History', we find (for example) 'History and Theory of Art', 'History of Art and Design', 'History of Art and Visual Culture' and 'World Art Studies'. These titles represent different emphases in both approach and curriculum. Some courses include the histories of architecture and design; some separate these out. Some emphasize a broad notion of 'visual culture', encompassing sources as diverse as film, advertising and photography, while others address a narrower concept of art circumscribed by the traditional media of painting and sculpture. Other courses, which are often labelled 'Fine Art', combine the practice of art – the production of paintings, sculptures, installations, videos, etc. – with the study of art history. This situation indicates that art history is an evolving discipline whose boundaries are shifting.

At the present time we are unlikely to find agreement not only about what art history *is*, but also about how to study it. The contemporary practice of art history is characterized by conflicting methods of interpretation. But disagreement is part of the process of intellectual life, and testifies to a discipline which is vividly alive. This atmosphere of debate could be seen as the mark of the relative maturity of the discipline, but it could also be seen as a sign of a discipline in crisis.

This is the situation in art history now. At the turn of the nineteenth century, however, the subject looked rather different. It was more closely bound up with the market in antiquities, works of art and luxury goods than it is today. The idea of the art historian was closely associated with that of the 'connoisseur' of art, a learned scholar who studied the works of specific artists, schools and styles of art in order to make judgements of quality. The 'connoisseur' was most likely male, often living on a private income and in possession of his own art collection. Connoisseurship and possession – or knowledge and property – often went hand in hand. This is not to say that nineteenth-century art history was wholly determined by economic interests. German universities produced more sophisticated approaches to the study of art, influenced by changing ideas in philosophy.[1] None the less, the study of art in Britain (featured prominently in this book) remained largely a preoccupation of a social élite.

Today higher education, in western countries at least, is a mass phenomenon. Art history, along with other academic disciplines, has become professionalized. As a result, it has produced specialized languages and abstruse forms of debate that leave many people with an interest in art feeling excluded from understanding. This series represents an attempt to address this condition by making some of these debates and art-historical methods accessible to the general reader.

An 'unruly' discipline

I want now to consider some of these debates in more detail. The professionalization of the discipline has involved both a broadening of the range of materials studied and a proliferation of the methods involved. At the same time, the nature and purpose of the subject have come under challenge from within. It has been called an 'unruly' discipline.[2] Historians of art have drawn on ideas and methods from other disciplines, such as sociology, literature, psychology, linguistics and anthropology. During the 1970s and 1980s the term 'the new art history'[3] came into use to describe

[1] A brief history of art-historical approaches and methods from antiquity to the 1990s has been mapped out in the introduction to Eric Fernie's *Art History and its Methods*. In his introductory section on the nineteenth century (pp.13–15) he discusses the writings of major German art historians such as Gottfried Semper, Jacob Burckhardt and Heinrich Wölfflin. This book includes an anthology of writings in which art historians and art theorists from the Renaissance to the present day expound their different approaches to the study of art.

[2] The idea of recent art history as an 'unruly' discipline which is now moving in multiple directions influenced by different forms of postmodern theory is considered by Mary Sheriff in 'Art history: new voices/new visions'. Some issues and models adapted from postmodern theory are explored in the final book in this series, *Contemporary Cultures of Display*.

[3] See, for example, Rees and Borzello, *The New Art History*.

these shifts in art-historical methods. Such 'new' historians criticized the tradition of connoisseurship and the study of styles in favour of more socially and historically rooted forms of analysis. They placed less emphasis on the individual artist and related concepts of 'genius' and 'inspiration'. Broadly speaking, these art historians were more interested in the social and ideological contexts in which works of art were produced.

An early and influential approach within this new art history was often labelled 'the social history of art' because of its emphasis on the wider social relations in which the practice of art is historically embedded (an emphasis influenced by Marxist theory).[4] The resulting analysis of historical data – for example, reading newspaper reviews of exhibitions and related contemporary events – and the general examination of the economic and social basis of culture as a key to the complex connections between 'art' and 'history' have led to this approach also being described as 'materialist art history'.[5] But the new art history has also evolved in many other directions, including approaches informed by feminism and studies of ethnicity in culture, and employing the methods of, among other things, semiotics and psychoanalysis. (These are complex terms which are explained in later books in the series. For a discussion of semiotics, see the second book, *The Changing Status of the Artist*, and for psychoanalysis see the third book, *Gender and Art*.)

Writing around the turn of the twentieth century, it is therefore difficult to identify any single working model of art history. The situation is pluralist in nature, although some models and approaches are more widely followed, and some are more compatible, than others. For this reason the series has been called *Art and its Histories*. It seeks to explore and reveal some of the different interests, approaches and forms of material which have characterized recent art-historical study. The books will engage not with any single, easily identifiable 'Art History', but rather with a variety of histories of art.

Thus far I have presented a picture of a discipline in the process of renegotiating its boundaries. That said, there have been attempts to represent some basic activities which could be said to characterize art history as it is *broadly* understood today, irrespective of the different methodologies employed. Most art historians would agree that the discipline involves the study of artefacts, an important part of whose function is that they were made to be looked at. This obviously includes the study of objects such as paintings and sculptures, but it can also be extended to other objects such as buildings, textiles, furniture or ceramics. Art historians are concerned to explain how these works came to look as they do. We also try to show how they produce meanings for the viewers who look at them – both at the time the objects were made and today, which may be hundreds of years later.

4 Arnold Hauser, a German Marxist historian, published *The Social History of Art* in 1951, a seminal work which is widely identified as the first attempt to produce a social history of art. See Fernie, *Art History and its Methods*, pp.201–13, for an extract from this book in which Hauser sets out his historical method. The work of the art historian T.J. Clark is often seen to have substantially refined and reworked this approach in the 1970s and 1980s. See, for example, his famous studies, *Image of the People: Gustave Courbet and the 1848 Revolution*, *The Absolute Bourgeois: Artists and Politics in France 1848–1851*, and *The Painting of Modern Life: The Art of Manet and his Followers*.

5 For a discussion of the nature of 'materialist art history', see Clayson, 'Materialist art history and its points of difficulty', pp.367–71.

In his anthology of writings on art-historical methods, Eric Fernie has suggested that at least four separate but overlapping approaches to the subject can be identified:

> (i) Investigation of available written documents, to provide information on the authenticity, date, technique, provenance, affiliation and purpose of the object in question.
>
> (ii) Investigation of the object, using visual techniques such as stylistic analysis, again to assess the authenticity, date, technique, provenance, affiliation and purpose of the object, and in addition to assess its quality and the visual types and pictorial traditions to which it belongs …
>
> (iii) Investigation of the social context to which the object belongs, including an examination of the conditions of its production and reception …
>
> (iv) Construction or selection of systems to relate the object to types of large-scale historical development, including an assessment of the relevance of ideologies and theories of art.
>
> (Fernie, *Art History and its Methods*, p.327)

Most forms of art-historical analysis involve the investigation of written documents, which Fernie lists as his first approach, although different art historians will emphasize different items on Fernie's list. The second could be associated with the tradition of connoisseurship which I have described above, and (iii) and (iv) are approaches more commonly associated with the new art history. Fernie's fourth (and more abstract) category of 'systems' could be fleshed out to include many of the different methodologies which have influenced recent developments in art history, among them psychoanalysis and linguistics.

Looking

One of the most important and the most obvious activities for the art historian is the process of *looking*. As our primary sources are objects and artefacts of a visual nature, our understanding of them will depend at least partly on how we see them. One criticism of the new art history – especially the social history of art – is that in its concern with social and materialist analysis and its examination of the historical processes which determine taste, it undermines the value of the pleasure which we take in looking, sometimes called the 'aesthetic experience'. Aesthetics is a complex field of study which is separate from art history: it forms a part of the philosophy of art. The term 'aesthetic' emerged in its modern form in the eighteenth century, when it was used to describe an experience which is somewhere in between an intuitive (or unordered) and a more rational, reflective (or ordered) response to a work of art. Since then the range of its meanings has evolved. The 'aesthetic' is now most often seen as connoting our responses to art which are to do with intuition and feeling, rather than with facts and rational explanations. This is a very fluid concept about which agreement can be hard to find.

It is difficult to dislodge fully some sense of an 'aesthetic' dimension from the study of art. Most of us have experienced some kind of pleasure or excitement in front of a painting, a sculpture, a building, a piece of furniture or an object which we have found beautiful or engaging. We have experienced an enjoyment in looking which can form an important basis for the work of the art historian. We may explain a work of art like any other artefact or document. But what we do – or what we experience – when we look at it

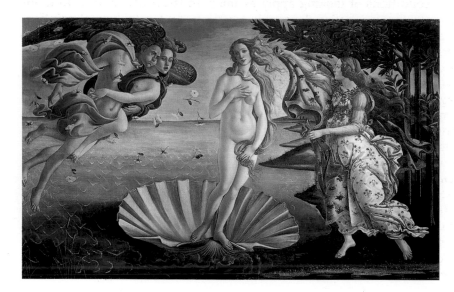

Plate 1 Sandro Botticelli, *The Birth of Venus*, *c*.1485, tempera on canvas, 173 x 279 cm, Uffizi, Florence. Photo: Scala.

through our sense of sight has quite a lot to do with why we might want to bother to explain it historically in the first place. And in response to the criticism of the new art history cited above, we could argue that the experience of pleasure in looking need not be incompatible with historical analysis. If we have more information about the historical and cultural context of the work, we might find that our enjoyment of it increases. In this series we do not directly address philosophical questions of aesthetic judgement or taste, although we note that such judgements and evaluations have markedly changed over time. However, in the following discussions of influential models of the nature and function of art, concepts of 'aesthetic' value are never far away.

Over the last few decades art historians have been increasingly concerned not simply with the social context of art, but also with the historical and cultural nature of looking itself. It has been argued that pleasure is itself historically located, and that looking is not a straightforward or 'innocent' process. The way we look at the world and interpret it will be affected by our position in history and the culture we are part of. For example, it may be affected by our class, race, religion or gender (issues of how 'looking' can be gendered are explored in the third book in this series, *Gender and Art*). Such factors can affect our expectations, our views of society and our (sexual) desires. On a very basic level, if we were to bring together a group of men and women with varied social and cultural backgrounds and asked them to describe and interpret an Italian Renaissance painting by Botticelli (Plate 1) and a modern abstract work by the American artist Jackson Pollock (Plate 2), I suspect that we would get some very different accounts.

Plate 2 Jackson Pollock, *Summertime Number 9A*, 1948, oil, enamel and house-paint on canvas, 85 x 550 cm, Tate Gallery, London. © ARS, New York, and DACS, London, 1999.

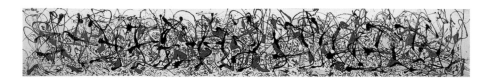

These conditions of looking apply as much to the artist as they do to the viewer (sometimes called the viewing subject). And in looking at paintings and sculptures, it is important to remember that they are always the artist's *representation* of what he or she sees, rather than mirror images or copies of the objects in question. Many western forms of painting and sculpture produced before the end of the nineteenth century appear to be based on images and objects visible in nature (what we call figurative art). But even the most naturalistic images – such as those produced by, for example, the French nineteenth-century Realist painters (Plate 3) – are representations rather than copies of the subject-matter chosen. This may seem like stating the obvious, but it is sometimes easy to forget that what we are looking at are *reconstructions* in paint on canvas, or in a sculptural medium such as bronze or stone, of objects in the visible world. In *The Stonebreakers* Courbet has skilfully applied his paint to simulate the appearance of two labourers. He has used line, colour and compositional organization to suggest the illusion of a three-dimensional, naturalistic image on a two-dimensional canvas. A key concern of our discipline, then, is the history of representation, how it has changed and developed over time; this concern runs throughout the series.

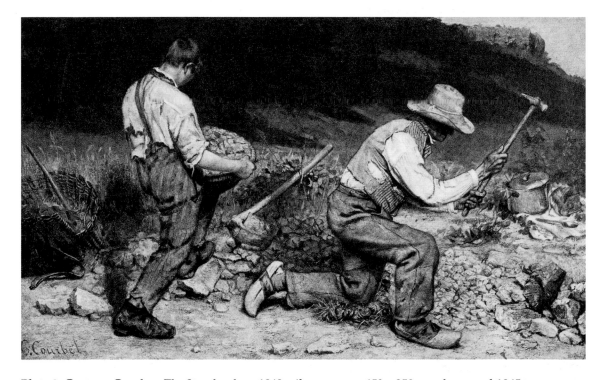

Plate 3 Gustave Courbet, *The Stonebreakers*, 1849, oil on canvas, 159 x 259 cm, destroyed 1945, Gemäldegalerie Neue Meister, Dresden. Photo: Deutsche Fotothek, Sächsische Landesbibliothek, Dresden.

What is the canon?

Many art historians have offered definitions of what 'art' means. Although as a group we are, of course, concerned with the visual arts (as distinct from other arts such as music, drama and literature), no lasting consensus has been reached. I am not seeking to resolve an issue which has been endlessly debated by art historians, art critics and philosophers over the last few centuries. I want rather to map out some different approaches to the problem in order to explore the close but complex relationship which has existed between concepts of 'art' and the idea of a 'canon' of art.

Perhaps the narrowest definition of art, which was certainly in circulation in western societies during the eighteenth and nineteenth centuries, describes works which are perceived to be 'great' or aesthetically superior to other artefacts produced by society. This attribute of 'greatness' is fundamental to the idea of the canon which we explore in this book.

The word 'canon' derives from the Greek for rule or measuring stick. At its simplest it merely means 'the standard' by which something may be measured. This is to leave open precisely *what* attributes (for example, size, beauty?) are being measured – an ambiguity that this book goes on to examine. However, some eighteenth and nineteenth-century conceptions of art suggested an appropriate measure should be its 'aesthetic value', sometimes called its 'quality'.

The word canon, as it is used today with reference to works of art, builds on these two ideas of 'aesthetic value' and 'one standard'. When people speak of 'the canon of art', they usually mean a body of works that have passed a (rather ambiguous) test of value. Despite its inherent ambiguity, the idea of a canon has assumed the air of spurious precision: it has come to mean a body of works deemed to be of indisputable quality within a particular culture or influential subculture. Only a few of those works classed as 'art' within a society are generally perceived to make up a revered canon. For example, some paintings may be seen to be indisputably works of art though judged by a majority to be of mediocre quality. In this case they are unlikely to be defined as 'canonical' in the sense of setting the standard of what a particular culture is going to view as 'great' art.

There are two additional points of definition here; both will be explored in the case studies which follow. First, there are changes over time to, and disagreements at any one time about, the list of great works. Second, in order to acknowledge the shifting nature of the canon, art historians tend to qualify their references to it. Thus we find 'the modern canon', 'the canon of high art' or 'the academic canon'. Such distinctions register the view that there are in fact a variety of canons and not one monolithic 'canon of great art'. In this book when we talk of 'the canon of western art', we are referring rather loosely to an evolving body of works and names in the history of western art rather than to a single, unchanging list.

In the following case studies we will explore some of the ways in which powerful cultural institutions in Britain and France sought to affirm and buttress canonical status for works of so-called high art. As we shall see, this notion originated in western academic theory[6] when it was used to separate the idea of a higher or more elevated practice of art (usually painting and sculpture) from the so-called lesser arts such as the decorative arts, applied design, crafts and popular art. Building on this concept of high art, some art historians have identified a 'great' western tradition of art from (to take a few examples) the sculpture of Greek and Roman antiquity (Plate 4) through to Italian Renaissance masters such as Michelangelo and Leonardo da Vinci (Plate 5), sixteenth-century northern 'masters' such as Rembrandt (Plate 6), and seventeenth-century French classicists[7] like Poussin (Plate 10). The nineteenth and twentieth centuries witnessed the emergence of a so-called modern canon of the French Impressionists through to artists such as Cézanne (Plate 7), Picasso, Matisse and others more recent. The fame of these artists, often referred to as 'masters' (there are few 'mistresses' among them!), rests on knowledge of an *oeuvre* (an artist's body of work) that has been researched and constructed by scholars using the techniques of connoisseurship discussed above.[8]

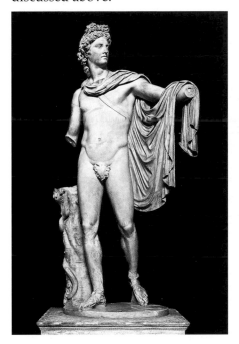

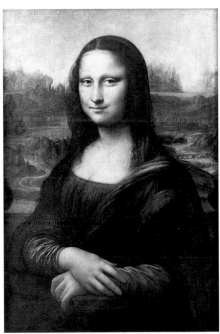

Plate 4 *Apollo Belvedere*, *c*.350 BCE, Roman marble copy after a Greek original, height 224 cm, Musei Vaticani, Rome. Photo: Alinari-Anderson.

Plate 5 Leonardo da Vinci, *Mona Lisa*, *c*.1502, oil on panel, 77 x 53 cm, Musée du Louvre, Département des Peintures, Paris. Photo: Copyright R.M.N.

[6] Academic theory refers to the ideas promulgated by academies of art in Italy, France and Britain. Part 2 of this book looks in detail at the role of the academies in the development of the western canon.

[7] Classicists followed the art and architecture of Greek and Roman antiquity and conformed to its models. The introduction to this book briefly explains the importance of the classical tradition to the western canon. Part 1 explores how the values underpinning the classical tradition changed when confronted with new discoveries in ancient art.

[8] A point taken up in *The Changing Status of the Artist* (Book 2 in this series).

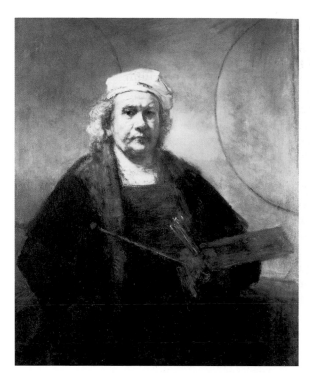

Plate 6 Rembrandt van Rijn, *Self-Portrait*, *c.*1665, oil on canvas, 114 x 94 cm, Kenwood, London, The Iveagh Bequest.

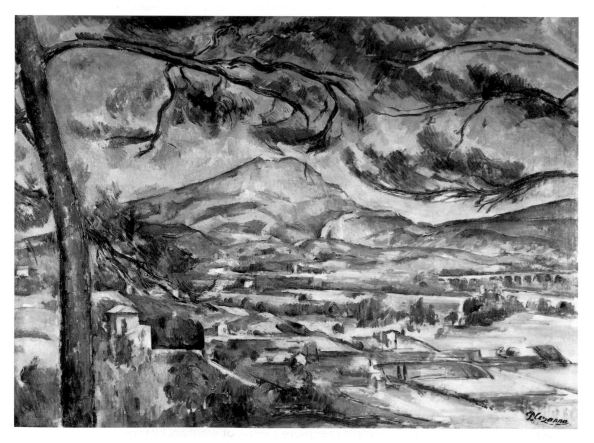

Plate 7 Paul Cézanne, *Mont Sainte-Victoire with Large Pine*, *c.*1886–8, oil on canvas, 66 x 90 cm, The Courtauld Gallery, London.

But these are just a few of many names which we could single out on the grounds of enduring popularity and continuing economic and aesthetic value which their works are seen to hold. In selecting certain names to represent a tradition of 'great' art, we are assuming that there is broad agreement within our culture on issues of aesthetic value, that there is a shared attribute of 'greatness' which defines and distinguishes certain works from other forms of art. However, as soon as we start to examine the reasons for each artist's inclusion in this canonical list, we find that too tight a definition begs more questions than it answers. If we look closely at the work of artists with enduring status as 'great', we will find that there are many inconsistencies in terms of the criteria for inclusion. For example, while Poussin's canonical status (Plate 10) is often largely attributed to his classicism, Rembrandt's appeal (Plate 6) seems to have been based on very different values: his tendency to break with some of the conventions of western art, and the relative informality and psychological insights of his portraits. Moreover, many of the works that we now identify as belonging to a modern canon of the late nineteenth and early twentieth centuries were certainly not universally admired when they were first exhibited. It is now part of the mythology of modern art history that artists such as Monet and Picasso suffered negative criticism and poverty during their early careers. The historical process which served to canonize avant-garde art from the end of the nineteenth century is one of the issues explored in the fourth book in this series, *The Challenge of the Avant-Garde*.

While the practices of connoisseurship have tended to assume the existence of a tradition of 'great' art, more recent forms of art history have questioned the principles upon which dominant notions of 'great' art are based. Many exponents of what we loosely label 'the new art history' have asked questions about the ideological sources of cultural and aesthetic values. They have asked questions such as: who decides which artists and works of art will be more highly valued than others? What political, economic or historical factors might govern those decisions?

Influenced by these debates, some art historians working today employ a broad concept of 'the visual arts' which includes a range of art forms and artefacts we perceive with (and are made to be perceived by) our visual sense. These may include objects varying from painting, sculpture and architecture through to graphic art, applied design, the decorative arts, film, advertisements, photography and so on. It has also been argued that a broader understanding of the label 'art' enables study of visual artefacts from a range of cultures. The canonical traditions of 'great' art which are explored and analysed in this book are specific to western culture, and are founded on values and beliefs which form the cultural, philosophical, political and religious basis of that culture. Many of those values are not easily adapted to analyse or understand the visual artefacts of non-western societies founded on different cultural and aesthetic principles. As students of western art history, the criteria we apply in an analysis of, for example, a painting by Poussin will probably not provide many clues as to the religious, ritualistic or aesthetic meanings of a work of Australian Aboriginal art (Plate 8). Poussin's classical principles of design, which are discussed in this book, do not help us to understand an image based on an Aboriginal creation myth. The fifth book in this series, *Views of Difference: Different Views of Art*, is concerned with such issues: it attempts to explore a sense of what art history might signify outside a primarily western context. It also examines the complex relationship between cultural identity and artistic practice.

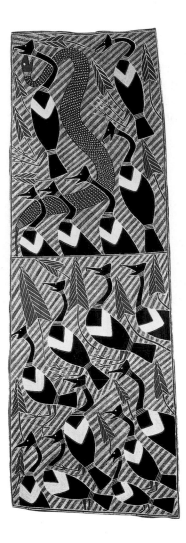

Plate 8 George Milpurruru, *Magpie Geese – Water Python*, 1988, earth pigment on bark, 237 x 78 cm, Museum of Mankind, London. Copyright © British Museum.

This book aims to map out some of the values which have underpinned the establishment and evolution of the western canon. Those values have increasingly been opened up to scrutiny, yet certain works seem to continue to engage the interest of the public and to sustain some kind of reputation as 'great' art (although the grounds for this may vary). Artists such as Leonardo da Vinci or Picasso (to take only two examples) continue to attract volumes of academic and popular publications, and their exhibitions continue to draw huge crowds. Clearly the reasons for their appeal are complex, and will depend at least partly on the decisions and preferences of exhibition organizers, museum curators, publishers, publicists and so on. But does the continuing popularity of such works reveal that the western cultural tradition merely reproduces its own value systems? In other words, are our criteria of judgement ultimately determined by a political and social culture from which we cannot escape? Can art have some kind of relative autonomy from the cultural context within which it was produced? Can some art works generate critical debate and reflection which actually help to sustain their value through history as objects to be enjoyed or engaged with? These are difficult and open questions which have been much debated by art historians during recent years. They will be explored in different ways by the authors who have contributed to this series.

We have seen that the methods by which art should be interpreted and the boundaries of the field of art itself are subjects of on-going debate. And one of the key concerns of more recent approaches to art history has been a questioning of the received canon of western art. As the case studies in this book suggest, the notion of a canon is in fact variable and contested, and may imply quite different values within different cultures. A canon is never a closed system.

References

Clark, T.J. (1973) *Image of the People: Gustave Courbet and the 1848 Revolution*, London, Thames & Hudson.

Clark, T.J. (1982) *The Absolute Bourgeois: Artists and Politics in France 1848–1851*, London, Thames & Hudson.

Clark, T.J. (1985) *The Painting of Modern Life: The Art of Manet and his Followers*, London, Thames & Hudson (first published 1973).

Clayson, H. (1995) 'Materialist art history and its points of difficulty', *Art Bulletin*, September.

Fernie, E. (ed.) (1995) *Art History and its Methods: A Critical Anthology*, London, Phaidon.

Hauser, A. (1951) *The Social History of Art*, 4 vols, London, Routledge & Kegan Paul.

Roos, A.L. and Borzello, F. (eds) (1986) *The New Art History*, London, Camden Press.

Sheriff, M. (1992) 'Art history: new voices/new visions', *Eighteenth-Century Studies*, vol.25, Summer.

Acknowledgements

Gill Perry edited this book, and Colin Cunningham played a key role in the initial selection of material. Open University courses undergo many stages of drafting and review, and the book editors would like to thank the contributing authors for patiently reworking their material in response to criticism. Special thanks must also go to all those who commented on the drafts, including the A216 course team, Nancy Marten and Open University tutor assessors Anne Gaskell, Peter Jordan and Sue Vost. We are especially grateful to Nicola Durbridge, who worked tirelessly to improve the arguments and content of the book. The authors are also especially indebted to Professor Will Vaughan, who provided detailed and constructive criticisms of an early draft of this book and whose ideas and comments influenced the subsequent development of the text. The course editor was Nancy Marten. Picture research was carried out by Tony Coulson with the assistance of Jane Lea, and the course secretary was Janet Fennell. Debbie Crouch was the graphic designer, and Gary Elliott was the course manager.

Introduction

COLIN CUNNINGHAM AND EMMA BARKER

Academies, Museums and Canons of Art is a collection of case studies that explore the ways in which some of the principal institutions of the western art world have been formed by producers and consumers of art, and in turn have shaped the way that art and our understanding of it have developed. That is to say, the range and type of art works in museums and galleries or visible in the public domain have been crucial in establishing a view of 'great' art that we call the western canon of high art. Equally crucial have been the ways those institutions themselves have developed and the personalities and value judgements involved. This book emphasizes the canonical and academic traditions in British art of the eighteenth and nineteenth centuries. We have chosen this distinctive focus to show how the core academic traditions, generally perceived to have been established in France, were reworked and disseminated within a specific national context.

It is divided into three parts. Part 1 looks at two examples of art that have been generally recognized as canonical, and explores some of the reasons why they have been valued. Part 2 introduces you to two of the principal art institutions in France and England and the associated ideas of 'academic' art; it addresses the more complex question of how they established certain values in art production. The final case study in this part compares two nineteenth-century British artists with very different positions in the canon. Part 3 explores the early years of the British National Gallery, its aims and its effect on the development of the canon. This part also includes a detailed study of one art work – the Albert Memorial in London – in the light of the development of the canon. The book ends with a brief study of the spread of canonical values to the provinces.

After you have studied this book you should have a grasp of the complexities involved in talking about a canon of art works. These include the values that sustain it as well as the influences at work in perpetuating those values, and the ways in which attitudes to the canon can be changed. It is important to remember that there never has been complete agreement about its constitution. We have also designed this volume to give you an opportunity to develop skills of visual analysis and interpretation of textual evidence.

The classical and the canon

In this book we focus on the classical tradition as the fundamental point of departure for the formation of the western canon. The art of ancient Greece and Rome, which primarily means antique sculptures since very few paintings of that era have survived, forms the core of the classical tradition. To this core have been added later European works of art inspired by their example, most notably those of the Italian Renaissance by artists such as Raphael (1483–1520). During the sixteenth and seventeenth centuries, art theorists and historians such as Giovanni Pietro Bellori (1615–96) rationalized the high

valuation accorded to works in this tradition on the grounds that they present a vision of ideal beauty (*Idea* in Bellori's terminology). According to Bellori, such ideal beauty reflected nature not as it normally appears but as it was conceived in the mind of God. He wrote, 'it is necessary to study the most perfect of the antique sculptures, since the antique sculptors … used the wonderful *Idea* and therefore can guide us to the improved beauties of nature' (quoted in Fernie, *Art History and its Methods*, p.66). The notion of ideal beauty carried with it connotations of order, harmony, proportion and grace: qualities which artists were expected to strive to attain in their own work.

Bellori was especially concerned to counter what he saw as dangerous tendencies in the art of his own day towards unmitigated naturalism, exemplified by the painter Caravaggio (1571–1610). One of the artists of Bellori's own time whose artistic practice exemplified his views, the French painter Nicolas Poussin, provides the focus of our first case study. We will examine in detail a single work by Poussin, *The Arcadian Shepherds*, as an example of classicism in painting. The case study goes on to consider the reasons why Poussin has continued to be regarded as a great artist ever since the seventeeth century. By contrast, the antique sculptures in Rome which Bellori admired and Poussin appears to have copied have long since been stripped of their former canonical status: they are now recognized to be only later Roman copies of Greek originals.

While the eighteenth-century German art historian Johann Joachim Winckelmann (1717–68), whose ideas are discussed in the second case study, expressed the greatest admiration for the famous antique sculptures in Rome, his emphasis on Greek art as the high point of classical art helped in the long run to undermine their pre-eminence.[1] For Winckelmann, antique sculpture still embodied an ideal of timeless beauty, but he added a new interest in the historical conditions in which Greek art had been made. This suggested that modern artists working in quite different circumstances could not hope to revive this beauty in their own work.

It was only in the first half of the nineteenth century that a number of authentic Greek sculptures were brought to Western Europe. Among the most notable of these were the Parthenon marbles, which are the subject of the second case study. As we shall see, the appearance of these sculptures came as rather a shock to some viewers since their naturalistic style undermined existing assumptions about the idealism of classical art.

During the course of the nineteenth century, classical art yielded its exclusive status as the model for high art. A new, expanded definition of the canon emerged which could embrace both Gothic art and architecture[2] (see Case Study 6) and Italian art before Raphael (see Case Study 7). This period also witnessed the emergence of a new and avowedly neutral approach to art history. Exponents of this approach claimed that they could examine every style according to its own merits. A leading example of this work was the

[1] See Fernie, *Art History and its Methods*, pp.68–76, for an extract from Winckelmann and an introduction to his ideas.

[2] Gothic refers to medieval art and architecture from the mid-twelfth century to the beginning of the Renaissance (early fifteenth century); Gothic art had its roots in northern Europe.

German art historian Heinrich Wölfflin (1864–1945); his immensely influential system of stylistic classification analysed the 'classical' art of the Italian Renaissance in contrast to the art of the Baroque[3] (exemplified by seventeenth-century artists such as Rubens). Rejecting such value-laden terms as harmony and grace, Wölfflin devised five pairs of visual concepts. For example, instead of talking about harmony, he offered the pair of unity and multiplicity: in a unified work of art the parts were subordinated to the whole (and vice versa).[4] Wölfflin's analysis is a formalist one; that is to say, he ignores the subject-matter or 'content' of paintings in order to concentrate on their visual appearance or form. His work has been criticized, most notably by the twentieth-century art historian E.H. Gombrich, for effectively smuggling value judgements back in under the guise of neutral description.[5] According to this critique, Wölfflin implicitly presents classical art as a standard against which every other kind of art can be not only defined but also judged.

In this book we do not aim to reassert the supremacy of the classical ideal, but rather to examine some of the ways in which art history has affirmed the 'classical' as canonical. In the process we shall explore various methods that can be used for evaluating works of art. We can undoubtedly make use of and benefit from the formal language of stylistic analysis pioneered by Wölfflin as long as we remain conscious of what we are doing. What is not helpful is to throw around labels such as 'classical' or 'Baroque' without explaining what we mean by them.

The following case studies will also seek to show some of the ways in which aesthetic judgements underpinning the canon of high art are bound up with social values and political realities. As regards social values, all works of art produced within the classical tradition presume a viewer who is able to evaluate it by reference to previous exemplars of that tradition. Obviously, this knowledge is likely to be confined to élite groups and to modern western society. The case studies also draw attention to the political element involved. Poussin's attainment of canonical status undoubtedly owed much to the usefulness of his work to King Louis XIV and his ministers, who endeavoured to show that France was the dominant cultural power in Europe. Similarly, the Parthenon marbles were put on display as major works of art in the British Museum in the early nineteenth century at least in part as a result of Britain's ambition to possess antiquities to rival the collections of the Louvre Museum in Paris.

[3] A term devised by nineteenth-century art historians to describe certain stylistic tendencies in seventeenth-century art, which could be said to transgress the rules of classicism.

[4] See Fernie, *Art History and its Methods*, pp.127–34, for an explanation of Wölfflin's ideas.

[5] Gombrich, 'Norm and form: the stylistic categories of art history and their origins in Renaissance ideals', pp.81–98. However, Gombrich himself has in his turn been criticized for remaining loyal to a narrowly canonical definition of great art focused on the Italian Renaissance.

Academies, education and the canon

Part 2 examines the role of academies in establishing and presenting certain works of art as canonical. Linda Walsh's case study on the seventeenth-century Académie royale in France under Charles Le Brun explores the way in which royal patronage and the institutionalizing of artistic education helped to determine the status accorded to works of art. One result of this pattern of patronage and training in the seventeenth century was the establishment of a hierarchy of genres (or categories) of painting, with those designed to convey elevating and moral messages – the so-called 'history' paintings – accorded the highest status.[6] (Poussin's *Arcadian Shepherds*, the subject of your first study, is an example of this genre.)

However, in Case Study 4 Gill Perry points out that the art market and differing national situations also affect the way work is valued. In Britain, although the hierarchy of the genres established in France was broadly accepted, the larger market for portraiture had a major impact on artistic practice. The Royal Academy of Art, the parallel institution to the Académie royale, was founded a century later and had different interests. None the less, it was concerned in the same way with academic training, and was a focus for the display of art through its annual exhibitions. The need for artistic training had been of concern to British artists such as Hogarth before the founding of the Royal Academy. However, as she argues, Hogarth's own practice resulted in a particular form of art closely related to theatre and partly disseminated through engravings; this art form was excluded from the 'academic' training favoured within the Royal Academy. She suggests that this type of art held an ambiguous position in relation to the academic values and practices supported by this institution.

The role of the French and British academies in training artists (and the similar intention behind the display of the Parthenon marbles in the British Museum, discussed in Case Study 2) served to entrench the values of academic art. The relationship of this value system to the hierarchy of the genres, and the relatively low status of landscape painting in the hierarchy, became an issue in its reception in the nineteenth century. In Case Study 5 Emma Barker traces the varying reputations and status of two nineteenth-century artists. Instead of the more traditional comparison of the contemporaries Constable and Turner, both of whom worked extensively in the landscape genre, she compares Turner with the later Frederic Leighton. She shows how Turner has been canonized in the twentieth century as one of the most original of all landscape painters, a progenitor of modernism.[7] In contrast, Leighton, who was an outstanding practitioner of traditional academic methods, is now seen as lacking in creative imagination though he was highly regarded during his lifetime. This comparison highlights one of the ways in which the canon changes over time as the art of the past is reappraised in the light of new artistic developments.

[6] Case Study 3 explains the hierarchy of the genres in greater detail.

[7] Modernism is used here to mean the avant-garde styles that have dominated western art and architecture in the twentieth century.

Displaying the canon: museums and monuments

In Part 3 the study of the Albert Memorial affords a further exploration of an art work that was designed fully within the academic conventions of sculpture. Here I detail some of the constraints on a major public work of art, and show how a close study of the memorial's subject-matter[8] tends to tie this public sculpture to its particular period. I also discuss the way in which the Albert Memorial, as the collaborative production of a large group of sculptors, is differently valued when compared with the works of individuals such as Turner. I suggest that this has the effect of leaving its place in the British canon somewhat insecure.

The central role of the academies in artistic training – and later of museums and galleries – helped to set a premium on the accepted works of earlier artists. Such attitudes placed an emphasis on tradition, and this is explored by Anabel Thomas in her study of the National Gallery in Part 3. She argues that accepted traditions, as well as the market, largely governed the way its collection grew. She also discusses the way in which its art works are organized and displayed, which in turn affects the viewer's perception of tradition and development. Finally, the brief study of art institutions in Manchester in the nineteenth century reveals something of the way that attempts to broaden public awareness of art were governed by educational and moral imperatives and limited by dominant ideas of an accepted canon.

As Thomas points out in Case Study 7, not all artists felt that the presentation of a particular canonical view was entirely for the good. Constable exclaimed in 1822 that 'there will be an end of the art in poor old England' when he saw the plans for the new National Gallery. Today our view of art history owes much to those who organized and developed the academies, galleries and museums and helped to disseminate ideas about art. The inclusion of certain artists within the western canon and the selection of works for display had a profound influence on the subsequent development of art as succeeding generations were taught to respect their works and to see them as a stage in the development of art. It is the principal role of art history to explore this process. We will begin by studying the seventeenth-century French artist Nicolas Poussin, whose work is widely acknowledged to belong firmly within the European canon.

References

Fernie, E. (ed.) (1995) *Art History and its Methods: A Critical Anthology*, London, Phaidon.

Gombrich, E.H. (1966) 'Norm and form: the stylistic categories of art history and their origins in Renaissance ideals', in *Norm and Form: Studies in the Art of the Renaissance*, London, Phaidon.

[8] An approach that focuses on the meanings attached to particular subject-matter is called iconography.

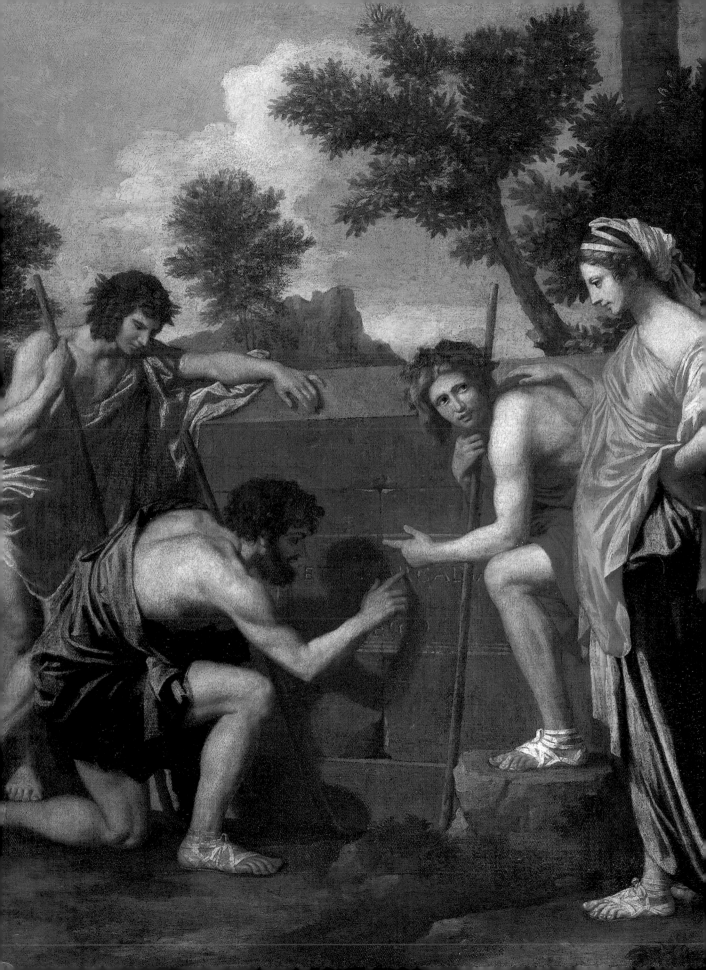

PART 1
THE CLASSICAL
AND THE CANON

CASE STUDY 1
The Arcadian Shepherds:
a painting by Poussin

EMMA BARKER

Introduction

The French artist Nicolas Poussin (1594–1665) is generally considered to occupy a pivotal position in the canon of art that has been established in Europe since the Renaissance. Poussin's canonical status rests on his development of a classical style of painting, derived ultimately from antique sculptures, which provided the starting point for a new tradition of 'academic' or 'neo-classical' art.[1] His art is admired, in other words, for being simultaneously a return to the past and an original creation. In this case study we will explore Poussin's seemingly paradoxical achievement by reference to a single painting, *The Arcadian Shepherds* (Plate 10). This work is often regarded as the most perfect expression of Poussin's art; in the words of one art historian, it is 'an image which, of all those ever painted by Poussin, has found a central place in the imaginations of art lovers throughout the world' (Haskell, 'Poussin's season', p.49). Why this should be so may be something of a mystery to you at first glance. As a first step towards understanding why *The Arcadian Shepherds* has become one of the acknowledged masterpieces of the western canon, we will need to take a closer look at the painting and consider what kinds of meaning might be read into it. This will provide a basic introduction to the skills that are required, as well as the problems that can be involved, in analysing and interpreting a work of art.

[1] As noted in the Preface, 'classical style' refers to the style of those artists (like Poussin) who followed the art and architecture of Greek and Roman antiquity and conformed to its models. The term 'academic art' is used to refer generally to paintings produced in accordance with the rules taught in academies of art, on which see Case Studies 3 and 4 below. 'Neo-classicism' is usually taken to refer specifically to new developments in art in the late eighteenth century which reinvigorated the academic tradition partly through a return to the example of Poussin.

Plate 9 (Facing page) Nicolas Poussin, detail of *The Arcadian Shepherds* (Plate 10).

Plate 10 Nicolas Poussin, *The Arcadian Shepherds*, 1638–40, oil on canvas, 85 x 121 cm, Musée du Louvre, Département des Peintures, Paris. Photo: Copyright R.M.N.

Approaching the painting

The Arcadian Shepherds was produced in a specific historical context with a certain kind of viewer in mind. We inevitably approach it without the kinds of knowledge (of classical art and literature, for example) that its original audience would have had. For the moment, let us make a virtue out of necessity and see what can be discovered about the painting simply by looking at it. The first thing that needs to be said about *The Arcadian Shepherds* is that it is a 'figurative' painting, one that represents the visible world that surrounds us. Although this may seem a very obvious point, it is not one that could have occurred to a seventeenth-century viewer. The very concept of a figurative image assumes the possibility of non-figurative or 'abstract' art, something that only developed in the early twentieth century. As this indicates, our view of Poussin's painting cannot help but be coloured by our own historical position, however hard we try to recover the mindset of the period in which it was painted.

Look at Plate 10 and set down what you see in this painting in literal terms – that is, as if you were reporting on the scene in real life. For example, whom do you see? What actions are they performing? Where are they? For the moment, try not to speculate about the meaning of the scene.

Discussion

Two men are bending over and pointing at some marks inscribed on a large stone block. At the left, a third man is leaning on the block and looking down at the others. A standing woman looks on, placing one arm on the shoulder of the right-hand man, who turns his head to look at her. All four are wearing loose garments which, in the men's case, leave much of their body uncovered. They are located in a fairly bleak-looking piece of countryside, with a few trees and a distant view of mountains. Although there are some dark clouds in the sky, it seems to be a fairly sunny day – the kneeling man casts a dark shadow on the stone block.

◆◆

Of course, what we are looking at is not a piece of reality but a representation, a rendering of solid objects and impalpable light in oil paint on a flat canvas. In order to depict a group of figures standing in a landscape, the artist has relied on a whole range of conventions for picture-making. For example, the reason that we can tell the large brown area in the centre should be understood as a rectangular block is that we are familiar with the use of perspective for depicting three-dimensional objects on a two-dimensional surface. This point can be emphasized by reference to the story of the Japanese artist who, on first seeing a perspectival drawing representing a cube, concluded that they made funny shaped boxes in the West.[2] (Similarly, if you identified the block as a tomb, this would be because you are familiar with western conventions of tomb construction.) For present purposes, however, it is most helpful to view *The Arcadian Shepherds* not as a work produced within the European artistic tradition but, more specifically, as the outcome of a whole series of decisions and calculations on the part of the artist. Poussin would have needed to begin by working out such elements as the shape or format of the painting, the size of the figures in relation to the overall space, how to group them in relation to the tomb, and the direction that they are looking in. All these are combined in the making of the painting and constitute its composition.

If we view *The Arcadian Shepherds* in isolation, it is difficult to get much sense of the process that Poussin went through to arrive at the final result. Fortunately, however, we can compare it with an earlier depiction of the same subject that Poussin painted around 1628–9 (Plate 11), roughly a decade before the more famous version. The alterations he introduced in the later composition are so fundamental that, as we will see when we consider the meaning of *The Arcadian Shepherds*, they affect the way the image is interpreted.[3] This point raises an important general problem about the approach that we have adopted here. Analysing the painting in primarily visual terms without regard for its subject-matter, as we are now doing, is actually a somewhat anachronistic procedure. For Poussin and his contemporaries, it would not have made any sense to talk about the composition in isolation from its meaning. For them, the subject of the work was paramount, as the comments on *The Arcadian Shepherds* cited below (p.32) make clear.

[2] This anecdote is cited in the entry on 'representation' in Fernie, *Art History and its Methods*, p.358.

[3] Presumably, indeed, Poussin returned to the subject because he felt that he had not done justice to it the first time round.

Plate 11 Nicolas Poussin, *The Arcadian Shepherds*, *c*.1628–9, oil on canvas, 101 x 82 cm, Devonshire Collection, Chatsworth. By permission of the Duke of Devonshire and the Chatsworth Settlement Trustees.

What are the main compositional differences between the two versions of *The Arcadian Shepherds* (Plates 10 and 11)? Use the list of compositional elements at the end of the paragraph before last for guidance; in particular, consider which of the paintings gives the greater sense of movement.

Discussion

In the first place, Plate 11 has an upright (vertical) format and Plate 10 a horizontal format. Overall, the figures seem to take up somewhat more of the space in the earlier version (Plate 11); we get only a fleeting glimpse of the setting rather than a broad view. The figures here also occupy most of the central and lower part of the composition while the tomb is shown to the right. In the later version (Plate 10) it is the tomb that occupies the centre while the figures are grouped around it in a more or less symmetrical fashion, facing inwards. In Plate 11, by contrast, the three central figures are all looking in the same direction, and the general impression is that they have just rushed up to the tomb; for example, the girl on the left has lifted her dress so as to run more easily. This produces a strong sense of movement whereas, in the later composition, the figures seem to be standing motionless around the solid mass of the tomb; the overall effect there is extremely calm and still.

◆◆

Indeed, it could be said that the most striking feature of the later composition is its almost geometric simplicity. The tomb forms a dominant horizontal element which is balanced by a number of vertical features; for example, the tall figure of the standing woman forms an upright which is carried on by the tree behind her. We can read the whole composition as a triangle or (as it is usually called) pyramid, which rises up from the two bottom corners of the painting and culminates in a point at the centre above the tomb, where a leafy branch is silhouetted against the sky. The figures are all placed to form a more or less straight line parallel with the bottom of the painting, whereas in the earlier version they are arranged on a diagonal with the woman in white standing furthest away from us. The paintings also differ in their overall colouring: predominantly warm and subdued in the first version, more inclined to cool, clear tones in the second. A shift also takes place from flickering effects of light and shade (notice especially the clouds and leaves in Plate 11) to much broader contrasts with sun-lit foreground elements standing out against a sombre background in Plate 10.

In conventional art-historical terms, the stillness and clarity of the later painting offer a model of classical principles of composition (we will consider the idea of classicism more fully below). For the present, it should be noted that the account of *The Arcardian Shepherds* given in the preceding paragraph constituted a formal analysis. Whereas, in the past, accounts of paintings tended to focus on their subject-matter, in the last century or so it has become possible to conceive of the form (line, colour, etc.) of a work as something quite distinct from its content or subject-matter.[4] To conclude our formal analysis of *The Arcardian Shepherds*, let us compare Plate 10 with another work by Poussin, *The Calm* (also known as *Landscape with Calm Weather*) (Plate 12).

[4] Some earlier writers on art do seem to anticipate the distinction between form and content – for example, the late seventeenth-century theorist Roger de Piles, mentioned below.

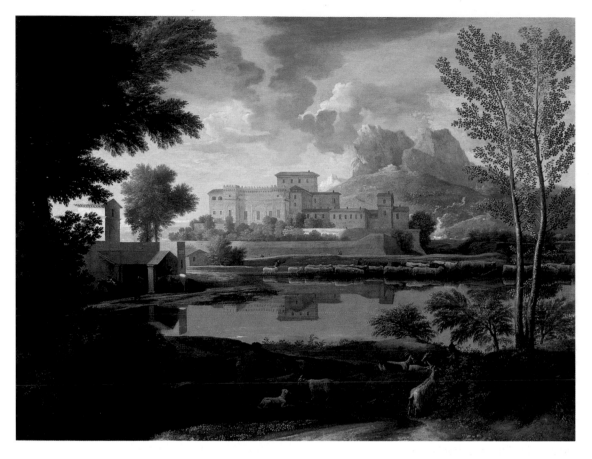

Plate 12 Nicolas Poussin, *The Calm* (also known as *Landscape with Calm Weather*), 1651, oil on canvas, 97 x 132 cm, The J. Paul Getty Museum, Los Angeles (97.PA.60).

Consider the format of the composition, the relative prominence of the figures, and what our viewpoint is in relation to the scene depicted: are we above or below, close in or far away? You will also find it helpful to compare the paintings' titles.

Discussion

In this case both paintings are horizontal in format, though the *Landscape with Calm Weather* is somewhat taller in relation to its length. However, the figures (who can also be identified as shepherds) play a much less prominent part here; they are small in scale and the only one near us is looking away so we can't see his face. We also look down on the scene from some considerable height, which affords us a panoramic view of the landscape. By contrast, we can see that the figure scale in *The Arcadian Shepherds* is really rather large and that our viewpoint is quite close up and more or less on the same level as the figures; if anything, we are slightly below them since the tomb blocks our view of the landscape. We can sum up these differences between the compositions with reference to their titles: with *The Arcadian Shepherds* it is the human figures who are the centre of attention, while the other work is a landscape painting in which the figures play a subsidiary role.

What this comparison highlights is that different genres or types of painting – in this case, figure and landscape – tend to follow different conventions in terms of their composition.

Meaning and interpretation

In the seventeenth century, figure compositions constituted the most highly regarded branch of painting. What was required, more specifically, was the imitation of human life in its most exalted manifestations. Serious artists were expected to depict saints, heroes and suchlike, drawing their subjects from the Bible and ancient literature. Most of Poussin's pictures fall into this category, which is known as 'history painting' (see, for example, *Eliezer and Rebecca* (Plate 80), which is discussed in Case Study 3). In the case of *The Arcadian Shepherds*, however, we are presented with something rather different from a conventional history painting, though no less high-minded in conception. Poussin's earliest biographer classified it among the artist's 'moral ideas expressed in painting' (Bellori, *Le Vite*, p.447; trans. Barker). The painting also presents special problems of interpretation because its meaning cannot be pinned down to any single literary source. Nevertheless, the image has a strongly verbal or textual aspect which differentiates it from a landscape or still life; the latter types of painting tend to seem more straightforwardly and exclusively visual.

Given what I said above about the artist using formal means (line, colour, etc.) to express the content of his painting, you would expect our analysis of the composition to give us some indication of the meaning of *The Arcadian Shepherds*. On this basis, we might deduce something from the insistent centrality of the tomb, the way that everything from the gestures of the figures to the underlying geometric structure serves to concentrate our attention on it. A further clue is provided by the inscription on the tomb which, as you may perhaps be able to make out, reads: 'Et in Arcadia Ego'. For the cultivated seventeenth-century viewer armed with a knowledge of Latin, this phrase would have provided the key to interpreting the painting.[5] It indicates that the scene is set in Arcadia, a remote and mountainous part of Greece which had come to be identified as an idyllic land where nymphs and shepherds lived in innocent bliss. Originating in Latin poetry with Virgil's *Eclogues*, the concept of Arcadia had since become a standard literary theme. This information allows us to account for the simple clothing worn by the shepherds and the wild landscape devoid of any buildings.

However, we still haven't established what the words inscribed on the tomb actually mean. For the sake of grammatical correctness, they should be translated as 'I too am in Arcadia' and signify that 'Death is even in Arcadia'. That is to say, we should understand the words as being uttered by Death in person. This is most apparent in Poussin's first version of *The Arcadian Shepherds* (Plate 11) where, as you can see, the tomb is surmounted by a skull which serves as a symbol of death personified. However, it is also possible to understand the words as being spoken by the person buried in the tomb,

[5] It is important to realize that, unlike a modern visitor to a museum or gallery, the viewer would not have been able to refer to an explanatory label placed alongside the painting.

and to translate them as 'I too once lived in Arcadia'. This translation gains authority from the literary tradition of Arcadia in which the motif of the tomb is associated with an individual shepherd whose death is being mourned. In a famous essay first published in 1955, Erwin Panofsky demonstrated that these differences of meaning have far-reaching implications for the interpretation of the image: on the one hand, a present threat; on the other, a remembrance of the past.

Now read the following extracts, the first two from texts by Poussin's contemporaries and the last two by twentieth-century art historians. What differences and similarities of interpretation do you find here? Note, in particular, the way each interpreter discusses death. In general, what kinds of qualities do they discern in the painting?

> The third moral poem serves to evoke the presence of death in the midst of human happiness. A shepherd from the happy land of Arcadia, resting with one knee on the ground, is pointing towards and reading the inscription on the tomb: 'Et in Arcadia Ego', which means that the tomb exists even in Arcadia and that death makes its appearance in the midst of bliss ... Another painting depicting the identical subject includes a figure of the river god Alpheus.
>
> (Bellori, *Le Vite*, p.448)

> The third painting represents the memory of death in the middle of the prosperity of life. Poussin has painted a shepherd with one knee on the ground and pointing out the words inscribed on the tomb, Et in Arcadia Ego. Arcadia is a country which poets have described as a delectable land: but this inscription serves as a reminder that he who lies in this tomb also lived in Arcadia and that death is to be met with amongst the greatest happiness. These examples are more than enough to allow one to understand with what intelligence, with what clarity of spirit and what nobility of expression our illustrious painter knew how to treat all sorts of subjects.
>
> (Félibien, *Entretiens*, p.379)

> Here, then, we have a basic change in interpretation. The Arcadians are not so much warned of an implacable future [as in the first version] as they are immersed in mellow meditation on a beautiful past. They seem to think less of themselves than of the human being buried in the tomb – a human being that once enjoyed the pleasures which they now enjoy ... In short, Poussin's Louvre picture [the second version] no longer shows a dramatic encounter with Death but a contemplative absorption in the idea of mortality. We are confronted with a change from thinly veiled moralism to an undisguised elegiac sentiment.
>
> (Panofsky, '*Et in Arcadia Ego*', p.359)

> The urgency of the earlier design ... has given way to a tone of contemplation, as the shepherds kneel or stand silently, meditating on the lesson which they have just read ... This deep calm is also expressive of a slight change in the moral of the story. In the earlier version the agitation of the figures conveys the sense of shock which the discovery of death has caused. In the second version all feeling of fear has vanished, and the shepherd and shepherdess contemplate death in undisturbed detachment, consonant with the principles of Stoicism.
>
> (Blunt, *Nicolas Poussin*, p.304)

Discussion

Already in the two seventeenth-century texts we can see a difference in interpretation. Bellori seems to opt for the first translation, referring to Death in the present tense ('death makes its appearance'), whereas Félibien clearly takes the view that words are uttered by the occupant of the tomb and shifts into the past tense ('He also … lived in Arcadia'). Panofsky takes account of both possible interpretations; he associates the first one with the earlier version of the subject and the second with the later one. In effect, he disagrees with Bellori's view that the two paintings are identical in their subject-matter. Both Panofsky and Blunt interpret *The Arcadian Shepherds* in terms of a move away from a direct threat of death in the midst of happiness towards a generalized meditation on human mortality. However, a slight difference of approach can also be seen in that Panofsky regards the later painting as the expression of 'an elegiac sentiment', a gently nostalgic emotion, whereas Blunt stresses the figures' lack of emotion, their coolly rational attitude to death, which he associates with the philosophy of Stoicism. All the commentators are preoccupied by the intellectual and moral significance of the painting, a point most obviously made by Félibien.

◆◆◆

Poussin's renown is inextricably linked with his reputation as an intellectual among artists or, as he is often described, 'a philosopher painter'. However, his work has also been criticized for being dull, dry and generally lacking in visual appeal. In his life of Poussin, André Félibien felt obliged to defend him against his critics, notably the art theorist Roger de Piles, who considered Poussin particularly weak in respect of colour.[6] Even Anthony Blunt, whose massive study of the artist detailed his intellectual attainments and, in particular, his interest in Stoicism, expressed the view that Poussin's highly serious conception of art led him to sacrifice 'spontaneity of design, freedom of handling, richness of colour, beauty in *matière*' in the work of his middle years (Blunt, *Art and Architecture in France*, p.295; the French word *matière* is here used to refer to the actual substance of the paint). From this perspective, the contrast between the first and second versions of *The Arcadian Shepherds* represents not only the emergence of his classical style of painting, but also a shift away from primarily aesthetic concerns to a strictly philosophical approach. Blunt's interpretation of Poussin has been opposed on two main grounds: first, that it fails to do justice to his true greatness 'as a painter' and, second, that it wildly exaggerates the extent of his learning. However, there is a more fundamental counter-argument for us to consider: are we not being confronted with a false dichotomy between art and ideas? By emphasizing one at the expense of the other, we risk losing sight of the richness and complexity of Poussin's pictorial inventions.[7]

[6] These comments form part of the quarrel between the Poussinists and Rubenists discussed in Case Study 3.

[7] Recent studies of Poussin offer this kind of interpretation, continuing to regard Poussin as a profoundly serious artist but also giving greater emphasis to the visual qualities of the painting. See, for example, Cropper and Dempsey, *Nicolas Poussin*, and Bätschmann, *Nicolas Poussin*.

Let us consider the following Blunt-influenced statement about *The Arcadian Shepherds*: 'It is as though he wished it to appeal to the mind rather than the eye and to impress the viewer more as a visual image than a painted surface' (Verdi, *Nicolas Poussin*, p.218). It must be granted that the handling of paint is much more sober and restrained than in Poussin's earlier version of the subject: compare, for example, the draperies of the female figure in each painting. But it does not necessarily follow that the artist had a purely intellectual rationale, particularly in view of the fact that he did not actually invent the subject himself: the inspiration seems to have come from one of his patrons, Cardinal Rospigliosi. The problem with Verdi's formulation is that it almost overlooks the 'visual image' itself. It also fails to take account of the emotional resonances that Panofsky discerned in *The Arcadian Shepherds*. As we have seen, the composition is of the utmost simplicity and concentration yet, far from making the meaning cut-and-dried, it effectively complicates matters. Recent accounts insist on the painting's ultimate indeterminacy.[8] There is no 'right' interpretation: each of us must decide for ourselves the significance of 'Et in Arcadia Ego'. It is this enigmatic, even mysterious, quality that surely explains why so many viewers have found *The Arcadian Shepherds* an exceptionally compelling and evocative image.

Classicism and the canon

So far, we have been considering *The Arcadian Shepherds* primarily with reference to the aesthetic values of our own time. The claim that the painting's special status is related to its lack of any fixed, clear-cut meaning, for example, undoubtedly reflects a now often stated preference for openness and ambiguity over closure and clarity. This enigmatic quality may indeed have been responsible for its enduring appeal over the centuries, but the fact remains that it is only quite recently that the painting has explicitly been evaluated in these terms. An awareness of the way that aesthetic values change over time is also required in dealing with the whole vexed issue of Poussin's 'intellectualism'. Blunt believed that concern for such matters led Poussin to sacrifice what he saw, judging by twentieth-century standards, as much more fundamental artistic values ('spontaneity of design, freedom of handling', etc.). By contrast, the emphasis that Bellori and Félibien placed on Poussin's erudition needs to be understood in the context of seventeenth-century aesthetic priorities.[9] Even in relation to a single, firmly canonical figure, therefore, we can see that definitions of what it is that makes a work of art 'great' may be inconsistent and that we cannot reach a definitive evaluation – that is, one which would hold true for any period or culture.

However, the notion that Poussin's greatness derives in large part from his classicism is one that has been held fairly consistently since the artist's own lifetime. We need now to consider what exactly we mean by this label. Any discussion of the question must start from the fact that Poussin lived in Rome

[8] This argument originates with Marin, 'Towards a theory of reading in the visual arts'. It might, however, be noted that Panofsky had already drawn attention to 'the picture's strange, ambiguous mood' ('*Et in Arcadia Ego*', p.361).

[9] These are discussed by Linda Walsh in Case Study 3.

for the greater part of his career, having moved there in 1620. For him, as for any other artist or art lover of the seventeenth and eighteenth centuries, the great attraction of Rome lay in its collections of antique sculpture, which included what were then the most famous and highly regarded works of art in the world. Both Bellori and Félibien recount how the young Poussin studied by copying the antique sculptures on display in the Belvedere courtyard of the Vatican; in particular, they say that he measured the *Antinous* (Plate 13), a statue regarded as one of the most beautiful surviving from antiquity, in order to establish its precise proportions. Subsequent commentators agree that Poussin's profound familiarity with antique sculpture ensured that his paintings are essentially (not just superficially) classical in character. Blunt, for example, wrote: 'Poussin's classical works of the 1640s and later have a solemnity and a grandeur which are strangely akin in feeling to Greek sculptures of the fifth century BC' (*Nicolas Poussin*, p.233).[10]

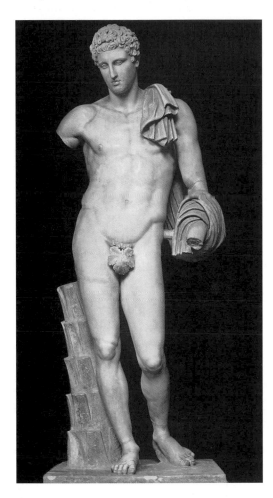

Plate 13 *Belvedere Antinous*, Roman copy of Greek original, marble, height 195 cm, Musei Vaticani, Rome. Photo: Alinari-Anderson.

[10] 'Strangely akin' because no authentic Greek statues of this period were known in Europe at this date; the situation was transformed in 1807 by the arrival in Britain of the Parthenon marbles, examined by Colin Cunningham in the next case study. It was only subsequently that it came to be generally acknowledged that the most venerated statues of Italy were merely Roman copies after lost Greek originals, and during the nineteenth century they slowly lost their hold over the imaginations of art lovers.

In the case of *The Arcadian Shepherds*, a specific antique source can be identified. The monumental female figure, with her flowing draperies, seems to have been based on a statue known as the *Cesi Juno* (Plate 14): compare the wrist resting on the hip and the extended foot of each. This rather obvious kind of borrowing might seem to contradict the claim, made by many commentators, that Poussin's classicism transcended the mere copying of actual poses (though we could also note that this is still a relatively early work). In so far as we are dealing with a figure type (tall, graceful, etc.) and not just a particular pose or attitude, however, this example accords with a use of antique sculpture as a standard or 'canon' of ideal beauty in the depiction of the human body.[11] Félibien, for example, declared that 'Poussin made use of the beautiful and elegant proportions of antique statues, of the majesty of their attitudes, of the great correctness and simplicity of their members, and even of the arrangement of their drapery' (*Entretiens*, p.386). This comment indicates that he subscribed (hardly surprisingly) to the central tenet of contemporary art theory: the belief that the imitation of classical art offered artists a short-cut towards their fundamental goal, which was the depiction of nature perfected.

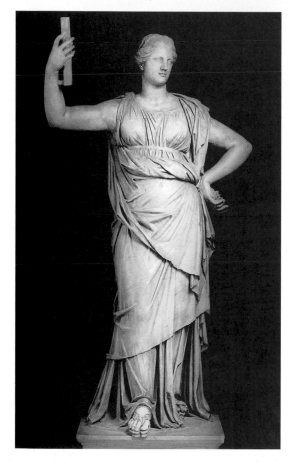

Plate 14 *Cesi Juno*, Roman copy of Greek original, marble, height 228 cm, Capitoline Museum, Rome. Photo: Alinari.

[11] The use of the term 'canon' to refer to a standard of ideal beauty relates much more closely than our modern usage to the original Greek meaning of the word (rule or measuring stick). See also Preface, p.12.

Poussin's classicism cannot be understood merely by reference to his admiration and use of the art of ancient Greece and Rome, important though it was. We also need to consider other sources of his art and other criteria by which his classicism was judged. Important in this respect was the work of Raphael (1483–1520), then the only artist of recent times to rival the ancients in prestige and to enjoy the status of a 'classic'. Raphael has been admired, above all, for his mastery of the principles of design, the coherent and harmonious way that he arranged the figures in his compositions (Plate 15). Poussin owed much to his example, though this debt is less obvious in *The Arcadian Shepherds* than in other paintings, such as *The Holy Family on the Steps* (Plate 16), which is closely related to a holy family by Raphael, *The Madonna of the Fish* (Plate 17). In dubbing Poussin 'the French Raphael', however, Félibien emphasized not what he had taken over from the Italian artist, but rather the almost coincidental 'resemblance in the grandeur of their conceptions, in the choice of noble and lofty conceptions, in the good taste of the drawing, in the beautiful and natural disposition of the figures' (*Entretiens*, pp.434–5). Somewhat strangely, you may think, the Raphael connection thus serves in this text as a means of demonstrating the distinctiveness of Poussin's approach and the impossibility of comparing him to other artists of his own century.

Plate 15 Raphael, *The School of Athens*, *c.*1509, fresco, Stanza della Segnatura, 770 cm at base, Vatican, Rome. Photo: Alinari-Anderson.

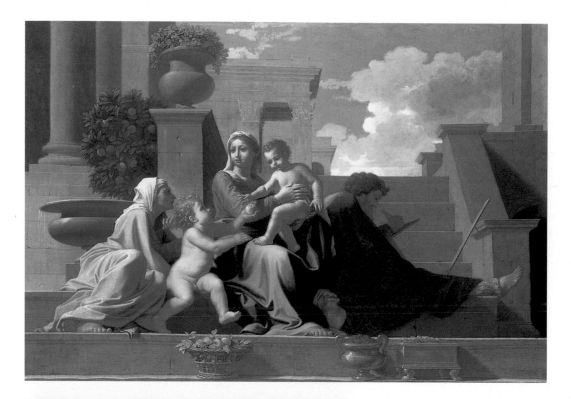

Plate 16 Nicolas Poussin, *The Holy Family on the Steps*, 1648, oil on canvas, 72 x 118 cm, Cleveland Museum of Art. © The Cleveland Museum of Art, 1997, Leonard C. Hanna, Jr., Fund 1981.18.

Plate 17 Raphael, *The Madonna of the Fish*, *c*.1513–4, oil on canvas (transferred from panel), 215 x 158 cm, Museo del Prado, Madrid.

The general point to be drawn from the above discussion is that our understanding of Poussin's classicism cannot simply be a matter of viewing his paintings in the context of the works of art that he himself admired and imitated. Rather, our whole perception of the artist is fundamentally shaped by a tradition of what we might call 'Poussin writing' which was initiated by Bellori and, most importantly, Félibien. We therefore need to consider the latter's insistence on Poussin's originality, his somewhat exaggerated claim that the artist never merely copied the great art of the past, in the context of his broader agenda. This emerges most clearly in the final sentences of Félibien's text: 'one must admit that this painter, without aligning himself with any particular style, has made himself his own master and the author of all the beautiful inventions that fill his pictures; that he has not learned anything from the painters of his time … And one can say that he has rendered a signal service to his native land in returning to it those intelligent productions of his spirit that so considerably raise the honour and glory of French painters and serve for the future as examples and models for those who wish to excel in their profession' (*Entretiens*, p.442). What matters most to Félibien, in other words, is that Poussin is a great and innovative *French* artist, one no less authoritative than the greatest in Italy.

We can only fully understand Félibien's text (a crucial document of Poussin's rise to canonical status) by reference to the cultural politics of the seventeenth century. This period witnessed France's emergence as the major power in Europe, a process that culminated during the reign of Louis XIV. In the 1660s the young king decided to take to new heights the existing practice of demonstrating power by lavish expenditure on the arts. He sought to enhance his own glory by appropriating the classical ideal for France, most obviously by acquiring some of the most renowned antique statues or at least obtaining copies of them for his palaces. An official campaign was launched to 'have in France everything that is most beautiful in Italy' (quoted in Haskell and Penny, *Taste and the Antique*, p.40). The enhancement of the royal collection included the acquisition of no fewer than 30 paintings by Poussin, among them *The Arcadian Shepherds*, which entered the collection in 1685. Unlike antique sculpture, they could be acquired without much difficulty since many were already in France; although he lived in Rome, Poussin worked largely for French collectors, especially after his stay in Paris in 1640–2, during which he was employed (somewhat unhappily) by Louis XIII. The patronage of these collectors, many of whom were government officials, made it possible for Poussin to be canonized as a national painter whose work testified to France's cultural, as well as political, supremacy.

At the beginning of this case study, I characterized Poussin's achievement as a paradoxical one, simultaneously looking back to the art of antiquity and forward to a new classical tradition. We can now view this apparent contradiction in relation to the circumstances of his career, poised between Rome and France. They allowed him to be presented by art theorists such as Félibien as a kind of conduit through which the art of painting was transferred from its Mediterranean home to a new one further north. In the process, the relatively small-scale canvases that Poussin had painted for the delectation of private collectors took on a new, public identity as major examples of French art that could provide the starting point for the education of later generations of young artists. However, the possibility of this shift in perception could be

said to be inherent in Poussin's paintings from the start since, unlike the frescoes and altarpieces[12] for which Raphael (for example) is chiefly celebrated, they were not site-specific but could be viewed by many people in a variety of settings. Simply in being transported from one cultural context to another – from Rome to Paris, for example – they would be seen in a quite different way. These circumstances suggest that the interpretative openness that we observed in *The Arcadian Shepherds* could be related to Poussin's need to cater to a potentially diverse audience.

Given the emphasis on Poussin's Frenchness in his native country, we might expect that his work would be viewed in a somewhat different light in Britain. This is not to say that his paintings were not appreciated; the first version of *The Arcadian Shepherds* is only one of many paintings by Poussin to have been bought by a British collector during the eighteenth century. Sir Joshua Reynolds expressed high praise for Poussin, who had 'a mind thrown back two thousand years, and as it were naturalized in Antiquity' (Reynolds, *Discourses*, p.256). However, Reynolds also echoed Roger de Piles in saying that Poussin took his study of the antique to such extremes that his paintings tended to be rather dry and hard in appearance.[13] In general, the preference among British art lovers tended to be for Poussin's later landscapes like *The Calm* (Plate 12) or for such light-hearted scenes as *The Bacchanal before a Herm* (Plate 18). This painting was judged in 1807 to be 'the finest Nicholas [*sic*] Poussin in the country' (quoted in Verdi, *Nicolas Poussin*, p.201). Within twenty years, it had been acquired by the newly founded National Gallery.[14] Still, Poussin was undoubtedly a less significant figure for British artists and collectors in the eighteenth and early nineteenth centuries than another classicizing French artist, landscape painter Claude Lorrain (*c*.1604/5–82).[15]

Today *The Arcadian Shepherds* can be seen in the Louvre, where it and the other paintings by Poussin collected by Louis XIV form the basis of the museum's unrivalled holdings of the artist's work. The works that remain in France are, however, outnumbered by the paintings now scattered around the world from the United States to Australia. Poussin's canonical status means that any major museum that wants to present a full account of the history of western art will endeavour to ensure it possesses an example of his work. If possible, an institution would want to own a representative sample of his work, including both early and late paintings, religious and classical themes, history painting and landscape. Since the mid-twentieth century the National Gallery, for example, has redressed the bias of its nineteenth-century acquisitions by shifting towards the more serious and high-minded aspects of his art. *The Bacchanal before a Herm* can now be viewed in juxtaposition to *The Adoration of the Golden Calf* (Plate 19), which shows the same group of intertwined dancers (though in reverse) but could otherwise hardly differ more. One is a scene of pagan revelry, while the other shows an episode from the Old Testament when the Israelites fell into the sin of idolatry. The latter is less accessible and appealing than *The Bacchanal*, but also a more complex work and perhaps more rewarding for the gallery visitor willing to stop and look at it attentively.

[12] Fresco (from the Italian for 'fresh') is a type of wall painting made on damp plaster with pigments suspended in water so that the plaster absorbs the colours. An altarpiece is a painting or sculpture placed upon an altar.

[13] For a discussion of Reynolds, see Case Study 4 by Gill Perry.

[14] On the early history of the National Gallery, see Case Study 7 by Anabel Thomas.

[15] On the admiration for Claude in Britain at this period, see Case Study 5 by Emma Barker.

Plate 18 Nicolas Poussin, *The Bacchanal before a Herm*, 1630–4, oil on canvas, 100 x 143 cm, National Gallery, London. Reproduced by courtesy of The Trustees, The National Gallery, London.

Plate 19 Nicolas Poussin, *The Adoration of the Golden Calf*, by 1634, oil on canvas laid down on board, 154 x 214 cm, National Gallery, London. Reproduced by courtesy of The Trustees, The National Gallery, London.

Conclusion

In this case study I have introduced a number of basic skills of analysis and interpretation that would be needed to develop an independent assessment of a canonical painting. In the process, I have tried to indicate some of the reasons why Poussin is regarded as a great artist. More specifically, I have examined the nature of his classicism. On the basis of the above discussion, we can now suggest that stylistic labels like 'classicism' do not have some kind of fixed and timeless meaning. As we saw, Félibien held up Poussin as a model for French art on account of his study of antique sculpture and the Raphaelesque manner in which he conceived his compositions. By contrast, modern art historians such as Blunt have defined classicism as a set of formal principles (clarity, unity, symmetry, balance, harmony, etc.) that happen to be embodied in certain canonical works of art. We might agree that Poussin's paintings do exhibit these qualities. Nevertheless, I want to emphasize the need to be self-conscious about what we are doing when we analyse a seventeenth-century painting by reference to a modern stylistic label. Also, by defining *The Arcadian Shepherds* as a 'classical' painting, we seem to be suggesting that is all there is to say about it. In fact, art historians today would probably also locate it within a broader cultural and social context.

References

Bätschmann, Oscar (1990) *Nicolas Poussin: Dialectics of Painting*, London, Reaktion.

Bellori, Giovanni Pietro (1672) *Le Vite de' pittori, scultori e architetti moderni*, Rome.

Blunt, Anthony (1967) *Nicolas Poussin*, vol.1, London, Phaidon.

Blunt, Anthony (1998) *Art and Architecture in France*, 5th edn, New Haven and London, Yale University Press.

Cropper, E. and Dempsey, C. (1996) *Nicolas Poussin: Friendship and the Love of Painting*, Princeton University Press.

Félibien, André (1688) *Entretiens sur les vies et sur les ouvrages des plus excellens peintres*, vol.5, Paris.

Fernie, E. (ed.) (1995) *Art History and its Methods: A Critical Anthology*, London, Phaidon.

Haskell, Francis (1995) 'Poussin's season', *New York Review of Books*, 23 March, pp.43–50.

Haskell, Francis and Penny, Nicholas (1981) *Taste and the Antique: The Lure of Classical Sculpture 1500–1900*, New Haven and London, Yale University Press.

Marin, Louis (1988) 'Towards a theory of reading in the visual arts: Poussin's *The Arcadian Shepherds*', in N. Bryson (ed.) *Calligram: Essays in New Art History from France*, Cambridge University Press.

Panofsky, Erwin (1970) '*Et in Arcadia Ego*: Poussin and the elegaic tradition', *Meaning in the Visual Arts*, Harmondsworth, Penguin.

Reynolds, Sir Joshua (1975) *Discourses on Art*, ed. Robert R. Wark, 2nd edn, New Haven and London, Yale University Press.

Verdi, Richard (1995) *Nicolas Poussin 1594–1665* (exhibition catalogue), London, Royal Academy / Zwemmer.

The Parthenon marbles

COLIN CUNNINGHAM

Introduction

We have chosen to study the marble sculptures from the Parthenon in Greece not because they can be seen as the foundation of a western 'canon' of art or even as the beginning of western art – both claims would be inaccurate – but because they are generally agreed to be a part, even an important part, of that canon. I aim to explore some of the reasons why they are considered 'canonical' and to suggest how their canonical status may in turn have affected the later development of western art. When you have finished this study you should have some understanding of how and why they were made, as well as how and why they came to be valued. The first pair of questions can be answered by close analysis of the works and their original context, but their value in later periods has depended on a variety of factors and on different notions of quality. You will see that part of the answer has to do with the role played by institutions such as the British Museum and the Royal Academy in establishing or maintaining the view that they are important.

In this case study I hope to foster your enjoyment of, and interest in, the sculptures of the Parthenon. I also hope to allow you to develop your confidence in analysing and talking about works of art and, in so doing, to become aware of the problematic nature of terms such as 'quality' and 'canonical'.

The nature of the Parthenon marbles and one notion of their quality

The Parthenon marbles is the name given to the group of sculptures – one long frieze, several square panels (called *metopes*) and two huge triangular compositions (called *pediments*) – from the main temple of the goddess Athene in Athens built in the second half of the fifth century BCE.[1] They are in fragments and scattered through half a dozen or more museums in Europe, with the largest number in the British Museum in London. Those in the British Museum are also known as the Elgin marbles after Lord Elgin, who brought them to England in 1807. They were the first large collection of genuine ancient Greek works to be seen in the West, and their authenticity was established because they had been removed from a temple known to have been built in the fifth century BCE, and still standing in ruins.

At the beginning of the nineteenth century, Benjamin West, the President of the Royal Academy in London, wrote: 'I have found in this collection of sculpture, so much excellence in art and a variety so magnificent and

[1] BCE is an abbreviation for 'Before Common Era'; this is the same as BC (Before Christ). CE means 'Common Era', which is the same as AD.

boundless, that every branch of science connected with the fine arts, cannot fail to acquire something from this collection' (Benjamin West to Lord Elgin, quoted in St Clair, *Lord Elgin and the Marbles*, p.167). With such an accolade from the leader of the art establishment of the time, it is no surprise that these sculptures were considered key items in the history of western art. Since their arrival in this country, they have become generally accepted as 'canonical' – that is to say, they have been seen as works of importance 'agreed to represent [the] greatest examples of [their] genre, and which hence provide a standard against which new work can be judged'.[2] Yet a first glance at the sculptures might leave you wondering why such a high value should be put on a collection of broken sculptures (Plate 20), most of which are headless, and which we cannot always identify for certain (Plate 21) or reconstruct with much accuracy. Clearly there is a problem in deciding just what constitutes 'quality' here. It is certainly not completeness.

Let's begin with the goddess *Iris* (Plate 20), often described as the 'flying Iris'. Can we even be certain that this figure is flying? There are no wings left,[3] and we cannot know whether the legs reached to the ground (though, as we shall see, it is possible by careful study to be a little more certain of the way this figure fitted into the whole composition made up of groups of figures). On the other hand, this fragment does have features that would indicate a certain sort of quality. The bent right leg and left leg stretched back, the raised right arm – all of which we can deduce from the position of the stumps – do indicate a figure in swift or energetic movement. Then the folds of the clothing pressed against the flesh, particularly over the belly where there is just a hint of the navel beneath the drapery, and where they flow back over the left leg suggest movement and the pressure of a breeze on the cloth. Finally, we could even add that the drapery is clearly a light material – cotton rather than wool – because of the fineness of the folds. If that adds up to 'quality', what is being valued is skill in representing: making the figure take on the appearance of life. It is, of course, the way the stone is carved that allows us to read it as representing what I have described. So one element in the quality of these works is the sophistication with which they represent the human form.

The idea that they represent the human form is not quite accurate for these figures are identified as gods, and we may need to ask which gods are represented and what they mean. Since we no longer believe in the gods of the ancient Greeks, these figures cannot have the same meaning for us as they did when they were created, and we shall return to that problem later. Yet do their original meanings have anything to do with the value of these sculptures as canonical works, or with the qualities that were valued by the early nineteenth-century critics? I think the answer is probably not. In any case, the ancient Greeks were used to conceiving their gods in human form, and it was the carving of human form that impressed Elgin and his

[2] See Fernie, *Art History and its Methods*, p.329; Fernie here uses the word 'genre' to mean simply 'type' (Case Study 3 discusses the importance of the term 'genre' in greater detail). See also Preface, pp.12–17, where the concept of the canon has been explored in detail.

[3] There are clear traces of fittings for wings in a socket on the back of the figure.

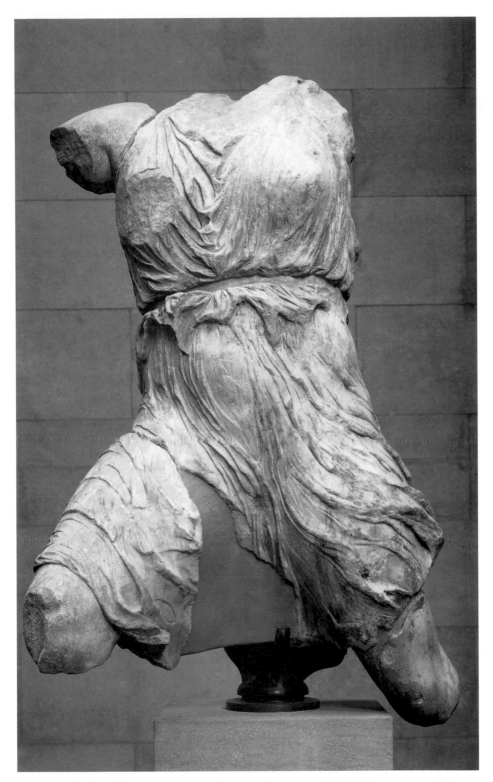

Plate 20 *Iris* from the west pediment, *c.*440–432 BCE, marble, height as preserved 142 cm, British Museum, London. Copyright © British Museum.

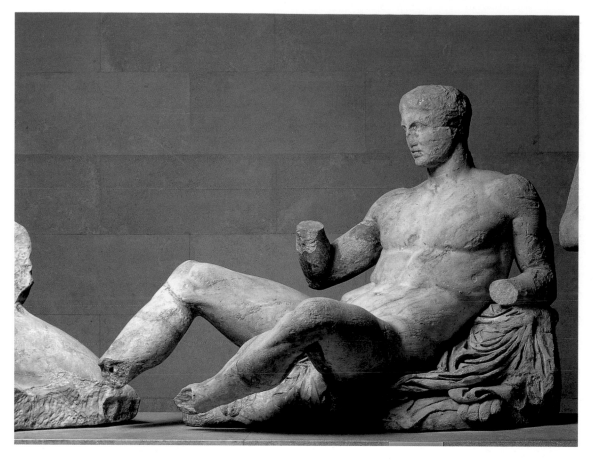

Plate 21 *Dionysus,* formerly identified as Theseus, from the east pediment, *c.*440–432 BCE, marble, British Museum, London. Copyright © British Museum.

contemporaries. The goddess Iris was thought of as the spirit of the rainbow, which makes it more appropriate that she be shown as flying, but her significance in the composition as a whole is unclear.

So, if their canonical status rests on a judgement of their quality as pieces of sculpture rather than their original function as elements of a religious complex, we need to accept that this status does not necessarily involve understanding all aspects of a work of art. The point is that just as individuals are involved in commissioning and making art works, so are individuals (often different individuals) involved in judging the value of those works. We can discover from reading ancient texts the value the ancient Greeks attached to these works, but it would not necessarily be the same as the value placed on them today. It is most often later generations – dealers, critics or museum directors – who subsequently establish individual works as canonical. It is the business of art history to disentangle the many strands of influence that sustain the particular view of art of any generation.

The Parthenon marbles and ancient classical art

Some measure of the importance the Parthenon sculptures have held on the stage of western art is shown by the fact that a picture of the Parthenon (the temple from which they come – see Plate 22) and its sculptures dominate the illustrations of the third chapter of E.H. Gombrich's *Story of Art*, one of the most influential surveys of western art. The chapter is called 'The great awakening', and that suggests something of the attitude we have towards these sculptures. In Greece in the years between about 1000 BCE and 447 BCE, when the Parthenon was begun, we can trace a development from stylized and unlifelike figure drawing to the convincing realism of the sculptures of the Parthenon. We might say that these sculptures represent western art 'fully awake', to extend Gombrich's metaphor.

They are often seen as the best examples of the 'high classical style',[4] and the choice of adjective underlines the respect in which they are held. It is as though all earlier Greek art was somehow low or imperfect, and later works decadent, rather than just different. You could put your reaction to the test by comparing the Parthenon sculptures with examples from other periods (Plate 4 and Plates 23–25). You may well agree, but the important point is to recognize that the acceptance of such peaks is a part of what we call the canon of western art. We shall also see that over the centuries there have been changes and shifts in that canon, and presumably will continue to be.

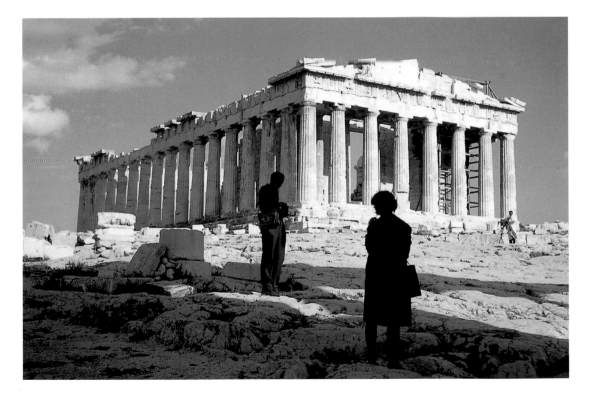

Plate 22 View of the Parthenon, *c.*447–439 BCE, Acropolis, Athens. Photo: Colin Cunningham.

4 See, for instance, Cook, *Greek Art*, pp.123ff.

Plate 23 *The Calf-bearer, c.575–550* BCE, *c.*three-quarters life-size, Acropolis Museum, Athens.

It is also central to our exploration of what is meant by a canon that we realize how these works came to be absorbed in the development of nineteenth-century art. Before they were displayed in the West, notions of the classical had been developed by artists such as Poussin, whose work you have just studied. Actual classical works were known from the examples excavated in Italy (such as Plate 24), but most of these were either Roman copies of Greek works or Hellenistic.[5] Thus the impact of a substantial collection of authentic fragments from the 'best' period of Greek art displayed in a major public museum was considerable, and brought a significant development in taste and in the concept of the canon.

[5] The term Hellenistic refers to the period of Greek history covering the three centuries after the death of Alexander the Great in 323 BCE.

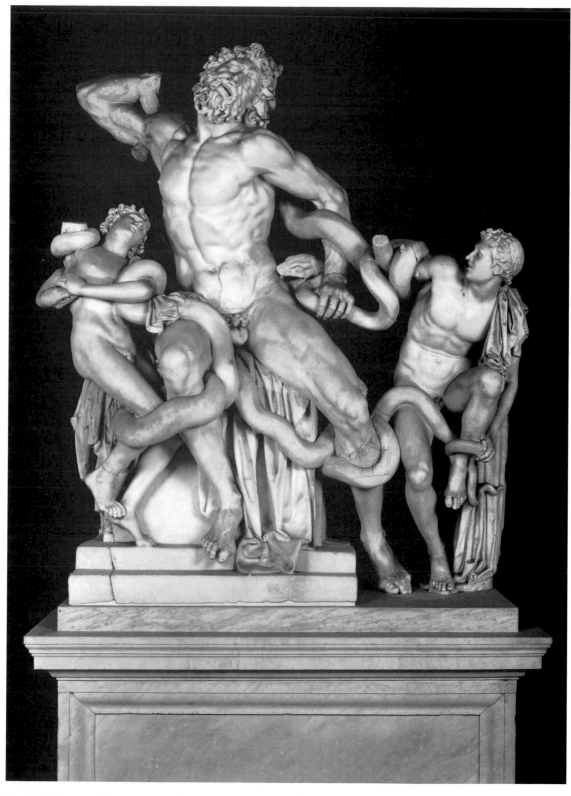

Plate 24 *Laocoon*, Roman copy, first century CE, of a Greek original of *c*.200 BCE, marble, just under life-size, Musei Vaticani, Archivio Fotografico, Rome.

Plate 25 Archaic *kore* (dedicatory statue of a maiden), *c*.520 BCE, plaster cast of original, colour restored by R.M. Cook, *c*.one-half life-size, Museum of Classical Archaeology, Cambridge.

Changes in the canon come about because new discoveries or a new approach to representation give us a new standard by which to judge previously admired works. The classical world had been a source of inspiration since the time of Poussin, but it was largely imagined by reference to Renaissance and later paintings rather than by ancient works of art, still less by Greek originals. The display of the Parthenon marbles signified a major change in the understanding of the classical. What is important is not only the place of the Parthenon marbles in the original development of Greek art, but the huge impact the rediscovery of ancient Greece in the late eighteenth century had on western art and art history.[6] Quite simply, a whole class of previously admired sculpture was now considered inferior in comparison with the sculptures of the Parthenon. To say that they are better is, of course, a judgement rather than an objective fact. In order to understand this judgement, we need to look at some of the ways in which they have been valued.

If we look at some of the comments made by scholars and critics over the centuries, it is often difficult to see precisely why these sculptures are so highly valued. Look at Plates 21 and 26–30, and then read the following extracts. Make a note of what each commentator values in Greek sculpture in general or the Parthenon in particular.

[6] The decline of Turkish power and the first stirrings of Greek independence greatly helped to focus attention on ancient Greece.

Plate 26 Parthenon frieze, North XLII, *c.*440–432 BCE, marble, height *c.*100 cm, British Museum, London. Copyright © British Museum.

Plate 27 Parthenon frieze, North II, *c.*440–432 BCE, marble, height *c.*100 cm, Acropolis Museum, Athens.

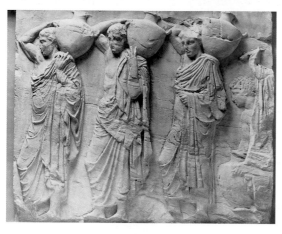

Plate 28 Parthenon frieze, North VI, *c.*440–432 BCE, marble, height *c.*100 cm, Acropolis Museum, Athens.

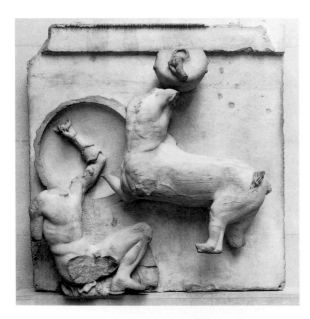

Plate 29 Metope, South IV, *c*.440–432 BCE, marble, height *c*.120 cm, British Museum, London. Copyright © British Museum.

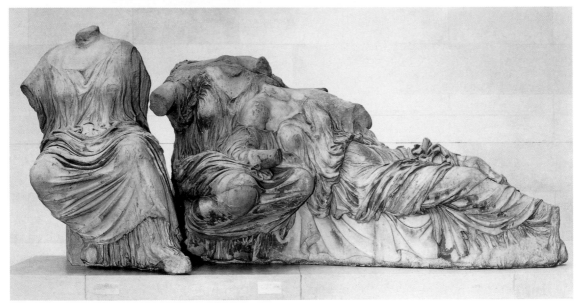

Plate 30 Three seated goddesses (Hestia, Dione, Aphrodite) from the east pediment, *c*.440–432 BCE, marble, height as preserved 193 cm, British Museum, London. Copyright © British Museum.

What is it that attracts the eyes of those to whom a beautiful object is presented, and calls them, lures them towards it, and fills them with joy at the sight? … Almost every one declares that the symmetry of parts towards each other and towards a whole, with, besides, a certain charm of colour, constitutes the beauty recognised by the eye …

(Plotinus,[7] *c*.260 CE, *Ennead* I.6.1)

[7] Plotinus was a philosopher writing in the middle of the third century CE – that is, 700 years after the Parthenon was built.

It is not only *Nature* which the votaries of the Greeks find in their works, but still more, something superior to nature; ideal beauties, brain born images ... The last and most eminent characteristic of the Greek works is a noble simplicity and sedate grandeur in Gesture and Expression ...

(J.J. Winckelmann,[8] 1767, *Reflections on the Painting and Sculpture of the Greeks*, pp.4, 30)

You have lost your labour, my Lord Elgin. Your marbles are overrated: they are not Greek: they are Roman of the time of Hadrian.

(Richard Payne Knight, 1806, quoted in St Clair, *Lord Elgin and the Marbles*, p.175)

The first thing I fixed my eyes on was the wrist of a figure in one of the female groups, in which were visible, though in a feminine form, the radius and the ulna. I was astonished for I had never seen them hinted at in any female wrist in the antique. I darted my eye to the elbow, and saw the outer condyle visibly affecting the form as in nature. I saw that the arm was in repose and the soft parts in relaxation. That combination of nature and idea was here displayed to midday conviction. My heart beat! If I had seen nothing else I had beheld sufficient to keep me to nature for the rest of my life ... But when I turned to the Theseus and saw that every form was altered by action or repose – when I saw, in fact, the most heroic style of art combined with all the essential detail of actual life, the thing was done at once for ever. Here were principles which the common sense of the English people would understand ...

(Benjamin Robert Haydon, 1806, quoted in St Clair, *Lord Elgin and the Marbles*, p.170)

The Hellenic ideal was the perfect shape, with little or no actively intellectual content ... The handsome young men of the Parthenon frieze are utterly unresponsive; they do not share a mental reaction between them, even when struggling with a refractory bull.

(Mortimer Wheeler, 1964, *Roman Art and Architecture*, p.160)

Discussion

Clearly there are differences in what was valued, and even nineteenth-century contemporaries such as Payne Knight and Haydon feel very differently about the same works. Plotinus' admiration for the symmetry of parts is especially difficult to appreciate in fragmentary works, though we might feel his comments were appropriate descriptions of the Dionysus (Plate 21). Winckelmann judges the sculptures to have noble simplicity and sedate grandeur of gesture and expression. This in turn is a little difficult to equate with Wheeler's disparaging comment (written to contrast these works with later Roman sculpture) that they were empty headed and without a trace of emotion. But the severest criticism comes from Payne Knight, who dismissed the sculptures as of little value since he thought they were not Greek.

◆◆

Neither Winckelmann's nor Plotinus' comments were written directly about the Parthenon but of Greek sculpture in general. Plotinus stresses 'symmetry of parts', which is more easily intelligible in relation to the composition of the pediment (which we now appreciate from reconstructions) than to the individual pieces. In this context it is interesting that Pausanias, who saw the Parthenon complete and in use, only mentions the two pediments and the

[8] Johann Joachim Winckelmann was an influential German scholar and art critic who first argued the superiority of Greek art over Roman. In fact, he never visited Greece and therefore never saw the Parthenon or its sculptures.

now lost cult statue.[9] He ignores both frieze and metopes completely. Winckelmann, on the other hand, was concerned with beauty and knew Greek art only from individual figures excavated in Italy, but his definition of beauty is as imprecise as that of Plotinus. You may very well agree that 'beautiful' is an appropriate word to describe these works; but if you also feel that that does not get us very far, we need to ask whether other factors have been at work in establishing these as canonical works of art.

Haydon is probably the most useful of the critics I have cited, for he explains very precisely what it was that he admired – namely, the truthful depiction of nature. Benjamin Robert Haydon (1786–1846) was a painter deeply interested in establishing in Britain a school of high-status 'history' painters influenced by the classical tradition (see Plate 31). His interests were thus parallel to the achievements of Charles Le Brun in France in the late seventeenth century (discussed in Case Study 3). In the event Haydon's efforts were unsuccessful, but his comments reveal a direct professional interest. He refers to specific elements of the human skeleton in his reference to the female figure. He goes on to describe the *Dionysus* (Plate 21) 'with the belly flat because the bowels fell into the pelvis as he sat' in contrast to the *Ilissus* figure (Plate 32) whose 'belly protruded, from the figure lying on its side'. This is something that can be easily observed, but it is significant that he summarizes the works as heroic as though the naturalism itself had some divine quality.

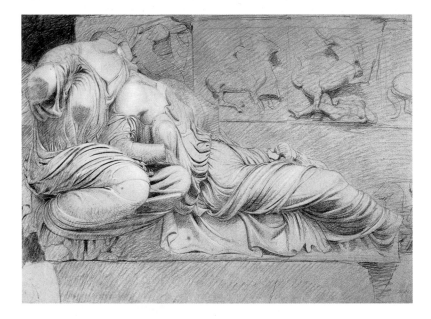

Plate 31 Benjamin Haydon, drawing of the three seated goddesses, then known as the 'Three Fates', from the east pediment of the Parthenon, 1809, pencil, British Museum, London. Copyright © British Museum (British Museum catalogue of drawings by British Artists, Haydon 3(6)).

[9] Pausanias, *Guide to Greece*, p.69. Pausanias (fl. 150–70 CE) was a Greek traveller and antiquarian who described the important buildings and monuments in Athens, almost all of which were still standing when he wrote. (The abbreviation fl. (for the Latin word *floruit*, or flourished) means the period when an individual was known to be actively working and is often used when their lifespan is unknown.)

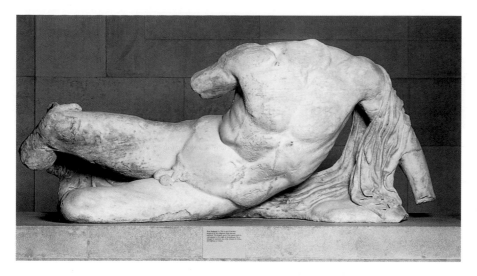

Plate 32 *Ilissus* (a river god) from the west pediment, *c.*440–432 BCE, marble, length as preserved 143 cm, British Museum, London. Copyright © British Museum.

Payne Knight was quite wrong in attributing the sculptures to the later Roman period, but we can nevertheless be interested in the reasons he gives to denigrate them. Payne Knight's denial of the quality of the marbles was based on the same assumption as Winckelmann: that Greek work was best. Yet Payne Knight was a well-known critic whose 1805 book on taste (*An Analytic Inquiry into the Principles of Taste*) had itself been very influential. In it he argued that ideal beauty did not exist but that there were 'certain standards of excellence which every generation of civilized man subsequent to their first production has uniformly recognised in theory how variously so ever they have departed from them in practice. Such are the precious remains of Greek sculpture, which affords standards of real beauty, grace and elegance, in the human form and the modes of adorning it, the truth and perfection of which have never been questioned' (quoted in St Clair, *Lord Elgin and the Marbles*, p.173). If his assumption that Greek works were best was widely accepted, then Greek works should form the standard by which others could be judged. That still leaves the question: best for what?

The Parthenon marbles and the western canon

There are probably two distinct ways in which we can continue our exploration. We can consider how far the Parthenon marbles have affected the development of the canon of western art, and then whether that canon itself is so securely established that we should continue to value them so highly. This would certainly be an important art-historical enquiry, and we shall return to it later in this case study and elsewhere in this book. Or we could try to satisfy ourselves that there was some justification for the admiration expressed, and in so doing spend some time examining the sculptures themselves. This is what we shall do now. But it is important to remember that in discussing what has been admired in a given art work, we are talking about the reactions of individuals who, in turn, are influenced by the cultural currents of their own time rather than simply by any inherent qualities in the work.

We shall begin by asking which of the commentators was most convincing and why. It is a difficult question and probably has no correct answer, but in addressing it we may discover some important factors that underlie the study of art history. In the first place, Payne Knight's mistaken identification of the statues as Roman is an interesting error. He made the remark at a dinner party before he had even seen the statues. This was unwise since, once they were on view, it was generally accepted by contemporaries that they were definitely Greek and of real quality, and Payne Knight's reputation never recovered. Yet it is not only the bad scholarship (an attribution without even seeing the sculptures!) that is interesting. There is also the assumption that Roman works were inferior to Greek. This attitude has its origins in the work of some Roman writers (like Virgil's *Aeneid* in the first century BCE) who were happy to claim that Rome's destiny lay in political and military prowess. They were content to employ Greeks as artists or to collect Greek works of art. However, during the Renaissance it became the common view that Rome and things Roman were the best models for artists. One part of the reason for this was simply that Greece was largely under Turkish domination, and so little known in the West.

The superiority of the Greeks as a tenet of art history was first argued by Winckelmann in the eighteenth century in opposition to the primacy of Roman art. Winckelmann viewed the development of art as analogous to human life, passing from infancy to maturity and thence to decline, perhaps in a repeated cycle. As we have said, he never visited Greece and knew Greek art mostly from Roman copies. Yet he was the first scholar to try to identify actual Greek works from descriptions in ancient sources,[10] and he was passionate about the superiority of Greek sculpture: 'The superiority which art acquired among the Greeks is to be ascribed partly to the influence of climate, partly to their constitution and government, and the habits of thinking which originated therefrom, and, in an equal degree also, to respect for the artist, and the use and application of art' (Winckelmann, *The History of Ancient Art*, 1764, quoted in Fernie, *Art History and its Methods*, p.74). Winckelmann was probably attracted to the sculpture of classical Greece for the realism of its depiction, but he goes on to associate political and intellectual characteristics of Greek democracy with the value he sees in their sculpture.

Winckelmann's view of Greek art as superior to Roman has dominated western thinking and is still widespread (if not universal, as the Wheeler extract indicates). That is not to say that there are not fine, even canonical, works of art from the Roman era. Yet the belief that they are somehow inferior to Greek work obscures the sense in which they were fulfilling different functions and represented different intentions. Plate 33 shows a section of an important relief from the early imperial Roman period, and could be compared to the frieze of the Parthenon. Indeed, it was in comparing these two that Mortimer Wheeler remarked on the lack of expression in the Greek work. His view was based on a belief in the importance of individualized portraiture. On the *Ara Pacis* (Altar of Peace) it is possible to identify several members of the imperial household. You should be able to identify several distinct faces, whereas if you compare faces in the frieze of the Parthenon, there is hardly any characterization. That is because the figures of the Parthenon frieze are not intended to be individual portraits. Most probably that would have been considered sacrilegious, since the sculptures were a

[10] The *Natural History* by Pliny the Elder (23–79 CE) contains several valuable descriptions and was available in translation from 1601.

Plate 33 *Ara Pacis*, detail of the south frieze showing a sacrificial procession with members of the imperial family, 13–9 BCE, marble, height *c*.180 cm, Rome. Photo: Fratelli Alinari.

part of a temple. So it is important to try to recover the intentions of the makers and the original function of an art work as a part of the study of art history.

The function of the Parthenon marbles

Meaning

So far we have discussed the sculptures of the Parthenon without paying attention to their context. We have not really addressed the basic questions: what are they and what were they made for?

Knowing the source of an art work, its provenance, can be important in establishing its value and its meaning. In the case of the Parthenon marbles, there was no doubt of their provenance, and their genuineness was further proved by the existence of descriptions of them *in situ* (in position) by Roman writers. That the temple was known to have been built in the fifth century BCE was conclusive proof that these were original Greek works and not Roman copies. At a time when Greek art was considered superior to Roman almost by definition, this fact alone was enough to establish these pieces as of high quality and probably, therefore, canonical. Since the temple was also one of the most important in classical Greece and was particularly richly adorned, it was a fair assumption that its sculptures would be some of the finest of their kind. We need, however, to consider how the fact that they come from a temple affects the way they appear. The sculptures can be divided into three groups: the metopes, the frieze and the pediment figures. This takes account of important factors in their making and reflects specific functions.

First, let us look carefully at the diagram showing the location of the sculptures (Plate 34) and check the location of Plates 30, 35 and 36 from the captions. We can then consider the effect these locations have on the way the sculptures

are made, as well as the effect the locations have on the viewer. The three goddesses (Plate 30) were set in the low gable space (pediment), and the metopes (Plate 35) were set below them as a series of separate frames. The frieze (Plate 36) is inside the colonnade, high up above the inner columns. This has a considerable effect on the way the various elements are made. The pedimental figures are just over life-size, and were arranged to fill the entire triangular space of the gable. This makes for extraordinary difficulties in the organization and composition, which Greek temple builders had been faced with for centuries. The solution on the Parthenon is a symmetrical composition on either side of the main figure (Plate 37). The diminishing height of the gable means that the principal figure, in this case Zeus (king of the gods), is carved to a greater scale and shown seated. He is flanked by groups of gods, first flying or standing, then seated (Plate 30), with the corners filled by the heads of horses which indicate the rising chariot of the sun and the exhausted horses of the moon's chariot sinking to rest (Plate 38). It seems to me that this is an extremely sophisticated arrangement in which the artist has used the limitations of his space to enhance the meaning of his composition. The scene shows the birth of Athene, the goddess to whom the temple was dedicated,[11] with all the gods in attendance, and the scene is set at dawn.

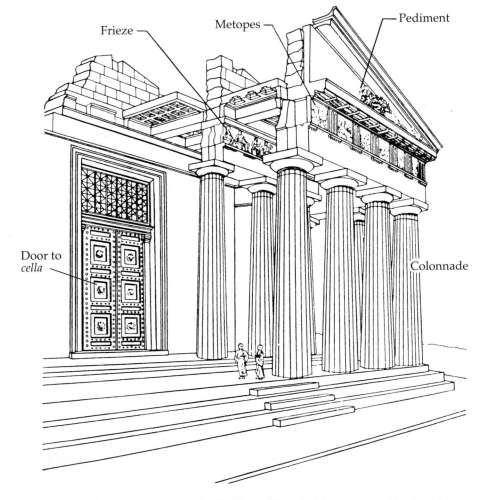

Plate 34
Diagram showing the location of the sculptures. Adapted from P.E. Corbett, *The Sculptures of the Parthenon*, 1959, Penguin.

[11] According to legend Athene was the daughter of Zeus by Metis, a personification of wisdom, but owing to a prophecy that this offspring would be greater than her father, Zeus took the embryo and swallowed it. Nine months later he developed a headache, which he cured by asking Hephaistos to split his head open with an axe. When this was done, the new goddess sprang forth fully armed. It is this moment that is shown on the east pediment of the Parthenon.

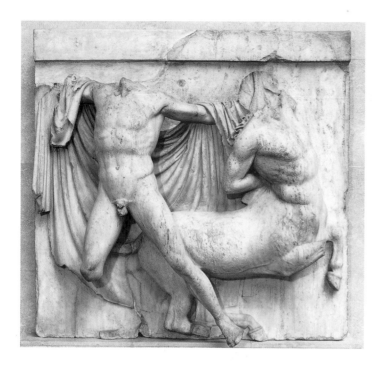

Plate 35 Metope, South XXVII, *c*.440–432 BCE, marble, British Museum, London. Copyright © British Museum.

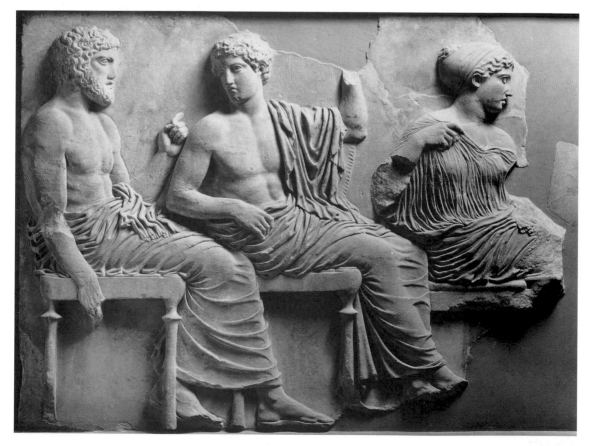

Plate 36 Parthenon frieze, East VI, *c*.440–432 BCE, plaster cast of original, height *c*.100 cm, Acropolis Museum, Athens.

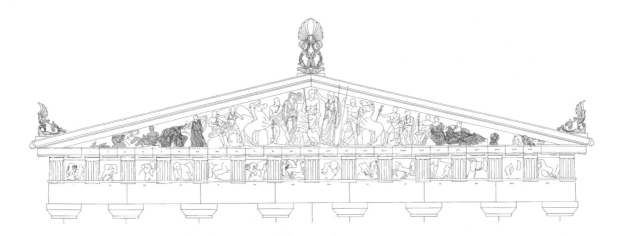

Plate 37 Reconstructed drawing of the east pediment shaded to show the fragments in the British Museum (composition reconstructed by E. Berger from casts assembled from different museums). Reproduced by permission of Professor E. Berger and Antikenmuseum Basel.

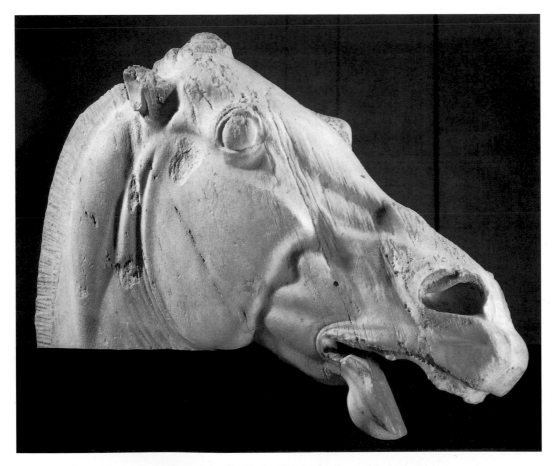

Plate 38 Horse's head from the east pediment, *c*.440–432 BCE, marble, life-size, British Museum, London. Copyright © British Museum.

The metopes are individual slabs, each of which is roughly 120 centimetres square, with a raised border at the top. On each slab a pair of figures is arranged[12] so that each composition fills a square, but there is little suggestion of a link from one to another. This is because the individual slabs were separated by the intervening ribbed panels (called triglyphs). On each side of the temple the metopes were designed to show a series of scenes related to different themes. The metopes in the British Museum come from the south side, and show centaurs[13] struggling with people known as Lapiths. (According to legend the centaurs had become drunk at a wedding, and a wild brawl ensued.) The struggling figures seem to me particularly dynamic designs. Since they were viewed from some 12 metres below, the designer frequently set his figures with either a head or a rounded object such as a wine jar high up so that from below the form would cut across the frame of the slab, giving even greater drama to the scene – the figures would appear to burst out of the frame (Plate 39).

The frieze is designed as a single long image. It measured roughly 160 metres in length, of which about 128 metres survive. A single continuous image fills the field, which is only about 100 centimetres high. This created enormous problems, which again I think the designer has handled with skill. The subject chosen involves a huge number of people in a procession – about the only

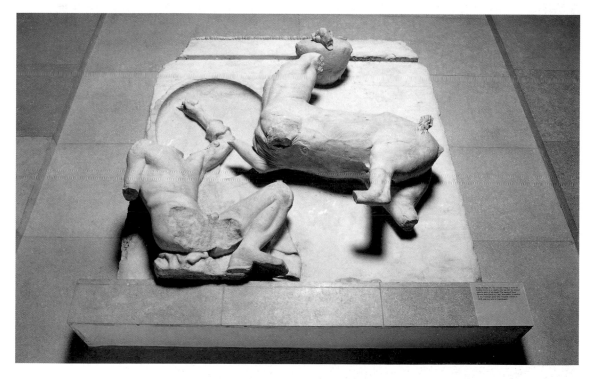

Plate 39 Metope, South IV, from below, *c*.440–432 BCE, marble, British Museum, London. Copyright © British Museum.

[12] In fact a few of the metopes, not illustrated here, had more than two figures.

[13] The centaur was a mythical monster, half man, half horse.

subject that would fit such a long shape. If you look at Plates 40–41, you will see how the sculptors have sometimes designed their figures so that they do not run over the joins, and at others have run the figures continuously across more than one slab. The effect of this is to give a sense either of slow movement or of continuous flowing movement, and the variation – as the procession forms up, moves off, gallops along or slows down at the approach to the holy moment – prevents the frieze from being monotonous.

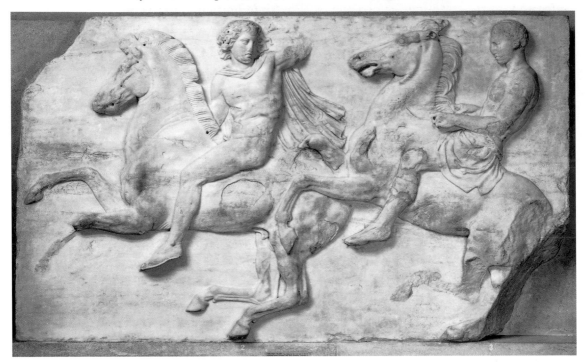

Plate 40 Parthenon frieze, West I, *c.*440–432 BCE, marble, height *c.*100 cm, British Museum, London. Copyright © British Museum.

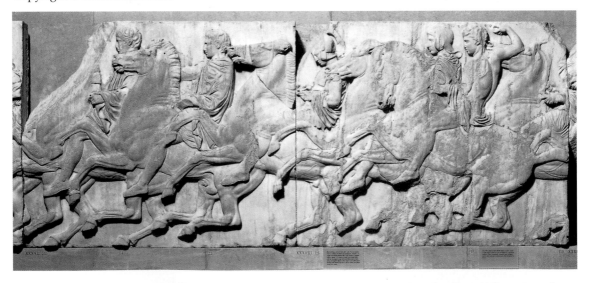

Plate 41 Parthenon frieze, North XXXVII and XXXVIII, *c.*440–432 BCE, marble, height *c.*100 cm, British Museum, London. Copyright © British Museum.

At this point it is worth pausing to consider the problems of dealing with such a large and varied group of figures. The whole collection consists of a very large number of figures, broken fragments and so on. As there is disagreement about the precise interpretation of some of the elements, it would not be possible to refer to all the scenes, still less individual figures, by a name or description without a risk of confusion. Instead we make use of the conventions of archaeologists. The two pedimental groups are simply referred to as the east and west pediments, with the figures identified either by name or by the number of the stone they are mounted on. The metopes are referred to according to the side of the temple from which they were removed, and numbered in sequence from left to right. The frieze is identified by the individual slabs, which are named for the side from which they originally came and numbered (with Roman numerals) in sequence from left to right, with the human figures also numbered (using Arabic numerals). Although this convention gives a degree of anonymity to the images, it is an important example of the need for precision in referring to art works, particularly multiple art works.

The status and function of architectural sculpture

All these sculptures were set high up on the temple, and can be described as architectural sculpture. In ancient Athens they were viewed from below and at rather a steep angle, so it was impossible to examine them close up and to admire the details of craftsmanship (Plate 42). We have seen how some elements of their design were deliberately aimed at making them appear dramatic from a distance. Yet the early nineteenth-century critics who admired them looked at them from close up as individual works of art, though they were conceived of only as subsidiary decoration for a building in which stood the cult statue of the goddess. And it was this statue that mattered to the ancient Greeks.

It is difficult for us to come to terms with the original fascination exerted by the cult statue, though it was important enough to be frequently copied in antiquity. We know that it was a colossal figure over 12 metres high and made of thin plates of gold and ivory set on a wooden frame. The gold made it a prime target for later vandals, and now nothing remains beyond a socket for the main support in the floor of the ruined temple. Yet it was this statue that was renowned and brought fame to the artist, Pheidias. The marble sculptures, hardly mentioned by Pausanias, had a much lower status. They were difficult to see in detail, and appear to have been as little thought about as the sculpture on the outside of the British Museum itself (Plate 43).

Architectural sculpture has a different status in the mind of the viewer, and is often dismissed as mere decoration, with an assumption that it is of little worth. There are many examples of architectural sculpture such as the British Museum pediment, and most of the time we hardly notice them, even if we visit the building on which they are carved. Just like Pausanias, we tend to concentrate on the treasures inside the museum rather than on the museum building itself. Yet in the case of the Parthenon marbles, art historians have accorded them the status that was originally reserved for the cult statue.

Plate 42 Parthenon, detail of north-east corner with metope and pediment, Acropolis, Athens. Photo: Alison Frantz/American School of Classical Studies, Athens.

Plate 43 British Museum façade showing sculpture in pediment, 1845–51, Portland stone, London. Photo: The Conway Library, Courtauld Institute of Art, University of London.

In considering the original location of these works, we have been thinking about their original function. This is often important in art history. Equally, it is often difficult to recover when works of art have been removed to a gallery or museum. You have to make an imaginative leap to get an idea of how they were intended to be seen. Plate 44 gives you some idea of what the sculptures may have looked like, but even in this imaginative recreation the artist has chosen to show the viewers up scaffolding, seeing the sculptures as they can only ever have been seen before the building was completed. Plate 45 shows how we see them today, with the sculptures brought down to the viewer's level.

One of the reasons why a modern museum might display the sculptures in a different context is because our interest in them is different from that of the ancients. Now that we have a chance to see them close up, it is possible to appreciate the sophistication of the carving and its detail. In short, we are invited to react to them aesthetically, as art objects in a museum.

Their original function was much more complex. They were adjuncts to a religious activity, and should also be read alongside what we know of the festivals they were made for. Such an approach can help us to understand why they were made as they are, but to do this we need to rely on the skills of archaeologists as well as the interpretation of ancient texts. This is more in the nature of a historical enquiry, and I can only summarize the main points that are agreed.

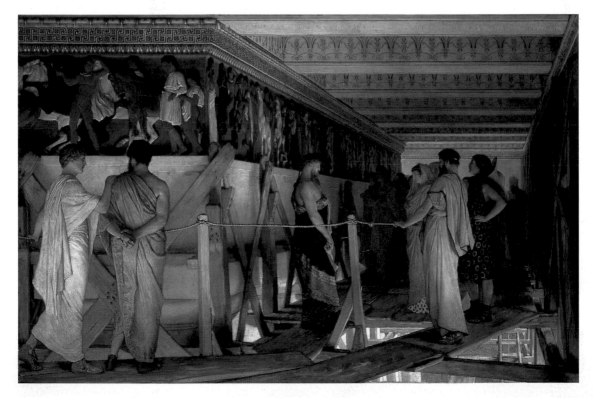

Plate 44 Sir Lawrence Alma Tadema, *Pheidias Showing the Parthenon Frieze to Pericles and his Friends*, 1869, oil on panel, 72 x 110 cm, Birmingham Museum and Art Gallery.

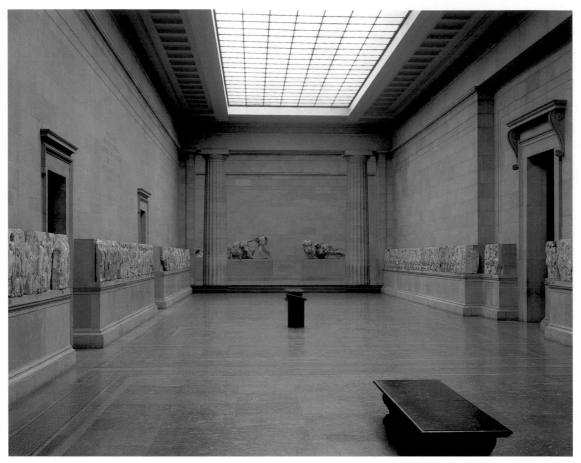

Plate 45 General view of the Duveen gallery, British Museum, London. Copyright © British Museum.

The Parthenon marbles decorated the principal temple of Athene in the city that bears her name. The temple is unusual in having sculptures in both pediments that refer to the goddess to whom it was dedicated. It is unique in Greece in having all 92 metopes decorated with sculpture. Unique also is the continuous frieze round the outside of the *cella* (the structure inside the colonnade – see Plate 34). Worshippers approached from the west, and the first sculptural element seen would be the west pediment. This showed the contest between Athene and Poseidon[14] for possession of the land, a contest which Athenians would have known the goddess won with her gift of an olive tree, symbolizing the basis of Athenian agriculture. The east pediment showed the birth of Athene, with Zeus seated at the centre of the gods (Plate 37). Both pediments would have been reminders of the importance of Athene in her city of Athens, and the richness of her principal temple would have served to remind visitors of the importance which Athens claimed among the independent city-states of Greece.

The series of metopes on each side of the rectangular temple showed battles. The ones illustrated here (Plates 29, 35 and 39) are of the battle between the mythical and wild centaurs and the Lapiths, and could be read as symbolizing the struggle for civilization. Again the Athenians would have felt that their city was an example to the world in its civilized democratic government. Because they were designed as individual panels, it is perhaps easier to enjoy them as isolated objects.

[14] In classical mythology the god who ruled the sea.

The frieze ran right round the inner wall of the temple. It began at the south-west corner and depicted two streams of worshippers moving, slowly at first and then more rapidly (compare Plates 26, 40 and 41), towards the east end of the temple, where the procession slowed with a more solemn group of people bearing sacrificial objects. Finally, over the entrance of the temple was the scene in which a robe was presented to the goddess in the presence of all the gods (Plate 36). The frieze would only be seen intermittently as the worshipper passed along the side of the temple. There is much argument about the precise interpretation of this frieze,[15] but it is generally agreed that it relates to the Panathenaic procession in which the youth of the city rode to her shrine with a new robe for the goddess.

Technique

One of the reasons why the frieze and the collection as a whole were so highly thought of by nineteenth-century critics is their technical virtuosity. The three subgroups – the pedimental figures, the metopes and the frieze – are each carved in a different way. The pediments are carved in the round, the metopes in high relief, and the frieze in low relief (also called bas-relief).[16] They are, however, all carved out of a solid block rather than built up. This method is known by the Greek word glyptic, where the method of building up and modelling, which is more suitable to clay or bronze that is cast from a clay mould, is known from another Greek word, plastic.

In glyptic sculpture, material is cut away to reveal the form inside a solid block of stone. The sculptor had not only to design a figure that would fit into the overall composition, but to conceive how the individual figure would fit inside a single block of stone. It was not possible to add material once it had been cut off. The figure would be roughed out by chipping away quite large pieces, and then the surfaces would be gradually smoothed down, sometimes using a drill (for undercutting deep folds) and sometimes chipping away tiny particles like sand. Finally, the surface would be rubbed with pumice to give a smooth, flesh-like texture.

Although the pediment figures could only be viewed from in front and below, they were carved 'in the round'. That is to say, they were made in such a way that, were it not for the setting, they could have been viewed from all sides, as they are in the gallery of the British Museum (see far end of gallery in Plate 45). You might wonder why the sculptors wasted all that effort on something that could never be seen, and we can only guess at answers. One reason might be that these sculptures were for the principal temple of the city, and so should be as perfect as possible.

[15] John Boardman in 'The Parthenon frieze, another view' links the figures of the horsemen to the dead of Marathon and sees the frieze as a part of the celebration of Athens' victory over the Persians. More recently, Joan B. Conelly in 'Parthenon and *Parthenoi*' suggests a revision of the interpretation of the east frieze relating it to ancient myths.

[16] High relief sculpture is moulded or carved so as to stand out from a surface with projections proportional to the objects represented. In low relief sculpture the projection from the surface is very slight.

We have seen how impressed later critics were by the naturalism of the carving, and this can be seen as the culmination of a long tradition in which various techniques for making figures appear natural were worked out. This progress can be seen clearly if you compare the treatment of the hair in Plate 23 and of the horsemen in Plate 40. Tracing this sort of stylistic development is one art-historical activity, but I am not sure that we should automatically assume the more naturalistic works are somehow 'better'. Indeed, this view of aesthetic progress has not always been assumed, and in some cultures – particularly, for instance, in Chinese art – would be largely irrelevant. On the other hand, we can appreciate some of the technical devices. One example will suffice.

Look at Plate 30 (page 52). How has the sculptor sought to convince us that there are limbs under the drapery?

Discussion

I hope you would agree that the figures are convincingly naturalistic. They seem to be bodies with clothes on rather than bundles of cloth with heads and hands sticking out. What the sculptor has done is to carve the folds of the drapery in such a way that we can 'read' leg-like forms under the drapery. You may notice that he has carved folds of drapery running across the thigh of the goddess on the left. Inevitably these folds are curved, and that curve suggests to us that under the drapery would be a rounded thigh. It is extremely convincing yet it is simply a device. If you think for a moment, folds do not naturally fall that way across a form. Cloth hangs down, and most folds are roughly vertical. Anyone who wanted their dress to have folds horizontally across their legs would need to arrange them very carefully! The effect, however, is to give a realistic round appearance.

◆◆

The relief sculptures are equally impressive in technique. Both the metopes and the frieze were built into parts of a wall (or colonnade), and so the background slab was a part of the sculpture. The metopes are carved in very high relief, sometimes projecting as much as 23 centimetres from the background. Most of the figures are fully formed and attached to the background slab (often only at one or two points) by small sections of marble that would have been invisible in front. One unfortunate result of this has been that many bits have broken off, as you can see if you compare Plate 29 with the seventeenth-century drawing of it in Plate 46. If we remember, however, that marble is a very brittle stone and liable to snap (especially when a small section has to support a large weight), the technical achievement of these metopes becomes impressive. I think the technical skill is one factor which has helped to establish these sculptures as canonical.

The frieze in low relief is also impressive technically for the way it depicts so many people and horses overlapping. Yet it is nowhere more than 6 centimetres deep. You can study Plate 41 and try to work out how many layers of people are shown. The left-hand block shows three horses and two riders, and the rear horse must just about overlap with the hindquarters of the front horse, which we cannot see. That would mean three horses, one behind the other, in a mere 6 centimetres.

Plate 46 Jacques Carrey, drawing of metope, South IV, 1674, crayon, Bibliothèque Nationale de France, Paris.

The frieze is naturalistically treated like the pedimental figures, but again the sculptor has manipulated our recognition. It is made up of figures standing and riding, yet the heads of the riding figures are no higher than those of the standing ones (Plate 26). Having all the heads at a similar level helps to maintain the rhythm of the composition, and is also essential in filling the whole height of the frieze with the design. The horses may seem to you a bit of a problem too, as they are rather smaller than we might expect. The sculptors have compromised with scale in order to achieve a unified design. You have to decide for yourself whether the result is satisfactory, but it is important to understand what is being done. These problems in making an art work are wide ranging, and we shall not always focus on them specifically.

There is a final point to consider: the material and original surface appearance. We have already seen that the cult statue which is now lost was made of gold and ivory. We can also discover from ancient sources that the Greeks valued bronze more highly than marble for statues (see Plate 47). Statues of bronze could have something more of the colour of sunburned flesh, and they were often made with inlaid eyes of glass or paste and with copper on the lips. Clearly the Greeks enjoyed colour, and we know that many of their statues were coloured. Plate 25 shows a reconstruction of the original colouring of a statue that was dedicated on the Athenian Acropolis[17] a generation or so before the Parthenon. Colour was used for the Parthenon too. The frieze had a background of blue, as did the metopes, and it is certain that the sculptures of the pediment were coloured as well. Several of the sculptures also had bronze attachments. You can make out drill holes on the frieze; these were made for the bridles of the horses that were added to the marble. This elaboration may make the sculptures seem garish to us – but if it does, that is because our western tradition of sculpture has been formed in part by the rediscovery of the Parthenon marbles, and they had lost their original colour during centuries of neglect. Recent discoveries and reconstructions are making

[17] The sacred hill on which the Parthenon stands.

Plate 47 Bronze warrior from Riace recovered from the sea in 1972,
460–450 BCE, height 198 cm, Museo Nazionale, Reggio.
Photo: Hirmer Verlag.

us think again about the original appearance of Greek sculpture. If the idea
of coloured sculpture seems strange to you, that shows the influence the
western canon has had on all of us. Yet much western medieval sculpture
was brightly coloured, and many other cultures regularly paint their
sculptures.

Artists and authorship

So far I have avoided saying much about the artist responsible for the
Parthenon marbles, but we generally think of an art work as being by
someone. In fact, the obsession with individuals is a relatively recent
phenomenon. Medieval artists worked as groups, often anonymously, and it
is really only in the last two centuries that we have seen the cult of the
individual 'genius'. In the case of the Parthenon we do know the name of the
artist, Pheidias, but a moment's reflection should make us realize that it would
be impossible for one man to carve all the figures himself. This group of
sculptures must have called for the employment of sculptors from all over

the Greek world, and possibly from beyond. Indeed, there had not been so elaborate a commission since the King of Persia built his summer palace at Persepolis (completed *c*.460 BCE), and it is possible that some sculptors who worked at the Parthenon could previously have worked in Persia (now Iran). The connection with Persia might even make you wonder whether these works belong entirely with western art. I prefer to think that boundaries of that sort are often unhelpful. Greece had close connections with both Persia and Egypt, and it is possible to argue that Greece is as important in the history of the Middle East as in that of the West.

The question of the role of Pheidias is a matter for speculation. The sophistication of the composition of the pediments and the consistent composition of the frieze both suggest that a single mind was behind the whole design. But there are inconsistencies of detail in the metopes and the frieze (especially in the treatment of hair), and different handling of drapery in the pediment figures also suggests different carvers (compare Plates 40 and 41). Pheidias was almost certainly the designer of the whole series, and he probably selected the subjects, or at least the way they would be treated. Since the cult statue was the most important element, it is likely that his own work was concentrated on it, so it is possible that he did not himself wield a chisel on any of the marble sculptures. Yet he is the only one who is remembered by name. Of course, as sculptor-in-charge he would have had the task of co-ordinating the disparate band of carvers.

Pheidias is a rather shadowy figure, though we know of some other works by him, and the Riace bronzes (Plate 47) could possibly be from his workshop. It may seem strange that works so important in the canon of western art are essentially anonymous. The problem of anonymity is only one of the difficulties in dealing with works of the classical period. We know relatively few names of artists, and many works have been destroyed. At this distance we are unlikely to discover much firm information about the artists, so our art history in the classical period must rely on the works themselves and descriptions of them.

The difficulty here is that the best sources are from the Roman period, several centuries after the Parthenon was built. On the other hand, the Romans admired Greek work, just like the eighteenth-century scholars. Many Romans collected Greek sculptures – the Riace bronzes were probably on their way to a Roman collection when their ship went down – and many more had copies made. Many famous works survive only as written descriptions or as copies, in which case we have no way of knowing whether the copy is at all accurate. Thus the facts that the Parthenon marbles are authentic works of the fifth century BCE and are by a named sculptor who was reckoned famous in his own day are compelling reasons for seeing them as important landmarks in the history of Greek art. These alone help to make them canonical, though you might feel there was a degree of accident in their survival where other works (such as the cult statue) are lost.

In the light of information provided so far, can you say which Parthenon sculptures would have been more important in antiquity and why? Which one of the surviving groups – metopes, frieze or pediment – seems to you most important? What materials were used for these sculptures? What effect have those materials had on works of art since the nineteenth century?

Discussion

In considering the importance in antiquity of the Parthenon sculptures, you should include the cult statue as well as the figures from the pediment, the frieze and the metopes. The one ancient source that describes the building makes clear that the cult statue was seen as more important. It was, after all, central to the religious function of the Parthenon. This no longer survives. Of the surviving works, many would rate the frieze the most important on the grounds that it is a highly sophisticated composition, and that it was technically difficult to depict such a rich array of figures in shallow relief. It is perhaps also significant that it is more complete. One could also argue that the pediment figures are the most important because they are at least mentioned in the ancient sources. Your own choice will probably be personal and might be based on the principle that one group gives you most visual pleasure.

The material of the surviving sculptures is marble, and much nineteenth-century sculpture is of marble. The colour is now lost, and we've seen that this has contributed to the western taste for uncoloured sculpture. There were also bronze attachments, but these too are lost. In the same way we are unused to sculpture in stone that incorporates other materials. Finally, the gold and ivory of the lost colossal cult statue have had very little influence. We generally expect statues in precious metals such as gold to be on a small scale, whereas stone sculpture is more often on the heroic scale or at least life-size.

◆◆

The Parthenon marbles in the western canon

Coping with what remains

If the Parthenon marbles are manifestly important in the study of Greek art, should they also be important for western art as a whole? Largely because of the attitude of eighteenth and nineteenth-century scholars, the work of Greek artists, and those of the fifth century BCE in particular, has been seen as the high peak of ancient art. Yet appreciation is made doubly problematic by the fact that these works are so damaged. Although the British Museum has the largest collection of sculptures from the Parthenon, there are other pieces in the Louvre in Paris, more in Athens, and scattered fragments elsewhere. Thus it is virtually impossible to recover the impression of the complete original. Simply because the fragments are scattered, it is extremely difficult even to work out which bits fit with which. Because the sculptures have been removed from their original locations, it has also been difficult to be sure where the figures belonged in the composition. The *Iris* (Plate 20), for instance, was for many years exhibited as from the east pediment rather than the west.

The remaining fragments are sufficient for us to be confident of the overall quality and to work out the composition of the whole complex. However, the history of the Parthenon marbles, almost from the moment the temple was finished, has had a major impact on the ways these works were viewed and the ways we are able to study them now. The pagan temple survived until early in the Christian era, though the gold from the cult statue was removed at a fairly early stage. It is likely that the bronze fitments were

removed in late classical times, but the first major alteration came in the fifth century CE when the Parthenon was turned into a Christian church. The whole of the central part of the east pediment was destroyed, partly to make an apse for the church and partly because the images were pagan. Many of the metopes were defaced at this time for the same reason. When Greece passed into the Ottoman Empire in the mid-fourteenth century, a mosque was erected in the temple and a minaret added to the west end. In 1687, while the Turks were at war with the Venetians, a stray shell hit a powder magazine in the temple and blew up most of what was left. Fortunately, a few drawings had been made shortly before (Plate 46), and they remain precious evidence for the original state of the sculptures.

Changing attitudes

We have seen how little attention was paid to these sculptures, as opposed to the cult statue, by Pausanias in the classical period. The ruins were left undisturbed by the Turks, though nothing was done to repair the structure and winter storms dislodged the odd sculpture, while fallen pieces were burned by the locals to make mortar. Few westerners visited Athens, though some scholars did note the importance of the temple and its sculptures.

In the late eighteenth century a very different view was taken, as the story of their recovery shows. Under Napoleon, the French took a lively interest in antiquities. The recording and collection of such things was a significant element in Napoleon's imperial designs. The French consul in Athens, Louis Fauvel, tried to collect sculptures from the Parthenon (Plate 48), and several fragments did eventually reach the Louvre in Paris (Plate 49).

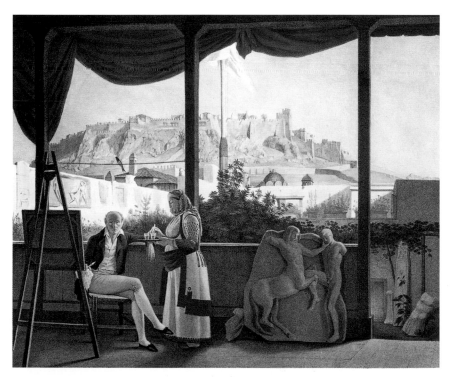

Plate 48 View of the Acropolis showing the French consul being served coffee by his Turkish servant, while a metope from the Parthenon stands on his loggia, eighteenth century, engraving, Cambridge University Library. By permission of the Syndics of Cambridge University.

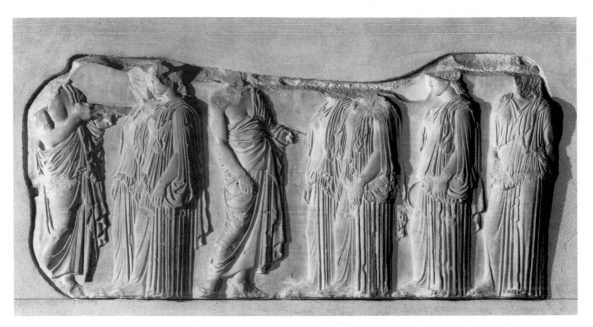

Plate 49 Parthenon frieze, East VII, *c*.440–432 BCE, marble, height *c*.100 cm, Musée du Louvre, Paris. Photo: Patrick Lebaube.

In 1799 Lord Elgin was appointed British ambassador to Turkey, and became interested in the sculptures. He hired artists (though he decided not to employ the young J.M.W. Turner), and planned to record and make plaster casts of as much as possible. At that moment there were good reasons (in the threat from France) why the Turkish authorities might wish to support the British, and Lord Elgin was given permission to put up scaffolding round what the Turks called 'the ancient Temple of the Idols', to make drawings and plaster casts, and to take away 'any pieces of stone with inscriptions or figures'.

Lord Elgin's collection was considerable. It included vases, coins, a large Egyptian carving of a scarab (bought in Turkey), fragments from a variety of buildings, some architectural samples from the Parthenon as well as the pedimental figures, fourteen metopes and about 90 metres of the frieze. The collection was assembled by 1804, and shipped back to England in two royal naval vessels. A further load aboard Elgin's own brig sank on the way home, and had to be salvaged. Elgin himself was captured in France in 1803 on his way home, and imprisoned until 1806. When he finally reached London, he found most of his collection waiting for him,[18] augmented by a few pieces captured from the French by Nelson.

Initially, the sculptures were displayed in a shed in the grounds of Elgin's house in London on the corner of Park Lane and Piccadilly, and only shown to selected visitors. These included artists such as Benjamin West, Benjamin Haydon (quoted above), Henry Fuseli, Sir David Wilkie, Sir Thomas Lawrence and John Flaxman. Flaxman, a pupil of the sculptor Canova and one of the designers hired by Wedgwood to model the figures for his classically inspired

[18] The last crates did not leave Athens until 1811. Lord Byron, who thoroughly disapproved of Lord Elgin's depradations, was a passenger on the same ship.

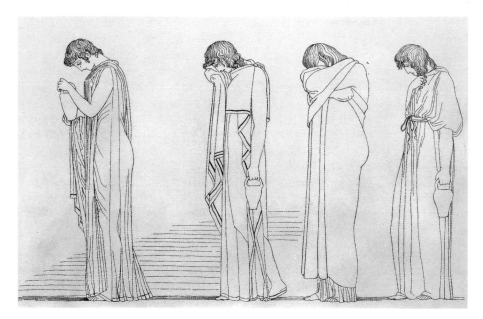

Plate 50 John Flaxman, figures based on the Parthenon frieze, steel engraving ('They bring oblations' from *The Choephoroi*, a play by Aeschylus). Engraved by Thomas Piroli and Frank Howard, *Compositions from the Tragedies of Aeschylus*, 1879, Sealey, Jackson and Halliday, Plate 24. Copyright © British Museum, Department of Prints and Drawings.

Jasper ware, declared Lord Elgin's marbles 'very far superior' to the Roman copies of Greek works that had until then been the only sources for what Winckelmann had established as 'correct' taste. Flaxman's drawings show the unmistakable influence of the Parthenon frieze (Plate 50), but it is probably more interesting that Elgin invited Flaxman to restore the sculptures. Clearly, Elgin felt that these broken stones were not good enough as they stood. However, Flaxman, believing that the value lay in the original work rather than in any modern restoration, argued that it would not increase their value and besides would cost some £20,000! Today we would feel it was fortunate that Elgin was persuaded to leave the stones as they were. Perhaps also fortunately, Elgin's financial situation meant that he could no longer afford to keep the collection for his private pleasure, and the general admiration for his sculptures led to the suggestion that they should be bought by the British Museum, where they were finally taken in 1816.

The influence of the museum

The fact that these works of art are in a museum rather than an art gallery might surprise you. You will shortly be studying the origins of the British National Gallery (Case Study 7), but it is important to remember that both galleries and museums as public institutions for the collection and display of art are relatively recent phenomena. The National Gallery was not founded until 1824, eight years after the Parthenon marbles reached the British Museum, and the British Museum itself only dated back to 1753. It also still contained all the specimens that were eventually to form the basis of the Natural History Museum, so in 1816 it was more like a collection of curiosities than what we would understand as an art collection. The addition of the Elgin marbles greatly enhanced the collection.

The British government tended to see the museum in comparison with the Louvre, and in 1816 the British collection was a very poor second to that great collection. So, given the French interest in the Parthenon marbles, we may read a degree of national pride in the decision to buy them and display them as great national treasures. Some 50 years later the newly unified German state took a similarly competitive view. The minister of culture wrote to the king: 'It is of particular importance that the collections of the museums ... acquire a work of Greek art that only the numerous Attic[19] and Near Eastern sculptures in the British Museum can compare to or approach' (quoted in Kunze, *The Pergamon Altar*, p.10). The result was the acquisition of the great frieze from the altar of Zeus at Pergamon (*c*.180–60 BCE), a leading example of Hellenistic sculpture, as the Parthenon frieze is of classical. So it is important to consider the extent to which nationalistic political or economic pressures may have a role to play in the valuing of art works.

There was a further tension. Were items such as the Parthenon marbles to be seen as aesthetic treasures (to be valued by artists) or as pieces of historical evidence (to assist classical scholarship)? They are, of course, both – but the way that question was answered would affect the way the sculptures were displayed. If they were to be seen as historical evidence, they might have no more importance than other objects such as coins, vases or pieces of architecture, and should perhaps be displayed alongside those so as to reveal the history of ancient Greece. If the other view was taken, then aesthetic considerations might govern the way they were displayed.

If we look at Plates 51–54, we can find evidence that the artists' view prevailed. The sculptures were displayed on their own, without other exhibits such as vases or coins which might present a complete picture of the history or daily life of ancient Athens. Even the architectural fragments, which were shown with the sculptures as late as 1912, are now in a separate room.

The painting by Archer (Plate 53), which shows the room where they were first displayed,[20] gives a hint why this might be, in that it includes a number of portraits of artists, and even shows one sketching. For many years the museum was a place to which Royal Academy students were sent to draw 'from the antique'. From the start the Parthenon marbles were considered as an essential teaching aid for artists, as is clear from the evidence offered by leading sculptors to the Parliamentary Commission enquiring into their purchase.[21] In the year after the sculptures went on public display, 223 artists were issued with tickets to draw them. It is possible to trace their popularity from the records, running at around 4–6,000 from the 1830s to the 1850s, with a peak of 15,626 in 1879 to a low of 518 in 1935.[22] Students were regularly set to copy these works, and further afield they were given plaster casts for

[19] [That is, classical Greek.]

[20] The painting does not record the original arrangement. The horse's head, for instance, was not displayed on the floor, and the standing nude and seated figure in the alcove do not come from the Parthenon. The painting also does not show the many architectural fragments that were displayed in the same room.

[21] An extract from this evidence is included in Edwards, *Art and its Histories: A Reader*.

[22] The details are recorded in the annual Parliamentary Returns for the museum, and are analysed in Jenkins, *Archaeologists and Aesthetes*, pp.30–2.

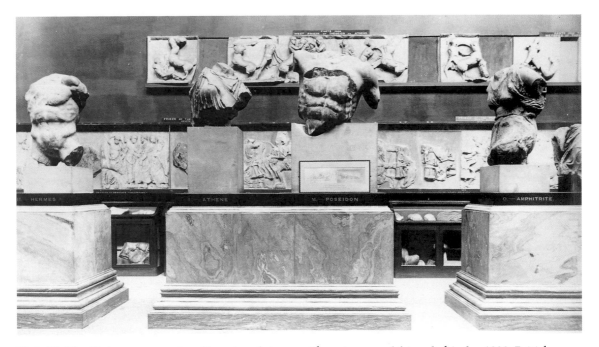

Plate 51 The Elgin room, west pediment sculptures with metopes and frieze behind, *c*.1890, British Museum, London. Copyright © British Museum.

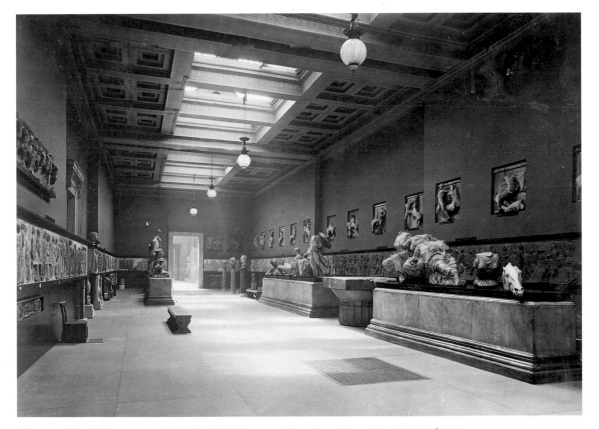

Plate 52 The Elgin room, *c*.1912, British Museum, London. Copyright © British Museum.

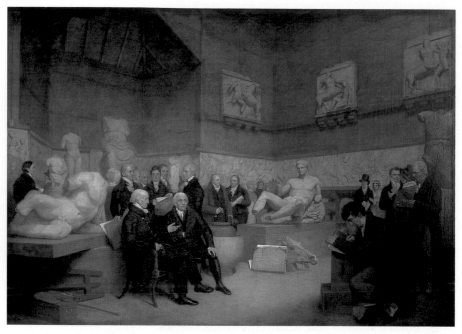

Plate 53 Archibald Archer, *The Temporary Elgin Room* (showing Benjamin Haydon sketching far left and Benjamin West, President of the Royal Academy, in profile seated left), 1819, oil on canvas, British Museum, London. Copyright © British Museum.

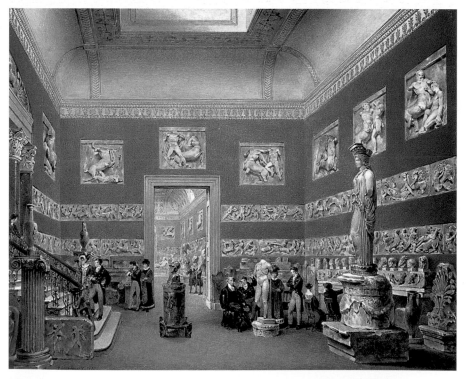

Plate 54 James Stephanoff, a gallery in the British Museum (some of the Parthenon metopes are shown, but the frieze is from another temple – more Parthenon sculptures are visible in the further gallery), 1818, watercolour, British Museum, London. B.M. PD 1935-3-9-3. Copyright © British Museum.

the same purpose (Plate 55). This example is an indication of the importance the British felt belonged to these works of art, even in Asia. Besides, the President of the Royal Academy was an *ex officio* member of the Board of Trustees of the museum, and thus could exert a good deal of influence. Also from 1808 to 1852 the arrangement of sculpture in the museum was in the hands of Richard Westmacott (1775–1856), Professor of sculpture at the Royal Academy, who also carved the pedimental sculpture on the outside of the museum (see Plate 43).

The importance of canonical status can be seen in the way the Parthenon marbles were compared to the museum's equally outstanding collection of Egyptian sculpture, and during the nineteenth century it also acquired Assyrian, Lycian and Hindu works. These were all seen as less advanced stages on the road that led to perfection in the Parthenon and the subsequent decline of ancient art. Today we might think of them merely as different, and not assume that the Egyptian, Assyrian and Hindu sculptors had been aiming at the same type of naturalism as the Greeks. Equally we might feel that the later Hellenistic and Roman sculptors (Plates 4, 24 and 33) had wanted to convey ideas of drama, psychological involvement or (in the case of the Romans) individual portraiture that were of no interest to the fifth-century BCE Greeks.

Plate 55 Student drawing after the antique (*Dionysus* from the east pediment), J.J. School of Art, Bombay. Photo: courtesy of Partha Mitter.

Display and meaning

The nature of the argument between artists such as Westmacott and the archaeologists had its effect on the way the sculptures could be viewed.

Compare Plates 45, 51 and 54, which show the Parthenon marbles on display in the early nineteenth century, late nineteenth century and late twentieth century. Looking at each arrangement, does it aim for a pleasing display or to reveal the way the sculptures were originally set?

Discussion

In the earliest view (Plate 54) I think it is the pleasing display that predominates. The gallery in 1890 (Plate 51) sets out the different groups of sculptures as they were originally, but not spaced as in their original relationship. In the Duveen gallery today (Plate 45), there is a different attempt to display the sculptures as they were originally disposed.

◆◆◆

I hope you noticed that the painting by Stephanoff (Plate 54) contains sculptures from other locations. The Parthenon marbles are not all in one room (you can make out the *Dionysus* through the door), and in fact the painting shows the temporary Phigalean room,[23] not the Elgin room. On the other hand, you may feel, as I do, that the red wall helps to set off the marble sculpture in a way that the plain stone walls of the Duveen gallery do not. However, it would also be true to say that the late nineteenth-century display (Plate 51) does not show the Parthenon marbles as they were designed to be seen originally, although it allows the works to have an impact as individual pieces or sets of pieces. You might also have noticed that in the 1890s it was difficult to see the individual works because, although they appear to be displayed together, each one is seen against a background of other pieces. It seems to me that this might be a more archaeological approach.

The Duveen gallery (Plate 45), in contrast, is more consciously elegant, though you may have spotted that the metopes cannot be seen in the view of the Duveen gallery. Concentration is emphatically on the pedimental figures and the frieze, which came to be considered the 'best' elements. That is because they show a more even style (pages 57–63 above explain the justification for this). The metopes are displayed on the sides of the transepts at the end of this gallery. What is less easy to see is that, by displaying the pedimental figures in the order they were set in the gable, a false impression is given. If you check against Plate 37, you will see that the British Museum only has figures from the corners of the gable, and there is a gap of some 18 metres where the figures have been destroyed. I would argue that this makes the scale of the original difficult to comprehend. There is also a problem with the frieze. It is beautifully set where the viewer can examine it in detail. But it was originally on the outside of a building, so that here it is effectively inside out. Also the design of the gallery means that it has to be arranged along the two long sides of the room, though it consists of sections from all four sides of the original temple.

[23] Called after the Temple of Apollo at Bassae in Phigaleia in southern Greece, from where the frieze set in the wall was taken.

Finally, we ought to consider just what the Duveen gallery is. The inscription on the wall records that 'these galleries designed to contain the Parthenon Sculptures were given by Lord Duveen of Millbank 1939'. In fact, because of the Second World War the display was not opened until 1962, and the world of the 1960s was very different from that of the 1930s. Perhaps this display represents only a stage in the development of the canon. The sculptures are displayed as pieces with an assumed quality not related to their original context or to other works of the same type. This approach to display was already beginning to be out of date when the gallery opened.

And there is the question of who Lord Duveen was. He made his fortune as a dealer in paintings, selling mainly to American collectors. It has been said that his genius was to spot that there was a great deal of art in Europe and a great deal of money in America, and to bring the two together. Certainly, Duveen helped to build up many of the outstanding private collections that now form the core of several prestigious American museums. From the European or British point of view, it would be possible to regret that he was the dealer who arranged for so many art works (such as Gainsborough's famous *Blue Boy*, formerly in the Duke of Westminster's collection and now in the Huntington Library in California) to be sold overseas. His whole career can be seen to have had a particular sort of impact on art history, since the works he was responsible for moving have often become the centrepieces of their collection, thus acquiring a new importance within the canon of western art. Yet his memorial is here in the Duveen gallery, and it is a measure of the importance of the Parthenon marbles in the western canon that he felt it was worth paying for a special gallery to house them.

However, the reverence that Elgin and Duveen felt for the Parthenon marbles is only one aspect of the meaning these sculptures have had in the history of western art. It is also important to remember that they have an additional, equally vital meaning in the land of their origin. Although Athens was never the capital of Greece in ancient times (whatever the Athenians may have felt), the sculptures of the Parthenon have become a national symbol for the modern state of Greece. One reason is that they were removed with the permission of the Turkish authorities (in Greek eyes a foreign occupying power), and that the event took place only a few years before the Greek War of Independence. There is now a lively campaign to have the marbles returned to their original home. (Presumably this should involve bringing together the fragments from the Louvre, Copenhagen and other museums.) A new Acropolis centre in Athens contains galleries the same width as the Parthenon, where it would be possible to display the pedimental figures correctly spaced, and where it would only be necessary to cross the road to see their original setting. This is no place to enter into the complicated political arguments, but the effect on art history if they were to be moved might be considerable. It would alter the manner of their display again, and effect a considerable change in the way we understand the sculptures. They would acquire yet another meaning.

Conclusion

In this study I have tried to provide you with some understanding of how and why the Parthenon marbles were made, and explanations of how and why they came to be valued. In doing so, I have attempted to demonstrate how judgements of the sculptures and attitudes to their display have changed over time. This is the essence of our problem that notions of quality and canonical status are not static.

We have explored some of the reasons why the Parthenon marbles have come to be seen as canonical, looking closely at the ideas and ideals of classical art which were involved. In conjunction with the preceding study on Poussin, this exploration of the history of the classical canon has revealed the power of critics, art historians and the institutions of art (such as museums and academies) in helping to establish, and sustain the value of, works which are now seen as landmarks within the western canon of art.

The values of art history can also be absorbed into a broader political culture. For example, the classicism of the Parthenon marbles was both appropriated as canonical by its British audience *and* identified with a contemporary political ideology. It has been argued that the marbles were even perceived by Victorians as helping to confirm the idea of Britain as a universal and civilizing imperial power. By exhibiting these works prominently within a public museum and identifying with the form of naturalistic art displayed, they could claim some affinity – or even continuity – with classical Greece.[24]

References

Boardman, J. (1977) 'The Parthenon frieze, another view', in Ursula Höckmann and Antje Krug (eds) *Festschrift für Frank Brommer*, vol.1, Mainz.

Conelly, J.B. (1996) 'Parthenon and *Parthenoi* – a mythological interpretation of the Parthenon frieze', *American Journal of Archaeology*, ns, vol.100, January.

Cook, R.M. (1976) *Greek Art: Its Development, Character and Influence*, Harmondsworth, Penguin.

Edwards, S. (ed.) (1999) *Art and its Histories: A Reader*, New Haven and London, Yale University Press.

Fernie, E. (ed.) (1995) *Art History and its Methods: A Critical Anthology*, London, Phaidon.

Gombrich, E.H. (1995) *The Story of Art*, 16th edn (first published 1950), London, Phaidon.

Hitchens, Christopher (1988) *The Elgin Marbles*, London, Verso.

Jenkins, Ian (1992) *Archaeologists and Aesthetes in the Sculpture Galleries of the British Museum, 1800–1939*, London, British Museum Press.

[24] These ideas are discussed in Hitchens, *The Elgin Marbles*.

Kunze, Max (1991) *The Pergamon Altar: Its Rediscovery, History and Reconstruction*, Mainz, Verlag Philipp von Zabern.

Pausanias (1971) *Guide to Greece*, trans. Peter Levi, Harmondsworth, Penguin.

Plotinus (1969) *Ennead*, trans. S. McKenna, 4th edn revised B.S. Page, London, Faber & Faber.

St Clair, William (1967) *Lord Elgin and the Marbles*, London, Oxford University Press.

Wheeler, M. (1964) *Roman Art and Architecture*, London, Thames & Hudson.

Winckelmann, J.J. (1972) *Reflections on the Painting and Sculpture of the Greeks*, trans. Henry Fusseli [*sic*], facsimile of 1765 edn, London, Scolar Press.

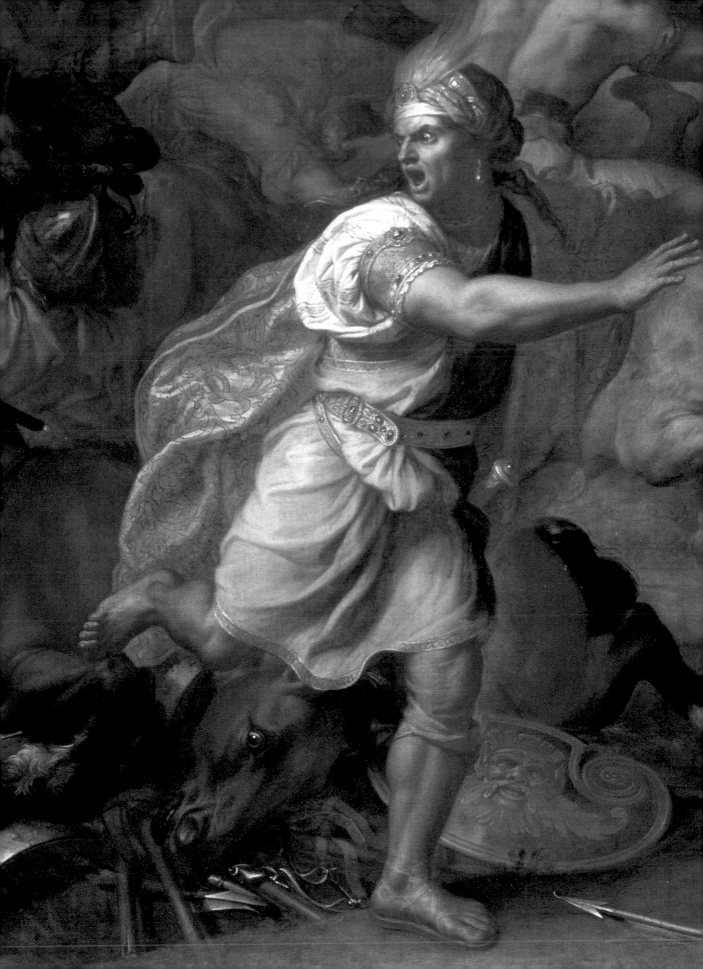

PART 2
ACADEMIES, EDUCATION AND THE CANON

Introduction

In this part we focus on the role of academies of art and what we loosely label 'academic' values in the construction and evolution of the canon of western art. While the two preceding case studies have explored the nature and persistence of classical values within this western tradition, here we shall explore those evolving values as they were institutionalized and absorbed into educational culture. Through detailed discussion of the activities and theories associated with two influential European academies – the French Académie royale de peinture et de sculpture (Royal Academy of Painting and Sculpture, founded in 1648) and the British Royal Academy of Art (founded in 1768) – we shall examine some of the contested ideals of canonical art which have been associated with the two institutions and some of the key figures active within 'academic' art at the time. The last case study in this part will further open up to scrutiny the concept of 'academic' art and its shifting relationship with canonical values through a study of two nineteenth-century British artists, Joseph Mallord William Turner and Frederic Leighton.

Plate 56 (Facing page) Charles Le Brun, detail of *The Battle of Arbella* (Plate 69) showing Darius's lieutenant.

Charles Le Brun,
'art dictator of France'

LINDA WALSH

Introduction

> For twenty years he remained the art dictator of France, and as such he became
> the real creator of the 'academicism' to which French art owed its world fame.
>
> (Hauser, *Social History of Art*, vol.2, p.182)

Arnold Hauser's comment represents a common view of the career of Charles
Le Brun (1619–90), First Painter (from 1661) to King Louis XIV of France,
Rector (from 1665) and then Director (from 1683) of the Académie royale
(Plate 57). It is often claimed that Le Brun used his position of influence to
dictate the subjects and styles of contemporary art. As First Painter to the
king, his role was to attend to important royal commissions and advise the
king on artistic matters. In the same way that the rule of Louis XIV (Plate 58)
was 'absolute' (that is, there were few curbs or checks on his power as head
of church and state), so the 'reign' of Le Brun is often seen as one in which
artistic independence was suppressed by his attempts to establish and enforce
universal laws or standards for art. His regime left little scope for democratic
debate or individual expression. The dangers of his regime were exacerbated
by the fact that the main form of patronage for artists at the time was that of
the royal court, exercised through its control over the Académie.

The issue is of importance for more recent analyses of art because it touches
on the vexed question of the relationship between paintings and the
institutional frameworks in which they were created. From the nineteenth
century onwards, great value has been attached to personal expression,
freedom and individual creativity in art. In such a climate, Le Brun's paintings
can appear too highly institutionalized. They seem to emerge too directly
from the rules and standards of taste sanctioned by the Académie in the
seventeenth century. According to Pierre Vaisse, the idea of Le Brun's art
dictatorship dates back precisely to the period when the term 'academic'
took on pejorative connotations, around 1800.[1] Such connotations usually
include the excessively erudite, the formulaic, the idealized and the
unthinking, élitist transmission of 'high' culture. Those who visit Le Brun's
works in the Louvre, however, will appreciate how modern taste can respond
to their grandeur, if not their subject-matter and technique. At the time of
writing, visitors can experience a separate space in the Louvre in which they
are surrounded by the massive canvases of Le Brun's Alexander series, some
of the paintings being over twelve metres wide and four metres high.

[1] Vaisse, 'L'esthétique XIXe siècle'. Vaisse explains how the terms 'academic' and 'official'
were closely associated in nineteenth-century discourse, thus emphasizing the academies'
perceptions of themselves as centres of state power.

Plate 57 Nicolas de Largillierre, *Charles Le Brun*, 1686, oil on canvas, 232 x 187 cm, Musée du Louvre, Département des Peintures, Paris. Photo: Copyright R.M.N.

Plate 58 Hyacinthe Rigaud, *Louis XIV*, 1701, oil on canvas, 277 x 194 cm, Musée du Louvre, Département des Peintures, Paris. Photo: Copyright R.M.N.

In this study we'll be investigating the accuracy of Hauser's view of Le Brun and of his influence by looking at examples of the works he produced and the theories he expressed. He devoted much of his attention to decorating Louis's royal residences, including the Palace of Versailles; he was asked to work on this after Louis had seen and envied Le Brun's magnificent decorations at Vaux-le-Vicomte, a chateau built for the Finance Minister, Fouquet. Le Brun's royal service took many other forms. He often accompanied Louis to his war camps and battle sites, for example, in order to make studies for paintings celebrating the king's campaigns. In an address to the Académie royale, Louis said, 'I entrust to you the most precious thing on earth – my fame.' We can gain some idea of Le Brun's role as royal flatterer by looking at Plate 59, *The King Governs Alone*. This is a ceiling painting executed by Le Brun between 1679 and 1684 for the Hall of Mirrors of the Palace of Versailles (Plate 60). Le Brun was in charge of the decoration of the palace and supervised a large team of artists and craftsmen who made tapestries, paintings, sculptures, ornaments and furniture as decorative ensembles. He also did many paintings himself.

In the painting we see Louis XIV, dressed in antique style, sitting in splendour on his throne (near lower edge as we view the reproduction). He looks towards a figure representing Glory who holds the royal crown; she is next to winged figures carrying trumpets, symbols of renown. Louis is surrounded by a host of allegorical figures[2] and objects emphasizing the qualities and achievements

2 Figures which stand for abstract qualities or attributes. Objects, actions and narratives can also have allegorical significance due to their historical and cultural associations.

Plate 59 Charles Le Brun, *The King Governs Alone*, 1679–84, oil painting of central vault, ceiling of the Hall of Mirrors, Versailles. Photo: Copyright R.M.N.

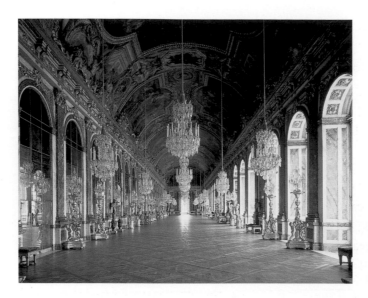

Plate 60 Hall of Mirrors, Versailles. Photo: Copyright R.M.N.

of his reign and country: Flora, goddess of flowers and fruitfulness (to the left of Louis) wearing her belt of flowers; Peace, carrying a cornucopia of flowers, to the left of Flora; Ceres, goddess of agriculture (in the lower left edge), wearing her traditional crown of ears of corn. The female figure (bottom left-hand corner) whose robes and shield are decorated with the fleur-de-lis, the French royal coat of arms, holds an olive branch representing peace and stands for the nation itself. Elsewhere there are references to commerce, agriculture, war and manufacturing: a pot of gold, pitchforks, spears and hammers, as well as objects and activities signifying everyday life – card games and musical instruments, for example.

The message is fairly clear: Louis inhabits the realm of the gods. Although Time, with his customary hourglass and scythe (the latter signifying death – the 'grim reaper'), flies above Louis's head, Louis is only partly mortal. These pagan references to Louis's divine status carried particular significance in Catholic France. It had been believed for some time that the monarchs of France ruled by divine right as God's representatives on earth. The strong union of state and Catholic Church in seventeenth-century France reinforced the 'heavenly' status of kings.

As Director of the Académie royale, Le Brun could influence both its teaching programme and its precepts: he could steer pupils and academicians towards priorities of style and subject-matter, both in his recommendations about which past masters should serve as models and in the formal resolutions passed at meetings and lectures. In this way he was at the centre of attempts to establish and transmit an artistic canon in late seventeenth-century France. I am using the word 'canon' in two senses here: first, as a body of works to which the highest value is attached within a particular society and, second, as a set of rules or principles which help to define such works as canonical. As we saw in the Preface (p.12), the word 'canon' can be defined as a general rule, principle or standard, as well as a set of authoritative works or texts. In other words, Le Brun wanted to establish a set of principles and practices which would be regarded as the norm for all those aspiring to produce high art, and as a touchstone against which the value of art and artists of all kinds

could be measured. The principles of high art established by Le Brun were intended to influence artists of his own and subsequent generations.

The broad aims of this study are to look at the way in which Le Brun's art and theory established an artistic canon within the framework of a powerful, state-supported institution and to examine Hauser's claim that this canon was developed and enforced in a dictatorial way. Its specific objectives are to enable you to begin to sketch out answers to the following questions:

1 How did the Académie royale provide an appropriate context for the canonization of art and artistic principles?

2 What artistic principles did Le Brun wish to establish as canonical?

3 Was Le Brun's canon really a form of dictatorship, as Hauser implies?

You have already seen, in the studies on Poussin and the Parthenon marbles, how a classical tradition derived from antique art was transmitted to seventeenth-century artists through the efforts and achievements of their Renaissance predecessors. Like Poussin, Le Brun inherited and revised this western canon or 'gold standard'. But was this at the cost of artistic freedom?

L'Académie royale de peinture et de sculpture (Royal Academy of Painting and Sculpture)

The foundation in Paris of the Académie royale in 1648 was the result of artistic rivalry, commercial competition and the desire to follow the example of Rome, where there was already an academy for artists, the Accademia di S. Luca (Academy of Saint Luke, the patron saint of painters). Essentially, the Académie royale was formed in response to a bid for greater power by the Maitrise, an artists' guild founded in 1391 which demanded from its members payment of dues and respect for its trade regulations. Members of the Maitrise had become increasingly concerned about the growing numbers of artists who escaped its regulations by obtaining royal commissions. Those artists who obtained such commissions were known as *brevetaires,* as they obtained from the monarch a *lettre de brevet* offering legal protection and exemption from the regulations of the Maitrise. There were other fringe benefits, such as free accommodation in royal buildings, including the Louvre (at the time a royal palace). Guildsmen resented such privileges as well as the diminishing opportunities to secure for themselves lucrative royal commissions.

The conflict between guildsmen and *brevetaires* was enmeshed in a wider political struggle of the first half of the seventeenth century between the monarchy and the Parlement, France's supreme court of appeal, which was dominated by disillusioned aristocrats who mounted a challenge to royal power in a series of armed conflicts known as the Fronde. The Parlementaires backed the Maitrise, and as they gained the upper hand in the power struggle, they tried to restrict the privileges and commissions of the *brevetaires.* Le Brun launched a counter-attack. He moved in circles of artists and enthusiasts of the arts who admired the Accademia di S. Luca for its teaching methods and for the tradition of great art, based on the example of ancient Greece and Rome, which it aspired to transmit. As Mazarin (Principal Minister to the Crown) and Anne of Austria, then Regent of France, regained ascendancy in the struggle for power, Le Brun's proposal to establish in Paris an academy

modelled on that of Rome won royal support. Members of the Maitrise were forbidden to interfere in any way in the running of this new academy.

The founding members of the Académie royale were not all practitioners of the most intellectual kind of art – morally serious history painting – but the institution as a whole made its mission the redefinition of the status of art, so that it should be considered a liberal art of the same intellectual status as epic poetry or ancient rhetoric.[3] There was a conscious attempt to remove painting and sculpture from their origins in craft practices and to shape artists into gentleman scholars. Theory and learning were to be more important than practical experience. Unlike the guildsmen, members of the Académie royale were not allowed to involve themselves directly in the commercial trading of their works, since retailing and trade of any kind carried a social stigma at this time. They were not entitled, by law, to keep shops – or even to display works in their studio windows. Nor did they establish any equivalent of the banquets and festivities which had characterized membership of the Maitrise. Academicians were advised instead to follow the loftier intellectual example of Rome, in which practical aspects of painting were elevated by a knowledge of history, mythology and literature in order to produce grand history paintings. The Académie royale was granted exclusive rights to hold life drawing classes so that it could emulate the life drawing classes which had distinguished the Accademia di S. Luca.[4] As a result, this became an area of expertise denied henceforth to the more 'lowly' guildsmen, with their essentially 'craft' practices based on apprenticeship served with a master and learning a trade through following practical example.

In order to transmit artistic skill and learning, the Académie royale familiarized its students with a body of great works of art produced by Italian Renaissance masters. In other words, a major function was the teaching and perpetuation of a canonical body of art – canonical in the sense that it was judged to be the best by the most influential opinion formers of the day. Emphasizing its role as transmitter of a great artistic tradition (initially at least) in the hope of alienating those members of the Maitrise whose interest in art was of a less intellectual kind, it established regular lectures (*conférences* in French) which were open to lay spectators as well as to its own full and student members. Le Brun inaugurated the series of lectures on 7 May 1667 with a commentary on Raphael's *Saint Michael*.

Based on close analyses of paintings in the royal collection, these lectures played a crucial role in teaching and in establishing a particular way of defining the priorities of artists. They strengthened the notion that art was a learned occupation informed by critical doctrine and knowledge of literature, the Bible and history. The lectures were followed by discussions which led in turn to the passing of formal resolutions on artistic practices and principles. Students and other members came away with academic 'policy' on line, light

[3] The liberal arts were traditional branches of learning which included rhetoric and poetry. Since antiquity, painting and sculpture had been classified as 'mechanical' rather than 'liberal' arts. The mechanical arts were so called because they were taught by practice and did not entail theory or scholarship (required by the liberal arts). Barker *et al.*, *The Changing Status of the Artist* (Book 2 in this series), discusses the liberal arts in more detail.

[4] You will find a discussion of the traditions and conventions of life drawing classes in European academies in Perry, *Gender and Art* (Book 3 in this series).

and shade, the proportions of the human figure, colour, expression and so on. They also had classes in perspective and anatomy. This was all part of the attempt to intellectualize art. We shall look later at one of the lectures delivered by Le Brun.

The Académie royale was a bastion of hierarchical structures. Membership was defined in accordance with a strict ranking of pupils, probationary academicians, academicians, teachers (professors) and directors. There were further subdivisions of (in descending order of rank) officers, councillors and ordinary members. Officers were the only ones entitled to the rank of professor and were usually history painters. Rank and status even determined the kind of seat upon which one was allowed to sit at meetings. Advancement to full membership was by submission of a suitable work, a 'reception piece'. The status of members was also affected by their choice of subject-matter. Throughout its history the institution protected such hierarchies through a deferential learning process and the award of prizes (for example, a scholarship to Rome) which rewarded those whose work best exemplified the current orthodoxy of style and subject-matter. André Félibien (1619–95), an architect and biographer who was appointed *amateur honoraire* (honorary expert or consultant), transcribed a number of the lectures delivered to the Académie royale in 1667. The appointment was conferred by Jean-Baptiste Colbert (1619–83), Minister of Fine Arts (and later of Finance) to Louis XIV. In his preface to the *Conférences de l'Académie royale de peinture et de sculpture pendant l'année 1667* (Lectures of the Royal Academy of Painting and Sculpture for the Year 1667) (1668), Félibien established the general principle that representation of the human figure – particularly in historical, mythological or religious narratives or in allegorical compositions – was the highest form of artistic endeavour and the greatest test of the liberal, intellectual qualities which distinguished art from manual craft.[5]

By the end of the seventeenth century the hierarchical codification of the genres, in the sense of categories of subject-matter, was well established. They were, in descending order:

1 history (including religious, historical, literary or mythological narratives, sometimes of an allegorical nature, as well as studies of individual sacred persons such as saints or the Virgin Mary)

2 portraiture (the higher the status of the sitter, the higher that of the portrait)

3 genre (in the sense of scenes from everyday life – this term only came into formal use in the eighteenth century)

4 landscape

5 still life.

History painting was regarded as the highest of the genres because it required the greatest modification of observable nature or 'reality'. It was felt that landscape and still life, in their most common form, called for relatively little imaginative transformation.

The Académie royale was ruled by a complex bureaucracy, and this bureaucratic trend intensified in 1664 when Colbert assumed power as Minister of Fine Arts. Colbert and Louis XIV brought about a situation in

[5] An extract from Félibien's preface is included in Edwards, *Art and its Histories: A Reader*.

which the court, from its bases in Paris and Versailles, became the main sources of artistic patronage. They intervened directly in matters of art and culture. We can see, then, how Le Brun's position as teacher and Director at the Académie royale would have placed him in the ideal position to reinforce the institutionalization of art practice and theory. The Académie's mission and educational programme placed it at the centre of attempts to transmit an institutionally defined canon of artistic production and values. And these values had to be acceptable to the monarchy.

The canon according to Le Brun

The principles embodied in Le Brun's own work

Please look at Plate 61, *The Queens of Persia at the Feet of Alexander* (also known as *The Tent of Darius*). This is the first of a series of paintings in which Le Brun depicted the main events of the life of Alexander the Great (in the pink plumed helmet), the hero of ancient Greece who conquered lands in the Middle East and beyond. The scene takes place on the day after Alexander's victory at the battle of Issus in the fourth century BCE. After a night of victory celebrations he visits the family of his defeated enemy, Darius, King of Persia. Darius himself has fled, for fear of being killed, leaving his family in his camp. It was traditional for victors to claim the wives and families of their enemy, but Alexander is much more magnanimous in his conduct. He is accompanied by his friend, Hephaestion (to the left of Alexander), who wears his traditional crimson cloak. According to legendary accounts, some members of Darius's family mistook Hephaestion for Alexander until a eunuch informed them of their mistake. Alexander reassured them, in their embarrassment, by saying, 'You have not made a mistake, for he too is Alexander.' Sisygambis, Darius's mother, leads the group of women and bows down before Hephaestion, apparently oblivious to Alexander. Alexander looks at Stateira, Darius's wife, who holds her son Ochus in front of her. Beside Stateira are Darius's two young daughters. The other figures include handmaidens and eunuchs, one prostrate on the ground, head in the dust.

The main aim of the history paintings of Le Brun and his contemporaries was to tell a story as eloquently and explicitly as possible. Paintings can't often describe precisely the kind of *sequence* of events I've just outlined, but good narrative paintings contain their own devices for relating a *particular moment* or *series of moments* within a story, even if their exact sequence is not clear.

Study closely *The Tent of Darius* (Plate 61) and say how the following aspects of Le Brun's painting help to tell the story: (1) the poses and gestures of the figures; (2) facial expression; (3) composition (in particular, the way in which the figures and their gazes are arranged).

Analysing the composition of a painting involves looking at the way in which all of its elements – figures, figure groups, objects, colours, light and shade, background, middle ground and foreground, scale and perspective – are arranged within the canvas. This gives us an idea about how an artist has used the total space available, about how an impression of depth and distance is created, and about the patterns, juxtapositions and contrasts which catch

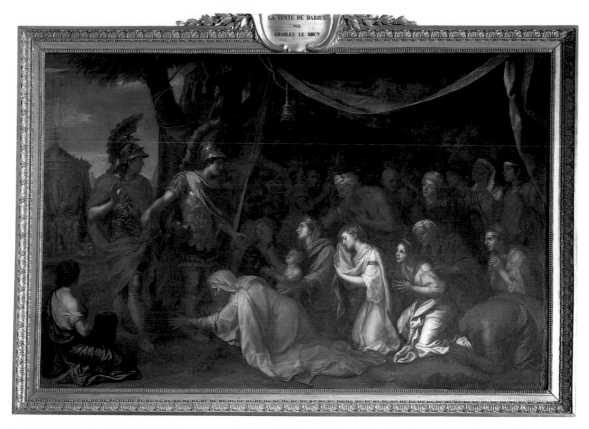

Plate 61 Charles Le Brun, *The Queens of Persia at the Feet of Alexander* (also known as *The Tent of Darius*), 1660–1, oil on canvas, 298 x 453 cm, Musée Nationale, Versailles (first placed in the *grand cabinet* of the king at the Tuileries). Photo: Copyright R.M.N.

our eye. In this case, you might find it helpful to know that, in order to make a composition expressive or effective, artists of this period often tried to guide the viewer's eye along lines or avenues of sight. It's often useful, when studying a painting's composition, to draw lines which trace the visual pathways and structural shapes within it. In this case, trace the lines following the direction of gaze of some of the main figures, as well as the line made by moving from one head to the next of the bending figures. Read the discussion below *after* you have made your own notes on these aspects of the painting: it's always important to base interpretation on first-hand observation. You'll then be in a better position to assess the force of some of the other judgements on the story-telling aspects of Le Brun's painting to which I'll refer.

Discussion

1 The poses of the figures are obviously highly significant. Alexander and Hephaestion are straight and upright in keeping with their 'manly' heroic status, while the women and servants are posed in varying degrees of prostration, indicating their subservience. We can imagine Alexander's open arms as a gesture of noble forgiveness and humility, as he claims his friend must share his greatness. All heads are turned towards the

heroes, and hands are used to express surprise (see the figure bottom left), anxiety (the woman on the extreme right) and supplication. Both Stateira and Ochus seem to plead for mercy. One of Darius's daughters joins her hands together to plead for mercy, while the other wipes her eyes. The prostrate pose of the eunuch perhaps expresses his desperation: he has no royal rank with which to bargain. In attributing significance to poses and gestures in this way, I am using an interpretative argument based loosely on knowledge of social conventions and on observation of human behaviour.

2 If we now turn to the faces, we can see how varied they are in the profiles they present and particularly in the direction of gaze, degree of openness of the eye, and position of the eyebrow. I will return to the whole issue of facial expression in general (and eyebrows in particular) at a later stage, but wish to note now the way in which these faces seem to express a whole range of emotions, from gentleness (Alexander) to pleading (Stateira), astonishment (the figure top right) and fear (the daughter of Darius on the right). Along with the poses and gestures, facial expressions help us to know more about what's going on in the story and how the 'characters' are reacting.

3 The arrangement of the figures helps us to sort out what's going on. Alexander and Hephaestion stand facing the crowd so that we can see clearly what impression each group makes on the other. Many of the eyes of the family group lead our eyes to the two main heroes. There is a triangular figure grouping, which was a conventional means of achieving a stable, neatly edged, self-contained and solid compositional effect. You can see this by tracing a diagonal line linking the heads of the top row of figures starting from the right-hand edge down to the prostrate Sisygambis in the yellow cloak. Then trace another line from Sisygambis linking the knees of the kneeling figures on the bottom row to the right-hand edge. Along with the vertical line of the painting's right-hand edge, these lines form a triangular shape. Finally, the glimpse of sky in the top left-hand corner alleviates the gloom of the rest of the painting and makes Hephaestion stand out more clearly.

◆◆

It's interesting to see how one of Le Brun's contemporaries interpreted the episode depicted by the artist. André Félibien reflected on the eloquence of Alexander's gestures:

> There are four different actions evident in his gestures. His compassion towards the princesses is apparent both in his bearing and the look of his eye. His open hand reveals his clemency and is a perfect expression of the mercy he shows to the entire court. His other hand resting on Hephaestion shows that the latter is his favourite or, rather, an incarnation of himself, and his left leg, which is pulled back, is a mark of the civility he shows towards the princesses. The painter did not have him bending forward any further because he is depicting him at the moment when he approaches the women, and it was not a Greek custom; moreover, he could not bend over much further due to a thigh injury he had sustained in the last battle.
>
> (Félibien, *Les Reines de Perse aux pieds d'Alexandre, peinture du Cabinet du Roy*, quoted in Gareau, *Charles Le Brun*, p.199)

For Félibien, then, the poses and gestures painted by Le Brun were part of a highly legible code. In 'decoding' them he drew on a combination of knowledge of social conventions (Alexander's bearing), historical accuracy ('it was not the Greek custom') and traditional symbolism (the open hand representing clemency). Félibien was very familiar with the work of 'great' painters past and present, as is indicated by the title of his *Conversations on the Lives and Works of the Most Excellent Painters, Ancient and Modern* (1666–88).[6] Félibien may also have had in mind the conventions of the court behaviour of his own time, but we would need to discover much more about such behaviour before establishing this link with the painting. Would Louis XIV use similar gestures of clemency in similar circumstances? This is perhaps the implication. Louis had specifically commissioned a painting on the subject of Alexander, and Le Brun had worked on it at the king's palace at Fontainebleau. It was completed in Paris and hung in the king's *grand cabinet* (a rather grand public office or study) at the Tuileries before being transported to Versailles. On the strength of this painting, Le Brun was nominated First Painter to the King.

In trying to decide whether Alexander is displaying the symptom of a gammy leg or social graces recognizable to the court and high society of his day, it is useful to consider the seventeenth-century social category of the *honnête homme*. This phrase is untranslatable but approximates to 'gentleman'. It conveyed honesty, decency and good breeding, and was commonly used in the literature written and read by Le Brun's contemporaries:

> It was in the *salons* [informal gatherings, based on dinner and conversation, hosted by society ladies] that the new ideal of the gentleman, the *honnête homme*, was formed; the rough-mannered warrior was replaced by the gentleman, distinguished for his refinement, good taste, and politeness towards the ladies. Needless to say, the *honnête homme* was a thoroughly aristocratic ideal; in the literature of the time … the nobleman, polished and refined by the *salons* through contact with the fair sex, is contrasted with the dull bourgeois.
>
> (Lough, *Introduction to Seventeenth-Century France*, pp.225–6)

Alexander represents a battlefield version of this ideal. He is certainly 'polite towards the ladies' (the Greek essayist Plutarch (*c*.46–*c*.126 CE) had called him 'honourable and princely'), and the cultural resonances and circumstances of patronage of this work would seem to suggest some kind of affinity with the courtly standards of behaviour to which Louis XIV himself might adapt when leaving the rough battlefield. This, at any rate, is the image of royal power offered by Le Brun. Contemporary court culture could inflict severe social penalties on those who ignored the social code. Perhaps, however, Alexander transcends the ideal of the *honnête homme* in order to express a kind of heroic magnanimity? Whatever our response to Alexander, it is worth pointing out that it was a commonplace of contemporary literature (at least in the earlier part of Louis's reign) to make comparisons between

6 Félibien is generally considered to represent the more orthodox views of late seventeenth-century academicians, even though some accused him of being less than accurate in his transcriptions of Académie lectures and discussions. One of his aims was to provide an approved way of viewing paintings (for example, focusing on expression, pose and narrative detail).

the Macedonian hero[7] and Louis XIV. In his choice of subject for the painting, Louis was no doubt influenced by other representations of kingly attributes. For example, at the age of seven he had seen a contemporary play by Gillet de la Tessonerie entitled *L'Art de regner ou le sage gouverneur* (The Art of Ruling or the Wise Governor) in which Alexander had personified the kingly virtue of continence: having fallen in love with Stateira, he surrendered her to her lover.[8] Louis perhaps wished artistic representations of himself to construct a particular (propagandist) public image.

Le Brun's pictorial values

Let us now compare Le Brun's work and that of an earlier artist, Paolo Caliari Veronese (1528–88), a painter of mythological and religious subjects (many in fresco form) well known to seventeenth-century artists. In this way we will be able to explore the special nature of the pictorial values exemplified by Le Brun. Before embarking on this exercise, it is important to know that Veronese was held by commentators on art from the Renaissance onwards to represent a set of pictorial values which placed dazzling colour and texture above the more 'intellectual' aspects of line and composition. The Roman school of painting to which Raphael had belonged was felt to uphold the claims of this more linear, intellectual strand of Renaissance art, while Veronese and the Venetian school in general were considered to place more emphasis on pleasing the eye and the senses of the beholder. Things were, of course, less clear cut than this but, as with many cultural and political debates, commentators simplified and polarized the issues for propagandist value, as well as enabling artists and public alike to determine where their own priorities lay.

Compare Le Brun's *Tent of Darius* (Plate 61) with Veronese's *Family of Darius before Alexander* (Plate 62). What differences can you see (1) in the use of colour; (2) in the use of ornamental detail; and (3) in the backgrounds or settings used?

A few tips: when thinking about the approach to colour and ornamental detail, you might like to consider how bright and well lit these paintings seem to be. How much 'dazzle', 'glitter' and pattern does each work contain and emphasize? You might also like to think about colour temperature and its effects. If you look at Plate 63 you can see how colours have traditionally (and scientifically) been classified as warm or cool. All other things being equal, warm colours seem to advance towards us, while cooler colours give the impression of receding away from us. Do both artists exploit such possibilities?

[7] Macedonia was a Slav region of south-eastern Europe which, under Philip II, conquered Greece. Philip's son Alexander spread Greek culture throughout the Middle East and North Africa.

[8] Posner ('Charles Le Brun's *Triumphs of Alexander*', pp.241–2) thinks this might have had a personal resonance for Louis XIV, who was forced to give up his mistress, Marie Mancini, in order to fulfil his political duty to marry the Spanish Infanta Maria Theresa.

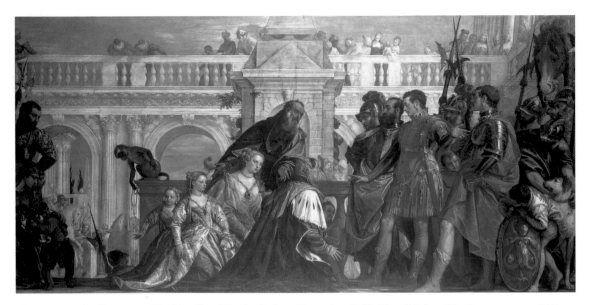

Plate 62 Paolo Veronese, *The Family of Darius before Alexander*, 1565–70, oil (identified) on canvas, 236 x 475 cm, National Gallery, London. Reproduced by courtesy of The Trustees, The National Gallery, London.

Plate 63 Colour wheel showing warm colours (reds and oranges) and cool colours (blues and greens). Adapted from Plate 1 of Faber Birren, *Principles of Color*, 1969, New York, Van Nostrand Reinhold.

Discussion

1 The light in Le Brun's painting doesn't fall on what *could* be the most vibrant colours – the reds, yellows and oranges, all warm colours which, if well lit, might have seemed as if they were 'advancing' towards the viewer. Instead it seems to travel from a point in front of and to the right of the foreground figures, to fall on the cool blues and whites of Stateira and her daughters. Le Brun seems to have muted his colours in order to soften them. Apart from the patches of relatively bright crimson on Hephaestion and the prostrate eunuch, there is little vibrancy of colour to grab or direct our attention here. In Veronese's painting there is no playing down of the vitality and sumptuous nature of colour. While Le Brun's colours are dulled by the relative darkness into which they are cast, Veronese's are thrown into relief against a neutral background.

(I don't expect you to have made this point, but it is interesting to note that Veronese juxtaposes complementary colours (red and green, yellow and violet) so that each colour appears brighter and stronger. Complementary colours are primary colours – red, blue and yellow – placed next to the secondary colour made from the other two primaries – red with green, blue with orange, yellow with violet. Their juxtaposition creates strong contrasts. The warm reds of the heroes' costumes (Alexander and Hephaestion on the right) make the two principal figures advance towards us, particularly as they are placed more or less on the picture plane.[9] Imagine how different the effect would be if these costumes were grey or black.)

2 Le Brun's painting also lacks 'dazzle' in its treatment of ornamental detail – the armour of Alexander and Hephaestion, the brocade of the tent and the women's costumes. Although these ornamental or decorative details are quite intricate and reflect the social standing of their owners, they are not generally brightly lit: the eye must not distract the mind. Contrast the celebration of the ornamental and textural qualities of silk, fur and armour in Veronese's painting.

3 The setting of Veronese's painting is almost like a theatre backdrop. Instead of Darius's tent we now see his palace. (You won't know this, but Veronese's Venetian patrons, the Pisani, had connections with the sixteenth-century architect Palladio, who designed buildings in the elevated classical style shown in the palace. The artist may have been flattering his patrons' tastes, as the palace was not the location mentioned in written accounts of Alexander's meeting with Darius's family.) The palace gives Veronese's version of the subject a more elegant and graceful mood than Le Brun's dark tent. The effect is theatrical and flamboyant by comparison with the more austere inner drama of Le Brun's.

◆◆◆

[9] The picture plane is 'the extreme front edge of the imaginary space in the picture … [It] is the plane at which the world of the spectator and of the picture make contact' (Murray, *Dictionary of Art and Artists*, p.342). Where the imaginary three-dimensional world of the painting starts for you (the viewer), what appears to recede is 'behind' the picture plane. What appears to come forward into your own space where you are standing is 'in front of' the picture plane.

The identity of the two male figures on the right of Veronese's painting is not entirely clear – either could be Alexander or Hephaestion. But Alexander is probably the figure in the pink tunic, arms outstretched, gesturing towards the figure in armour, his general, Hephaestion (whose breastplate carries a laurel leaf symbolic of victory). Sisygambis, centre foreground, seems to have switched her gaze towards Alexander while the other women still have slightly misdirected gazes. It has been suggested that Alexander's finery may be explained by his body odour problem, reported by Plutarch in his *Lives* (33:21): he had to wash and change after the heat of battle (Thomas, *Illustrated Dictionary of Narrative Painting*, p.111). Educated artists and clients would have been familiar with such sources and anecdotes.

Whatever the truth of Alexander's condition – stiff leg or body odour – the comparison between Le Brun's painting and Veronese's illustrates two important points in relation to our exploration of Le Brun and canonical works and values. First, we can see how he was working within a tradition of subjects and themes from classical antiquity and the Renaissance. Veronese and other artists who had treated the Darius subject were well known to Le Brun and his contemporaries, many of whom were familiar with the works in the king's collection and many of whom had visited Italy in order to study classical statuary and architecture, as well as Renaissance works, at first hand. Second, we can see how Le Brun interpreted canonical subjects within his own framework of stylistic priorities, so that colour and vibrant visual effects became less important than graceful but legible gestures, poses and expressions and carefully reasoned compositional effects. His contemporaries shared his distrust of colour, which was often viewed as a means of distracting the eye at the expense of exercising the intellect.

Colour versus design, Rubens versus Poussin

In 1672 Le Brun had to arbitrate in what has become known as the 'Quarrel of Colour and Design'. For some time, academicians had been split into two camps, the so-called Poussinists and the Rubenists. Supporters of Poussin (renowned for his careful drawing of the human figure and for his clear but powerful compositions – see Plate 80) argued that 'design' (which incorporated the general conception or composition of a work as well as drawing) was more important than colour in determining the total effect and status of a work of art. Followers of Rubens (famed for his rich colouristic effects – see Plate 64) argued the opposite. In practice, of course, the work of artists was rarely so one-sided in its characteristics as this quarrel implied. Le Brun settled the argument by means of a compromise which nevertheless revealed his own (Poussinist) priorities. While he admitted that design was more essential to art, because it was the main means of imitating and expressing what we know and experience (including our passions), he also conceded that colour could add perfection and beauty to a work. When painting a face, for example, flesh tones could add a beauty of their own as well as having a particular expressive value (in, for example, facial pallor or blushing). As we saw in the introduction to this book (pp.19–20), in seventeenth-century aesthetic theory it was common to assert that there was a universally accepted, objectively defined notion of beauty. Beauty was often defined in terms of the process of perfecting natural forms for which the ancients were renowned. But this process of perfection was most often

discussed in terms of the visual harmony resulting from the correct application of mathematical proportions in drawing. Because statuary was the main source of influence, colour was less readily associated with beauty.[10]

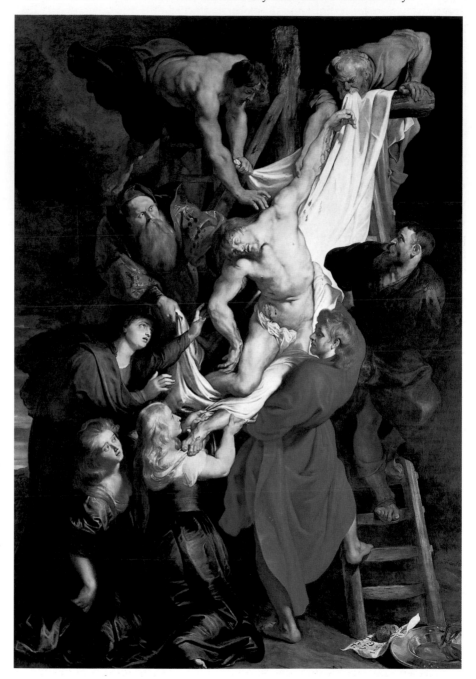

Plate 64 Peter Paul Rubens, *The Descent from the Cross*, 1611–14, oil on panel, 420 x 310 cm, Antwerp Cathedral. Photo: Scala.

[10] As we saw in the previous case study on the Parthenon marbles, the European preference for monochrome sculpture has arisen because the original colour was lost from antique sculpture.

The Quarrel of Colour and Design had been significant because colour was thought to delight the eye and the senses rather than the intellect. Le Brun's judgement was that although intellectual elements of form or design must be given higher status, colour must not be neglected. But the virulence of this particular quarrel, and the amount of pamphleteering and lobbying it generated, are testimony to the fact that his authority did not go unchallenged. Artists such as Pierre Mignard (1612–95), Le Brun's main rival, and theorists such as Roger de Piles (1635–1709) identified themselves as 'moderns' keen to challenge the artistic values of the 'ancients'. Their view that colour constituted the main achievement – rather than a minor embellishment – of art later bore fruit in eighteenth-century artistic practice.[11] This debate helps to illustrate the extent to which so-called canonical values are constantly contested and changing.

Le Brun's working method

We can gain a clearer idea of Le Brun's priorities by considering his own working methods, admirably described by Michel Gareau (*Charles Le Brun*, pp.67–81). The first thing Le Brun had to do was to choose a subject. Given that he normally worked for kings, bishops and ministers, he often had strong guidelines or instructions on this. Cardinals asked him for biblical subjects and Louis XIV, when he assumed sole charge of the kingdom in 1661 (after Mazarin's death), commissioned first battle scenes such as the Alexander series and then allegorical battle scenes with the king himself at their centre. Later in Louis's reign, as military glory was less in evidence and matters of religion were discussed (from 1683 onwards) on a daily basis at meetings of the king's council, biblical subjects regained popularity. Le Brun engaged in serious scholarly research into his subject, consulting the Bible or ancient poets such as Virgil and Homer; he studied the customs of past ages and the many visual symbols used over the centuries in connection with Christian and mythological subjects (as we saw in *The King Governs Alone*) in order to make his paintings as authentic and explicit in meaning as possible. Intellectual understanding and scholarship lay at the basis of his working method.

Having chosen a subject, Le Brun next had to consider its final destination or location: this would influence the size, shape and colour of the finished work. Most of his works were large, in keeping with the grand apartments of the patrons for whom they were destined. Like all art, his was influenced by its intended function: Louis's commissions were usually for grand historical or moral subjects to be displayed in public, rather than private, spaces.

Le Brun would then sketch out on paper, in black chalk, an idea for a composition: this was a traditional method for artists of his generation. He obeyed strict laws of anatomy, proportion and geometry both in the individual elements of his compositions (human figures, for example) and in their overall distribution. Artists of this period used copy-books which encouraged them to study and imitate the anatomical details and mathematical proportions of

[11] Case Study 9 in Barker *et al.*, *The Changing Status of the Artist* (Book 2 in this series), identifies Watteau's art as similarly dedicated to the expressive and decorative qualities of colour.

classical statuary, as well as Renaissance figure studies, since these were felt to provide the true measure of beauty. Le Brun made extensive use of diagonal lines and pyramidal shapes and groupings in his compositions. It's interesting to note that in a preparatory sketch for *The Passage of the Granicus* (Plate 65), one of a series of four massive paintings currently at the Louvre known as the Alexander cycle (Plates 66–69), the soldiers, weapons and horses are arranged beneath a diagonal line stretching from the top right-hand corner of the canvas to the middle of the left-hand side. In the finished work, however, the figures are grouped in a pyramidal formation with an apex above and slightly to the right of Alexander's head (Plate 66).[12] It is worth pausing to consider the effects of these compositional devices. Traditionally, the use of diagonal lines is thought to add a sense of drama and movement, whereas triangular and pyramidal shapes and groupings are considered to generate a sense of stability. Do you think these plates bear this out – or are matters more complicated?

Plate 65 Charles Le Brun, *The Passage of the Granicus*, compositional sketch, pen and black ink with grey wash over red and black chalk, 29 x 47 cm, Musée du Louvre, Département des Arts Graphiques, Paris. Photo: Copyright R.M.N.

[12] In *The Passage of the Granicus* we see Alexander, with white-plumed helmet, about to cross the river Granicus in order to attack the troops of Memnon, one of Darius's generals. According to historical accounts, Alexander wanted to avenge previous Syrian attacks on Greece. One of his cavalrymen saves him from attack by a Persian with a sword in both hands.

Plate 66 Charles Le Brun, *The Passage of the Granicus*, 1661–5, oil on canvas, 470 x 1209 cm, Musée du Louvre, Département des Peintures, Paris. Photo: Copyright R.M.N.

Plate 67 Charles Le Brun, *The Triumph of Alexander* (also known as *Alexander's Entry into Babylon*), 1661–5, oil on canvas, 450 x 707 cm, Musée du Louvre, Département des Peintures, Paris. Photo: Copyright R.M.N.

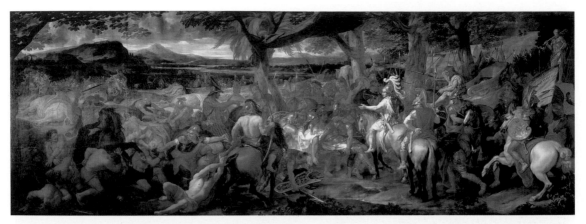

Plate 68 Charles Le Brun, *Alexander and Porus*, before 1673, oil on canvas, 470 x 1264 cm, Musée du Louvre, Département des Peintures, Paris. Photo: Copyright R.M.N.

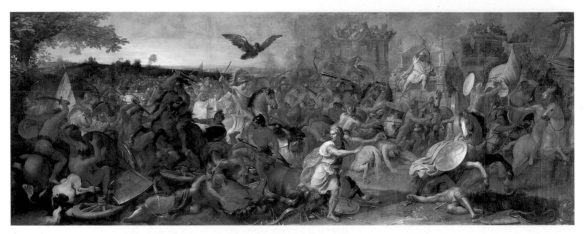

Plate 69 Charles Le Brun, *The Battle of Arbella*, before 1673, oil on canvas, 470 x 1265 cm, Musée du Louvre, Département des Peintures, Paris. Photo: Copyright R.M.N.

Le Brun experimented with different ways of representing his hero's prowess and, indirectly, that of his own monarch. In *The Battle of Arbella* (Plate 69) a large pyramidal grouping reaches an apex at the eagle above Alexander's head, but there are other pyramidal groupings within the painting, such as the one culminating in the golden chariot of Darius. This painting shows Alexander on his horse, sword in hand, engaged in a battle which took place at the foot of the Gordian mountains on the plain of Arbella with an army of 40,000 men. Darius, his enemy, could only effectively use a proportion of his army of a million; there were too many men on the battlefield and the ensuing chaos, reflected in the chaotic mass of figures and action in Le Brun's painting, was Darius's downfall. Next to Alexander we see a man with white hair, a soothsayer pointing to the eagle above Alexander's head, a symbol of Jupiter and victory. Notice how Le Brun always tries to add a patch of bright sky in a corner of his composition in order to relieve the darkness and to allow the viewer's eye some respite from a scene of tumultuous action. All of his

compositions were carefully planned: he even worked out his own geometric systems for lighting and for the arrangement of the planes (layers of depth) on which he placed his action and figures. His emotive art was devised in a highly rational way.

Once he had worked out an overall plan he accentuated details of figures and objects with the use of grey, white or brown highlights in pencil, with more chalk or, like his predecessor Poussin, by making a sketch in black ink (see Plate 70). He then used his drawing skills to add what he saw as the most expressive or poetic elements: facial expressions, hands and feet. All of these elements could express the feelings and thoughts of his figures. Finally, he gave his figures clothes and armour. At every stage of his figure sketching he respected the laws of anatomy and proportion in which the sculptors of antiquity had given such a strong lead. His own visit to Rome and his studies in France had trained him, like all academic artists of the day, in the art of improving on nature by referring to plaster casts, originals and engravings of antique statues (see Plates 13 and 78).

Plate 70 Charles Le Brun, highlighted drawing of *The Battle of Arbella*, pen and ink with grey wash over red and black chalk, 27 x 43 cm, Musée du Louvre, Département des Arts Graphiques, Paris. Photo: Copyright R.M.N.

At last Le Brun was in a position to take up his brushes and paint, using as a guide the multitude of sketches he'd worked on (see Plate 71). He sometimes left backgrounds and scenery to assistants, but would always put the final, unifying touches to a work himself. Artistic status was often bound up with such divisions of labour. It seems evident, from this account of Le Brun's method, that any originality of design or expression was constrained within a carefully reasoned and researched framework. The same applied to Le Brun's approach to facial expression.

Plate 71 Charles Le Brun, three sketches for *The Battle of Arbella*, Musée du Louvre, Département des Arts Graphiques, Paris. Photo: Copyright R.M.N.

Establishing a canonical approach to expression

Le Brun's *Conférence sur l'expression* (Lecture on Expression*)* was published in 1698, 1702, 1718 and again in 1728.[13] Many other writers reported or modified his views on expression well into the eighteenth century, and his work on this topic influenced generations of history (and genre) painters into the nineteenth. In this section we'll be looking in detail at part of Le Brun's *Conférence* as a way of understanding the principles involved in his quest for a highly legible, rational and idealized artistic practice.

Before we do so, we should perhaps consider why Le Brun felt expression to be such an important topic and, indeed, what he meant by the term 'expression'. In the *Conférence* he defined it as 'a simple and natural image of the thing we wish to represent … this which indicates the true character of each object' (quoted in Montagu, *Expression of the Passions*, p.126). For Le Brun, expression in art is a visual representation which captures the essence or inherent quality of something known or experienced by the artist. It is the

13 An extract is included in Edwards, *Art and its Histories: A Reader*.

only means of ensuring the 'perfection' of a work of art, although, like many of his contemporaries, he tends to talk about perfection by means of circular definitions: good expression, drawing and composition make for perfection, and perfection results from good expression, composition and drawing. The general idea was that perfection was achieved by emulating the high standards set by the classical tradition – and that it *was* possible, on the basis of this tradition, to speak of an objective standard of beauty and perfection towards which all artists should strive.

In this particular lecture, Le Brun placed an emphasis on the expression of the passions or the emotions, particularly through the movement of facial features. He felt the topic of expression was important, however, because it applied to *all* aspects of art, including colour, drawing and composition. These could be used to express the true character of things; all these instruments of expression (such as colour, drawing and composition) were necessary to an artist who wished to create an illusion of reality. Le Brun was anxious that he was developing a formula for a convincing *illusion* of reality rather than teaching means of capturing likenesses of photographic accuracy. What he and other classically inspired artists sought was a visual code or *equivalence* for things existing in the real world which would allow viewers to recognize the 'true character' (rather than the superficial peculiarities) of the sights, events and personalities he wished to depict. He wanted to provide sufficient visual clues to enable the spectator to engage imaginatively with the scenes he created. Although much had already been written on the topic, Le Brun felt his own lecture would help students and fellow academicians to understand the subject more clearly.

Le Brun saw the passions as movements of the sensitive or feeling part (as opposed to the reasoning or other parts) of our soul. They help us to pursue or avoid what is good or bad for us – they are a kind of early warning system, letting us know whether we should chase or flee. They also make parts of our body move by affecting our nerves, which send signals to our muscles. He believed that the passions make a strong impression on the brain, and particularly on a small gland, the pineal gland (see Plate 72), situated in the centre of the brain. (The Concise Oxford Dictionary informs us that the pineal gland is 'a pea-sized conical mass of tissue behind the third ventricle of the brain, secreting a hormone-like substance'.) The brain, thus affected, could then have an impact on other parts of the body, including facial features, via the nervous system. Le Brun's ideas were based on those expressed in *The Passions of the Soul* (1649) by René Descartes (1596–1650), an important philosopher who attempted to describe the physiological effects of the emotions as part of a wider enquiry into the way in which humankind's immaterial, spiritual soul interacted with the material, physical body. In our own age of advanced medical and psychological research, many of Descartes's ideas appear to be based largely on supposition. Many of his ideas on the composition of the soul and the workings of the body were in fact derived from ancient Greek and Roman thinkers and physicians such as Aristotle, Hippocrates and Galen. But we do need to appreciate their currency and authority at the time in which Le Brun was writing.

Plate 72 Charles Le Brun, drawing showing location of the pineal gland, pen and black ink over black chalk heightened with watercolour and red chalk, 14 x 39 cm, Musée du Louvre, Département des Arts Graphiques, Paris. Photo: Copyright R.M.N.

Le Brun asserted (with a touching confidence) that the eyebrow is the most expressive part of the face because it best shows the 'nature of the agitation' of the soul. Plate 72 shows how the eyebrows are linked to the pineal gland situated 'in the middle of the brain' – the brain being the part of the body 'where the soul exercises its functions most immediately'. Although Le Brun conceded that eyes, mouths and noses can betray or express emotion (he also mentioned clenched fists ready to strike or legs ready to flee as emotional signals), he felt that the eyebrow was capable of the greatest and most subtle range of positions, and thus able to express passions of all kinds. Plates 73 and 74 show some of the different degrees and directions of curvature of which, according to Le Brun, the eyebrow is capable.

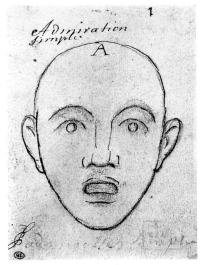

Plate 73 Charles Le Brun, drawing showing astonishment with terror, black ink over chalk, c.14 x 11 cm, Musée du Louvre, Département des Arts Graphiques, Paris. Photo: Copyright R.M.N.

Plate 74 Charles Le Brun, drawing showing simple admiration, black ink over chalk, c.14 x 11 cm, Musée du Louvre, Département des Arts Graphiques, Paris. Photo: Copyright R.M.N.

Many of Le Brun's illustrations of eyebrow movements appear as exaggerated and unnatural facial contortions. Generations of artists and critics after Le Brun looked for more naturalistic ways of expressing the feelings of human figures. But it could be argued that Le Brun was taking natural expressions, filtering out and exaggerating their main characteristics in the interests of greater legibility and impact. Cartoonists work in a similar way.

A large number of Le Brun's facial types, both theoretical and practical, drew on other sources – particularly ancient statuary, Leonardo da Vinci, Michelangelo, Raphael, Veronese, Domenichino and Poussin (see Plates 24, 75 and 76).[14] But his insistence on returning, in his *Lecture on Expression*, to first principles (specifically, the physiological principles established by Descartes) again demonstrates a tendency to allow study of the art of the past to test and develop, rather than dictate, his artistic values. We might say that his expressive prototypes were driven more forcefully by experimentation with audience response: he wanted spectators to recognize and respond to the passions he represented.

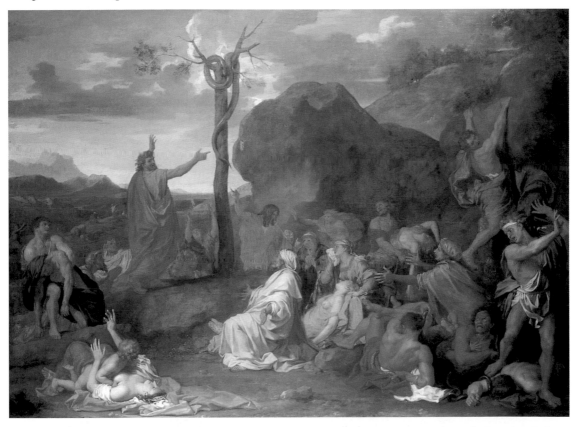

Plate 75 Charles Le Brun, *The Brazen Serpent, c.*1647, oil on canvas, 95 x 133 cm, Bristol, City Art Gallery. By permission of the City of Bristol Museum and Art Gallery. (According to the Bible, the Children of Israel were punished by a plague of poisonous snakes after complaining to Moses about their arduous journey out of Egypt. Many of the Israelites died from snake bites, whilst others turned to Moses begging for help. Moses was advised by God to make a fiery serpent and set it up on a pole. God promised Moses that all those who had died would come alive again if they looked at this brazen image.)

[14] According to Montagu (*Expression of the Passions*, p.35) the *Laocoon* (Plate 24) provided the model for the face of the man holding the dead girl in *The Brazen Serpent* background, right of centre (Plate 75). There is not space here to enter into precise comparisons between Le Brun and the artistic precedents on which he drew, but Montagu does this very well (*Expression of the Passions*, chapters 3 and 5).

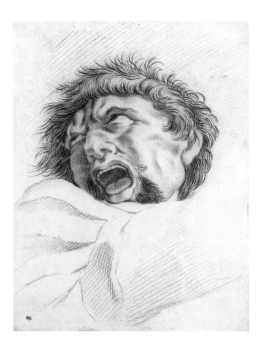

Plate 76 Charles Le Brun after Raphael, *Head of a Follower of Heliodorus*, ink and wash on paper, Musée du Louvre, Département des Peintures, Paris. Photo: Copyright R.M.N. (According to Montagu, this provided the model for the head of the fallen man at the right in *The Brazen Serpent*.)

Le Brun's guidelines on facial expression allowed artists and educated spectators to share a common language of expression. His approach was systematic and schematic in the visual shorthand it proposed, but it was also complex. For example, he linked precise movements of the eyebrow with specific configurations of other facial features. He indulged openly in generalization, confidently stating, for example, that 'when the heart is dejected all the parts of the face will be cast down' (quoted in Montagu, *Expression of the Passions*, p.131). Exaggeration and over-simplification were perhaps an inevitable consequence of the desire to be clear and rigorous.

We must remember that Le Brun wanted his prototypes to be as clear and explicit as possible so that students could learn from them. As they were intended largely for history painting, with its scenes of high passion and drama – battles, plagues, miracles and so on – extremes of expression were appropriate. The prototypes were intended to be modified for less dramatic subjects. In the genre of portraiture, where different conventions and expectations applied, Le Brun's approach to facial expression was more naturalistic (Plate 77).

Plate 77 Charles Le Brun, *Self-Portrait*, 1684, oil on canvas, 80 x 63 cm, Uffizi, Florence. Photo: Scala.

Summary of the canonical values guiding Le Brun's artistic practice and teaching

What, then, were the canonical values guiding Le Brun's artistic practice and teaching? First, rational planning lay at the basis of all aspects of his art, especially when it came to the methods to be used for expressing the least rational or passionate aspects of human behaviour; there was a 'code' and theoretical framework for everything. Drawing and composition were further elements of this rational or intellectualized approach to art.

Second, the demands of legibility (clear, explicit meanings) were much more important than those of artistic individuality, originality or 'sincerity'. The elements of Le Brun's paintings might be regarded as parts of a visual signalling system whose relationships to one another and to the viewer's knowledge of such a system were more significant than any connection with the authentic feelings of the artist.

Third, ancient Greece and Rome were, along with the Bible, the chief sources for his subjects. His study of 'antique' precedent, such as the copies of the statues frequently studied by students at the Académie royale, carried with it assumptions about the 'best' or canonical models and standards to be followed. Following the ancients meant trying, as they had, to improve on nature. Le Brun's prototypes for facial expression are not based on particular expressions observed at particular moments in specific, individual faces. They represent what were felt to be the most eloquent and significant configurations of features, based on what had been worked out to be the essential character and physiological impact of the passions in question. Contemporary aesthetic debate distinguished between the 'real' (a faithful representation of the external appearance of things, warts, peculiarities and all) and the 'ideal' (the essential characteristics of things, belonging to a hidden, transcendent but more significant reality). Contemporary commentators referred to the latter as 'beautiful' or 'ideal' nature: the hidden order and shape of things, more perfect than what we observe in everyday life because it was the distilled essence of such observations. This view was based on the ideas of the Athenian philosopher Plato (c.429–347 BCE), who had conceived of a world of ideal forms, essences or prototypes, of which individual objects in this world are only imperfect copies. An individual tree, for example, is only an imperfect copy of a purer idea or prototype tree which is nevertheless recoverable from the world of variable and fluctuating appearances we inhabit.

A similar rational search for essential and prototypical qualities characterized Le Brun's depiction of the human body: like the ancients and the Renaissance masters who had transmitted their ideas, Le Brun wanted to improve on nature by representing the body not only in accordance with anatomical study but also having regard for some idea of perfect proportion. This idea stemmed from the works of classical mathematicians and philosophers (such as Pythagoras and Plato) who had made connections between geometry, harmony and beauty. The beautiful form would be identified by the proportions between its parts (for example, the length of a head in relation to a body). To those initiated into the wonders of ancient sculpture, these proportions satisfied an expectation of a harmonious, rather than jarring, effect on the eye. They also expressed perfectly the physical or psychological attributes with which the artist was concerned. On the basis of such

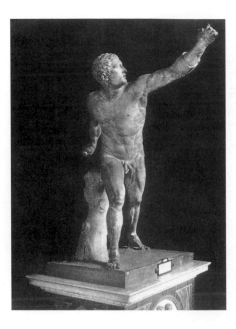

Plate 78 *The Gladiator*, marble, life-size, Musée du Louvre, Paris. Photo: Alinari.

connections between geometry, harmony and beauty, Greek and Roman sculptors devised the 'perfect' proportions for beauty (for example, in the figure of Antinous – see Plate 13), athleticism (in the Gladiator – see Plate 78) and so on; the human form must express perfectly its qualities and function.

Fourth, Le Brun worked within the strict hierarchy of genres outlined earlier (p.93). He dealt with the highest kinds of subjects, his portraits generally being of the more eminent members of society. Le Brun's extreme facial prototypes suited the 'larger than life' subjects and methods of the history genre. An emphasis on this genre was in line with the Académie royale's aim of raising painting to the status of a liberal art such as epic poetry: artists were to be painter-poets, more concerned with the mind and soul than with the body. They were to show human beings engaged in dramatic or morally significant actions. Invention (the artist's imaginative conception of a subject) was seen as superior to execution (his technical skills).

Le Brun was able to reinforce the canonical status of these values by his position as teacher and Director of the Académie. Indeed, his influence spread beyond it as, in 1663, he was put in charge of the Gobelins factory, the centre of production of royal furniture, tapestries and mosaics. The Gobelins employed members of craft guilds: gilders, metal casters, tapestry-makers, gold and silversmiths, as well as painters and sculptors. Le Brun was just as adept at designing a candelabra, a basin or a door lock (as he did at Versailles) as he was at designing a painting. Many of his paintings were transformed into tapestry designs (compare Plates 75 and 79). It was common for artists of high standing to be commissioned to execute tapestry designs (which might involve grisaille[15] sketches and full-size cartoons) or for their paintings to be 'converted' into tapestries. This was, in a sense, a fusion of their old (craft) status and new (liberal) status, but tapestries were usually commissioned for grand, prestigious settings. Like paintings, tapestries were often conceived

[15] Painting in grey or greyish monochrome (that is, a single colour).

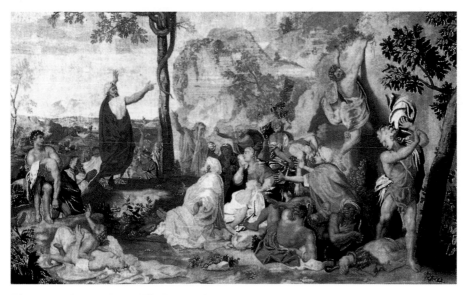

Plate 79 After Le Brun, *The Brazen Serpent*, tapestry, Musée du Louvre, Paris. Photo: Copyright R.M.N.

in this period as part of a decorative whole, as overdoor and panel decoration; they were chosen with a particular context of paint, furniture and ornament in mind. In the present-day Louvre, Le Brun's tapestry cartoons are exhibited as prominently as his painted works, perhaps attempting to restore the alliance of art and craft undermined in earlier times.

In 1666 Colbert founded the Académie de France in Rome, a kind of annexe to the Académie royale at which prizewinners of an annual competition were allowed to study for three or four years. Le Brun's involvement with these competitions, as well as his lectures, ensured that he could play a significant part in reinforcing certain artistic values and practices. But was he really a dictator of taste? Let's turn now to our third and final question.

Was Le Brun's canon really a form of artistic dictatorship?

In answering this question, we need to take into account the seventeenth-century context. Although the teaching sessions led (and often concluded) by Le Brun often resulted in the passing of resolutions intended to guide student painters, there is very little evidence that such resolutions caused violent disagreements or were likely to force painters into working in ways which they found unacceptable. If there was any 'dictatorship', it seems likely that it was that of the system as a whole (court-dominated sources of patronage) rather than an individual artist: the real tyranny was the social and political context in which artists worked. There is plenty of evidence from the records of Académie lectures and discussions kept by Félibien that healthy debate took place. These debates may have taken place within a restricted framework of the concerns of grand history painting, but they do demonstrate that respect for a canon of 'great masters', past and present, was moderated by a quest for scholarly and scientific accuracy.

One such debate arose concerning a painting by Poussin, his *Eliezer and Rebecca* (Plate 80). This work tells the biblical story of Abraham's servant Eliezer (centre foreground), who had been sent to find a wife for Abraham's son Isaac. Eliezer had been promised that a sign from God would help to identify the right wife for Isaac: the girl in question would reveal herself by offering water to Eliezer and the camels with which he was travelling (Genesis 24:22–7). In Poussin's painting Rebecca (centre-right foreground) has already identified herself in this way and is being presented with jewels and an offer of marriage. In 1668 Phillipe de Champaigne delivered a lecture (repeated in 1682) on this painting. He felt that Poussin should have included the camels, as he had done in an earlier version of the subject: the camels would have introduced a more down-to-earth note into this mass of idealized (in the sense of too perfect, unrealistic) beautiful women. Le Brun and Félibien, however, felt that Poussin had had good reason to deviate from the biblical text: camels would have been a bizarre, incongruous element in a painting of such grace and beauty. At stake, in Le Brun's view, was the principle of an artist's right to freedom in formulating a composition. Both sides of the debate had their own supporters, and discussion of the problem of Poussin's camels has continued to the present day, one commentator arguing that Poussin's decision to omit the camels may have been due to the fact that he saw the subject as a kind of Annunciation – a parallel to Mary's receiving the news from the Angel Gabriel that she would give birth to Christ.[16] This is but one example of the debates that took place; others were of a less historical, more scientific nature.

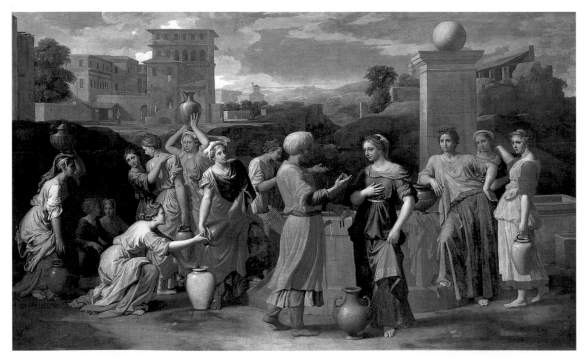

Plate 80 Nicolas Poussin, *Eliezer and Rebecca*, 1648, oil on canvas, 118 x 197 cm, Musée du Louvre, Département des Peintures, Paris. Photo: Copyright R.M.N.

[16] See Glen, 'A note on Poussin's *Rebecca and Eliezer at the Well* of 1648', pp.221–4.

It could be argued that some of these debates were so constrained in their terms of reference – a narrow canon of artists, the Bible – that they represented no significant threat or alternative to dominant artistic values. There is, however, another way of looking at this. If academies can institutionalize art and crystallize canonical principles, they are also the natural context in which canons can be questioned. The Académie's debates could be seen as attempts to subject canonical art and principles to rational, scholarly and scientific scrutiny, albeit within the boundaries and emphases of seventeenth-century knowledge. This is a trend which was to continue well into the eighteenth century, and in retrospect we can see how these small beginnings in scrutinizing an artistic canon led to much more dramatic developments and challenges to canonical academic values in the late eighteenth and nineteenth centuries. The Académie royale of the seventeenth century did much to establish works of art as objects of study in their own right,

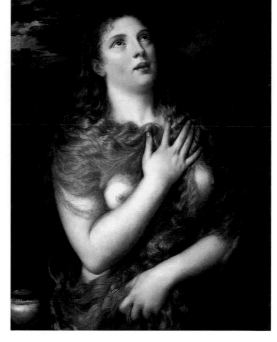

Plate 81 Titian, *Saint Mary Magdalen in Penitence*, c.1530–5, oil on panel, 84 x 69 cm, Pitti Gallery, Florence. Photo: Scala.

as well as to provide a wider public with a vocabulary and way of analysing art which would later allow it to form independent judgements.

Le Brun's era was an age of rule making and of a quest for the universal – for truths which could apply at all times and in all places. For example, Nicolas Boileau set down rules for poets and writers in his *Art poétique* (1674). François duc de la Rochefoucauld laid down rules for social conduct in his *Réflexions ou sentences et maximes morales* (1664). Le Brun's rules on expression must be seen in this context. In modern times there is generally more scepticism about the validity of 'universal truths', and hence the modern tendency to question the notion of a canon of art.

Almost as soon as Le Brun's ideas on expression had received a wide currency, other theorists came along in order to challenge both the apparent rigidity of these ideas and Le Brun's emphasis on drawing at the expense of colour. Charles-Antoine Du Fresnoy, Henri Testelin and Roger de Piles led the way in demanding a less schematic, more 'natural' approach to expression. (De Piles also promoted the cause of the Rubenists or colourists – see above, p.103.) We should also remember that during Le Brun's 'reign' at the Académie, his fellow artists were free to praise in their lectures the merits of artists such as Veronese (Plate 62) and Titian (Plate 81), renowned for their rich colouristic effects and for the pleasure these effects gave the eye, as well as those renowned for their drawing skills. Le Brun himself was not above experimenting with the rich effects of colour prized by followers of Titian and Rubens, as we can see in his *Penitent Magdalen* (Plate 82) and *Descent from the Cross* (Plate 83 – compare with Plate 64), originally destined for a chapel for Carmelite nuns in Lyons.

Plate 82 Charles Le Brun, *The Penitent Magdalen*, oil on canvas, 252 x 171 cm, Musée du Louvre, Département des Peintures, Paris. Photo: Copyright R.M.N.

Plate 83 Charles Le Brun, *The Descent from the Cross*, *c.*1679, oil on canvas, 545 x 327 cm, Rennes, Musée des Beaux-Arts. Photo: Louis Deschamps.

It would seem, then, that a respect for a well-defined canon of artistic works and principles did not prevent Le Brun or his contemporaries from experimenting with a variety of approaches within carefully circumscribed limits. Le Brun's 'dictatorship', such as it was, did not entirely suppress the rights of the individual artist.

Conclusion

We have seen how the prevailing political and cultural conditions of seventeenth-century France encouraged the enshrinement and canonization of particular works of art and of the principles which they embodied. But this did not totally suppress changes and shifts in emphasis: academies were, after all, centres of learned debate. While artists such as Jean-Baptiste Jouvenet (1644–1717) (Plate 84) and Antoine Coypel (1661–1722) (Plate 85) carried forward many of Le Brun's traditions and priorities, others such as Charles de la Fosse (1636–1716) (Plate 86), who was commissioned to do some work for Versailles, developed more fully the colouristic and painterly[17] aspects of their art. The latter paid less attention to clearly defined, sculptural forms and more to the textural effects of paint which might delight the eye rather than the mind: the antithesis of a polished academic finish/paint surface, in which the individual brushstroke must be concealed. Under the patronage of Pierre Crozat, a wealthy collector, de la Fosse, a senior academician, helped to establish a taste for the pictorial values which would later contribute to the success of painters like Watteau in the eighteenth century. Canonical traditions popularized by Le Brun scrutinized and refined, rather than adopted or rejected without question, the traditions of the past. In eighteenth-century France the scrutiny of canonical values derived from the classical tradition was to intensify and gather pace. In other countries – as you will see in relation to Hogarth, discussed in the next case study – artists working outside the constraints of the large academies also helped to broaden the boundaries of art. This process of liberalization has continued to the present day, when the virtues of canonical art are no longer taken for granted and the institutionalization of art in any form is the object of (at least) critical scrutiny and (at most) a deep-seated aversion proclaimed in the name of independent creativity.

[17] A painterly approach is one which exploits the texture and physical properties of paint and which uses indeterminate patches of colour rather than clearly outlined forms.

Plate 84 Jean-Baptiste Jouvenet, *The Resurrection of Lazarus*, 1706, oil on canvas, 388 x 664 cm, Musée du Louvre, Département des Peintures, Paris. Photo: Copyright R.M.N.

Plate 85 Antoine Coypel, *Athalia Banished from the Temple*, 1696, oil on canvas, 156 x 213 cm, Musée du Louvre, Département des Peintures, Paris. Photo: Copyright R.M.N.

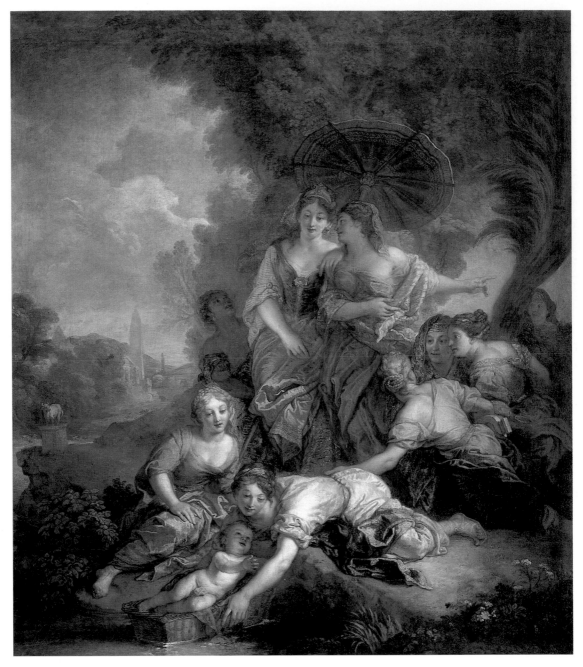

Plate 86 Charles de la Fosse, *Moses Rescued from the Water*, 1701, oil on canvas, 125 x 110 cm, Musée du Louvre, Département des Peintures, Paris. Photo: Copyright R.M.N.

References

Barker, E., Webb, N. and Woods, K. (eds) (1999) *The Changing Status of the Artist*, New Haven and London, Yale University Press.

Edwards, S. (ed.) (1999) *Art and its Histories: A Reader*, New Haven and London, Yale University Press.

Félibien, A. (1972) *Conférences de l'Académie royale de peinture et de sculpture*, vol.8 of *The Printed Sources of Western Art*, ed. T. Besterman, Portland, Collegium Graphicum (first published 1668).

Gareau, M. (1992) *Charles Le Brun, First Painter to King Louis XIV*, New York, Harry N. Abrams, Inc.

Glen, T.L. (1975) 'A note on Poussin's *Rebecca and Eliezer at the Well* of 1648', *Art Bulletin*, vol.57, no.2, June.

Hauser, A. (1951) *The Social History of Art*, 4 vols, London, Routledge & Kegan Paul.

Lough, J. (1969) *An Introduction to Seventeenth-Century France*, Harlow, Longman.

Montagu, J. (1994) *The Expression of the Passions: The Origins and Influence of Charles Le Brun's Conférence sur l'expression générale et particulière*, New Haven and London, Yale University Press.

Murray, P. and L. (1976) *Dictionary of Art and Artists*, Harmondsworth, Penguin.

Perry, G. (ed.) (1999) *Gender and Art*, New Haven and London, Yale University Press.

Posner, D. (1959) 'Charles Le Brun's *Triumphs of Alexander*', *Art Bulletin*, vol.61, no.3, pp.237–48.

Thomas, A. (1994) *Illustrated Dictionary of Narrative Painting*, London, Murray.

Vaisse, P. (1987) 'L'esthétique XIXe siècle: de la légende aux hypothéses', *Le Debat*, Mars–Mai, no.44, pp.90–105.

'Mere face painters'? Hogarth, Reynolds and ideas of academic art in eighteenth-century Britain

GILL PERRY

Introduction

In 1745 the artist William Hogarth (1697–1764) painted a large-scale portrait of the famous actor and stage director David Garrick in dramatic pose as King Richard III (Plate 87). Although now perhaps better known as a graphic artist who produced many prints on contemporary social themes, Hogarth was an accomplished painter and portraitist. However, this painting is more than just a portrait study; it goes beyond a simple likeness of the sitter in the manner of, for example, his earlier portrait of George Arnold (Plate 88). In contrast with the simple pose and lack of props in the latter, Hogarth has painted his friend Garrick acting the Shakespearean role of Richard III. Although this is a part which Garrick had famously played on the stage of the Drury Lane Theatre, the assumed role gives the portrait a literary level of meaning. It provides the viewer with a narrative in which Richard III, in historical dress, is posed somewhat melodramatically with hand raised and a shocked facial expression as he awakes from a terrifying dream in his tent on the battlefield of Bosworth Field. According to the Shakespearean text, he has just seen a succession of ghosts of his murdered victims. Hogarth has chosen to represent one of the dramatic moments from the play, thus giving his work an added theatrical quality which is also particularly appropriate to the character of the sitter.

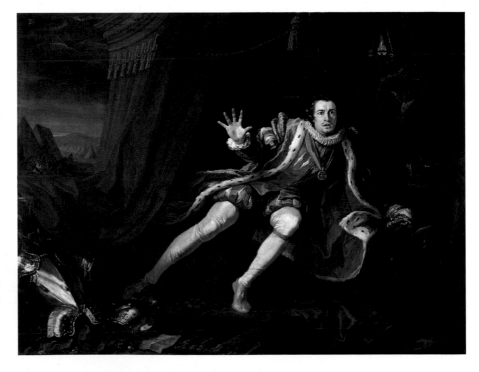

Plate 87 William Hogarth, *David Garrick as Richard III*, 1745, oil on canvas, 191 x 252 cm, Walker Art Gallery, Liverpool. Reproduced by permission of the Board of Trustees of the National Museums and Galleries on Merseyside.

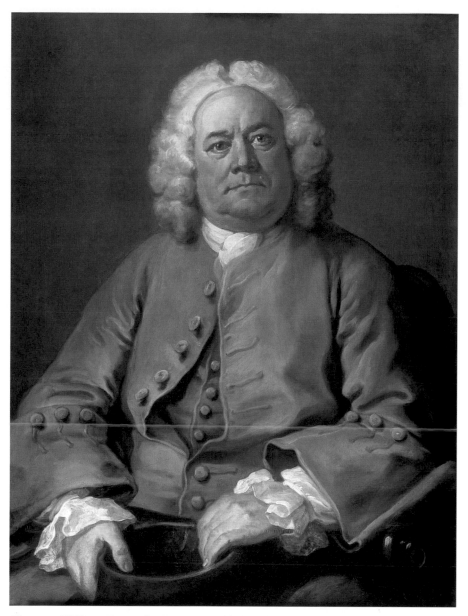

Plate 88 William Hogarth, *George Arnold of Ashby Lodge, c.*1738–40, oil on canvas, 91 x 71 cm, Fitzwilliam Museum, Cambridge. Reproduction by permission of the Syndics of the Fitzwilliam Museum, Cambridge.

The British market for portrait commissions had been buoyant during the first half of the eighteenth century, and Hogarth's painting raises some interesting questions about the function and status of portraiture during the period. A question which was often posed during the period was: should portrait painters concentrate on producing a straightforward likeness of their sitters, or should they seek to elevate or aggrandize their clients by representing them in dignified or alien roles and poses? These sorts of questions were much debated at the time, and one of the century's first writers on aesthetics, the Earl of Shaftesbury, had written in 1711 that 'the mere face

painter has little in common with the poet' (*Characteristicks of Men, Manners and Opinions*). Shaftesbury was suggesting (somewhat controversially) that the portraitist was nothing more than a copyist, and therefore had little in common with 'men of invention and design', who were more likely to reveal their 'invention' in history painting.

In this case study I want to look at the shifting status of portraiture in mid-eighteenth-century Britain, its relationship to ideas of academic art, and the implications of that relationship for the establishment of a canon in art. In the process I want to look critically at the notion of a canon and what it might have meant to an eighteenth-century British audience. And following on from the preceding study on Le Brun and the Académie royale, I want to explore the difficult question of the relationship between supposedly canonical paintings and the institutional frameworks within which they were produced. I shall argue that within a British context their relationship can be usefully explored through the study of portraiture by both Hogarth and Sir Joshua Reynolds, first president of the Royal Academy of Art.

Between portraiture and history painting

Hogarth's *David Garrick* raises some important questions about the status and meaning of portraiture. Apart from being a portrait, it could qualify for the label 'history painting'. According to the conventions and hierarchies established in many European academies of art, history painting was seen as the highest genre (or category) of painting, above the genres of portraiture, landscape or still life. As we saw in the preceding study, history painting was traditionally based on noble themes from history, mythology, literature or the Bible, was usually painted on a grandiose scale and often contained allegories. Such allegories might add another level of meaning relevant to the contemporary political situation. As we shall see, the economic demand for portraiture meant that relatively few British artists from the period were exclusively history painters, although the Scotsman Gavin Hamilton (1723–98) was one of the best-known eighteenth-century exponents of the genre.

Please look at Hamilton's *Hector's Farewell to Andromache*, first exhibited in 1762 (Plate 89). The subject is taken from Homer's *Iliad*, an ancient Greek source popular with eighteenth-century artists and writers. What aspects of this work would you single out in describing it as a history painting?

Discussion

I would say that this provides a useful example of how the different elements of history painting discussed above can work together to produce meaning. The artist employs a host of classical details in the representation of architecture, furniture, costumes, the frieze-like arrangement of figures (reminiscent of an ancient sculptural frieze) and the exaggerated poses. The effect of these somewhat mannered poses in a relatively sparse setting is to evoke a sense in the spectator of the universal meanings of the themes and emotions expressed. Thus the treatment of the figures appears generalized and idealized as they are caught in one dramatic moment.

◆◆◆

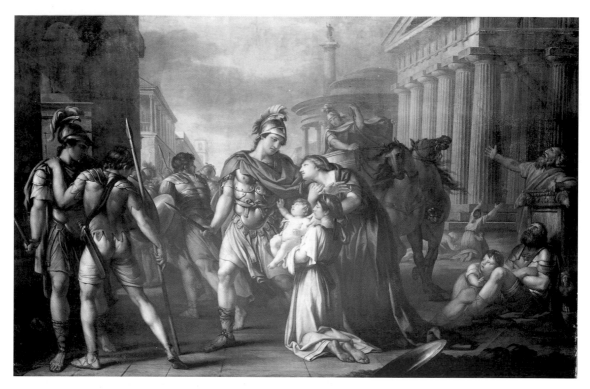

Plate 89 Gavin Hamilton, *Hector's Farewell to Andromache*, 1762, oil on canvas, 315 x 399 cm, Palace of Holyroodhouse, Duke of Hamilton. Copyright Hunterian Art Gallery, University of Glasgow.

This work, like many history paintings, was executed in what was described by some contemporary theorists as the 'Grand Manner'. This term was used to describe a style influenced by classical and Old Master sources, especially those of the Italian Renaissance, which were believed to reveal 'dignity'. If we return to Hogarth's painting of Garrick, we can see that although it is primarily a portrait study, the dramatic pose, the assumed role of Richard III (which is both heroic and tragic) and the context of the battlefield help to give this work some of the pretensions of a history painting. However, at the time that Hogarth painted his portrait in the 1740s, there was a relatively small market for history painting in Britain (unlike France), while the demand for portrait commissions, particularly from the growing middle class, was strong. As Louise Lippincott has argued, 'Commissions for history paintings were exceedingly rare in a nation where state patronage of the arts was limited and institutional patronage sporadic.'[1]

It was not until over twenty years later that attempts were made to give history painting some kind of official institutional support in the activities and critical discourses associated with the Royal Academy of Art, established under royal charter in 1768. Its first president, Sir Joshua Reynolds (1723–92)

[1] For further information about how portraiture and history painting fared in the marketplace, see a fascinating article by Lippincott, 'Expanding on portraiture: the market, the public, and the hierarchy of genres in eighteenth-century Britain'. The relationship between shifting developments in English portrait painting, rapid economic expansion, and the rise of an art market in eighteenth-century England is discussed in David Solkin's useful book, *Painting for Money: The Visual Arts and the Public Sphere in Eighteenth-Century England*.

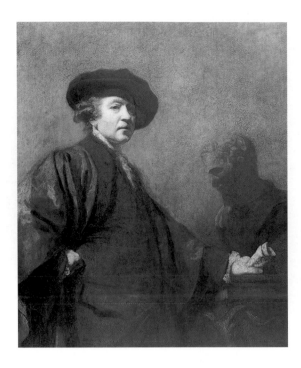

Plate 90 Sir Joshua Reynolds, *Self-Portrait*, *c.*1780, oil on panel, 127 x 102 cm, Royal Academy, London. Photo: Prudence Cuming Associates Ltd.

(Plate 90), gave a series of annual lectures (*Discourses*) to students and academicians between 1769 and 1790 in which he set out some of his theoretical ambitions for an academic institution keen to advertise its members as learned professionals who practised and taught an elevated intellectual art. He was anxious to separate art from the associations of 'mere' copying referred to by Shaftesbury. Reynolds sought to elaborate a theory of art which would raise painting and sculpture to the status of a liberal art comparable with poetry, echoing the ideals of the Académie royale in France described in the last case study. Thus in some of his early *Discourses* Reynolds advocated an art which is not merely a depiction of the world around us but which is imbued with great ideas. It is this which distinguishes it from what he called a 'mechanical trade', from a more servile process of artistic production. In *Discourse III* he wrote of the 'intellectual dignity … that ennobles the painter's art' and distinguishes him from a 'mere mechanic' (Reynolds, *Discourses on Art*, p.43).

In early eighteenth-century Britain the practice of painting was still widely perceived as a trade rather than a profession. The early academicians were keen to be presented as professionals with intellectual qualifications, thereby separating themselves from what they saw as the more 'mechanical' practices of, for example, printmakers, topographical and animal painters, copyists and wax modellers. This attempt to set up hierarchical distinctions between 'high art' and supposedly lower art forms has influenced art practice and theory in Britain since the eighteenth century; it is central to the idea of the western canon and to its claims for some objective measure of aesthetic quality. It has also been suggested that the bid to promote a theory of high art with rhetorical and intellectual meanings was partly politically motivated. Reynolds and many early academicians have been seen to be propagating a theory of high art which reinforces a notion of 'gentlemanly' status. In other words, the austere high-mindedness of history painting carried with it important *public* and social meanings; it suggested an audience of public citizens and gentlemen (its audience was generally perceived to be largely

male) educated and politicized to respond to its high-minded messages. Such messages were often derived from – or related to – the public values of classical, especially ancient Greek, culture.[2]

Such ideas have important implications for our understanding of eighteenth-century views on what constituted the 'great' or canonical forms of art of that period. As I suggested in the Preface to this book, the processes whereby art becomes canonized are complex and sometimes difficult to determine in that they are inseparable from wider social, cultural, political, educational and aesthetic concerns and issues. I would argue that one reason why the establishment of, and culture associated with, the Royal Academy of Art is a fruitful area within which to examine some of these complex processes is that the canon is itself in part an educational institution. The idea of the canon, of art of indisputable quality, is based on the belief that the values and 'superior' practices of this higher form of art can be taught. This is what separates Reynolds's notion of high art from the lower arts which are learnt through the more mechanical acquisition of a 'trade'. This form of art requires a teacher – and a student – who are able to discriminate between sources provided by the art of the past, and to select and reconstitute from these sources to produce a superior art of 'quality'. The canon then implies a certain code of aesthetic value which its practitioners seek to reproduce and elaborate. As we shall see in this study, one of the most important activities of the Royal Academy was performed in the Academy Schools which trained artists (in theory at least) to become academic painters.

I will return to these points in the sections which follow, but from my discussion so far you have seen that within academic circles history painting was thought to have a greater claim for intellectual – and therefore canonical – status. However, in Britain this theoretical aim was by no means fulfilled in practice. Relatively few British academicians were *primarily* history painters, unlike the situation in France at the time, in which the dominance of state patronage and a centralized Académie royale since the seventeenth century had helped to encourage the production and marketability of history painting. As I suggested earlier, portrait painting was the genre most in demand in both middle-class and upper-class British society during the period. As a result, many portraitists who were also academicians developed devices for raising the status of portrait painting. Reynolds, for example, became renowned for his allegorical portraits, as in his famous *Lady Sarah Bunbury Sacrificing to the Graces* and *Mrs Hale as 'Euphrosyne'* (Plates 91 and 92), in which the protagonists act out mythological scenes in pseudo-classical costume while also being recognizable as likenesses of the sitters in question. *Mrs Hale as 'Euphrosyne'* will be discussed in more detail in a later section,

[2] These public values were thought to be most fully expressed in the writings of Aristotle (384–322 BCE), whose ideal of civic virtue is based upon a distinction between the 'free man' and the 'mechanic'. Only 'free men' are capable of being active citizens – that is, of governing in the public interest. In essence, this is an aristocratic ideal, for the 'free man' is defined as independent, with no need to work for a living and with the leisure to occupy himself in public affairs. During the Renaissance Florentine civic humanists revived this idea of active citizenship; it was given its clearest expression in the political writings of Machiavelli (1469–1527). John Barrell has linked the discourse of civic humanism to artistic debates in early eighteenth-century England, in particular those associated with the Royal Academy of Art, which he calls the civic humanist theory of painting. This theory was concerned to reinforce the relationship between 'public taste' and 'public virtue', and advocated that the most dignified function to which painting could aspire was the promotion of public virtues. See Barrell, *The Political Theory of Painting from Reynolds to Hazlitt*.

but the point I want to make here is that in practice the boundaries between genres were perhaps more flexible than the rigid academic hierarchies (clearly elaborated, as we have seen in the doctrine of the Académie royale) might lead us to believe. Moreover, an understanding of that very flexibility may help us to perceive some of the ways in which the canon was reconstituted and elaborated.

This fluffing of boundaries was a focus of my discussion of Hogarth's portrait of Garrick. Although he died four years before the Royal Academy of Art was established, Hogarth had already disassociated himself from the artistic

Plate 91 Sir Joshua Reynolds, *Lady Sarah Bunbury Sacrificing to the Graces*, 1765, oil on canvas, 242 x 152 cm, Art Institute of Chicago. Mr and Mrs W.W. Kimball Collection 1922.4468.

Plate 92 Sir Joshua Reynolds, *Mrs Hale as 'Euphrosyne'*, c.1764, oil on canvas, 236 x 146 cm, Harewood House, Yorkshire. Reproduced by kind permission of the Earl of Harewood and the Trustees of the Harewood House Trust.

circles and some of the theoretical ambitions which helped to nurture its foundations. Despite this, we have seen that Hogarth had already been using devices to elevate his subject from the status of a 'mere' likeness over twenty years before Reynolds became famous for his allegorical portraits. Interestingly, the latter also painted the famous actor, as in his *Garrick between Tragedy and Comedy* of 1761 (Plate 93), in which the artist also seeks to elevate the genre and, one might argue, the character of Garrick himself. One of the earliest accounts of this painting, written by Horace Walpole in 1761, explains the allegory:

> Reynolds had drawn a large picture of three figures to the knees, the thought taken by Garrick from the judgement of Hercules. It represents Garrick between Tragedy and Comedy. The former exhorts him to follow her exalted vocation, but Comedy drags him away, and he seems to yield willingly though endeavouring to excuse himself, and pleading that he is forced. Tragedy is a good antique figure, but wants more dignity in the expression of her face. Comedy is a beautiful and winning girl – but Garrick's face is distorted, and burlesque.

(Quoted in Penny, *Reynolds*, p.205)

Plate 93 Sir Joshua Reynolds, *Garrick between Tragedy and Comedy*, 1761, oil on canvas, 148 x 183 cm, private collection.

The term allegory is derived from the Latin *alia oratio*, which means 'other speech' or containing another layer of meaning. When applied to visual representation rather than speech, we find that allegory can operate through the visual personification of other meanings. Thus Tragedy and Comedy in this painting are female personifications of dramatic conventions. But there are other possible levels of meaning which could be interpreted as allegory. As Walpole suggests, the painting refers to decisions which Garrick had to make in his career as a theatre director. He was the leading actor and joint manager of the Drury Lane Theatre for 30 years from 1746, renowned for his intelligent interpretations of Shakespearean roles. In this image he seems to be yielding to the woman who personifies Comedy, while his somewhat humorous expression suggests that he is pleading light-heartedly with Tragedy (herself an awesome, serious figure). Later in his career, Garrick showed a preference for putting on comedies, a choice which is represented here as a Herculean struggle. (According to the Greek mythological tale of the labours of Hercules, he is forced to choose between following the path of moral virtue and that of pleasure.) Walpole's concern that Garrick's face is 'burlesque' suggests that he found the portrait wanting in the dignity and stoicism traditionally associated with the Herculean theme. Garrick hardly seems to be struggling with the most heroic decision of his life. This element of bathos may have been intended by the artist, who was a friend of Garrick, to remind the viewer that, despite the elevating classical references, this is a portrait of a well-known contemporary personality.

While the male protagonist – the subject of the portrait – is a modern figure, the two female figures are (as we have seen) personifications. As Muses they belong to a well-established tradition in literature and the arts in which women were used to symbolize various forms of artistic creativity. In Greek mythology nine named Muses signified specific aspects of learning and the arts, of whom the two best known were Thalia (Comedy) and Melpomene (Tragedy).[3] In a later section I will be looking more closely at the gendered implications of these traditions, but I want to concentrate here on what they might signify within Reynolds's portrait. The artist has painted these two Muses in different styles, giving the painting another possible level of meaning. The pseudo-classical style and pose of Tragedy has been compared with the lighter, more intimate style employed to paint the figure of Comedy.[4] Thus the painting could reveal another allegorical meaning in which the artist hesitates between a dignified 'academic' style associated with many of his public exhibition pieces (Plates 91 and 94) and a more intimate style associated with portraits such as *Nelly O'Brien* (Plate 95).

How do the conventions (the poses of the figures and the organization of the composition) employed in Reynolds's *Garrick between Tragedy and Comedy* (Plate 93) compare with those employed in Hogarth's portrait of Garrick (Plate 87)?

[3] According to classical mythology, the nine Muses were sisters, daughters of Zeus and Mnemosyne (or Memory).

[4] While the style of Tragedy has been compared with that of the seventeenth-century Italian painter Guido Reni, that of Comedy has been likened to the softer, lighter style of the sixteenth-century Italian painter Correggio.

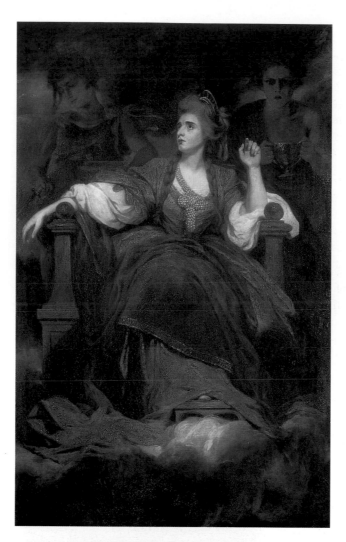

Plate 94 Sir Joshua Reynolds, *Mrs Siddons as the Tragic Muse*, 1789, oil on canvas, 240 x 148 cm, Dulwich Gallery, London. Reproduced by permission of the Trustees of Dulwich Picture Gallery.

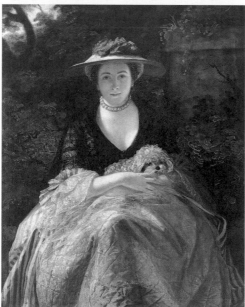

Plate 95 Sir Joshua Reynolds, *Nelly O'Brien*, 1760–2, oil on canvas, 128 x 112 cm, Wallace Collection, London. Reproduced by permission of the Trustees of the Wallace Collection.

Discussion

Although Hogarth's portrait does not reveal a comparable use of allegory, his protagonist assumes a less 'burlesque' pose. Following the Shakespearean narrative, Hogarth's Garrick assumes a more serious, dramatic pose. In Hogarth's portrait the seriousness of the pose recalls the traditions of history painting. Unlike Reynolds's portrait, the artist seems to have conveyed a stronger sense of the seriousness of the moment captured. And the carefully balanced compositional structure in which the centred figure of Garrick is framed by the drapes of the royal tent adds to this seriousness. In contrast, Reynolds's group of three figures, in which two seem to be attempting to lure Garrick in their direction, presents a less focused and more light-hearted image.

◆◆

The pose in Hogarth's Garrick was commonly found in theatrical portraits, especially the work of Johann Zoffany (1733–1830) in this genre (Plate 96). However, Hogarth, like Reynolds, was by no means consistent in the conventions and techniques which he adopted. Other, more informal portraits by Hogarth from this period suggest that only occasionally did he give his sitters such heroic gestures or roles (see Plates 88 and 97). The complex nature of these shifts in interest in the work of both Hogarth and Reynolds is a major concern of this study. And, as I shall argue, such shifts and contradictions in the portrait conventions adopted for depicting both male and female subjects point to what we might call a 'crisis in representation' in portraiture in mid-eighteenth-century Britain. Reynolds's attempt to elevate the genre and give it academic respectability is (as I suggest) one of many responses to this crisis.

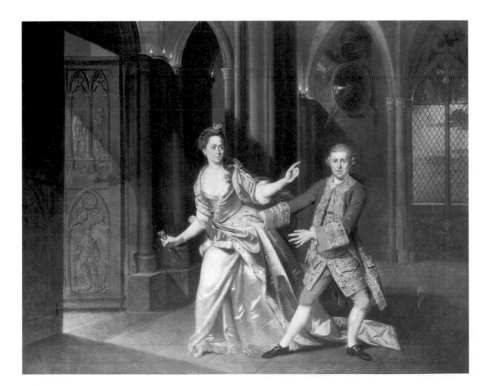

Plate 96 Johann Zoffany, *David Garrick and Hannah Pritchard in Macbeth*, *c*.1760, oil on canvas, 102 x 128 cm, Garrick Club, London. E.T. Archive.

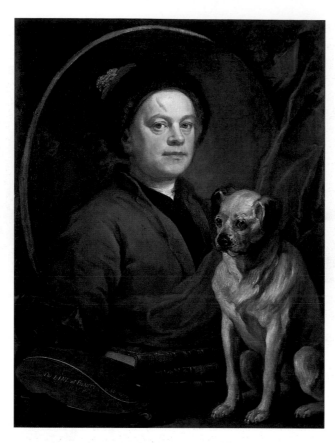

Plate 97 William Hogarth, *The Painter and his Pug*, 1745, oil on canvas, 91 x 71 cm, Tate Gallery, London. Copyright Tate Gallery, London.

In fact, Reynolds painted several portraits of Garrick, who invited and encouraged portrait commissions from many artists, recognizing the value of paintings as advertisements for his professional roles and status. Successful portraits were often popularized through engraved copies (Plates 98 and 99), and the wide dissemination of such reproductions, priced relatively cheaply, ensured a popular audience for such images and the personalities they represented. This form of exposure greatly extended the narrower audience which was able to attend public exhibitions, or the artists' studios, where the original portraits might be displayed. It could also be argued that the increased public knowledge of the work (albeit in reproduction) helped to establish the canonical status of the original painting.

For example, Reynolds's *Garrick between Tragedy and Comedy* was exhibited at the Society of Artists (then the most important exhibiting society in London) in 1762, where it generated considerable interest and was subsequently engraved and widely reproduced. Fourteen different mezzotints[5] of the painting now survive (Plate 98), and the image became so well known that it often appeared in caricatured form within other satirical engravings. It was used in 1772 on the title page of a satirical poem attacking Garrick (among others) for his poor treatment of actors and his declining judgement (Plate 100). In this image, the respected figures of Tragedy and Comedy are now both unsuccessfully trying to interest him on the left, as he seems to be

[5] 'A method of engraving in which the artist works from dark to light. The whole ground is first of all covered with a regular fine scratching ... This takes the ink and appears as a black background. The design is burnished onto it, does not take the ink and therefore appears in white' (Lucie-Smith, *Dictionary of Art Terms*, p.120).

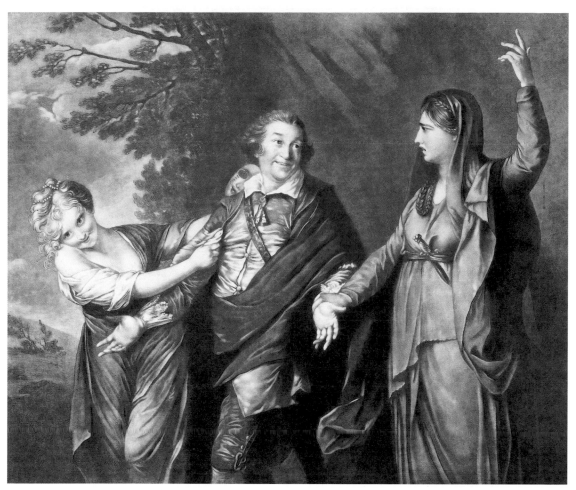

Plate 98 E. Fisher after Reynolds, *Garrick between Tragedy and Comedy*, 1762, mezzotint, British Museum, London. Copyright © British Museum.

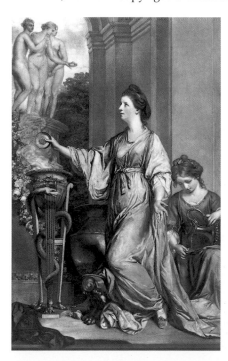

Plate 99 E. Fisher after Reynolds, *Lady Sarah Bunbury Sacrificing to the Graces*, 1766, mezzotint, 60 x 37 cm, Fitzwilliam Museum, Cambridge. Reproduction by permission of the Syndics of the Fitzwilliam Museum, Cambridge.

beguiled instead by a tailor, scene-builder and stage machinist on the right, and walks disdainfully over the plays of Shakespeare, Jonson and Rowe. The satirical claim being made here is that in his later years Garrick has abandoned respected drama of literary merit for more popular pantomimes and farces which employ spectacular stage sets and theatrical devices. You may have noticed that although this image belongs (in academic terms) to the 'lower' art form of engraving, it also employs precisely those devices which, as we have seen, could ennoble forms of high art. Symbolism (in the trampling underfoot of the respected plays) and allegory (in the classical Muses of Tragedy and Comedy acting out their roles) are employed both to make a critical point and, one might argue, to satirize the pomposity of the devices themselves as they are used in the original portrait.

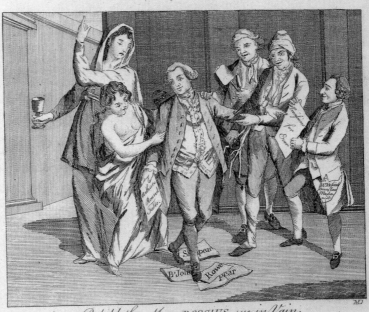

THE
THEATRES.
A
POETICAL DISSECTION.
. By Sir NICHOLAS NIPCLOSE, Baronet.

Suppose JOB living 'midst the Critic train,
Our Theatres would ope his angry vein.

Behold the Muses ROSCIUS sue in Vain,
Taylors & Carpenters usurp their Reign.

LONDON:
PRINTED FOR JOHN BELL, IN THE STRAND, AND C. ETHERINGTON, AT YORK.
M.DCC.LXXII.

Plate 100 Title page to 'The Theatres. A Poetical Dissection. By Sir Nicholas Nipclose', 1772, etching and engraving, British Library, London. By permission of the British Library.

Such symbolic conventions were part of a contemporary visual language that would have been understood by an audience which was not restricted to the most highly educated upper classes. While the more sophisticated levels of meaning in Reynolds's portrait, such as the possible allegory of the actor's choice, might only have been appreciated by a more élite audience, the allegorical conventions themselves and the mythological references would have been understood by a wider social group, albeit one which probably did not extend far beyond the middle classes. Moreover, the rapidly growing market for engraved copies and popular prints suggests that the consumption of 'art' (understood in its broadest sense) in the mid-eighteenth century was expanding way beyond élitist aristocratic and upper-class circles. As we shall see, it was precisely this wider middle-class market which Hogarth sought to address in his own series of engravings.

I have suggested that in this satirical print of 1772 the contemporary practices of both art and theatre are under attack. So far I have deliberately chosen to focus on visual representations of theatrical characters and themes in order to help 'set a scene', and later in this case study I shall be looking more closely at the complex relationship between the forms of artistic and theatrical representation. We have seen that both portraits of Garrick by Hogarth and Reynolds use literary and/or mythological references and poses to give the sitter a more elevated status. Thus Garrick's role as an actor and theatre director is presented as a high-ranking, even intellectual profession. During this period the theatre, like painting, was seeking to improve its public status and gain recognition as a profession, and Garrick played an instrumental role in this process. Moreover, both portraits of Garrick helped to establish a relatively new and increasingly popular subgenre within portraiture: the theatrical portrait. Apart from Reynolds, who became well known for his many portraits of actresses (Plate 94), we have seen that Johann Zoffany (who became a Royal Academician in 1768) took up the genre in the 1760s (Plate 96). In my section on portraiture below, I will consider some of the meanings which these works held for an eighteenth-century audience.

The similarities we have discussed between the two portraits of Garrick mask some important differences and contradictions in the artistic practices and approaches adopted by the two artists *and* within the range of practices developed by each. My argument is that the art and ideas produced by both play an important part within the complicated network of interests and factions which made up the English art world and its academic ambitions in the mid-eighteenth century.

The first British academies: institutionalizing art

One of Hogarth's earliest prints, and the first which he published as an independent enterprise (rather than as an illustration for another publication), was *The Taste of the Town* or *Masquerades and Operas* (Plate 101). It shows a street scene dominated by crowds attending a harlequin's performance of the play *Dr Faustus*[6] on the right, and a masquerade (or masked ball) on the left. Facing the square is a portico surmounted with sculpted figures, which marks the entrance to 'The Academy of Arts'. Each of these institutions and

[6] The story of Dr Johannes Faustus, who according to legend made a pact with the devil Mephistopheles, was dramatized in England by Christopher Marlowe in 1589. Goethe wrote his play *Faust* in the late eighteenth century.

events is the object of Hogarth's critical gaze. Three figures assuming foppish poses look up in admiration at 'The Academy of Arts', as one points to the statue of the Italian-influenced architect and landscape gardener William Kent (1685–1748) above the pseudo-classical pediment. Beneath him, the Italian Renaissance artists Michelangelo and Raphael occupy more lowly positions on the corners. The design of the portico and Kent's dominant position are intended to mock the contemporary taste for Palladian[7] and neo-classical architecture at the expense of an English tradition. For Hogarth this 'Academy of Arts' symbolizes the decay or corruption of English artistic culture and the infiltration of foreign (Palladian) values. These beliefs echoed those of a group of British artists in the 1720s, among them the history painter Sir James Thornhill (1675/6–1734), who was to play an important role in the Saint Martin's Lane Academy, one of the first British institutions for the teaching of art.

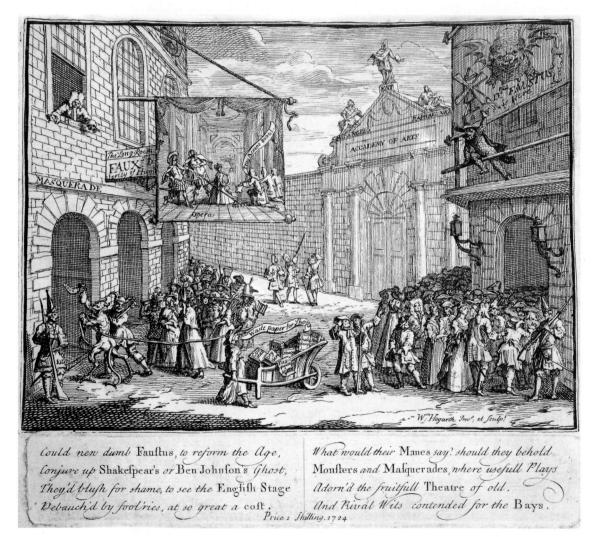

Plate 101 William Hogarth, *The Taste of the Town* (also known as *Masquerades and Operas*), 1724, etching and engraving, 11 x 17 cm, British Museum, Department of Prints and Drawings, London. Copyright © British Museum.

[7] The Palladian style was fashionable during the first half of the eighteenth century, and was named after Italian architect Andrea Palladio (1508–80). It was based on a rigid theory of proportion.

In his engraving *The Taste of the Town*, Hogarth makes an association between the taste for Palladianism (in 'The Academy of Arts') and debased forms of popular entertainment in the foreground. The *Dr Faustus* is being vulgarized and popularized through a harlequinade, while the masquerade on the left is a form of popular entertainment which depends on disguise. The pomposity of the Academy's portico is thus echoed in the debased popular spectacles on either side of the image, in which theatrical metaphors of disguise and deceit are employed to satirical ends. Moreover, the contemporary taste for such spectacles at the expense of more serious drama is attacked in the foreground image in which a figure carries off a wheelbarrow full of the discarded works of respected English writers – including Shakespeare, Congreve, Dryden and Addison – to be disposed of as 'waste paper'.

To understand the many implications of Hogarth's comment on the English art scene, we need a fuller picture of the context in which Palladianism was seen to be infiltrating the culture. David Bindman has described the situation as follows:

> There was no academy as in France to lay down an orthodoxy, there were no places of exhibition, very few places of formal instruction and hardly any books of art theory. It was very difficult to see works of art, for there was no system by which they could be made accessible. There was, however, no shortage of demand for art of most kinds, but understandably patrons preferred to employ well-trained and talented foreigners, who were always available, rather than nurture native artists who, it was believed, would need a lengthy training abroad anyway. At the top end of the profession were the painters of allegorical wall decorations, for they carried with them the prestige of the Grand Manner and they had the ability to create astonishing effects of illusion which, at their most opulent, could create a completely false architectural space and ornamentation out of a plain room.
>
> (Bindman, *Hogarth*, p.18)

As we saw in the preceding case study, circumstances were rather different in France, where the Académie royale, founded in 1648, exerted enormous influence and encouraged classes in drawing and the promotion of history painting. A number of Italian cities also boasted academies which had flourished since the Renaissance, among them the famous Accademia di S. Luca in Rome. Within such institutions the teaching of art tended to follow rather rigid and hierarchical structures, and the absence of equivalent British schools of training helps to explain the relative success of the lesser genre of portraiture in Britain during the first half of the eighteenth century. However, the codification of aesthetic doctrines in Italy and France played an important role in public perceptions of the status of art in those countries. The institutionalization of art, preferably with royal patronage and support, was crucial in helping to create a culture of professionalism for the discipline and, as I have suggested, in the establishment of a canon.

For that culture to thrive and develop, adequate facilities must be provided for both education in, and access to, art. In early eighteenth-century England access to paintings and collections of Old Master works was almost entirely confined to stately homes in which aristocratic owners had built up personal collections or employed Italian or French artists to decorate their apartments. Hogarth was one of many artists to draw attention to the need to provide training, exhibiting space and public access to art in the early eighteenth century, and during the first two decades there were several small-scale attempts to provide such facilities.

In 1711, on Saint Luke's day (the patron saint of artists), the first London academy of painting and drawing from life (that is, using live models) opened in a room in Great Queen Street, Lincoln's Inn Fields. Its governor was Sir Godfrey Kneller, then one of Britain's most successful portrait painters, and the Board of Directors included Sir James Thornhill, renowned for his decorative wall paintings on historical themes. According to surviving reports, the early history of the academy was characterized by internal bickering and power struggles, and Thornhill replaced Kneller as governor in 1716.[8] The former's artistic and political ambitions appear to have been closely entangled. He was appointed Sergeant-Painter and knighted in 1720, and elected a Member of Parliament in 1722. Internal struggles continued at the academy, and it moved to rooms in St Martin's Lane in 1720, when William Hogarth's name first appears on the membership list. This institution appears to have thrived until, according to popular myth, embezzlement of funds by the treasurer caused a financial crisis. Meanwhile, Hogarth had married Thornhill's daughter, and after his father in-law's death in 1734 he reconstituted the academy in St Martin's Lane in 1734–5. This institution, which was run on democratic lines giving all members equal rights, became known as 'The St Martin's Lane Academy', and flourished until the 1760s when plans for the Royal Academy were consolidated. Hogarth was one of several directors, and in 1764, shortly before his death, he described his early involvement thus:

> attributing the failure of the preceding Academies to the leading members having assumed a superiority which their fellow students could not brook, I proposed that every member should contribute an equal sum towards the support of the establishment and have an equal right to vote on every question relative to its affairs. By these regulations the Academy has now existed nearly thirty years, and is for every useful purpose equal to that in France or any other.
>
> (Hutchison, *History of the Royal Academy*, p.10)

This retrospective account would seem to contradict Hogarth's well-known scepticism towards the influence of foreign 'Academies of Art', which he was indirectly satirizing in *The Taste of the Town*. But Hogarth's scepticism clearly masks some problems and contradictions behind the definition of a desirable 'British' art. In mid-eighteenth-century England it was difficult to find practising artists who were not influenced in one way or another by the work of French and Italian decorators, painters and engravers, for whom the London art world had become a popular destination and source of commission. In fact, among the teachers at the St Martin's Lane Academy were the French engraver Hubert Gravelot and the sculptor Louis François Roubiliac. And, as we shall see, much of Hogarth's own graphic work and his famous 'conversation pieces' such as *The Graham Children* (Plate 114) were influenced by the work of French Rococo[9] engravers and painters.

[8] Details of the various academies which preceded the formation of the Royal Academy of Art, and the political struggles involved, are described in Hutchison, *History of the Royal Academy*.

[9] Rococo, which emerged in France around 1700, was a development from the Baroque style and was generally seen to be characterized by lightness and grace of design.

His somewhat self-congratulatory comparison with the situation in contemporary France was both seeking acknowledgement for the success of the democratic principles of the St Martin's Lane Academy and a bid for professional recognition for the practice of art in England. During the 1750s and 1760s there had been many discussions and proposals among artists from the school for the establishment of a larger, more prestigious academy which would put Britain on a par with its continental neighbours, and which eventually materialized with the foundation of the Royal Academy in 1768. Hogarth's comment from the early 1760s was thus seeking recognition for the important role played by the St Martin's Lane Academy in changing opportunities for the development of art in England, in helping to assert the viability of a professional culture of art.

While the St Martin's Lane Academy provided tuition, attempts by many of its members (including Reynolds, Thomas Hudson, Gavin Hamilton, Roubiliac, George Moser and others) to advance plans for a more prestigious academy were also provoked by the pressing need to provide public exhibition space for their members. This was to be one of the most important roles of the Royal Academy, and its two main forerunners in this respect were the Foundling Hospital, established by the philanthropist Captain Thomas Coram (Plate 102) in 1739, and the Society of Artists founded in 1761 in a large room in Spring Gardens, Charing Cross. The former was in fact a hospital for orphaned and abandoned children which, under Coram's patronage, built up an extensive collection of pictures that could be viewed by the public in return for a charitable donation. The Foundling collection became a fashionable institution for an educated art public to visit, and in the process anticipated some of the social and cultural rituals associated with the later Royal Academy shows. As a contemporary observer recorded, the paintings 'being exhibited to the public, drew a daily crowd of spectators in their splendid equipages; and a visit to the Foundling became the most fashionable morning lounge of the reign of George II' (Hutchison, *History of the Royal Academy*, p.16). The Society of Artists was primarily an exhibiting society which included Reynolds, Hogarth and the portrait painter Thomas Gainsborough (1727–88) among its participants and obtained a royal charter in 1765. In the early 1760s this society enjoyed considerable success, with well-attended annual exhibitions, until internal dissensions in 1767 encouraged some members to pursue plans for the establishment of the Royal Academy.

The public conventions for consuming art, usually at a price, were thus already established in mid-eighteenth-century England, although this group of consumers often came from a relatively élite group of middle- and upper-class patrons. For a modern audience used to a thriving 'gallery culture' and state-patronized national museums (of which the National Gallery is to feature in a later case study), these eighteenth-century channels for the consumption of art might seem rather limited. But as David Solkin has argued, during the mid-eighteenth century there was a marked expansion in public facilities for viewing art when 'Britain effectively acquired the components of a modern art world' (Solkin, *Painting for Money*, p.2). My (albeit sketchy) mapping of some of the early institutionalizing processes for art should help to give you an idea of the very different social and political perceptions of, and context for, the practice of art during the period. What we now take for granted as a 'professional' activity with a widely disseminated influence on our culture was, in a sense, in its infancy in the eighteenth century.

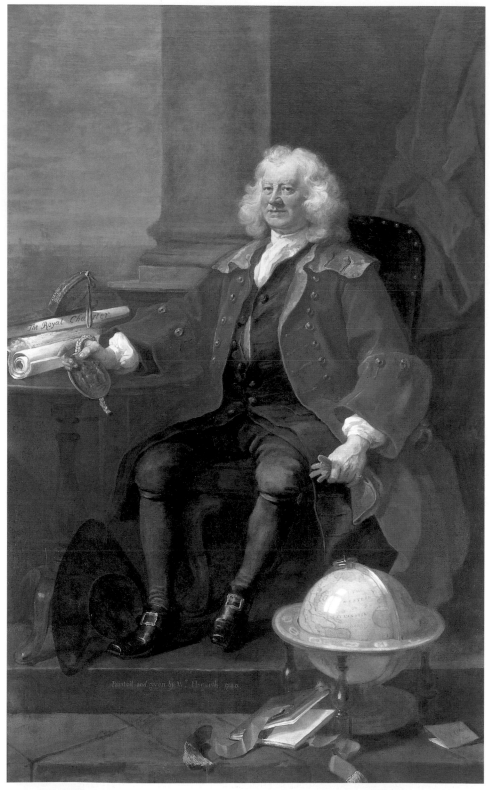

Plate 102 William Hogarth, *Captain Thomas Coram*, 1740, oil on canvas, 239 x 147 cm, Thomas Coram Foundation for Children, London. Photo: Bridgeman Art Library.

One of the crucial distinguishing features of the Royal Academy – which ensured its political and institutional survival – was that it was conceived of and established under the protection of the Crown and government. While most of its predecessors were founded independently by groups of artists, the Royal Academy sought the support of George III (who came to the throne in 1760) at an early stage in its conception, and in December 1768 he signed a charter setting out the constitution and its original membership. However, we should note that this royal charter, while providing political status, was also intended to *enable* certain 'freedoms'. The founder members hoped that by establishing themselves as an officially sanctioned independent body, they might actually *reduce* their dependence on aristocratic patronage. They believed that the stamp of approval from George III would effectively give them more control over the practice and teaching of art, limiting interference by aristocratic clients. By taking control of the theory behind the teaching and production of art, they could thereby control its value systems. Of course, this relative freedom was still exercised within an immensely hierarchical society in which the institution had to be seen to promote interests which were at least compatible with many of its patrons. Through the provision of teaching, lectures, regular public exhibitions (Plate 103) and the distribution of prizes and awards, the Royal Academy became an important and powerful disseminator of such value systems.

As I have suggested, these processes of institutionalization are themselves instrumental in helping to establish a canon of art. For a canon to survive and flourish, it must provide exemplars of values which can be imitated and

Plate 103 Richard Earlom after Charles Brandoin, *The Exhibition of the Royal Academy of Painting in the Year 1771*, 1771, mezzotint, Royal Academy of Arts, London.

refined, or rejected and challenged. As aesthetic values are disseminated and passed on, they evolve and develop. Thus the sense of relative freedom from aristocratic control which I described above enabled the academicians to develop an image of themselves as both drawing on tradition and respected classical values, and also refining and reworking them to produce an art of modern relevance and quality. A canon, then, is not static; while it may assume a dominant (that is, powerful and controlling) role within the art of a particular society, it is always evolving and reshaping itself, responding to ideological, political and aesthetic shifts in the culture which it represents.

Membership and academic values

Of the 36 artists listed in the founding constitution of the Royal Academy, only two were women: Angelica Kauffmann (1741–1807) and Mary Moser (1744–1819) (Plates 104 and 105). Within the contemporary art world, women were more likely to be seen as the objects of art, often in symbolic or allegorical disguise, than as serious professional practitioners. In fact, after Kauffmann and Moser no women were given membership (that is, the full status of academician which entitled them to the initials R.A.) until 1920. In a much cited painting by Johann Zoffany of the first academicians, *The Academicians of the Royal Academy* (Plate 106), Kauffmann and Moser are famously excluded from the group of male founder members who contemplate plaster casts after antique sculptures and 'living models'. As women were prohibited from copying from nude models, they are depicted as an absent presence, as mere head-and-shoulder portraits on the wall to the right of the assembled group.

Plate 104 Angelica Kauffmann, *Zeuxis selecting Models for his Painting of Helen of Troy*, c.1778, oil on canvas, Brown University Library, Providence. Ann Mary Brown Memorial Collection.

Plate 105 Mary Moser, *Vase of Flowers*, 1764, tempera on paper, 61 x 45, Victoria and Albert Museum, London. Copyright V & A Picture Library.

Plate 106 Johann Zoffany, *The Academicians of the Royal Academy*, 1771–2, oil on canvas, 101 x 147 cm, Royal Collection. Copyright Her Majesty Queen Elizabeth II.

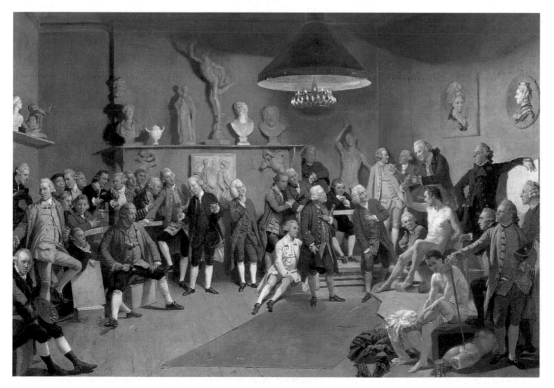

The painting was intended as a kind of group portrait – a historical record of the first members shown in relation to key academic concerns. Drawing from plaster casts and the live model were a major part of the teaching at the Royal Academy Schools, although women were excluded from these classes. In fact, the only female form to be shown as part of the central academic activity is quite literally an object: a plaster cast of an antique sculpture, itself headless and legless and consigned to the side of a bench. The artist Richard Cosway, who was elected to full academician in 1771, is shown in a somewhat mannered pose, pressing his stick dismissively into the damaged female torso. Several other figures, including Joshua Reynolds in the centre, assume similarly mannered poses which remind us that the artist, like his objects of representation, is indebted to classical prototypes and is thus qualified to claim the status of 'academician'.

An implicit association is made here between the appreciation of classical objects and an exclusively male group. This was a common theme in contemporary art, and is itself the subject of one of Cosway's own paintings, *Charles Towneley with a Group of Connoisseurs* (Plate 107). Towneley was a well-known antiquarian and connoisseur, shown here in a group portrait with male friends admiring works from his collection – works which are largely sculpted female bodies. Given the way in which these figures are scrutinizing the sculpture, it's hard to avoid the possibility that the artist might have intended the work to have another, more voyeuristic, sexual level of meaning. While painting this picture, Cosway corresponded with the collector, often openly referring boastfully to his own promiscuity. One could argue, then, that in this painting Cosway has carefully veiled any intended sexual overtones through the representation of an identifiable high art theme – the learned contemplation of classical objects.

Long before this work was even conceived, Hogarth had already attacked both sets of interests in a satirical engraving featuring Richard Cosway. In 1761 he published a 'tailpiece' to the catalogue for the Society of Artists exhibition (Plate 108). In a clear reference to his promiscuity, Cosway is represented as a dandyish monkey (a traditional symbol of sexual promiscuity) who is watering dead trees labelled 'exoticks'. The label 'exotick' was intended as a reference to foreign Old Master paintings, which were much beloved by connoisseurs at the expense of a British school of art. Even in the 1760s, then, Hogarth was still railing against the 'foreign' influences which were ultimately to form an important aspect of the culture that nurtured the establishment of the Royal Academy and helped to inspire Zoffany's famous painting (Plate 106).

Not surprisingly, perhaps, the print medium which Hogarth used so adeptly to make his satirical points was consigned to a lowly status within those academic hierarchies enforced by the Royal Academy Schools. The 1768 constitution decreed that there should be 40 Royal Academicians, 'Painters, Sculptors or Architects, men of fair moral characters, of high reputation in their several professions'. Absent from this group were engravers, an exclusion which generated some controversy inside and outside the institution for many years. The persistent belief (within some circles) that engraving should qualify as a 'lesser art' is one of the themes of the following section.

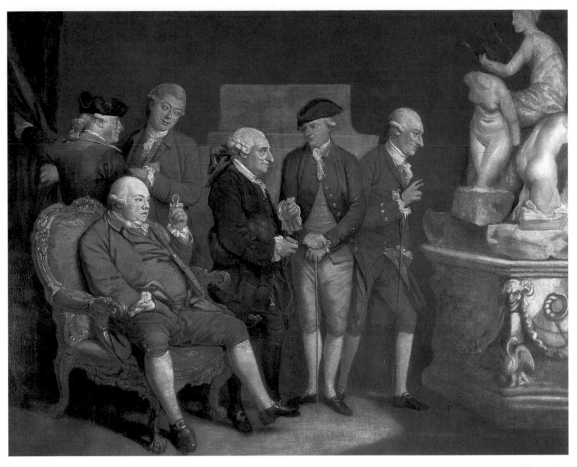

Plate 107 Richard Cosway, *Charles Towneley with a Group of Connoisseurs*, 1771–5, oil on canvas, 85 x 111 cm, Towneley Hall Art Gallery, Burnley Borough Council. Photo: Bridgeman Art Library.

Plate 108 Charles Grignion after Hogarth, tailpiece to *A Catalogue of Pictures exhibited in Spring Gardens*, 1761, etching and engraving, 11 x 13 cm, British Museum, London. Copyright © British Museum 11630d.3(14).

Painting and the 'lesser arts'

Hogarth's controversial views on the dominance of foreign influences within the British school, and the wide range of his aesthetic interests revealed in his painted *and* graphic work, contributed to his shifting and sometimes problematic relationship with a contemporary canon of art. Despite academic attempts firmly to establish the canonical status of easel painting as 'high art', during the mid-eighteenth century many other forms of artistic production were thriving and expanding, and often provided artists with more economically viable forms of employment. Hogarth made extensive use of the print medium, which along with miniature painting, topographical painting and decorative art (that is, for domestic designs and decorative schemes) was a buoyant area of production during the period.

Hogarth's reputation, and much of his income, came from his prints, in particular his famous series of 'Progresses'. These appeared in the 1730s and included *A Harlot's Progress* (Plate 109), *The Rake's Progress*, and *Marriage à la Mode*. Each of the 'Progesses' consisted of a series of engraved images which told a moral tale of contemporary life, a continuing narrative which progresses much like a strip cartoon. For example, in plate i of *A Harlot's Progress* an innocent country girl has just alighted from the York stage in the City of London. She is on her way to her cousin, for whom she carries a goose, but is waylaid by a well-dressed older woman who appears to admire her looks. A contemporary chronicler of Hogarth's works, called Vertue, tells us that the older woman is the 'bawd' Mother Needham, notorious for luring young country girls into her employ. The image is packed with details which invite us to interpret the narrative. While Mother Needham is respectably dressed, her pockmarked skin betrays her profession and inner corruption. And many details provide symbolic references to impending disaster and moral decay, such as the horse which kicks over a pile of pans, and the cracking and crumbling plaster on the walls of the inn in the background.

Please look carefully at plate ii of *A Harlot's Progress*. Suggest how the narrative or story-line is continued through the imagery of this plate. Can you identify the various symbols which represent a continuing moral degeneration?

Discussion

In this image the young protagonist's (to whom Hogarth gives the name M. Hackabout) moral decay is well advanced. She is shown about to lose her position as the kept woman of a wealthy Jew,[10] to whom she has just been unfaithful. Her lover is shown hurriedly slipping out with the help of a maid in the background. While Ms Hackabout's fine dress, comfortable surroundings including (significantly) Old Master paintings on the walls, and the black servant suggest that she now enjoys a life of affluence and

[10] The character of the Jew and possible associations with, or references to, eighteenth-century anti-semitism are discussed by Ronald Paulson in *Hogarth*.

respectability, that fragile respectability is shown crashing to the floor with the symbolism of the broken crockery. Other details such as the pet monkey – symbol of her promiscuity – and the mask on her dressing table – evidence of her taste for the deceit of the masquerade – bear witness to the degeneration of her morals.

◆◆

Later plates in the series continue this complex exposition of her degeneration. In plate iii she is shown working as a Covent Garden prostitute in relative squalor; her black servant has now been replaced by a fat, pockmarked female assistant, as the armed watch arrives to take her away. In plate iv she is now in Bridewell, a house of correction in which the inmates are largely prostitutes, while in plate v the narrative becomes progressively more tragic as she sits dying (presumably of venereal disease) in impoverished circumstances with her child next to her by the fire. The final plate shows the scene of mostly unsympathetic mourners around her coffin, after her premature death at the age of 23. Apart from the obvious moral message behind *A Harlot's Progress* on the effects of the exploitation of poverty and ignorance in the pursuit of sexual vice, there are several related recurring themes in this series which appear in all the 'Progresses'. As the cultural historian David Dabydeen has described it, 'people are always seen in relation to *things*, a relation that is indicative of the depersonalisation of human life' (Dabydeen, *Hogarth's Blacks*, p.11). Relationships are often represented in terms of financial or commercial transactions, of money or objects changing hands. The result is an on-going preoccupation with exploitation and hypocrisy in contemporary society, a preoccupation which, it has been suggested, stems in part from Hogarth's own family experiences of childhood poverty as the son of a bookseller who was imprisoned for debt.

Although the print series of the 'Progresses' were successful in establishing Hogarth's reputation, each of these prints was first produced in painted versions, or 'novels in paint' as they have been called (Plates 110 and 111). However, he found it much more difficult to sell the original paintings, indicating that the market for the latter was much more restricted – and restricting. Dabydeen has suggested that the subject-matter of the Progresses itself separated this body of work from the category of 'high art':

> With the *Harlot's Progress* paintings of the 1730s Hogarth became the first English artist to represent on canvas the lives of the common people in a serious and sympathetic way. He invests their lives with significance, and the capacity for tragedy, suffering and redemption, and insists that they are subjects 'worthy' of painting: this at a time when painting was seen as the province for 'serious' 'elevated', 'religious' or 'historical' themes, the lives of the common people fitting none of these categories. This championing of the common people which violated the spirit of the age earned him the rebuke of connoisseurs of art and gentlemen of taste who either dismissed him as a 'bad' painter or condemned him for 'lowering the standards of art'.

(Dabydeen, *Hogarth's Blacks*, pp.14–15)

Plate 109 William Hogarth, *A Harlot's Progress*, plates i–vi, 1732, engravings, *c*.31 x 38 cm each, British Museum, Department of Prints and Drawings, London. Copyright © British Museum.

i: Ensnared by a Procuress

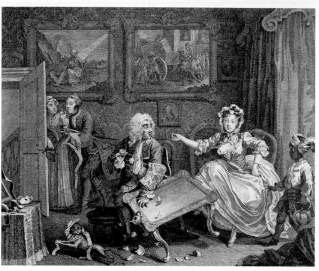

ii: Quarrels with her Jew Protector

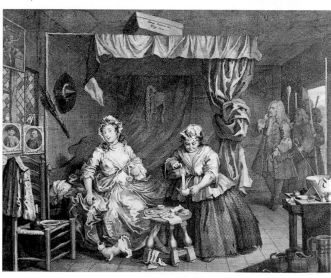

iii: Apprehended by a Magistrate

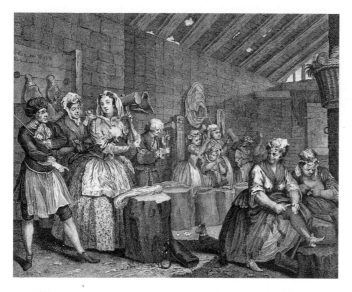

iv: Scene in Bridewell

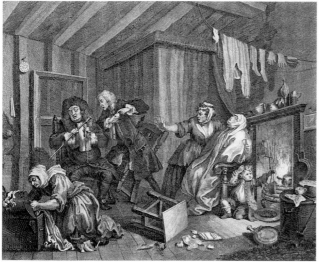

v: Expires while the Doctors are Disputing

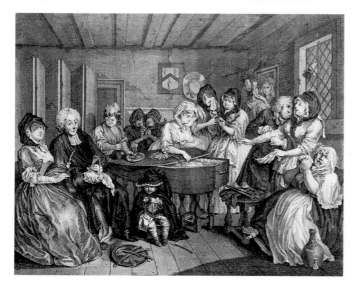

vi: The Funeral

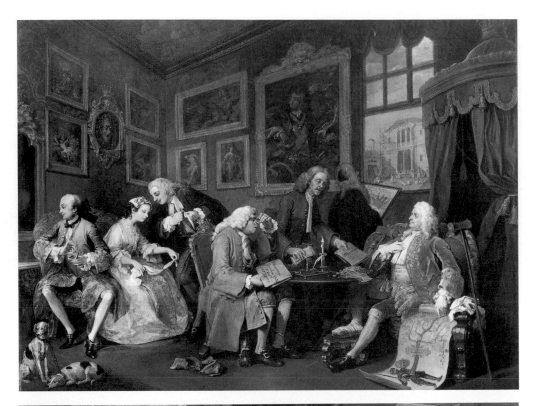

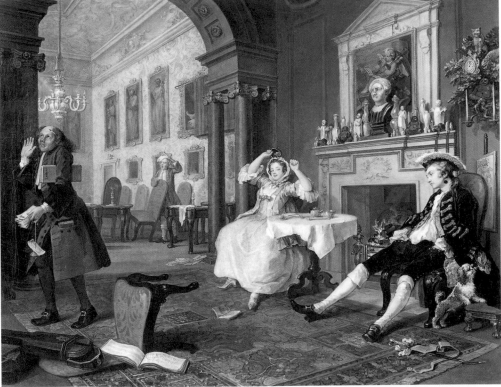

Plate 110 William Hogarth, *Marriage à la Mode, i: The Marriage Contract* and *ii: Shortly after the Marriage*, 1743, oil on canvas, 69 x 89 cm each, National Gallery, London. Reproduced by courtesy of The Trustees, The National Gallery, London.

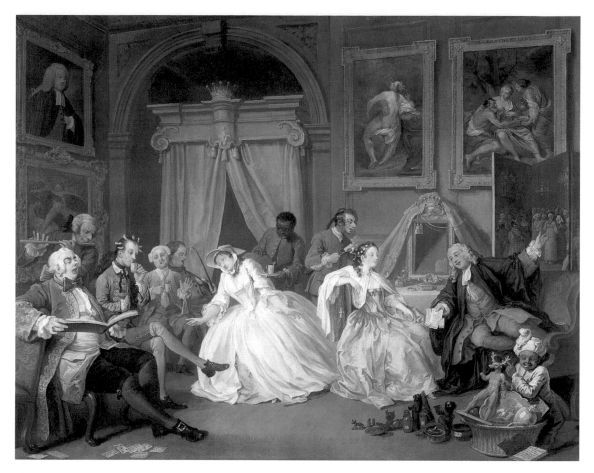

Plate 111 Hogarth, *Marriage à la Mode, iv: The Countess's Levée*, 1743, oil on canvas, 69 x 89 cm, National Gallery, London. Reproduced by courtesy of The Trustees, The National Gallery, London.

Dabydeen suggests, then, that as paintings these works were not easily absorbed into recognized – or canonical – categories of artistic value. Like some of the other images I have discussed so far in this study, they seem to sit on the boundaries between established genres and categories of artistic production. They draw on a repertoire of poses, attitudes and expressions, the acquisition of which (as we saw in the preceding study on Le Brun's models of expression) was part of a traditional artists' training, and they develop complex narratives and layers of symbolic meaning. Yet, as Dabydeen suggests, the themes which Hogarth explores did not qualify for the 'elevated' status sought after (in theory at least) in conventional history painting. As works on moral themes derived from contemporary social issues, they were separated from the more austere classical themes thought desirable for the highest form of art. In some respects this series of Hogarth's paintings comes closer to the category of painting which was to enjoy so much success in nineteenth-century Britain – known as 'genre' painting – which purported to represent everyday life, and which was much influenced by the work of the seventeenth-century Dutch school (Plate 112). In a sense, Hogarth had created his own genre: somewhere between history painting and genre painting, but with the satirical edge of the popular print.

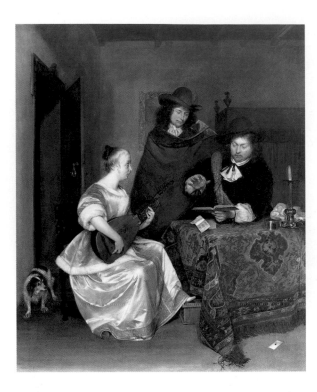

Plate 112 Gerard Ter Borch, *A Woman playing a Theorbo to Two Men*, *c*.1667–8, oil on canvas, 68 x 58 cm, National Gallery, London. Reproduced by courtesy of The Trustees, The National Gallery, London.

The fact that these painting cycles were so closely related to (that is, were copies of) the graphic versions of the *Progresses* may itself have contributed to the lack of status attached to the former. The whole process of copying held an ambiguous status for advocates of high art. And Ronald Paulson has suggested that copying itself becomes an important theme in Hogarth's work in that the story-line is 'about the copying of inappropriate behaviour' (Paulson, *The Art of Hogarth*, p.22). Given the popularity and relative visibility of the prints, the visual language employed (the complex narratives, crowded images, etc.) could be seen as more suitable to the graphic medium. And the success of the engravings may also have served to undermine the 'unique' status of the paintings. While the copying of successful Royal Academy exhibits by established engravers could increase the status of the original painting, Hogarth was himself producing the same image in two different media, thus undermining any sense of a unique and revered original. An important and emerging theme in contemporary critical attempts to raise the cultural profile of painting was the idea of the 'original' which is distinguished from mechanical copying as it 'rises spontaneously from the vital root of Genius; it *grows*, it is not *made*' (Young, *Conjectures on Original Composition*).

The desire to see painting (with sculpture and architecture) as a 'high' or 'liberal' art, practised by 'men of fair moral characters, of high reputation', was a recurring theme in much of the criticism and writing about art which accompanied the establishment of the Royal Academy of Art. In some respects our modern concept of 'art theory' has its origins in the eighteenth century, when attempts to institutionalize and codify art practices were necessarily accompanied and supported by theoretical justifications. This involved a growth in critical writing not just in the broad area of aesthetics (which already

had a strong philosophical tradition), but also about the practical issues of what resources (subjects, genres) to select and how to paint them. Reynolds's series of *Discourses* constitutes one such attempt to provide a theoretical justification for contemporary art practice, its philosophical ambitions, and its relationship with the art of the past. And despite Hogarth's hostility towards some of the ideas about art which were to emerge with the success of the Royal Academy, earlier in the century he had already sought to provide a theoretical framework for his interests with the publication of his *Analysis of Beauty* in 1753.

This early essay on the theory of art reveals an imaginative and inventive thinker who is concerned to open up the subject of beauty to a broader audience than those élite 'men of letters' who had hitherto dominated aesthetic debate. In keeping with his pragmatic approach to the discipline, Hogarth wrote that what was needed was an analysis based on a 'practical knowledge' of the whole art of painting.[11] In this respect, Hogarth could be seen to be targeting a rather different – or at least wider – audience to the high-minded gentlemen who, as we have seen, helped to constitute the public for Reynolds's theoretical ambitions.

Art and theatre

In my earlier discussion of Hogarth's *A Harlot's Progress* (Plate 109) I mentioned the strip cartoon effect of the print series in which each image forms part of a continuing narrative. You probably noticed that the sequence of images unfolds rather like a play; each involves a change of scene, but the series as a whole follows a clear plot with a beginning, middle and end. Within each scene there are dramatic incidents, and characters often assume theatrical poses and gestures. Hogarth seems to 'stage' his image as if it were a play, and there is ample evidence that this was part of a conscious strategy. I have already cited his interest in the theatre and his friendship with David Garrick, but his painted and graphic work suggests that he also saw parallels in the conception of, and the techniques adopted in, these two art forms. In his *Autobiographical Notes* he wrote of constructing an image in which he 'let figure[s] be consider[ed] as Actors dressed for the sublime genteel comedy or same in high or low life' (quoted in Bindman, *Hogarth*, p.108).

There are, of course, certain types of art for which this analogy with the stage seems relatively obvious. Conventional forms of history painting, for example, often depend on theatrical devices to convey their effects and meanings. If we look again at Gavin Hamilton's *Hector's Farewell to Andromache* (Plate 89), you will notice that the scene is arranged across the canvas rather like a stage set, with figures across the foreground plane and a classical 'backdrop' behind them. The figures act out dramatic roles, and the artist deliberately juxtaposes impassioned or tragic poses and gestures. Thus the whole scene appears very theatrical in its attempt to convey the appropriate heroic or tragic message. Hogarth used these sorts of devices in his adaptation of other genres: both David Garrick and Ms Hackabout were depicted at dramatic moments of surprise or tragedy, evoked by a melodramatic pose or gesture.

[11] Extracts from *The Analysis of Beauty* are reproduced in Edwards, *Art and its Histories: A Reader*.

Hogarth's interest in the relationship between art and theatre is evident on several levels. We have seen that he often used themes from the theatre – such as plays, masquerades, masked balls and actors – as part of his repertoire of (often satirical) subjects. The repetition of such themes in his engravings and paintings provides clear evidence of his use of the metaphor of life as a stage, of his preoccupation with the relationship between reality and artifice, hypocrisy and deceit. One fascinating print from the 1730s took up the theme of the theatre with a focus on the role of the actress in eighteenth-century society, *Strolling Actresses Dressing in a Barn* (Plate 113).

Hogarth depicts a crowded group of players, dressing in a barn before going on stage, who appear to be preparing a complicated play with many characters. It's difficult to read from a reproduction, but the playbill lying on the bed gives us the title of an unknown play, *The Devil to Pay in Heaven*, and lists the characters as Jupiter, Juno, Diana, Flora, the Night, a Siren, Aurora, an Eagle, Cupid, two Devils, a Ghost and Attendants, 'To which will be added Rope dancing and Tumbling'. The range of characters suggests an absurdly pretentious mythological play, probably intended by Hogarth as a satirical reference to the early eighteenth-century obsession with the classical past,

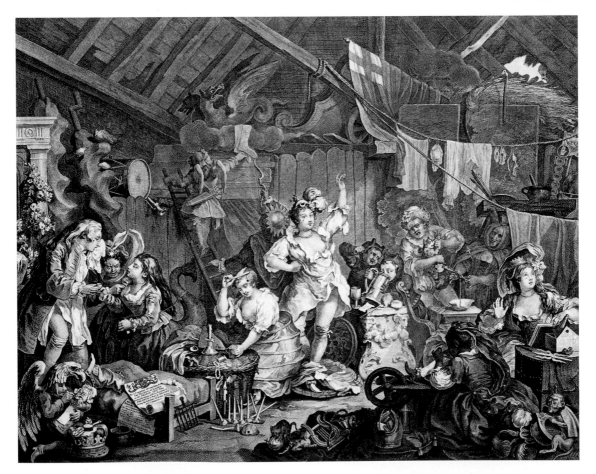

Plate 113 William Hogarth, *Strolling Actresses Dressing in a Barn*, 1738, etching and engraving, 43 x 53 cm, British Museum, Department of Prints and Drawings, London. Copyright © British Museum.

and perhaps to the bathos of mythological roles being taken on by coarse, lower-class women. The 'low-life' origins of these actors would have been immediately evident to a contemporary audience familiar with the troupes of 'strolling' players who travelled around the countryside giving performances. These troupes were the poor relations of the big urban theatres, and their players were easy targets of satire. Moreover, the actresses in these travelling groups were generally seen to be women of 'ill-repute' and low morals. Such troupes were thought to nurture dissenting political voices and forces of disorder, and were very much in the public eye at the time: in 1735 the 'Playhouse Bill' which limited their activities had been passed in Parliament, and in 1737 (one month after Hogarth started work on the print) an act was passed which made it illegal for a company to perform without a royal patent. This meant that the only legal companies at the time were the Drury Lane and Covent Garden theatres in London. These two royal playhouses, rather like the early academies of art, sought to establish a more professional and respectable context for the production of their art.

What kind of image of eighteenth-century actresses does this engraving (Plate 113) suggest?

Discussion

Strolling Actresses represents a space almost exclusively inhabited by women. It's not clear if the figure on the left is a man or a woman dressed as a man. And these women are not on stage performing, but are backstage dressing. They are shown in a context which is closer to their real existence, which reveals the process of 'dressing up' and deceit involved. Thus their actual roles in life are shown alongside their assumed roles. The women in this crowded image are shown feeding babies, drinking, mending stockings, rehearsing their parts and so on, while the semi-clothed actress in the centre plays Diana, goddess of chastity. As she assumes her somewhat ridiculous goddess-like pose, she is watched through a hole in the roof by a young boy (perhaps a reference to her mythological partner, Actaeon). All around the barn are scattered traditional emblems of *vanitas* or vanity, many of them theatrical props, including a crown, orbs, mitres and a helmet.

◆◆◆

This is an image, then, which is concerned with specifically feminine roles and activities. What's more difficult to sort out is the extent to which Hogarth sought to satirize or criticize those roles. The print appeared at a time when literary forms of anti-feminist satire were flourishing. The poetry of Alexander Pope and Jonathan Swift frequently targeted 'woman', seeking to unmask some contemporary myths of femininity as merely concealing 'feminine' vices such as vanity, deceit, sexual intrigue and frivolity. The theme of feminine masquerade and the idea of 'woman' as consummate actress recur in the poems of both writers, including Pope's famous *Epistle to a Lady* of 1735.[12] Such critical and often misogynistic representations were frequently opposed to a supposedly more desirable, polite ideal of femininity, of woman as a

[12] Among the most famous lines from this misogynistic poem is 'ev'ry woman is at least a Rake'.

more passive and virtuous domestic creature. Literary and visual images of 'woman' were often adopted as a symbol of the theatre and masquerade, an association which Hogarth exploits to the full in his *Strolling Players*. On one level, the idea of woman as consummate actress seems to be the determining theme of Hogarth's work, as actresses are shown in different stages of their disguise, both masked and unmasked.

There is little doubt that this image would have been read by contemporary viewers as a satire on the pretensions of strolling players, and perhaps also as a broader metaphor for the deceit and hypocrisy of life 'as a stage'. However, by the time that Hogarth produced the work, the players he depicts would have been out of a job as a result of the Act of 1737. It has been suggested that this image functions on another level, that it is also a more sympathetic and complex image of the relationship between femininity and theatricality. The art historian Christina Kiaer has argued that, in interpreting the image, we need to be aware of what it would have signified to audiences of different class and gender. She suggests that 'female viewers, especially lower-class ones, could recognise central and salient aspects of their own experience in *Strolling Actresses*. The carefully articulated manifestations of the everyday life of women, presented in a language of sensuous beauty, call into question the adequacy of the term "satire" to describe the working of this picture' (Kiaer, 'Professional femininity', p.240). For Kiaer the crowded activities of the barn relate closely to the experience of many lower-class women for whom the 'household' usually consisted of one room in which all domestic roles were enacted. The print is packed with minor narratives in which women act out the harsh realities and experiences of everyday life, including feeding the baby and dressing, having cooked and washed (indicated by the line of washing and cooking pots behind the group). All this takes place while they are also preparing for the play. Kiaer writes: 'Hogarth depicts the actresses as completely comfortable in their communal twilight world; topsy-turvy as their domestic life is, their household seems to function quite smoothly according to its own rhythms' (Kiaer, 'Professional femininity', p.240). I would agree that this representation of camaraderie and domestic activity in conditions of extreme poverty takes some of the edge off the satirical message, and might well have appealed to those poorer women who would have been able to view copies of the image displayed in taverns or public places.

Kiaer's argument about the 'language of sensuous beauty' is a reference to the techniques adopted in this print. The organization is rather different to that adopted in the *Progresses*, which are designed to be read in sequence and which involve more clearly organized spaces within each scene. *Strolling Actresses* is not only packed with separate narratives (scenes within scenes), but space seems to be organized around a series of interwoven lines. In his *Analysis of Beauty* of 1753, Hogarth advocated what he called 'the serpentine line' ('being composed of two curves constrasted') as the first principle of beauty which 'gives play to the imagination and delights the eye'. In Chapter 7 he describes this line as having the 'power of super-adding grace to beauty' (Hogarth, *Analysis of Beauty*, p.41). Kiaer argues that the almost exaggerated use of this line gives the print a sensual rhythm which is more in keeping with the techniques of painting than those of the print. In her view this effect is reinforced through the use of subtle distinctions between light and shade and variations in texture (often more difficult to achieve in the print medium).

These techniques do seem to contribute to the general sense of graceful ebb and flow of the whole composition, although my own view is that it is quite difficult to argue conclusively that such techniques actually undermine the satirical impact of the work. Many other aspects of this engraving, such as the ludicrously ambitious cast list and the poses assumed by some of the characters, tell us that it was at least partly designed to make fun of the theatrical pretensions of strolling players. It is possible that, given the close relationship between Hogarth's painted and graphic work, he may have deliberately sought to create a more painterly effect in this print, perhaps seeing it as more appropriate to the feminine subject-matter. But we could also argue that this graphic technique still retains a linear emphasis and employs exaggeration and distortion in some objects, and is therefore close to the category of 'caricature' which we usually associate with satirical prints.

One of the interesting aspects of this print is, I think, precisely its ambiguous status between the categories of painting and print making. This underlines a key theme I have been developing in relation to Hogarth: that his art provides rich material for study because it seems to straddle the boundaries between those categories and genres which many of the evolving institutions of art were seeking (in theory at least) to codify and canonize. We have seen that both the technique and content of his work raise questions about the extent of the artist's intended satire. In my view the complexity of the image suggests that Hogarth may have intended it to be read as a more wide-ranging and multi-levelled commentary on contemporary femininity, class and the theatrical world.

Portraiture and the canon

In 1757 Hogarth announced publicly that he intended to spend the rest of his time mostly in portrait painting, recognizing perhaps that portraiture was an area in which academic compromises were most successfully achieved, particularly with the growing popularity of the 'Grand Manner' portrait. This compromise had been successfully achieved with his painting of Garrick (Plate 87), which fell between the genres of history and portrait painting. However, many contemporary artists made their living as 'face painters', or what Shaftesbury had called 'mere face painters', working in studios in which processes were standardized and assistants employed to work on and reproduce commissioned portraits. As we have seen, Shaftesbury's derogatory sense of the word 'mere' was a reference to the supposedly mechanical and unintellectual processes involved in copying a face – in attaining nothing more than a likeness.

Implicit in Shaftesbury's assertion is the view that an idealized or more universal image is preferable to a carefully observed representation of nature's imperfections – hence the contrast with the 'poet' (see p.126 above). Such attitudes are often associated with the culture of the Augustan era at the beginning of the eighteenth century, when classical sources and ideals (in particular, those accessible through Roman sources) became fashionable models for achievement. As an art form through which appearances were made public, portraiture was a powerful medium for the communication of social and cultural values and beliefs. Hence the growing popularity of 'Grand

Manner' portraits which provided more than a 'likeness' – which aggrandized or elevated the sitter through the use of historical, literary or classical references. Increasing demand for portraits from the growing middle class contributed to an expanding art market, and encouraged the upper classes (largely the nobility and landed gentry) to patronize forms of painting which could somehow represent ideas of 'dignity' and the social status with which they identified. Some of the aesthetic debates which ensued found a focus in the activities of the Royal Academy.

The growing instability of the portrait genre, particularly in relation to history painting, is revealed and exploited in the texts of Reynolds's *Discourses*. He both represents it as a lower genre without full academic status *and* advocates a form of portraiture which follows the principles of what he calls the 'Grand Style'. This value system is, in a sense, his own version of the 'Grand Manner'; it involves the reworking of both antique and Renaissance sources in pursuit of some higher aesthetic formula. Moreover, in his attempts to develop an academic theory of portraiture, he actually plays down the idea that 'likeness' involves minute observation or copying. In *Discourse IV*, delivered in 1771, he argues:

> Even in portraits, the grace, and we may add, the likeness, consists more in taking the general air, than in observing the exact similitude of every feature.
>
> (Reynolds, *Discourses on Art*, p.59)

I indicated earlier that despite his theoretical exhortations to artists on the value of historical subjects, Reynolds, like many contemporary British artists, made his living largely through portrait commissions. Even in the annual shows held at the Royal Academy, portraiture was more commonly exhibited. Many shows included examples of Reynolds's full-length portraits of noble clients, which were designed to hang on the walls of country houses, where they would be seen by a limited public of guests and visitors to the family house (see Plates 91 and 92). Through the exercise below, I want to develop these issues in relation to a number of paintings, selected to represent some different types of portraits which were popular during the period.

Please look at the following illustrations:

Hogarth, *The Graham Children*, 1742 (Plate 114)

Hogarth, *Benjamin Hoadly, Bishop of Winchester*, c.1743 (Plate 115)

Reynolds, *Lord Middleton*, 1762 (Plate 116)

Reynolds, *Mrs Hale as 'Euphrosyne'*, c.1764 (Plate 92)

Reynolds, *Mrs Siddons as the Tragic Muse*, 1789 (Plate 94)

How would you describe the form and content of Hogarth's *Graham Children*, and how would you distinguish it from the other portraits listed?

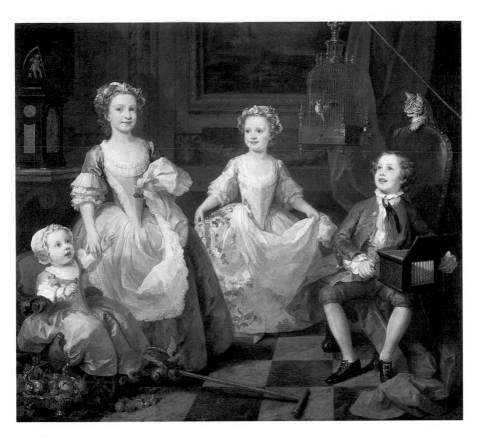

Plate 114
William Hogarth, *The Graham Children*, 1742, oil on canvas, 163 x 180 cm, National Gallery, London. Reproduced by courtesy of The Trustees, The National Gallery, London.

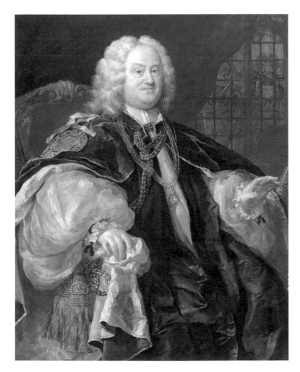

Plate 115 William Hogarth, *Benjamin Hoadly, Bishop of Winchester*, *c.*1743, oil on canvas, 127 x 102 cm, Tate Gallery, London. Copyright Tate Gallery, London.

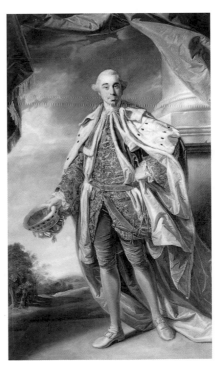

Plate 116 Sir Joshua Reynolds, *Lord Middleton*, 1762, oil on canvas, 236 x 145 cm, collection of The Lord Middleton. Photo: Paul Mellon Centre for Studies in British Art.

Discussion

Hogarth's *Graham Children* is a different sort of portrait in that it depicts a group rather than a single figure. (As such it is related to a subgenre called the 'conversation piece', for which Hogarth became renowned. This was usually a group portrait of adults, so-called because the sitters were often shown interacting or conversing within the painting.) At first glance the scene has an intimacy and air of informality about it appropriate to the subject of children, as opposed to some of the more formal, posed portraits of adults by both Hogarth and Reynolds which I have included in this list.

The interaction between the figures of *The Graham Children* suggests there may be a narrative meaning to the work. I would suggest that the seemingly informal organization of the composition of *The Graham Children* belies some other carefully orchestrated levels of meaning. The oldest girl seems to assume the most solemn and formal pose of the group, as she restrains the youngest from seizing a bunch of cherries. We've seen that Hogarth made extensive use of symbolic references in his painted and graphic work, so we can reasonably speculate about the symbolic meaning of this portrait. Thus the restraint of age (in the figure of the oldest girl) is set against the spontaneity and innocence of youth, and several images symbolize disasters to come (in adult life?). On the left a clock is mounted with a scythe-carrying Cupid, and the cat on the right seems about to pounce on the goldfinch's cage. The terrified warble emitted by the bird is mistaken by the young boy as a happy response to the noise from his musical box. This painting is thus an intimate image of children and domesticity, but also evokes a more general poetic message of the loss of innocence and the decline of age which is more often found in history painting. Once again, Hogarth has produced a work which defies easy categorization.

◆◆

The more formal paintings of adults could be described as 'Grand Manner' portraits. They show the sitter in elaborate robes or costume which revealed hereditary rank, or military, political or ecclesiastical office, a style of portraiture which had helped to establish the reputation of the seventeenth-century painter Anthony Van Dyck (Plate 117). Robes could thus be used to convey status, magnificence and power, a convention which is adopted in both Hogarth's *Benjamin Hoadly* and Reynolds's *Lord Middleton*. While the former wears the robes of his ecclesiastical office as a bishop, Lord Middleton sports the extravagant coronation robes of a baron, every detail of which expresses his affluent and noble status. His red velvet mantle and silk-lined tunic are both trimmed with ermine; his coat is brocaded silk and his shoes are fastened with gold buckles.

Despite these parallel uses of costume, the general effect of each of these masculine portraits is rather different. The full-length pose, the setting framed with a drape and a neo-classical column, and the aloof expression of Lord Middleton give the work a somewhat imperious grandeur. In contrast, Benjamin Hoadly appears slightly more informal in his seated pose and less generalized appearance. While Hogarth appears to have borrowed from the conventions of the 'Grand Manner' portrait, combining them with his own interests in more realistic forms of representation, Reynolds seems to be

Plate 117 Anthony van Dyck, *Lord John Stuart and his Brother Lord Bernard Stuart*, *c.*1638, oil on canvas, 238 x 146 cm, National Gallery, London. Reproduced by courtesy of The Trustees, The National Gallery, London.

developing his 'Grand Style' of portraiture to evoke 'dignity' and status in his sitter, conscious of the powerful public functions of portraits of the nobility. This form of portraiture, then, could have some claim to academic worthiness.

In *Discourse IV*, in which Reynolds discusses the main characteristics of the 'Grand Style' and history painting, he considers the importance of 'expression' to denote rank: 'Those expressions alone should be given to the figures which their respective situations generally produce. Nor is this enough; each person should also have that expression which men of his rank generally exhibit' (Reynolds, *Discourses on Art*, p.60). Not surprisingly, the issue of rank is exclusively associated here with the male subject. The display of political, hereditary or military rank was part of the public culture of the upper classes. As women of the same noble class were unenfranchised and rarely occupied comparable professional or political roles (although there were a few acceptable roles such as hostesses, patrons, etc. through which upper-class women could exercise some social and economic power), the representation of rank was largely a male preserve. Given that women were largely denied the possibilities of representing political or ecclesiastical rank, what devices could be used to elevate the portrait of a female sitter? 'Noble breeding' was the only (hereditary) rank available to a few privileged women, and Reynolds developed various aesthetic conventions to represent a woman's status, among them the famous classical disguises and associations which ennobled, for example, *Lady Sarah Bunbury* and *Mrs Hale as 'Euphrosyne'* (Plates 91 and 92).

Mrs Hale (born Mary Chaloner) was the sister-in-law of Edward Lascelles, who later became the first Earl of Harewood, and this portrait still sits today in the music room of Harewood House in Yorkshire. As a large-scale, full-length portrait with mythological pretensions, the portrait epitomizes Reynolds's ambitions to raise the status of portraiture. Euphrosyne was one of the three mythological Charities or goddesses, daughters of Zeus who personified grace and beauty. Euphrosyne personified joyfulness, and shared with her two sisters the ability to add refinement and elegance to life. Allied with the Muses (see p.133), these goddesses watched over poetry and athletic skills. Mrs Hale's stylized pose (possibly taken from Raphael's *Saint Margaret* in the Louvre), her hybrid dress (part pseudo-classical, part modern), her sprightly manner and the array of symbolic figures behind her all contribute to the aggrandizing associations deemed appropriate to the sitter's character. And the extent to which Reynolds (and presumably the patron) intended such works to function both as portraits *and* as forms of history painting is reinforced by the artist's exhibiting policy. During the early Royal Academy shows, portraits of noble women were usually hung (and listed in the catalogue) without their names.[13]

Such elevating allegorical conventions were not, however, exclusively reserved for Reynolds's upper-class clients. His later large-scale portrait of *Mrs Siddons as the Tragic Muse* (of which Reynolds painted two versions in 1784 and 1789) brings me back to the theme of representation of the actress in eighteenth-century society, which I raised in relation to Hogarth's *Strolling Players*. Needless to say, the associations of class and public status evoked in Reynolds's work are very different to those of the Hogarth print. Mrs Siddons signified the more respectable face of the 'actress'; her work on the London stage in revered forms of classical drama gave her some claims to the 'professionalism' so sought after in the theatre at the time. During the 50 years since the appearance of Hogarth's print, much work had been done to raise the status of the acting profession and public perceptions of the 'actress', although social prejudices were deeply ingrained and 'actress' still signified for many a woman of ill-repute, a dangerous form of femininity.

I have chosen to finish this case study with a discussion of this portrait because I think that it both draws together many of the themes which I have been developing and raises some pertinent (but tricky) questions. Mrs Siddons assumes the disguise of the classical tragic Muse (Melpomene) and a pose which is probably borrowed from Michelangelo's figure of the prophet Isaiah on the Sistine Chapel ceiling. For a painting in what Reynolds called the 'Grand Style' (or the Grand Manner), these are impeccable credentials. But there is an ironic twist in the possible meanings suggested by this portrait. Mrs Siddons was famous for her part as the tragic Muse when she was actually wheeled on stage in the role in a performance of Garrick's play *Jubilee* at the Drury Lane Theatre in 1785. This is not simply a painting of a woman in disguise, removed from her actual role in society. *Mrs Siddons* is at one and

13 For example, in the first Royal Academy show in 1769, Reynolds exhibited four allegorical portraits of women, each listed without a name. I discuss the implications of these allegorical disguises both for contemporary notions of femininity and for academic culture in my essay, 'Women in disguise'. For a discussion of similar issues and problems within contemporary portrait conventions, see Pointon, *Hanging the Head: Portraiture and Social Formation in Eighteenth-Century England*.

the same time a grand historical subject replete with ennobling allusions, a conventional image of woman as Muse, *and* a recognizable likeness and representation of an actual role played by the sitter. Thus several possible images of the femininity of Mrs Siddons are evoked at the same time: she is woman as consummate actress, woman as Muse *and* woman affirming her career as a 'professional'.

Conclusion

What this discussion of *Mrs Siddons* should help reveal is that paintings (like prints) are complex texts which can often be read in a number of different ways. In this study I have been concerned with some of the ways in which artistic, social and moral values and interests can be mediated through painted and graphic images, and the implications of these values for the idea of a canon of art. In seeking to understand what these works might have meant to a contemporary audience, I have looked at some of the ways in which allegory and symbolism are employed by different artists. In the process, I have focused on the network of relationships between ideas of academic art, art theory, debates about the nature of portraiture, and the relationship between art and theatre in mid-eighteenth-century Britain.

The question which still remains open is: what is – or was – the canon of art during the period? I have suggested that although there are no easy answers to the question, we can identify certain processes and practices which have helped to establish the idea of a 'canon'. These include contemporary attempts to give art practice an academic and institutional basis and to establish some recognized criteria of quality. I have argued that the canon is itself in part an educational force through which certain value systems are refined and reproduced. That said, what tends to be seen today as the canonical work of the period is not merely the most 'elevated' official or academic art – the history painting – but rather some of the varied forms of portrait painting which are now represented as the art of 'quality' of the period. Many of those works which during the eighteenth century were seen to have an ambivalent relationship with recognized canons of art, such as some of Hogarth's painted and graphic work, are now widely acknowledged as belonging to a 'great tradition' of British art. As I suggested earlier, the canon is not static; perceptions of what constitutes the 'great' art of a particular period will vary and shift according to the historical perspective of the observer.

As I argued in the Preface, much work has been done in recent years which questions the whole concept of a canon. From this perspective, our perceptions of what constitutes the art of quality of a particular era will always be framed by ideological and institutional perceptions which are deeply embedded in our culture, and which have determined what gets written into art history and what gets excluded. These ideas are underscored by the belief that the canon is itself an ideological construct, and that by accepting it we subscribe to an ideology which marginalizes and excludes certain forms of artistic production. These arguments have been important in recent years in the development of feminist art history and gender studies, and the study of race and ethnicity in visual imagery.[14] However, one of my projects in this

[14] Perry, *Gender and Art* (Book 3 in this series) and King, *Views of Difference* (Book 5 in this series) explore these issues in greater detail.

case study has been to look more closely at what a canon of art might be, rather than to engage directly with this wider question of the ideological framework of the canon. Hence my emphasis on the work of Hogarth and Reynolds and the early British academies. But in trying to pinpoint some of the aesthetic and social processes which helped to produce – or to challenge – the idea of a canon, I hope I have helped to equip you to ask (if not necessarily to answer!) some of the wider questions.

References

Barrell, J. (1986) *The Political Theory of Painting from Reynolds to Hazlett: 'The Body of the Republic'*, New Haven and London, Yale University Press.

Bindman, D. (1981) *Hogarth*, London, Thames and Hudson.

Dabydeen, D. (1987) *Hogarth's Blacks: Images of Blacks in Eighteenth-Century English Art*, Manchester University Press.

Earl of Shaftesbury (1711) *Characteristicks of Men, Manners and Opinions*, London.

Edwards, S. (ed.) (1999) *Art and its Histories: A Reader*, New Haven and London, Yale University Press.

Hogarth, W. (1997) *The Analysis of Beauty*, ed. R. Paulson, New Haven and London, Yale University Press (first published 1753).

Hutchison, S.C. (1986) *The History of the Royal Academy 1768–1986*, 2nd edn, London, Royce.

Kiaer, C.H. (1993) 'Professional femininity in Hogarth's *Strolling Actresses Dressing in a Barn*', *Art History*, vol.16, no.2, June.

Lippincott, L. (1995) 'Expanding on portraiture: the market, the public, and the hierarchy of genres in eighteenth-century Britain', in A. Bermingham and J. Brewer (eds) *The Consumption of Culture 1600–1800: Image, Object, Text*, London, Routledge.

Lucie-Smith, E. (1984) *The Thames and Hudson Dictionary of Art Terms*, London, Thames and Hudson.

Paulson, R. (1975) *The Art of Hogarth*, London, Phaidon.

Paulson, R. (1991) *Hogarth*, revised edn, 3 vols, New Brunswick, Rutgers University Press (first published 1971, 2 vols, Yale University Press).

Penny, N. (ed.) (1986) *Reynolds*, London, Royal Academy.

Perry, G. (1994) 'Women in disguise: likeness, the Grand Style and the conventions of "feminine" portraiture in the work of Sir Joshua Reynolds', in G. Perry and M. Rossington (eds) *Femininity and Masculinity in Eighteenth-Century Art and Culture*, Manchester University Press.

Pointon, M. (1993) *Hanging the Head: Portraiture and Social Formation in Eighteenth-Century England*, New Haven and London, Yale University Press.

Reynolds, J. (1975; reissued 1997) *Discourses on Art*, ed. R. Wark, 2nd edn, New Haven and London, Yale University Press.

Solkin, D. (1992) *Painting for Money: The Visual Arts and the Public Sphere in Eighteenth-Century England*, New Haven and London, Yale University Press.

Young, E. (1759) *Conjectures on Original Composition*, London.

Academic into modern: Turner and Leighton

EMMA BARKER

Introduction

In the first two case studies of this part, we investigated the role of academies in defining and supporting a canon of aesthetic values based (in theory at least) on the supremacy of history painting and the prestige of classicism. However, as Linda Walsh pointed out with reference to Le Brun, the very word 'academic' now has overwhelmingly negative connotations. As greater value has been attached to originality, spontaneity and self-expression, the term has come to signify pedestrian conformity to the established codes and conventions of artistic practice. Although this usage can be traced back to the late eighteenth century, it only became standard after the middle of the nineteenth century with the emergence of modernism: that is, of new forms of art which presented a direct challenge to academic orthodoxy.[1] In this case study we will explore this shift in values with reference to two nineteenth-century British artists, Joseph Mallord William Turner (1775–1851) and Frederic Leighton (1830–96).

As you will observe from their dates, Turner and Leighton were not exact contemporaries. The older artist exhibited at the Royal Academy for the last time in 1850, five years before the younger made his first London appearance. It would thus have been impossible for a nineteenth-century viewer to compare them during both of their lifetimes. In the context of our enquiry, this chronological separation can help to clarify the distinction between an artist who is now generally regarded as one of the greatest, if not the greatest, of all British artists and a figure who tends to be seen as one of art history's also-rans. In most twentieth-century accounts of nineteenth-century art, Turner appears as a towering figure whose forcefully original work broke with tradition and looks forward to subsequent developments in modern art. Leighton, by contrast, is usually dismissed as a fundamentally derivative artist who remained faithful to the tired recipes of the academy even though his career coincided with the first flowering of modernism. Their respective reputations are thus a function of the modernist values underlying the current canon of art.

In order to shed light on the workings and also on the limitations of a conventionally canonical history, we need first to establish on exactly what grounds Turner and Leighton have respectively been judged to be 'modern' and 'academic'. As we shall see, each artist owes his placing in one or other category not simply on account of his choice of subjects or the style in which he painted, but more fundamentally because of the very nature of his artistic

[1] I am using the term 'modernism' loosely here to signify the values associated with modern art. On these issues, see Wood, *The Challenge of the Avant-Garde* (Book 4 in this series).

practice. My broad purpose is to suggest that celebrating Turner for being on the side of progress and denigrating Leighton for his failure to match up to these standards is rather simplistic. I will argue that such an approach is problematic because it not only fails to take account of its own prejudices and preconceptions, but also glosses over the actual complexities of nineteenth-century artistic practice.

Two paintings

Let us begin by looking at a major example of the work of both artists. Each painting is an example of the genre in which its author specialized: landscape in Turner's case and history painting in Leighton's. Both works were painted relatively late in the artist's career, in 1844 and 1888 respectively, and were exhibited at the Royal Academy in the same year. Both passed straight from the artist's possession to a public collection. *Rain, Steam and Speed* (Plate 118) formed part of Turner's bequest to the nation and now hangs in the National Gallery, while *Captive Andromache* (Plate 119) was bought from Leighton the year after it was finished by Manchester City Art Gallery.[2] In every other respect they could hardly differ more.

Plate 118 J.M.W. Turner, *Rain, Steam and Speed,* before 1844, oil on canvas, 91 x 122 cm, National Gallery, London. Reproduced by courtesy of The Trustees, The National Gallery, London.

[2] See Case Study 8 on art in the provinces.

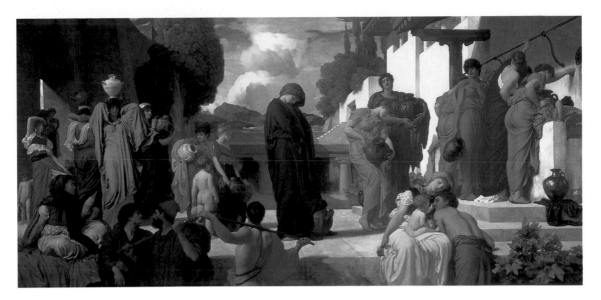

Plate 119 Frederic Leighton, *Captive Andromache*, c.1886–8, oil on canvas, 197 x 407 cm, Manchester City Art Gallery. Copyright Manchester City Art Galleries.

Whereas Leighton chose a mythological theme drawn from classical antiquity, Turner has depicted a scene of modern life. The full title of his painting is *Rain, Steam and Speed – The Great Western Railway*. At the time, nothing could have been more up to date than the sight of a train speeding over a bridge. Railways were a recent and exciting development, and the Great Western Railway exerted a special fascination. It was then the longest railway line in Britain, and its designer, Isambard Kingdom Brunel, had become renowned for the scale of his engineering works. One of these feats of technology, the bridge over the river Thames at Maidenhead, is shown here. Not only was it virtually unprecedented for an artist to paint a train, but *Rain, Steam and Speed* also contravened conventional notions of what was appropriate to art. Turner's great admirer, the influential art critic John Ruskin (1819–1900), later claimed that he had set out '[to] show what he could do even with an ugly subject' (quoted in Butlin and Joll, *Paintings*, vol.1, p.256).

Leighton, by contrast, took his subject from a source which had inspired generations of artists: Homer's epic poem, the *Iliad*. *Captive Andromache* is based on a passage in which the Trojan hero, Hector, bids farewell to his wife Andromache and imagines the fate that will befall her if he is killed in battle. He tells Andromache that he fears she will be taken by the victors to Greece and forced to perform menial tasks (Book 6). Leighton came up with the idea of showing the widowed and enslaved Andromache waiting with other women to get water from a well. The prestige of the ancient Greek text and the solemn, even tragic mood of this episode are appropriate to the high status and moral seriousness of history painting. At the same time, Leighton undoubtedly calculated on the visual appeal of a large number of attractive female figures. A precedent for such a scene is provided by Poussin's *Eliezer and Rebecca* (discussed in Case Study 3 – see Plate 80), which also depicts women getting water at a well. The subject gave him the opportunity for a fanciful reconstruction of life in ancient Greece (the women carry vases that can be dated to different centuries).

The contrast between the paintings extends to the way in which Turner and Leighton depicted their subject. One of the most important differences is something that you cannot easily appreciate without actually seeing the paintings themselves. If you check their measurements, you will realize that *Rain, Steam and Speed* is quite small while *Captive Andromache* is very large. What you may be able to see even here is just how much their surfaces differ even though both artists worked in oil paint on canvas. In *Rain, Steam and Speed* the paint has been applied so loosely that we get a sense of the artist's brush moving over the canvas. The paint is generally thin and watery, but in some places – especially the sky and the centre of the lower part of the composition – there are thick, sticky-looking areas of mostly white pigment. *Captive Andromache*, by contrast, has a completely smooth, even glossy surface. The paint has been so evenly applied that we are oblivious to its material quality as pigment and to the physical labour of applying it to canvas. To summarize, we can say that the first painting is characterized by loose brushwork, the second by a high finish.

How do these differences in technique affect the representation of the subject? Consider, for example, how much detail there is in each painting, how the composition is organized, whether the overall effect is one of stillness or movement, and how this effect is achieved.

Discussion

The loose brushwork of *Rain, Steam and Speed* makes it difficult to distinguish any details. You may have picked out a boat on the river and some figures on the bank, but probably did not observe the man ploughing at the far right or the hare running along the track in front of the train. Everything in the landscape melts into a misty vagueness as air and water seem to meet each other in a blur of pale paint. Even the railway train seems hardly more than a dark blot rushing towards us (an effect created by the steep perspective of the track which pulls the eye sharply back towards the horizon).

The overall effect of *Captive Andomache*, by contrast, is one of utter stillness and clarity of form. A weighty architectural setting provides a stage on which a large number of figures are arranged. Each one is precisely outlined and distinguished from the others by the subtly varied tones of their richly coloured draperies. The eye is thus encouraged to move slowly along the queue, taking in the minutely realized detail. Andromache herself seems frozen to the spot, caught in the dead centre of the composition and framed by the 'wings' of the stage-like setting.

◆◆◆

Close analysis of the compositions reveals certain superficial resemblances: both focus on a dominant black feature set within a framework of receding perspectival lines leading towards a vanishing point.[3] Yet this only serves to heighten our sense of the fundamental differences between them. Whereas

[3] Perspective here refers to the system of single-point perspective, which is used to convey the illusion of recession into depth on a two-dimensional surface. It relies on sets of inclined lines directed towards a vanishing point, which marks the imaginary deepest point of the image. It exploits the way that parallel lines appear to converge as they move away from us; for example, think of the way the lines of a railway track appear to meet at the horizon.

Andromache is a pathetic figure, the railway train has an almost sinister power (some commentators have suggested that it is about to run the hare down). It seems to be about to come hurtling out of the picture space into our own, making it difficult for us to feel remote from and uninvolved by the scene. The raised, stage-like setting of Leighton's painting, by contrast, means that the figures seem to be set in their own separate, lofty world. This effect is reinforced by those on the lower level at the front who turn their backs to us. Whereas the overall impression here is of a world without change, as timeless and static as the queue in which Andromache stands, Turner presents us with a dynamic vision of change and movement, of a world in which neither the forces of nature nor the works of humanity stay still. All these features contribute to the distinctively 'modern' character of *Rain, Steam and Speed* as opposed to the fidelity to the classical tradition represented by *Captive Andromache*.

The broader picture

How, then, might we assess both paintings so as to justify each artist's canonical status? The answer would probably run something like this. First, the boldness and dynamism of *Rain, Steam and Speed* mean that it remains a distinctively modern and undeniably powerful work even today. The depiction of new technology charging forward, both liberating and destructive, still has resonance for us. By contrast, the now little-known classical theme and static, indeed stiff, composition make *Captive Andromache* appear irrelevant and boring. There is a profound disjunction between the tragic subject and the merely decorative appeal of the figures in their immaculately rendered draperies. You could, however, challenge this emphatic judgement. After all, why should we take for granted that a nineteenth-century painting really *ought* to be innovative and challenging like *Rain, Steam and Speed*? Does the formal discipline of Leighton's composition necessarily detract from the emotional power of *Captive Andromache*? Why can't we take it at face value as a moving and uplifting vision of timeless beauty?

Rain, Steam and Speed has been judged to be a great painting and *Captive Andromache* a wretched failure not on account of any absolute qualitative distinction, but because both assessments are made with reference to a single set of aesthetic values which takes the superiority of the first painting for granted. The modernist assumption that the major artists of the period were the innovators who broke with tradition ensures that Leighton's exclusion from the modern canon is a foregone conclusion. On this account, his fidelity to the classical tradition is nothing more than a hopeless attempt to resist the inevitable tide of change. Indeed, he himself acknowledged that the social and technological changes registered by the work of Turner made his own cult of beauty difficult to sustain: 'painting [is] no longer the natural attaining of the sense of beauty and wonder that dwelt in all. [T]he turmoil and complication of modern life make an artist's task incomparabl[y] more difficult and artificial … doubts and self-consciousness beset and hamper us' (quoted in Ormond, *Lord Leighton*, p.83). As these words show, Leighton was not a blind reactionary but rather a more or less conscious anachronism and, as such, possibly a more interesting artist than he has been given credit for. In other words, I am opting for the compromise position of admiring him as a kind of heroic failure.

It should also be noted that the example of Turner's work we are discussing here is probably the most forcefully 'modern' that he ever painted. Any account of his significance as a precursor of modern art will necessarily give pride of place to *Rain, Steam and Speed*, which became a key work for the group of French artists of the later nineteenth century commonly known as the Impressionists. We can, for example, discern a debt to Turner's vision in a late painting by Claude Monet (1840–1926) depicting a bridge over the Thames (Plate 120). For the Impressionists, as a group of them emphasized in a letter of 1885 to the Director of the Grosvenor Gallery in London, the British artist provided a precedent for their own struggle against 'conventions and routines' and in favour of 'the scrupulously exact observation of nature' and 'the most fleeting phenomena of light' (quoted in Gage, *Turner: 'Wonderful Range of Mind'*, p.14). Turner's reputation as a truly innovative artist rests primarily on these aspects of his art rather than his choice of subject-matter. It was for them that he was celebrated in *Modern Painters* (1843–60) by Ruskin who, as we saw earlier, did not much care for *Rain, Stream and Speed*. He argued that Turner's greatness as a landscape painter, his superiority to the masters of the past, lay in the way that he depicted even the most evanescent natural phenomena with scientific exactitude. To do justice to these issues, we now need to consider the working methods employed by Turner and Leighton.

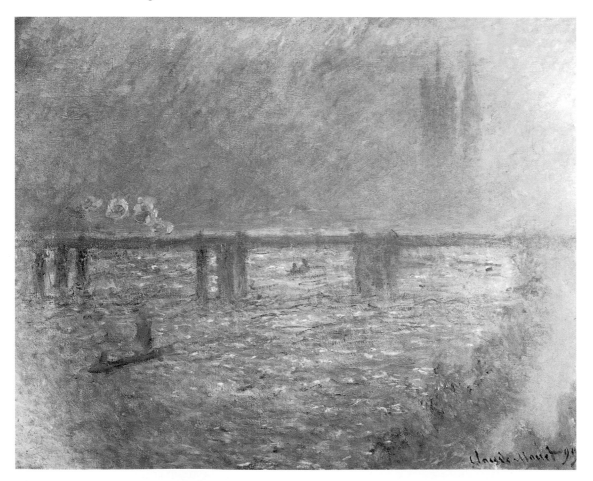

Plate 120 Claude Monet, *Charing Cross Bridge*, 1899, oil on canvas, 64 x 79 cm, Santa Barbara Museum of Art. Bequest of Katherine Dexter McCormick in memory of her husband, Stanley McCormick.

Looking again at *Rain, Steam and Speed* and *Captive Andromache*, how do you think each artist might have set about producing the picture? Did he plan it in advance? Which do you think took the longest to paint? Both are oil paintings, as we have seen, but do either of them remind you of any other art form?

Discussion

The sketchy quality of *Rain, Steam and Speed* suggests that it was painted quite spontaneously without forethought or calculation. This would mean that the sense of speed and movement was produced by a similarly rapid working process. It might also have occurred to you that the picture looks much less solid and substantial than you would expect of an oil painting and in fact resembles a watercolour – that is to say, a work painted in a water-based medium on paper – in its paleness of tone and airy lightness of effect. The vast and complex composition of *Captive Andromache*, however, could only be the result of a slow and deliberate working process. In order to group together so many figures without confusion, Leighton must have worked everything out very carefully in advance. The smooth surface of the painting must also have taken a long time to accomplish even though the effect is, as we have seen, to banish any sign of actual work. The arrangement of the figures in a fairly shallow space parallel to the picture plane,[4] with many of them facing in the same direction, and the elaborate folds of drapery may remind you of classical relief sculpture such as the Parthenon marbles.

◆◆◆

The contrast with Leighton's idealizing view of a carefully reconstructed classical past has the effect of reinforcing our sense of the directness and spontaneity of *Rain, Steam and Speed*. However, we need to be wary of exaggeration and myth-making about these qualities. An old anecdote of dubious reliability (quoted in Gage, *Turner: Rain, Steam and Speed*, p.16) traces the origin of the painting to a train journey in a storm, during which Turner is supposed to have stuck his head out the window to observe the effect and got soaked to the skin. The implication is that the impact of strong sensations on the artist moved him to recreate them directly on the canvas. But, if you think about it, the painting does not give us a view *from* the train but a view *of* the train from an impossibly high vantage point, somewhere in mid-air. Far from simply recording his personal experience, the artist has carefully devised a composition in order to convey the desired effects. Nevertheless, as the story suggests, Turner did have a particular interest in atmospheric effects, in observing the movement of the sky and of water. He travelled a great deal, making innumerable quick drawings from nature which he would subsequently use as the basis for watercolours (Plate 121) and oil paintings. It is also true that Turner was renowned for the speed with which he worked. In his later years he was in the habit of sending almost bare canvases to the Royal Academy exhibition and of working them up into completed paintings on 'varnishing day', which took place just before the official opening.

[4] See Case Study 3, p.100, for an explanation of the picture plane.

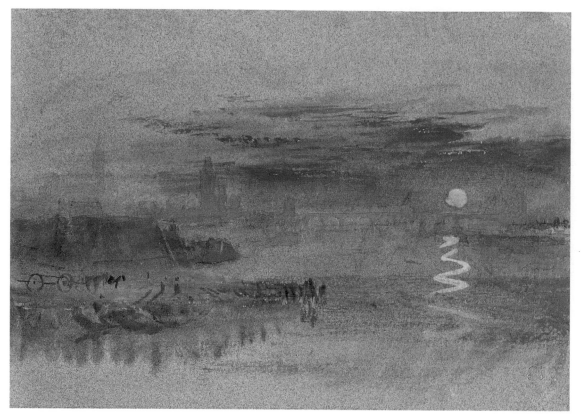

Plate 121 J.M.W. Turner, *Tours: Sunset*, *c*.1832, watercolour and gouache[5] on blue paper, 13 x 19 cm, Tate Gallery, London. Copyright Tate Gallery.

Leighton's working methods, by contrast, were extremely slow. The actual painting of *Captive Andromache* would have taken at least a year, but this represented only the final stage of a much longer process: the first drawings for the composition date to around 1870. Every stage of its elaboration took place behind closed doors in the studio of his house in London.[6] Nothing was left to chance. The studio window faced north, away from the sun, so as to ensure a consistent, unchanging light source (there was also a plaster cast of part of the Parthenon frieze built into one wall). Here he would make studies for each figure in the painting from models, drawing each figure first in the nude even if they were going to be fully clothed in the final work (Plates 122 and 123). In so doing, Leighton was consciously emulating the working procedure used by the great artists of the Renaissance such as Raphael or Michelangelo. These methods had been taught in the academies of Europe ever since, and continued in use by French academic artists such as William Adolphe Bouguereau (1825–1905). In Britain, this tradition was less firmly established and, in fact, Leighton had gone abroad for his training.

[5] Opaque watercolour paint which gives a 'chalky' look even to dark hues. It is often used in paintings on tinted paper to heighten the effect of highlights.

[6] This point is usefully demonstrated by Prettejohn, 'Painting indoors: Leighton and his studio'.

Far from being conventional, his rigorous 'academicism' set him apart from most Victorian artists. By this period, history painting had become an even more marginal practice in Britain than it had been in the eighteenth century (see the previous case study on Hogarth and Reynolds).

Plate 122 Frederic Leighton, figure study for *Captive Andromache*, 1887, black and white chalk on blue paper, 25 x 32 cm, Leighton House Museum, Royal Borough of Kensington and Chelsea, London.

Plate 123 Frederic Leighton, compositional drawing for *Captive Andromache*, 1887, pencil on tracing paper, 20 x 41 cm, Leighton House Museum, Royal Borough of Kensington and Chelsea, London.

Reputations

Turner's consistently high reputation in the century and half since his death was reaffirmed relatively recently by the opening of the Clore Gallery extension to the Tate Gallery in 1987 (Plate 124). The building of a gallery dedicated entirely to the works that Turner left to the nation meant that the terms of the artist's will have at last been more or less fulfilled. His bequest was made on condition that a special wing to be called 'Turner's gallery' be added to the National Gallery (it was only later that the Tate Gallery was founded to house British art).[7] The decision to use a very pale tone for the walls on which the paintings hang, rather than the dark red characteristic of early nineteenth-century art galleries, further testifies to Turner's canonization as a modern artist who prefigures not merely Impressionism but also twentieth-century abstract art. (White is the standard colour used in museums of modern art.[8]) While the Clore Gallery allows visitors to see the diversity of Turner's art (and not just his 'modern' aspect), the effect of displaying his work in this way, apart from other examples of British art, is to suggest that such a great artist rises above any specific time and place.

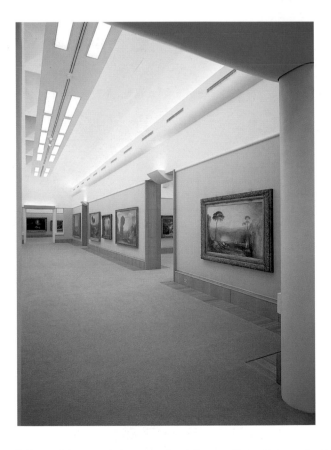

Plate 124 View of Clore Gallery interior (central passage), Tate Gallery, London. Copyright Tate Gallery.

[7] Turner's bequest is an example of the way that artists can try to shape their own public image; on this issue, see the second case study of Barker *et al.*, *The Changing Status of the Artist* (Book 2 in this series).

[8] On the modern museum, see Barker, *Contemporary Cultures of Display* (Book 6 in this series). It should also be noted that staff at the Tate were not entirely happy with the results and that the gallery has since been modified, with the walls being painted a soft pink.

Leighton, by contrast, fell dramatically from favour after his death. Already, towards the end of his career, aesthetic values had shifted to such an extent that his work began to be criticized for lacking spontaneity. He had some difficulty in selling such a vast and elaborate painting as *Captive Andromache* and had to halve the asking price before he could do so. For much of the twentieth century, Leighton remained an almost totally forgotten figure. Since the 1960s, however, his reputation has undergone something of a revival. His lavishly decorated studio house (begun in 1864), which had been preserved as a museum after his death only to fall prey to neglect in the years that followed, has been carefully restored (Plate 125). In 1996 this process of rehabilitation culminated in the staging of a major exhibition at the Royal Academy to mark the centenary of his death. For the Academy it was an act of piety towards one of its most notable presidents since Sir Joshua Reynolds. The current president expressed the hope that 'our visitors will rediscover an outstanding 19th-century British artist whose achievement has too long been overshadowed by his better-known French contemporaries' (*Frederic Leighton*, p.7).

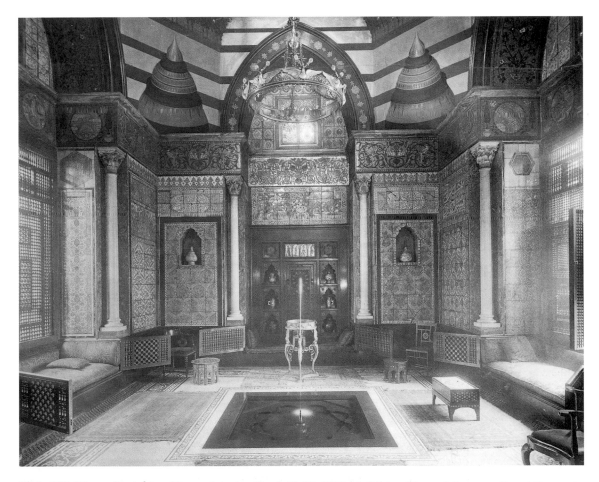

Plate 125 View of Leighton House interior (Arab Hall), 1890s, Leighton House Museum, Royal Borough of Kensington and Chelsea, London.

On the basis of the following quotations from reviews of the exhibition, would you say that Leighton has finally escaped the disparaging 'academic' label? What qualities do the critics attribute to his work, and how do they account for them?

> thoroughly disheartening spectacle ... pseudo-art ... almost entirely worthless ... relentless in its hypocrisy ... entirely phoney and melodramatic ... He was obviously a deeply frustrated man, in the classic Victorian mould.
>
> (Waldemar Januszczak, *Sunday Times*, 18 February 1996)

> this icy artist ... His technique is so technical as to be boring. The naked figures are boring too ... There's no emotion in his pictures ... Leighton sought marble grandeur ...
>
> (Tim Hilton, *Independent on Sunday*, 18 February 1996)

> sublimely ridiculous ... the negation of art: devoid of emotion, pompous in subject and physically repulsive ... his originality and energy were suffocated by convention ... [and] Victorian prudery.
>
> (John McEwen, *Sunday Telegraph*, 18 February 1996)

> the least painterly of painters ... His paintings are predetermined to death ... Leighton's work is dressed up with elevated feelings, high moral purpose and even higher Victorian pomp, and a great deal of repressed, suppressed and otherwise disguised sexuality.
>
> (Adrian Searle, *Guardian*, 20 February 1996)

Discussion

It would be difficult to find a more damning reassertion of the critique of Leighton as academic. Indeed, two of the critics go so far as to deny that his paintings are art at all. Judging the paintings against a standard of expressiveness and originality, the critics find them impersonal. Such phrases as 'the least painterly of painters' and 'technique so technical as to be boring' reveal a profound antipathy to his meticulous approach and characteristic high finish. The critics accuse Leighton of being a slave to convention, and characterize him by reference to the stereotype of the Victorians as sexually repressed and hypocritical. On this basis, they find Leighton's high seriousness merely pompous and absurd. You might be left wondering why they should adopt quite such an extreme tone in discussing a long-dead artist.

◆◆

Perhaps we should not take these comments too seriously (in the event, the exhibition attracted around 150,000 visitors, quite a respectable figure). On reflection, it is not really very surprising that art critics still cling to the simplicities of a 'winners versus losers' account of nineteenth-century art. It certainly makes for a much more colourful review than would a relativistic approach which could concede that Leighton's work may be successful in its own terms, however alien these terms may since have become. What enraged the critics was, in fact, not so much the actual paintings but the exalted position that Leighton achieved, eventually becoming the only English painter ever to be granted a peerage (the *Sunday Times* piece carried the headline: 'Lorded for his Lies'). They deplored the current trend towards a revival of Leighton's

reputation, made manifest in the exhibition, on the highly moralistic grounds that this one-time darling of the establishment had got the come-uppance he deserved. In so doing, they were repeating the grand narrative of modern art, according to which the discrediting of the academic 'villains' provides the necessary finishing touch to the belated canonization of the heroic pioneers, whose bold pictorial experiments met only with derision during their own lifetimes.

To what extent does this polarity of difficult, controversial pioneer and pompous official artist accord with the documented facts of our two artists' biographies? Turner's paintings were indeed endlessly criticized by his contemporaries, who found his loose, sketchy finish perplexing in the extreme. The standard complaint was that his works were simply unfinished and that in exhibiting them in this condition Turner was perpetrating a fraud on the public. It was in response to one such review that Ruskin took it upon himself to champion the artist. Nor did Turner receive official recognition, consistently failing, for example, in his attempts to gain royal patronage. By contrast, the first painting that Leighton ever exhibited in London, *Cimabue's Celebrated Madonna is Carried in Procession through the Streets of Florence* (Plate 126), received near universal praise and was immediately bought by Queen Victoria on the advice of her husband, Prince Albert. An early prediction that he would become president of the Royal Academy was fulfilled in 1878. As well as being a highly effective administrator, Leighton achieved a prominent social position. He was the perfect public man, almost too good to be true in the eyes of some observers; Henry James portrayed him in his short story, *The Private Life*, as Lord Mellifont, who ceases to exist when he is by himself.

If we can find evidence to support the polarity outlined above, this is by no means the whole story. Turner was no struggling, unsuccessful artist. Although as he grew older he lived in conditions of semi-secrecy in a succession of run-down houses, his lifestyle had nothing to do with want of

Plate 126 Frederic Leighton, *Cimabue's Celebrated Madonna is Carried in Procession through the Streets of Florence*, 1853–5, oil on canvas, 232 x 521 cm, National Gallery, London. Reproduced by courtesy of The Trustees, The National Gallery, London. On loan from the Royal Collection.

Plate 127 J.M.W. Turner, *Petworth Park: Tillington Church in the Distance*, *c*.1828, oil on canvas, 64 x 149 cm, Tate Gallery, London. Copyright Tate Gallery.

money. Contemporary accounts indicate that he was simply eccentric and miserly. Whatever difficulties his later paintings presented to visitors to the Academy exhibitions, he was nevertheless an established and indeed famous figure who did not lack for admirers. Throughout his career, he worked on commission for wealthy, sometimes aristocratic patrons, often developing close relations with them. In 1828, for example, he produced a series of landscapes for the Earl of Egremont, depicting scenes at or near Petworth, the latter's estate in Sussex (Plate 127). For Turner, it seems, the new, wider public of the exhibition was no substitute for these traditional forms of private patronage.[9] Unlike the general public, these wealthy and sophisticated collectors had an interest in questions of technique and could appreciate, instead of being perplexed by, Turner's experimentation with increasingly bold painterly effects.

In Leighton's case, you could try to argue that he was not really so complacent and conventional (I hinted as much earlier). Rather than personalizing the issue and reducing it to a question of individual character, however, it is more helpful to show how his priorities and concerns derive their logic from a historically specific social and cultural context. The huge disparity between his lifestyle and Turner's can be partly explained in terms of the greatly enhanced status of artists in the later nineteenth century. By living in a splendid house built specially for him, Leighton was fulfilling contemporary expectations of a successful artist. His personal ambition was inseparable from his dedication to the cause of art. His house, for example, was conceived as much as a temple to beauty as a testament to his own wealth and position. Like other artists and thinkers of the period (including Ruskin), he was committed to the principle that art could help to redeem a materialistic society, and therefore endeavoured to ensure that its uplifting qualities should make an impact on as many people as possible. This led him to seek commissions for mural paintings, which would be permanently accessible on the walls of public buildings. He also became chairman of the South London Art Gallery, which was founded in the late nineteenth century to bring art to working people who would never go near the National Gallery.

[9] However, Turner did not simply disregard the possibility of reaching a wider audience. On the contrary, many of his watercolours were produced to be engraved and published as prints.

Reassessment

Ultimately, any revision of the conventionally canonical (and unthinkingly modernist) assessment of the two artists must be based on their painting. Recent scholarship on Turner has reversed the modernist bias of older writing on his work and placed him in his historical context, demonstrating how much he owed to traditional artistic practice. (It should be noted that the artist, a former student of the Academy, subsequently became a loyal member and took part in its teaching.) In particular, art historians now emphasize that, contrary to perceptions of Turner as a forerunner of abstraction, he actually put a great deal of care into devising the subjects of his paintings.[10] Throughout his career he depicted historical and literary themes: *Dido Building Carthage, or the Rise of the Carthaginian Empire* (Plate 128), for example, is based on Virgil's *Aeneid*. Turner retained a special affection for this painting, which he left to the nation on condition that it and another example of his work hang in the National Gallery between a pair of pictures by Claude Lorrain, for whom he always felt the greatest veneration. (The National Gallery continues to honour his wishes.) One of them, *Seaport with the Embarkation of the Queen of Sheba* (Plate 129), which Turner first saw in the Angerstein collection,[11] provided one of the major sources for *Dido Building Carthage*.

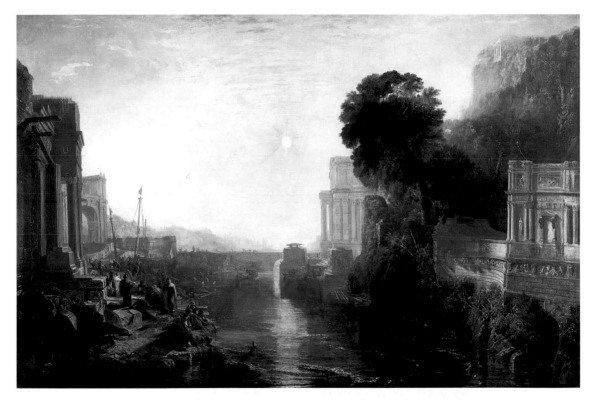

Plate 128 J.M.W. Turner, *Dido Building Carthage, or the Rise of the Carthaginian Empire*, 1815, oil on canvas, 156 x 232 cm, National Gallery, London. Reproduced by courtesy of The Trustees, The National Gallery, London.

[10] In addition to the work by John Gage already cited, see, for example, Nicholson, *Turner's Classical Landscapes*.

[11] The Angerstein collection formed the basis of the National Gallery's collection; see Case Study 7.

Plate 129 Claude Lorrain, *Seaport with the Embarkation of the Queen of Sheba*, 1648, oil (identified) on canvas, 149 x 194 cm, National Gallery, London. Reproduced by courtesy of The Trustees, The National Gallery, London.

Make a note of the similarities and differences between Claude's and Turner's compositions. You may find it helpful to look back at the previous comparison that we constructed between two paintings (p.172) and consider again how your eye is led through the picture space. Try to locate the heroine of the scene in each case.

Discussion

Both depict a port with classical architecture, but whereas Claude shows only a ruined fragment of colonnade on the left, Turner's painting contains more grandiose buildings and hordes of busy workers. On the right, Claude shows a few trees behind a palace while Turner depicts a cliff with luxuriant vegetation, a hint of the wilderness out of which the city is rising. In the Claude, we see the shore in the foreground with a boat in the centre and another behind so that the eye is led gently towards the palace, where the Queen of Sheba is embarking. Turner, by contrast, at once confronts us with a long channel of water which draws the eye back sharply along the broad reflection of the sun in the water. The yellow intensity of his sky contrasts

with Claude's gentle evening light. You probably had difficulty in spotting Dido, who appears in blue and white directing a group of men with plans amid the building works. She is less prominent than the girl facing us, who looks towards a group of boys kneeling by the water looking at a toy boat (what you probably see as a blob on the water).

◆◆◆

Turner's painting was widely admired when it was exhibited at the Royal Academy, with the main dissenting voice coming from the collector Sir George Beaumont, who complained that it was 'painted in a false taste, not true to nature', noting specifically the way his colour differed from Claude's (quoted in Butlin and Joll, *Paintings*, vol.1, p.95). For Beaumont, Claude's landscapes represented a model of naturalism against which his modern rival could only seem deficient.[12] For Turner himself, the example of Claude provided a model by which he could seek to raise the status of landscape painting by taking over some of the ambitions of history painting (even though, as we have seen, he did not follow the traditional practice of clearly identifying the main character).[13] This apparently 'academic' concern with the classical tradition of landscape should not be seen as something apart from and irrelevant to the great achievements of Turner's later years. Rather, he consistently sought to provide a moral commentary on the historical unfolding of human and national destinies so that past and present are seen to be inseparable from each other. In *Dido Building Carthage*, for example, the launching of the fragile toy boat on the water has been taken to offer a stern warning about the inevitable transience of Dido's new empire and, by implication, of all others.[14] Turner undoubtedly intended a parallel either with the ascendant British empire and/or the recently defeated French empire of Napoleon. The irony is that his contemporaries appear to have been largely unaware of this complex layering of meaning. It is for this reason that it has been left to present-day art historians to try to make sense of his intentions.

Turning now to Leighton, we can also complicate the picture that we drew earlier. Art historians now argue that he was sympathetic to new developments in art throughout his career and, at least to start with, was himself an innovator. Art critics of the mid-Victorian period disapproved of his paintings of female figures, devoid of all action and expression and often more or less nude. Such images abandoned the high moral tone of history painting for sheer, pointless visual pleasure (known as 'art for art's sake', then a very new term). Leighton continued to work in this vein until his death, though, in the less severe moral climate of the late nineteenth century, they no longer seemed daring. One of his very last works, *Flaming June* (Plate

[12] Beaumont was one of the early benefactors of the National Gallery, to which he left paintings by Claude and Constable among others.

[13] As we saw in the case study on Poussin, the scale of the figures is one factor that distinguishes landscape from history painting. Thus Plates 128 and 129 would be categorized as landscape.

[14] A companion painting exhibited in 1817 (and now in the Tate Gallery) depicts *The Decline of the Carthaginian Empire* with the Carthaginians waiting passively for Rome to conquer them. The scene is dominated by the setting sun in symbolic contrast to the sunrise in *Dido Building Carthage*.

130), depicts a sleeping woman curled up on a marble bench under an awning in front of a sunlit sea. Her rippling orange draperies convey a sense of utter lassitude in the intense heat. The exaggerated foreshortening of the figure, together with the impossible length of her thigh which echoes the horizontal lines of the architecture, creates a peculiar flattened effect. Despite the classical setting, these formal distortions and the subtle artifice of the colour scheme (reproductions tend to make the orange too bright and cheerful) are highly sophisticated and even modernist in their abandonment of traditional representational practices. The composition can be read as a play on appearances as it subverts the illusionistic techniques used by artists to convey reality. The most thickly painted part of the canvas is what in realistic terms should be the least solid: the meeting of light and water which can be seen at the top of the painting.

I do not mean to argue that Leighton was 'really' a modernist and should therefore be rehabilitated in these terms. Nevertheless, this analysis of *Flaming June* reinforces my suggestion that he might be a more interesting artist precisely because of the self-consciousness that prevented him being entirely classical. It allows us to get away from condemning his work as boring or, still worse, as nothing more than soft-porn pin-ups (as was implied by some of the critics of the 1996 exhibition, whose disapproval, rather ironically, echoed that of their despised Victorian predecessors). Whereas the complaint about being boring applies to paintings like *Captive Andromache*, the accusation that Leighton's work is just too easy on the eye to be taken seriously applies especially to *Flaming June*, which circulates very widely in reproduction. It has become an immensely well-known and popular image, even though the

Plate 130
Frederic Leighton, *Flaming June*, c.1895, oil on canvas, 119 x 119 cm, Museo de Arte de Ponce, The Luis A. Ferré Foundation, Inc., Ponce, Puerto Rico.

actual painting has hung in a Puerto Rican collection since 1963 when no British gallery could be persuaded to buy it. Renowned for his pretty pictures of gorgeous women, Leighton is now accessible to many people who seldom if ever go to art galleries. The painstaking technique, which in his own day served as a marker of his high-minded refusal to work quickly and sell on a large scale, makes Leighton's paintings ideal for reproduction (something that the critics also inevitably sneered at in 1996). As a result, the high artist who strove to perpetuate the tradition of history painting has been turned into a figure in low or mass culture.

Ultimately, if we cannot accept the great modernist myth of reputations being reversed after an artist's death, our discussion of Turner and Leighton does provide us with an example of how the cultural status of an image can change over time. When Turner painted *Rain, Steam and Speed*, he was depicting a subject that had hitherto been confined to cheap, ephemeral prints; *Flaming June* has ended up as a modern equivalent of such low-status images. High art and popular culture are not so separate as you might have thought but feed off each other. At the same time, it can be suggested that the relative popular appeal of each artist has not changed quite so decisively as you might expect in the light of the impact of modernism on the canon. As we saw, it required a certain knowledge of painterly practice to appreciate Turner in his own lifetime, something that remains true today. After all, he has never enjoyed quite the same popularity as his fellow landscape painter and near contemporary, John Constable. By contrast, Leighton, as we also saw, aspired to communicate with the widest possible audience so that perhaps he would not, after all, be too consternated to discover his mass appeal today.

References

Barker, E. (ed.) (1999) *Contemporary Cultures of Display*, New Haven and London, Yale University Press.

Barker, E., Webb, N. and Woods, K. (eds) (1999) *The Changing Status of the Artist*, New Haven and London, Yale University Press.

Butlin, Martin and Joll, Evelyn (1984) *The Paintings of J.M.W. Turner*, 2nd edn, 2 vols, New Haven and London, Yale University Press.

Frederic Leighton (1996) exhibition catalogue, London and New York, Royal Academy of Arts/Harry N Abrams, Inc., 1996.

Gage, John (1972) *Turner: Rain, Steam and Speed*, London, Allen Lane.

Gage, John (1987) *J.M.W. Turner: 'A Wonderful Range of Mind'*, New Haven and London, Yale University Press.

Nicholson, Kathleen (1990) *Turner's Classical Landscapes: Myth and Meaning*, Princeton University Press.

Ormond, Leonée and Richard (1975) *Lord Leighton*, New Haven and London, Yale University Press.

Prettejohn, Elizabeth (1996) 'Painting indoors: Leighton and his studio', *Apollo*, vol.143, February, pp.17–21 (special issue on Leighton).

Wood, P. (ed.) (1999) *The Challenge of the Avant-Garde*, New Haven and London, Yale University Press.

PART 3
DISPLAYING THE CANON: MUSEUMS AND MONUMENTS

Introduction

In this final part we are concerned with some of the ways in which canonical forms of art have been presented, displayed and consumed for and by the British public during the nineteenth century. The first study looks at the Albert Memorial, a sculptural monument which, since its construction in the 1860s, has held a problematic and controversial status as 'great' art. The study considers some of the political and national issues involved, in particular the ways in which the artistic and sculptural forms of the monument can be seen to relate to the religious and aesthetic values disseminated within Victorian Britain. The case studies which follow on the National Gallery in London and art in Manchester also explore some of the political, national and educational issues which helped to shape these major collections. Issues of shifting taste, systems of classification, and notions of 'public' and 'private' art are explored, revealing some of the complex factors which helped to shape canonical values and museum culture in both national and regional contexts.

Plate 131 (Facing page) Sebastiano del Piombo, detail of *The Raising of Lazarus* (Plate 146).

The Albert Memorial
COLIN CUNNINGHAM

What is the memorial?

The Albert Memorial is a problematic work. It is probably the most significant piece of public sculpture of nineteenth-century Britain, yet it was designed by an architect. We might assume it should be a work of quality since the Director of the National Gallery, Sir Charles Eastlake, was Queen Victoria's personal adviser in the choice of design, yet it has been reviled by many as vulgar and lacking in taste. In spite of its status as the nation's memorial to the monarch's husband, it languished for decades in a growing state of disrepair. Only a protracted campaign led the government to fund its overhaul at a cost of some £10 million, scheduled for completion in 1999. The aim of this study is to alert you to the problematic nature of this monument's relation to the canon, and to raise some of the issues involved in establishing criteria for inclusion in a canon. We need to ask questions such as: how do we assess this memorial? What criteria should we use? We can begin by asking, who made it and what was it made for?

Study the photograph of the Albert Memorial (Plate 132) and the diagram (Plate 133). Make a list of those involved, and note the type of work they produced (marble or bronze sculpture, mosaic, etc.). What problems might this involvement of a number of artists cause, and how might it affect the way we view it?

Discussion

My list is as follows:

H.H. Armstead	bronze allegorical figures, marble frieze
J. Bell	marble group of America
W. Calder-Marshall	marble group of Agriculture
Clayton & Bell	glass mosaic panels in gables
J.H. Foley	bronze portrait of Albert, marble group of Asia
J. Lawlor	marble group of Engineering
P. MacDowell	marble group of Europe
J.B. Philip	bronze allegorical figures, marble frieze
J. Redfern	upper tiers of bronze angels, bronze virtues
G.G. Scott	overall design of the work as architect
W. Theed	marble group of Africa
T. Thorneycroft	marble group of Commerce
H. Weekes	marble group of Manufactures

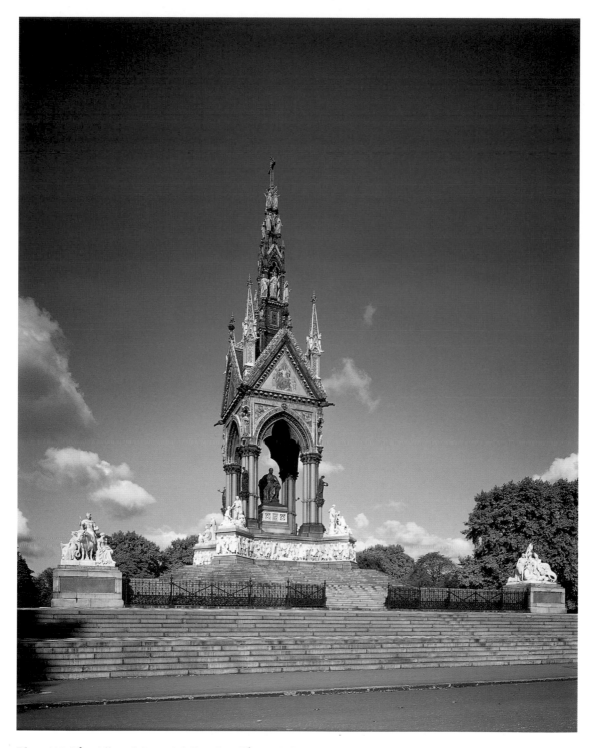

Plate 132 The Albert Memorial, London. Photo: A.F. Kersting.

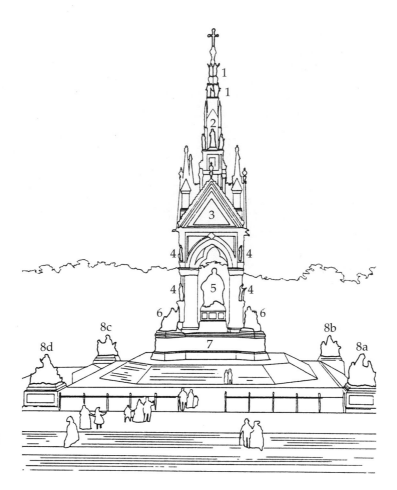

Plate 133
Diagram of the
Albert Memorial
identifying
sculptures.

Key:

1 Two ranks of angels, bronze, by J. Redfern.

2 Four Christian and four moral virtues (Faith, Hope, Charity, Humility and Fortitude, Justice, Prudence, Temperance), bronze, by J. Redfern.

3 Architecture, Sculpture, Painting, Poetry and Music, mosaic gables designed by Clayton & Bell.

4 The sciences (top row: Rhetoric, Medicine, Philosophy and Physiology; bottom row: Astronomy, Chemistry, Geology and Geometry), bronze, by H.H. Armstead and J.B. Philip.

5 Portrait statue of Albert, bronze, by J.H. Foley.

6 Skills, marble: Engineering by John Lawlor; Commerce by Thomas Thorneycroft; Manufactures by Henry Weekes; Agriculture by William Calder-Marshall.

7 Frieze of 169 artists, writers, musicians, sculptors and architects, marble, by H.H. Armstead and J.B. Philip.

8 The four quarters of the globe, marble: (a) Asia by J.H. Foley; (b) Africa by William Theed; (c) America by John Bell; (d) Europe by Patrick Macdowell.

Architect in charge of overall design: G.G. Scott.

I hope you did not leave out Scott since he was in overall charge, but you may well have been tempted to see the sculptures as the 'art' element and the architecture merely as the setting. Either way it is difficult to think of so many artists working under the close control of one guiding imagination. You may also have wondered at the name Clayton & Bell as one entry in the list. They were partners in a firm, mainly engaged in designing stained glass, and the involvement of a commercial firm may make you wonder whether their contribution would really have ranked as 'high art'. The memorial is clearly a multi-authored work. There is an interesting parallel here with the Parthenon marbles, which were also the result of a large group of sculptors working under the direction of one master. The modern tendency, dating not much further back than the eighteenth century, is to concentrate on the idea of individual 'genius', which might give Scott greater stature in comparison with the other artists, perhaps giving him credit that it turned out so uniformly.

◆◆

You may be surprised to learn that Scott does not seem to have concerned himself much with the detailed design of the sculptures. It is also easy to see from the diagram that the four groups that provide the corners of the monument are different in shape. Yet, if you look again at the view of the monument (Plate 132), you can see that the sculpture is arranged according to a pattern, and it is the overall composition that holds the whole together. Indeed, from the full view it is quite difficult to see any details of the sculptures. However, the sculptures were often reviewed separately as though their place in the whole memorial was irrelevant, and the variety of composition in the individual groups enabled critics to attack the monument as a flawed work of art, although at the time it was conceived it was claimed: 'There is now one of the noblest opportunities which can possibly offer for uniting the three sister arts, architecture, sculpture and painting or 2-dimensional art' (*The Builder*, 23 May 1863, p.361).

We still have to consider what this work was made for. It consists of a square arched canopy topped by a tall spire that rises fully 16 metres from the ground. Under the canopy is a large portrait statue. The central part of the monument is 18 metres square, but the sculptural groups at ground level and the approach steps give it a frontage of 61 metres. It commemorates Prince Albert, Consort of Queen Victoria, who died at the relatively young age of 42 in December 1861. Designed in 1863, it was not finally completed until 1876. It stands in Kensington Gardens in London, which is not where he is buried, so this monument is different from a tomb. It faces the area of London that was beginning to be developed as 'Albertopolis', a cultural and intellectual centre with the Albert Hall, Victoria and Albert Museum and so on. There are Albert Memorials in many parts of the United Kingdom, but this functions as the national one. So its purpose is as a reminder of his character and his contribution to society. We shall consider some examples of the way this purpose is expressed later, but for the present we can accept that it is likely to be laudatory, something approaching propaganda or at least an advertisement for Prince Albert's virtues.

The relation of the Albert Memorial to a canon of art

You have seen from previous case studies that a canon is constantly developing. Not only does it reflect changing tastes, but there is also scope for argument about whether an individual work or artist does or does not merit inclusion. Reasons for inclusion might be principally aesthetic or principally historical. And it is important to remember, too, that defining a canon is itself problematic. There is little doubt that the Albert Memorial would have a central position in a canon of Victorian Art. It was so popular when it was first completed that eight policemen had to be posted to keep the crowds in order. But that contemporary popularity is part of the problem, because we cannot simply equate popularity with canonical status and popular acclaim does not automatically secure a place in the canon. There is a link, but judgements of technique, intellectual and imaginative quality and so on (often made by professionals such as critics and gallery owners) are also involved. You have already seen in Case Study 5, for instance, how Frederic Leighton was accorded canonical status in the nineteenth century. Of the artists involved in the Albert Memorial, probably only Scott and Foley would have been ranked with Leighton, and their contributions were particularly important.

However, the contemporary popularity, the opinions of periodicals such as *The Builder* and the status of the artists at the time are part of the nineteenth century's assessment of this art work. Today the Albert Memorial does not even rate a mention in most published histories of world art. *A World History of Art* by Hugh Honour and John Fleming has a section on nineteenth-century British architecture, but illustrates only the Houses of Parliament (Honour and Fleming, *World History of Art*, pp.620–3). There are good reasons for considering other works more important than the Albert Memorial in the field of architecture, and the number of sculptors involved makes this a problematic example in an age when 'great' art is usually considered to be the product of individual effort or even genius. It would also be fair to say that most histories regard late nineteenth-century Britain as something of a backwater in art history, so the Albert Memorial has become a doubtful candidate in relation to the canon of western art.

However, it seems significant that the nineteenth century witnessed the founding of the National Gallery in London (with its director involved in the selection of designs for the memorial). And in late nineteenth-century Britain there was a very large market for original art works and reproductions: artists were generally held in high social esteem. The British Empire also took British art and taste to many parts of the world. In attempting to understand the art of the nineteenth century, then, a work that epitomizes the values of British society should be recognized as historically important. If that does not mean it is readily included in the canon, the implication is that other criteria are at work. There may, for instance, be issues of the development of style which militate against its inclusion.

The Gothic Revival style

The Albert Memorial is a late example of the Gothic Revival style that was the dominant feature of the British architectural scene from around 1830 to 1875. It is a marked contrast to the classical ideal epitomized by the architectural setting of the Parthenon marbles. The Gothic Revivial style (which copies the pointed arches, pinnacles and buttresses of medieval, or Gothic, architecture) was chosen by Queen Victoria in preference to other, non-Gothic designs (Plates 134 and 135). One reason for the importance of the Gothic Revival in Britain was that it was seen as a national style. It was felt that Gothic, which had developed in that part of Europe north of the Alps, was essentially different from the 'imported' style of the Renaissance that had been based on Rome and Greece. Gothic Revival harked back to the great cathedrals, which many regarded as the finest buildings of the land. It is hard to explain the reasons why an industrial society – with railways, iron and glass, artificial light and central heating – should turn to the Middle Ages for inspiration in its architecture and painting. The phenomenon is one aspect of what is generally known as Romanticism, a reaction against the domination of art by rules of taste promulgated by people such as Le Brun and Reynolds (Case Studies 3 and 4); the novels of Sir Walter Scott are often cited as a prime inspiration in Britain. Yet in architecture and the arts in general, the movement was by no means confined to Britain. The German classical architect Karl Friedrich Schinkel (1781–1841) was also deeply imbued with the Gothic spirit.

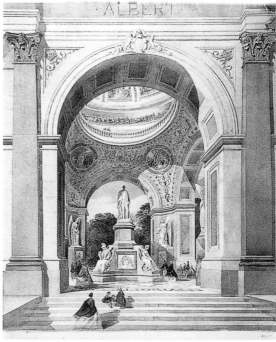

Plate 134 P.C. Hardwick, design for the Albert Memorial, 1863, British Architectural Library, RIBA, London.

Plate 135 Charles Barry, design for the Albert Memorial, 1863, British Architectural Library, RIBA, London.

But the revival of old styles conflicts with a view of art history as a continuous development, with each generation creating something new, and late examples of a style are often less highly regarded in contrast to examples of a new development. The English painter John Constable was particularly scathing about the Gothic Revival, which he described as 'a vain endeavour to reanimate deceased art, in which the utmost that can be accomplished will be to reproduce a body without a soul' (quoted in Honour and Fleming, *World History of Art*, p.621). The architect who perhaps did most to further the Gothic Revival was A.W.N. Pugin (1812–52), a convert to Roman Catholicism who believed passionately that the evils of his day were rooted in the abandonment of Christian virtues that had begun with the Reformation. He was principally engaged in church building and in the attempt to recreate what he saw as the better world of the Middle Ages. His influence was passed to painters and designers who were also dissatisfied with the world around them, and their designs are imbued with what they individually saw as the best qualities of medieval craftsmanship. These painters – the Pre-Raphaelites[1] – and designers such as William Morris are generally regarded as the significant contribution of British nineteenth-century art to the western canon of fine art and the decorative arts.

One thing that these designers and artists were deeply opposed to was the mass production of 'art objects' that had been celebrated in the Great Exhibition of 1851. Yet this was one of the chief achievements of Prince Albert, and the catalogue of the Great Exhibition is commemorated in the book held by the portrait figure of Albert on the monument. People like William Morris who admired traditional hand craftsmanship would hardly be likely to delight in the involvement of a commercial firm such as Clayton & Bell. Still less would they like the extent of mechanical work in the architectural elements of the memorial. Besides, where Pugin had inspired architects with a vision of 'real' Gothic building, it was left to others (such as Scott) to adapt Gothic forms to modern use, to fit plate glass sash windows into pointed arches and to use the new modern material of iron. Scott may have been inspired by medieval objects such as the Gothic monstrance shown in Plate 136, adapting their small scale to the size of the memorial. The structure of the Albert Memorial is of iron, though it is entirely concealed, another factor that would have displeased Pugin. In other words, there were designers and artists in Britain at the time who were ready to see the Albert Memorial as an example of the taste of the establishment rather than forward-looking, as a piece of sham structure rather than honest building. This ambivalent reaction, at a time when the Gothic Revival style was itself on the wane, could hardly help to establish the work as a part of the wider canon.

In the light of the case study so far, can you identify reasons why the style of the Albert Memorial might be considered particularly suitable for the national monument to the Prince Consort? Are there any reasons why it might have been felt to be unsuitable?

[1] The Pre-Raphaelite Brotherhood was founded in 1848 by a group of artists including William Holman Hunt (1827–1910) and John Everett Millais (1829–96). Its declared aim was a 'return to nature' and an attack on academic practices.

Plate 136 Italian Gothic
monstrance, *c.*1330–70,
copper gilt with
champlevé enamel
plaques, height *c.*28 cm,
Victoria and Albert
Museum, London.
(This was acquired by
the museum in 1861,
shortly before Prince
Albert's dealth.)

Discussion

The fact that it was seen as the national style might make it particularly
suitable. Even though Albert was of German extraction, he still came from
the area in which Gothic architecture had developed. In addition, the style
was associated with buildings of the Christian religion, which could be seen
as particularly suitable for a memorial to a Christian prince. Yet at that time
the established canon, particularly in sculpture, placed a high value on the
individual artist and was largely defined by relation to works of the classical
tradition such as the Parthenon marbles. A further disadvantage might have
been that the Gothic style was becoming less fashionable by 1876, though
this was not the case in the early 1860s when the memorial was designed.

◆◆◆

It may also be worth considering whether it is even possible to set out to
create a canonical work. It may be the intention to do so, but if a canon has
any lasting value, it is at least partly because the works included have
something to say to later generations. There has to be a message or basis for
discourse in relation to the art work that remains relevant to different ages.
Thus, if the message of the Albert Memorial was totally bound up with the
values of Victorian Britain, it would be less likely to appear to later generations
as much more than a historical curiosity. This is probably to overstate the
case against the memorial, since there is also the point that each era's creativity
is of interest because it reveals something about the nature of that society.
And if the canon represents the supposedly high peaks of the development
of western art, then we could argue that it should include examples from all
periods.

Architecture or art?

Look at the illustrations of the memorial (Plates 132, 137–143), paying particular attention to the materials and colour. List as many different ones as you can, identifying which materials are used for which elements. You do not need to worry about precise names; red stone, bright blue glass, or green metal are all you need to distinguish different substances.

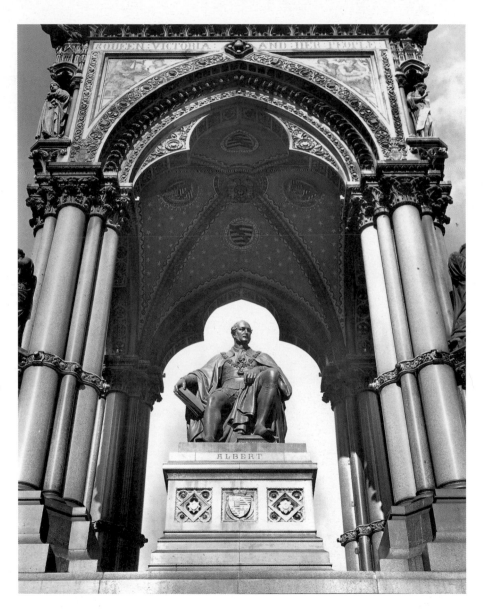

Plate 137 J.H. Foley, *Prince Albert*, detail of Albert Memorial, London. Photo: A.F. Kersting.

Plate 138 J.B. Philip, detail of frieze of sculptors showing Michelangeo seated (he is positioned in the centre of this side of the memorial) and Cellini (with his back turned), Albert Memorial, London. Photo: A.F. Kersting.

Plate 139 J.B. Philip, *Geometry*, detail of Albert Memorial, London. Photo: Conway Library, Courtauld Institute, University of London.

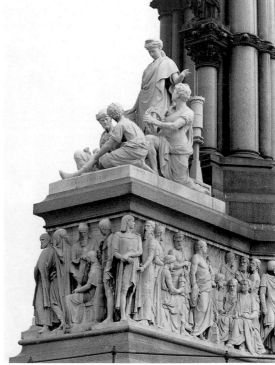

Plate 140 J. Lawlor, *Engineering*, detail of Albert Memorial, London. Photo: RCHME © Crown copyright.

Plate 141 R.A. Artlett after J.H. Foley, *Asia* (from the Albert Memorial, London), 1871, engraving, *Art Journal*, p.169.

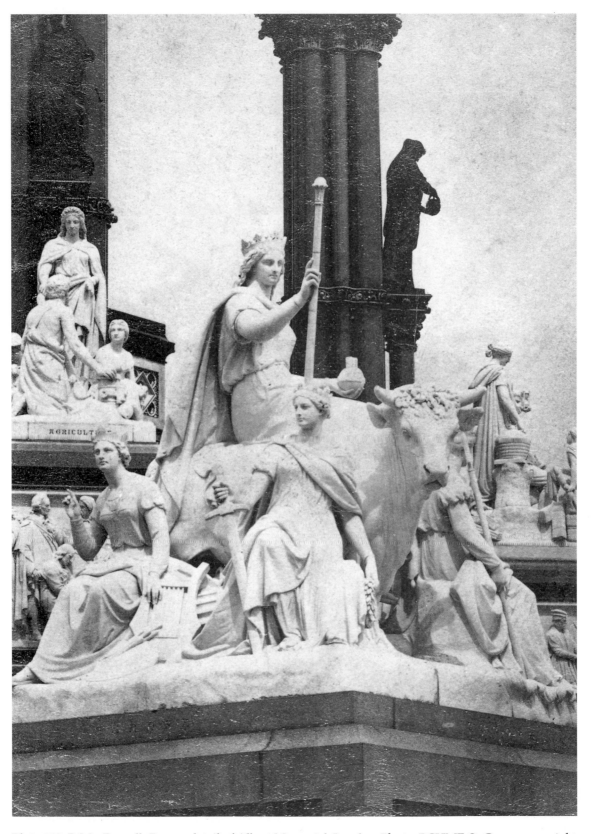

Plate 142 P. MacDowell, *Europe*, detail of Albert Memorial, London. Photo: RCHME © Crown copyright.

Plate 143 Detail of spire and pinnacle, Albert Memorial, London. Photo: Colin Cunningham.

Discussion

My list is as follows:

white Sicilian marble	the frieze and sculptural groups
red granite	frame of the podium and columns
grey granite	bases and columns
buff limestone (Darley Dale)	pinnacles and parts of steps and platform
red sandstone (Mansfield)	parts of steps and platform
slate	parts of steps and platform
bronze	statues of Albert, figures on columns and spire, also many ornamental parts of the structure
glass mosaic	images in gables (there is also glass and semi-precious stones set in the ornamental bands)
enamel	heraldry
lead	ornamental roofing, covering to some columns
copper	roof cresting
gold	some parts are gilded (originally these included the statue of Albert himself and all the figures on the spire)

Do not worry if you missed some, but check the locations I have given for each element if your list is much shorter than mine. The important thing to realize is the great diversity of materials used.

◆◆

It is easy to see that there is a variety of craftsmanship involved, but that might even make it difficult to decide whether this was a work of sculpture or architecture. One critic wrote of the design: 'Everything will depend on the sculpture. This will be the life or death of the monument' (*The Builder*, 23 May 1863, p.361). We have already seen that the overall design was in the hands of an architect, and that a number of sculptors were involved. The combination is a reminder that we need to be careful in categorizing art works by type or medium: there is not always a clear dividing line. We have already considered in Case Study 2 whether the Parthenon marbles are best thought of as sculpture or adjuncts to architecture.

In the case of the Albert Memorial, where the sculpture is still in its original position, it is easier to appreciate the work as a whole. The overall effect seems to me one of richness and elaboration. This may not be to our taste, but we should consider whether technical virtuosity should justify inclusion in a canon. On the whole, the memorial has been recognized as a masterpiece of craftsmanship, and the sculpture is technically of a high standard. If there are still those who dispute its value as a canonical piece, that suggests mere technical mastery cannot by itself justify inclusion in a canon. I have already argued that the meaning of a work of art, and the extent to which elements of that meaning are relevant across the eras, are also essential in defining a work as canonical.

Meaning and iconography

The iconography of the memorial – analysing the message conveyed by its various elements – is particularly revealing of the attitudes of British society at the time of its making. Thus it is worth considering this symbolic language in some detail.

Study the diagram of the memorial again (Plate 133). Can you identify the various qualities of the prince's achievement that are commemorated? (You will need to rely on the key to identify the figures. On the memorial individual figures are labelled, and Victorians assumed viewers could identify them by their symbols.)

Discussion

We may best begin at the top. Two tiers of angels suggest Albert's commitment to Christianity and the hope that he is in heaven. Below these are the four Christian virtues (Faith, Hope, Charity and Humility) and the four moral virtues (Prudence, Temperance, Fortitude and Justice). Then the mosaics contain allegories of poetry and music, painting, sculpture and architecture. Below are eight figures of the sciences: Physiology, Rhetoric, Medicine and Philosophy in the niches, and against the columns are Geometry, Astrology, Chemistry and Geology. Four sculptural groups symbolize the industrial arts of Manufactures, Engineering, Agriculture and Commerce. Below them is a great frieze of 169 figures representing all the most famous poets, musicians, painters, sculptors and architects, while at the corners four large groups emblematic of Europe, Asia, Africa and America associate Albert with world trade, and in particular the countries that contributed to the Great Exhibition. This long list of virtues, sciences and arts is an extraordinary eulogy for the prince, if we suppose he was personally to be credited with them.

◆◆◆

What sort of meanings do all these elements suggest? The general meaning was actually summarized before the monument was begun: 'One leading object in the design was the union in one great work of the various arts which the Prince so anxiously fostered' (*The Builder*, 23 May 1863, p.361). The portrait of Albert is carefully made half seated but stepping down 'as if taking an earnest and active interest in what might be supposed to be passing around him' (*Handbook to the Prince Consort National Memorial*, London, 1872, quoted in Brooks, *The Albert Memorial*, p.54). An earlier design (Plate 144) showed him praying. In the final version he holds the catalogue of the Great Exhibition of 1851, which had been held on a site nearby and with which Albert had been closely connected. The Great Exhibition had been intended to demonstrate Britain's prowess in manufacture and design. Effectively, therefore, we can see the symbolic message as a summary of many of the aspirations of educated Victorian society, aspirations which are associated here with imperial ambitions.

Plate 144 John Bell, model for statue of Prince Albert as a Christian knight, The Royal Archives, Windsor Castle. Copyright © Her Majesty the Queen.

The great frieze of artists is of particular interest to art historians because it sets out the mid-Victorian view of the art-historical canon. The contents have been analysed in detail by Francis Haskell (*Rediscoveries in Art*, pp.11–13). Here I can only note that Pheidias, the sculptor of the Parthenon, is included, as are Poussin and Turner. Raphael is featured, as is Michelangelo, but that is less surprising when we learn that Raphael was a particular favourite of Albert. On the other hand, Constable is omitted, there are none of the Dutch painters such as Vermeer, and the Italian Renaissance artist Sebastiano del Piombo (whose work you will consider in the next case study) does not appear. The list demonstrates what was valued in the 1860s, and it is interesting to compare it with a present-day assessment of western artists from antiquity to the nineteenth century.

The meaning of the monument is specific to its period: today we would question a depiction of Asia that revolved round the figure of India (then a British colony), with China in a distinctly subsidiary position (see Plate 141). Equally, Europe seems to consist only of Britain and France, Germany and Italy, with the status of these countries marked by crowns (see Plate 142). This version of world politics and geography hardly matches present-day reality, but is easier to understand through the colonial mind-set of mid-Victorian Britain. Perhaps that specificity is one reason why this monument has had such a problematic relationship with the canon.

Another difficulty with this elaborate iconographical programme is that the meanings are rather rammed down our throats. Compared, for instance, to Poussin's *Arcadian Shepherds* (Plate 10), there is not a great deal left for our imagination. Instead, we are invited simply to 'read' and admire. There is a determination not to encourage any misinterpretation or alternative views.

We can best understand the Albert Memorial, then, as a mid-Victorian monument. It is also a major work by virtue of its contemporary status, the number of established artists involved, and probably its cost and technical virtuosity. Another valuation states, 'There can indeed be no doubt that the public expect a monument of great and conspicuous magnificence' (*The Builder*, 18 April 1863, p.276). This seems to describe the memorial effectively, and if you enjoy magnificence, its overall character will satisfy you. Yet this 'magnificence' or technical virtuosity may be insufficient to establish a secure place in the western canon. We have seen that such a place requires that an art work meet a whole range of complex criteria, and over time these criteria may change.

Previous case studies have emphasized attempts to define objective standards for beauty as criteria for inclusion in a canon. In the case of the Albert Memorial, it seems to me that political and ideological factors are perhaps more relevant in establishing its long-term value than purely aesthetic ones. Certainly, the aesthetic values of the Victorians are less highly thought of by many critics now than they were at the time. On the other hand, it is possible to argue that there are a number of reasons why this monument ought to hold canonical status: it is a national memorial, in the dominant style, involving leading sculptors and technical virtuosity. However, as we have seen, technical virtuosity alone seems hardly to justify inclusion and the involvement of many artists does not sit well with the status accorded to individual 'genius'. By 1876 the Gothic Revival style was almost outmoded,

so the monument could in no way be seen to be advancing art or as part of a late nineteenth-century avant-garde. The uncertain relationship of a monument so central to nineteenth-century British society is a clear reminder of the problematic nature of the canon itself, and the difficulties that must attend any attempt to establish criteria for inclusion or exclusion.

References

Brooks, Christopher (1995) *The Albert Memorial*, London, English Heritage.

Haskell, Francis (1976) *Rediscoveries in Art: Some Aspects of Taste, Fashion and Collecting in England and France*, Ithaca, Cornell University Press, and London, Phaidon.

Honour, H. and Fleming, J. (1995) *A World History of Art*, 4th edn, London, Laurence King.

The National Gallery's first 50 years: 'cut the cloth to suit the purse'

ANABEL THOMAS

Introduction

In this case study I will explore the origins of the National Gallery in London, showing how many of the paintings now on public display came originally from private collections. I will explain how early acquisitions reflected prevailing tastes among private collectors. I will also show that the original intention was to educate public taste rather than consciously to develop a comprehensive view of Western European art. This case study should help you to examine some of our everyday assumptions about the status and value of art in public collections. More specifically, I hope that after reading it you will understand how the inclusion and display of paintings in a public collection can help us to define the essential qualities of canonical works, and how the presentation and arrangement of works as 'great' art influence our assessment of both their historical and their aesthetic significance. I hope also that you will gain a broad understanding of the extent to which the tastes and preferences of private collectors in nineteenth-century Britain and the influence of financial restrictions combined to form and subsequently to shift public taste.

Keeping up with the neighbours

When the new National Collection of Pictures opened its doors to the public in May 1824, there were fewer than 40 paintings on display. All of these had previously been in the private collection established by the Lloyds insurance broker John Julius Angerstein between 1794 and 1811. The British government was persuaded to set up a new gallery to rival those already established on the Continent, and Angerstein's death and the subsequent availability of his collection presented a perfect opportunity to acquire a ready-made collection for the nation. Britain had been slow in establishing a national gallery. Although the British Museum had been founded in 1753 and the Royal Academy opened in 1768, the foundation of a national collection of paintings lagged behind many of those established on the Continent. During the eighteenth and early nineteenth centuries a number of great art galleries had been established. The Uffizi in Florence (which was based on the collections of the Medici family in Italy) was handed over to the state of Tuscany in 1737, and the Albertina in Vienna opened as a national collection in Austria in 1781. In relatively quick succession the Louvre was established in Paris in 1793; the Rijksmuseum in Amsterdam in 1808; the Prado in Madrid in 1809, and the Kaiser-Friedrich Museum in Berlin in 1830. All these collections had been built up as a result of the continuing patronage of one particular family over a number of centuries. In all but the case of the Uffizi, these patrons were royalty. By comparison with the Louvre, the new national gallery in

Plate 145
Charles Joseph
Hullmandel, *100
Pall Mall exterior,
c.*1830, litho-
graph, 31 x 22
cm, National
Gallery, London.
Reproduced by
courtesy of The
Trustees, The
National Gallery,
London.

London must have seemed a very modest affair. Indeed, there were many
cartoons to that effect in the national press. Not only did the new collection
differ greatly in size and magnificence from its French counterpart, but it
was also displayed in a private house rather than in a lavish palace (Plate
145). And it contained a ludicrously small number of paintings.

Genre and the canon

Plans for the new gallery had not received universal acclaim. In 1822 John
Constable wrote, 'there will be an end of the art in poor old England' (quoted
in Langmuir, *Companion Guide,* p.11). Constable was not just voicing suspicion
of foreign art, which dominated the collection. He also feared that this new
national collection would result in the work of certain artists (rather than
their sources of inspiration: their subject-matter) being set up on pedestals as
models of perfection. There were, of course, many sources of inspiration,
among them the events of the biblical and classical past. And painters of
such subjects – the so-called history painters – might feel no fear about missing
their place on a pedestal. But Constable's own inspiration, natural landscape,
was deemed a less noble muse. Constable understood that for many people
– and particularly the academic establishment – landscape by itself lacked
nobility since it carried no obvious moral or historical message; it gained
significance only when associated with sacred subject-matter or scenes of
heroic deeds. Constable thus feared that the national gallery would reinforce
prejudices against his values.

Some of Constable's contemporaries, among them the academician Joseph Farington, greeted the idea of a new national collection with approval. Farington argued that it could be used for the encouragement of historical painting. It is, of course, relevant that Farington specialized in history painting himself! As we saw in the two case studies on the French and British academies in Part 2, distinctions between different genres (or categories of painting) have always played a significant role in establishing the canon.

In April 1824 £60,000 was made available by a special vote of the House of Commons to purchase 38 paintings from Angerstein's private collection. William Seguier, an art dealer and picture restorer, was asked to make a selection for the nation. Because no other space was available, the pictures were initially displayed in Angerstein's old home at 100 Pall Mall (Plate 145). Seguier was appointed as the gallery's first Keeper, and several months later the Treasury agreed the election of a 'Committee of Six Gentlemen' (who later became Trustees) to undertake the superintendence of the pictures and 'to give such directions as may be necessary from time to time, to Mr. Seguier' (Baker and Henry, *National Gallery Catalogue*, p.x). At this time also much attention was given to the function of the new gallery and the effect the paintings might have on the public. It was generally agreed that public art should both ennoble and educate the spirit and mind.

One of the works acquired for the nation was the huge *Raising of Lazarus*[1] by the Italian painter Sebastiano del Piombo (*c*.1485–1547) (Plate 146). This painting was one of the first to enter Angerstein's collection. Even now it is regarded as one of the most important works in the national collection. One of the reasons for this may be the artist's historical significance. The enduring fame of this painting and its continuing prominence in the gallery's display derive in great part from Sebastiano del Piombo's association with Raphael and Michelangelo, two of the leading artists of the Italian High Renaissance.[2] *The Raising of Lazarus* was probably painted in direct competition with *The Transfiguration of Christ*[3] by Raphael (Plate 147). Both works were commissioned by Cardinal Giulio de' Medici for the cathedral of Narbonne shortly after he was appointed archbishop there by his cousin Pope Leo X. Giulio de' Medici intended that Sebastiano's painting should be a companion piece to Raphael's altarpiece and that both works should hang in the cathedral.

Look at Sebastiano del Piombo's painting (Plate 146) and write down your response to it as a viewer today. For example, do you admire it? If so, what specifically do you admire? Do you understand it? Does it stir you emotionally? Then consider how the painting's translocation (from cathedral to gallery) might influence the viewer's response.

[1] The Christian miracle where Christ raised the dead Lazarus, the brother of Martha and Mary, from the tomb.

[2] The period during the first half of the sixteenth century in Italy when prominent painters such as Raphael gathered to work in Rome.

[3] The event described in the Gospels of the New Testament, where Christ appeared to his disciples as if surrounded by a blazing light or 'glory' in the company of the Old Testament prophets Moses and Elijah.

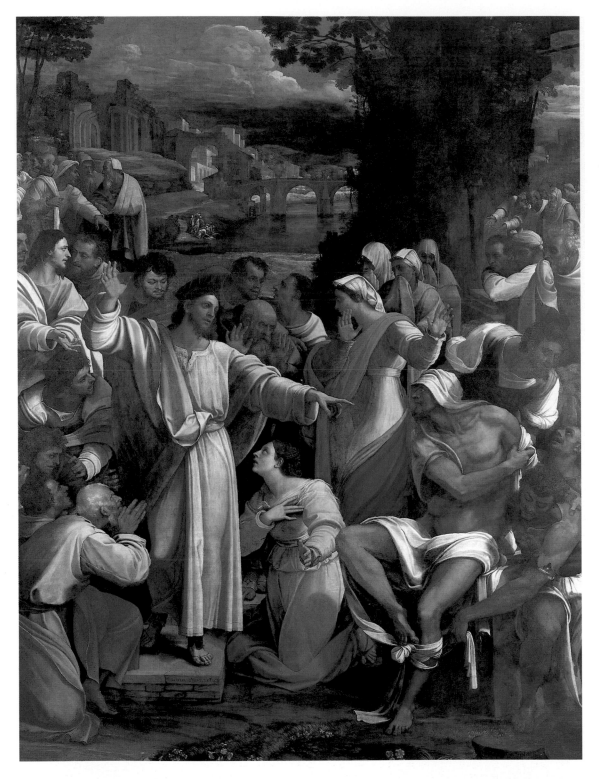

Plate 146 Sebastiano del Piombo, *The Raising of Lazarus*, *c.*1517–19, oil on canvas (transferred from panel), 381 x 290 cm, National Gallery, London. Reproduced by courtesy of The Trustees, The National Gallery, London.

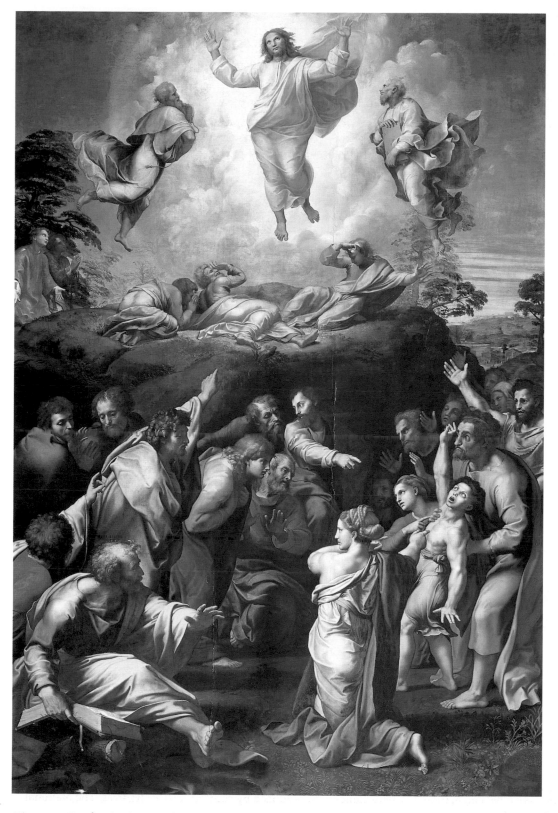

Plate 147 Raphael, *The Transfiguration of Christ*, 1517–20, oil on panel, 405 x 278 cm, Vatican, Pinacoteca, Rome. Photo: Scala.

Discussion

Even though we still recognize Sebastiano's pedigree as an associate of Raphael and Michelangelo, we may feel uncertain about the painting's 'quality' or 'value'. We may not even like it. Our initial reactions as uninformed viewers may be to wonder why it is considered a 'great' painting. Some might argue that it must be so since it is displayed in the National Gallery. Its inclusion on the damasked wall of a public collection is sufficient proof of its artistic value. But it may seem curious that we are now asked to appreciate and respond to an image that began its life in very different surroundings. Such translocation prompts a number of questions. How is it that a painting of this size and subject-matter, which was originally intended for display in the huge space of a cathedral and viewed from a distance under dim lighting conditions, was subsequently considered desirable for the domestic and personal space of a private collector and after that the walls of a public art gallery? To what extent might the original location have influenced the artist's design or choice of colours and lighting effects? And how does the original location or artist responsible for the work influence the way it is subsequently viewed? In a later age and removed from its original location, Sebastiano del Piombo's painting is shorn of much of its original significance. It may cause interpretative problems if we have different religious backgrounds, or little or no familiarity with the story of the life of Christ. It may even elicit a negative response from those of us who find it alien or overtly didactic in its religious content, though we should not forget that such paintings were originally intended to teach as well as serve as a focus for religious devotion. Individual responses to 'great' works of art can be very revealing. We do not necessarily respond intuitively to, or feel comfortable with, the canon (in the sense of its being an accepted body of works of excellence). Nor do we necessarily like what we respect, or want to decorate our own personal spaces with such art.

◆◆◆

Nineteenth-century responses

We can gain some insight into the response of the nineteenth-century viewer by reading the description of this painting in the 1832 catalogue of the national collection. This concentrates on the technical and historical merits of the painting, describing it as 'the production of an eminent colourist, … admirable for its merits as a work of art, and interesting from the circumstances which are connected with its history' (Ottley, *Descriptive Catalogue*, p.8) The reader is encouraged to view the painting as a great work of art not only because it was produced by a contemporary of Raphael and in the manner of Michelangelo, but also because it depicts a religious event in the edifying style of a history painting. James Dennistoun (one of the individuals who gave evidence to a House of Commons Select Committee on the National Gallery in 1853) was also interested in the painting's pedigree. As a fine example of the 'best age of painting', this work could not fail to elevate public taste (*Report of the Select Committee on the National Gallery*, para.5830).

The 1832 catalogue entry describes the subject-matter in some detail. This is the moment after the miracle, when the spectators' emotions have 'given place to varied feelings of astonishment, reverence, or devotion' (Ottley, *Descriptive Catalogue*, p.9). Clearly, one of the most impressive features for a

nineteenth-century audience (apart from its immense size and the dramatic treatment of light and colour) was the nature of the event depicted. The evidence of another witness to the 1853 Committee, Lord Overstone, indicates that in his view *The Raising of Lazarus* was likely to improve national taste and the moral sentiments of the uneducated classes, although he was also anxious that such an event should be depicted in a dignified manner. He had criticized the purchase of an *Adoration of the Shepherds* which presented the shepherds and the holy family as ordinary people. For Lord Overstone Sebastiano del Piombo's painting would not only have been spiritually uplifting through its subject-matter, but also have added dignity to the event through its depiction of refined and classically robed figures.[4]

Angerstein's purchase of Sebastiano's painting and the selection of the same work for the new collection indicate that it was considered an appropriate example – in terms of historical significance and perceived artistic quality – for both private and public display. (In fact, the Louvre had already offered Angerstein £10,000 in a bid to acquire the painting for themselves.) Sebastiano's perfect pedigree as a landmark of High Renaissance Italian painting along with Raphael and Michelangelo is sufficient to establish his historical significance. Contemporary accounts suggest that quality was perceived in a number of ways. The questioning of James Dennistoun before the 1853 Select Committee indicates that the term reflected the work's overall character (including technique, design and attribution). Yet, when giving evidence to a similar committee in 1857, the writer and art critic John Ruskin appeared to equate quality with 'the noblest efforts of the time' during which the works were produced (*Report of the Site Commission*, para.2450).[5]

Understanding 'great' paintings through the company they keep

Our understanding of a painting is often affected by its position on the wall and the nature of the surrounding display. The size of *The Raising of Lazarus* alone has always guaranteed it a prominent position, whether in the private or public arena. According to Ruskin, such paintings required a room of their own for proper appreciation. An early interior view of the original premises in Pall Mall (Plate 148) shows Sebastiano's painting hanging in a central position but surrounded by a variety of smaller works. Closer inspection shows that these works were painted by a number of different artists from a number of different schools[6] and depicting a number of different scenes. Yet by comparison with *The Raising of Lazarus*, these smaller paintings seem to pale into insignificance. In effect, they provide a framework for Sebastiano's painting, which gains significance by becoming a central focus point in the

[4] The 1832 catalogue entry for *The Raising of Lazarus* and extracts from Dennistoun's and Overstone's evidence are included in Edwards, *Art and its Histories: A Reader*.

[5] An extract from Ruskin's evidence is included in Edwards, *Art and its Histories: A Reader*.

[6] A term used to distinguish artists in different periods and countries.

wall's display. It must have been difficult to position this painting in the comparatively small spaces of Angerstein's private house. It was, after all, designed to hang in a cathedral, and Angerstein's public reception room could not vie with the breadth and height of such a structure. Even the interior spaces of a public gallery can bear little comparison with the size and grandeur of its original location. The size of a painting inevitably influences the display of other works in the collection. If the display area is limited, there is usually not enough room to hang more than one large painting on any one wall. Such isolation immediately indicates the significance of a work even before we look closely at it.

The Raising of Lazarus does in fact claim our attention when we enter Room 8 in the National Gallery today (Plate 149). It also creates an important vista for anyone approaching from the Wohl Room to the north (Plate 150). In its original function as an altarpiece, the aim was no doubt to awe and silence the viewer with the sombre thought of death. Displayed in a public gallery with other paintings of the sixteenth century, it is presented in a different guise as the most significant example of the High Renaissance and Mannerist[7] period in that room. Yet, significantly, some visitors spend more time looking

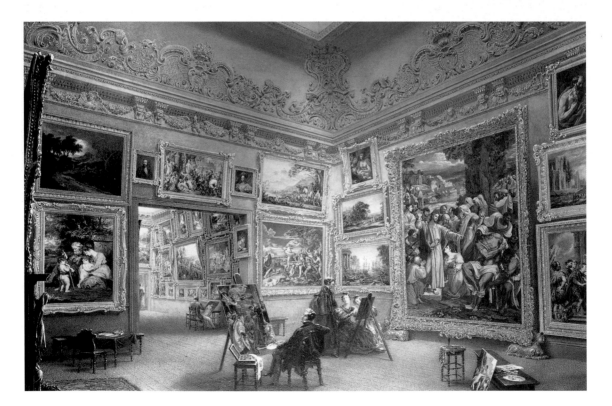

Plate 148 F. Mackenzie, *The Principal Rooms of the Original National Gallery*, *c*.1830, watercolour, 47 x 63 cm, Victoria and Albert Museum, London (exhibited Old Watercolour Society, 1834).

[7] The term now applied to those paintings produced mainly in Italy during the sixteenth century which displayed distorted or 'mannered' proportions, gestures and colours.

at the smaller paintings displayed around it. These appear easier to engage with, partly because of their size and partly because they can be 'read' from close quarters. When asked about the education of the working classes in art, and whether comparatively uneducated people preferred art before or after the time of Raphael, Ruskin claimed that the love of detail was what most caught their imagination. Ruskin might therefore have argued that the paintings which now surround Sebastiano's are easier to appreciate. Adequate viewing of Sebastiano del Piombo's painting requires us to stand back some distance from it, thus losing the detail. *The Raising of Lazarus* is not a painting we engage with closely. Nor was it apparently the most popular painting during the collection's early history. When evidence was given to a Select Committee of the House of Commons in 1841, an attendant reported that it was *The Infant Saint John with the Lamb* (Plate 151) and *The Good Shepherd* by the Spanish artist Bartolomé Esteban Murillo (1617–82) that were the 'greatest favourites' with the public.

Plate 149 Room 8 at the National Gallery, London. Reproduced by courtesy of The Trustees, The National Gallery, London.

Plate 150 Ground plan of the main floor of the National Gallery, London. Reproduced by courtesy of The Trustees, The National Gallery, London.

Plate 151 Bartolomé Esteban Murillo, *The Infant Saint John with the Lamb*, 1660–5, oil on canvas, 165 x 106 cm, National Gallery, London. Reproduced by courtesy of The Trustees, The National Gallery, London.

Do we like what is good for us?

The kind of small 'animal genre' painting represented by Plate 151 became increasingly popular with new middle-class collectors during the later nineteenth century, perhaps because it caught their emotions on the simplest level of touch and sentiment. Murillo's Saint John embraces a soft animal, as any young child might be expected to cuddle a pet. It is an easy image to view because of its size and because it poses no great problems of interpretation. Our emotions are engaged but we are not intellectually challenged in order to understand the image. Perhaps such images offered the 'uneducated' viewer relaxation after the moral education and dramatic gestures of history painting.

During a statistical survey of taste or personal preference in the field of literature, music, film and art collated by two academics in the Department of Psychology at Leicester University in 1995, people were asked to construct a list of those works which they considered the 'best' and the 'best loved'. Significantly, Michelangelo's Sistine Chapel paintings were voted the 'best' or 'greatest', but his work was not the 'best loved'. Nor, it seems, would most people like to have reproductions of his work to decorate their own private spaces. The preference was rather for a nineteenth-century French Impressionist painting or a Constable landscape. One conclusion which could be drawn is that although we realize we are in some way improved by viewing works which are accepted as 'great' or edifying, we may not enjoy looking at such art. There is an important distinction to be made between what people feel might be edifying and/or instructive, and what they actually feel comfortable with. There are also links to be made between Victorian views extolling the virtues of hard work with its concomitant spiritual gains, and expectations by the establishment that the new national collection should both ennoble and educate. In this respect, the choice of Sebastiano del Piombo's *Raising of Lazarus* for the national collection must have seemed entirely appropriate.

Is 'great' art good for us?

Please read the two statements below. The first was included in evidence submitted to a Parliamentary Commission in 1857. The other is an extract from the *National Gallery Complete Illustrated Catalogue* published in 1995. What evidence do they provide of shifting attitudes to the purposes of a national collection?

> The existence of the pictures is not the end of the collection, but the means only to give the people an ennobling enjoyment.
>
> (Quoted in Langmuir, *Companion Guide*, p.12)

> Alone among the great national collections of Europe, the National Gallery was formed not by making public a royal collection, but by a decision of Parliament to provide great pictures for the enjoyment of all.
>
> (Baker and Henry, *National Gallery Catalogue*, p.x)

Discussion

One stresses ennoblement through art, while the other emphasizes enjoyment.

◆◆

During the nineteenth century clear distinctions were made between work and leisure, duty and pleasure, the intellect and the emotions. Although many of the public statements about the new gallery anticipated that members of the public would welcome the opportunity to see great works of art, the emphasis was almost entirely on the learning potential offered by a display of this kind. When Ruskin was asked the answer to the question most frequently put to him – 'What do you want to teach us about art?' – he referred to one of his prized possessions, the painting known as the *Ruskin Madonna* (Plate 152), as a perfect model for the moral education of ordinary working people. Ruskin believed that this image of the Virgin kneeling in reverence in front of her newborn child was significant for its illustration of the supreme virtues of obedience and humility that one might hope to find in the perfect woman. The *Ruskin Madonna* depicts the Virgin as a woman who listened to the word of God, pondered its meaning, and obeyed its command. The painting thus emphasizes the virtues of humility, understanding and obedience so revered by the Victorians. For a nineteenth-century philanthropist like Ruskin, the educational properties of such a painting were clear.

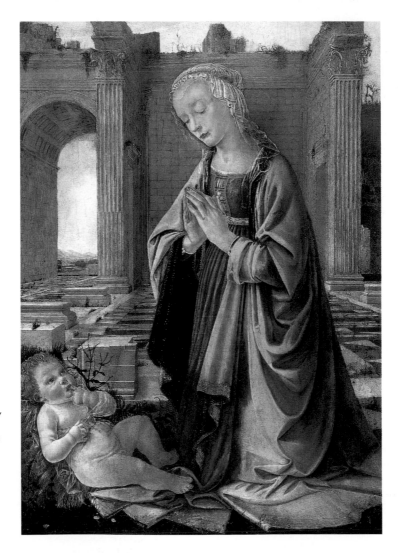

Plate 152
Sometimes attributed to the workshop of Andrea del Verrocchio, *Madonna and Child* (also known as the *Ruskin Madonna*), late fifteenth century, tempera on canvas transferred from panel, 107 x 76 cm, National Gallery of Scotland, Edinburgh.

Ennoblement and education were not the only nineteenth-century expectations. Parliament also envisaged a collection of paintings which would appeal to many different people. In 1833 *Lo Studio* (an analytical journal of the fine arts) carried an article pointing out the benefits of the new gallery for all people including 'the working classes of the metropolis' who were intent on 'intellectual improvement'. Likewise, when asked for his opinion concerning the proposal to purchase two paintings by the sixteenth-century Italian Correggio, the artist David Wilkie wrote that the *Ecce Homo* and *Mercury Teaching Cupid* would be most desirable acquisitions 'whether to interest the Public in the higher purposes of Art, or to guide the taste of the student' (National Gallery Archives, Minutes, February 1834). Art students were considered important members of the viewing public, not least because it was believed that their own art would benefit from the study of Old Master paintings, and in reflecting these would educate future generations. For some the collection was to offer an even more immediate advantage. Study of the nation's paintings, it was argued, could so improve industrial design that manufacturing trade itself would be transformed, leading to a noticeable boost in British exports. The new collection would rebuff foreign competition.

Other contemporary reports indicate that the new collection was considered beneficial even for those who would spend little time studying it. Addressing the Parliamentary Commission in 1857, Mr Justice Coleridge stated that the collection should be for those who were 'not rich enough to form collections of their own and who did not have a vast amount of time to look at them' (*Report of the Site Commission*, Appendix III, no.1, p.167). Further reference was made to a 'large class of persons very moderately acquainted with art, very desirous of knowing more, very much occupied in business, who have occasionally an half-hour or hour of leisure, but seldom a whole day' (quoted in Langmuir, *Companion Guide*, p.12). The emphasis here was not so much on the ennobling of the spirit but rather on broadening the working person's everyday experience. This was where ordinary working people could come, even if only for a short time, and experience art. It was anticipated that this alone would have a profound effect on their lives, since they could not fail to learn something from their viewing, even if it was only that these paintings constituted an important part of their national heritage. It could be argued that the National Gallery continues to function in a similar way today.

Private and public taste: what's the difference?

Early statements show that the original nucleus and works acquired thereafter (many of them also from private collections) immediately assumed a different character. They were no longer the paintings that Angerstein or another private collector had bought; they were invested instead with a national and public significance. Nevertheless, the original nucleus is significant for what it reveals about Angerstein's private taste and the extent to which this reflected a preference for seventeenth-century art, and in particular paintings from France and Italy in the classical style. No work was dated earlier than 1500, and there was only one example of contemporary British art (David Wilkie's *Village Holiday* of 1809–11). Thus in acquiring part of Angerstein's private collection, the new gallery offered a selection of Old Masters made up almost entirely of 'classicizing' artists like Claude and Poussin. Members of the

Carracci family were also favoured – demonstrating a preference for the academic style of late sixteenth-century painting in Italy. It is also significant that paintings by Claude were valued by Seguier at consistently high sums. But the highest valuation of all (£8,000) was allotted to Sebastiano del Piombo's *Raising of Lazarus*, placing it in the category of one of the four most valuable paintings in the world at that time.

Although the original selection included works from a number of different schools, a comparatively small number of artists (only sixteen) were represented. One conclusion we might draw is that the taste of early nineteenth-century private collectors had a narrow base. Significantly, the narrow base of Angerstein's collection was not radically broadened during the early history of the national collection. Over a decade after its opening, nearly half of the collection consisted of works produced by only thirteen artists.

Private taste continued to exert its influence during the early years of the national collection's development, when bequests exceeded purchases in a most dramatic manner. When the collection was first presented to the public, no clear financial policy had been devised concerning its future. Funds were only allocated for the purchase of works when specific requests were put to the Treasury, and in the event sale prices were often deemed unacceptably high. It was clearly easier, and in many ways preferable, to rely on private donations. The result was a haphazard and unstructured expansion with a bias in favour of only a few artists. Moreover, decisions on purchases were 'in the hands of enthusiastic amateurs among the Trustees or of those with an interest in the fine arts who held government office during the first twenty-five years of the Gallery's life' (Baker and Henry, *National Gallery Catalogue*, p.xii). As a result, the collection developed according to the taste of individuals rather than as a result of a rational educational or art-historical plan. Public taste during the early nineteenth century was thus influenced by the individual whims and artistic preferences of those private collectors who subsequently made bequests to the nation. In many ways it was a collation of rich men's views.

Because of the relatively modest dimensions of Angerstein's house and the financial restrictions under which the new gallery operated, the only practical way forward was to establish a sizeable collection of (preferably small) paintings as quickly and cheaply as possible. Eventually this haphazard acquisition policy attracted a great deal of criticism, which led to the foundation of an annual purchasing grant from Parliament. But for the first twenty years authorship, subject-matter and quality took second place to size, expectation of bequests and available purchasing funds.

One of the 'Committee of six Gentlemen' appointed in July 1824 was Sir George Beaumont. Like Angerstein, he played an important role in fashioning the look of the new collection. Beaumont had a strong personal interest in the new gallery since he had always intended leaving his own collection to the nation. Beaumont first offered his paintings to the British Museum, but as plans for the erection of the British Museum building dragged on, the premises in Pall Mall emerged as an alternative exhibiting space. In 1826 Beaumont changed his earlier decision, and his paintings were removed from his private house to 100 Pall Mall.

Beaumont's bequest included works by the Flemish artist Peter Paul Rubens (1577–1640) (*An Autumn Landscape with a View of Het Steen in the Early Morning*, Plate 153) and the Italian painter Canaletto (1697–1768) (*The Stonemason's Yard*, Plate 154). It complemented the original Angerstein nucleus in a number of ways. The emphasis on religious imagery and mythological scenes in Angerstein's paintings was lightened through the addition of Beaumont's genre[8] scenes and landscape views. But, as with the original nucleus, this bequest reflected the private preferences of one collector. As our discussion of Angerstein suggests, private collectors at that time tended to select what they liked or were advised to buy with an eye both to quality and to investment. By contrast, works acquired and displayed for public consumption were invested with certain moral dimensions. But the transformation of a private collection into a public display inevitably carries with it a resonance of the previous owner which, as argued above, plays a great part in fashioning public taste. Sir George Beaumont's works were the first to shift the existing canon represented by the new national gallery established by Angerstein's collection. But other bequests contributed to further shifts in artistic taste. The 1831 Holwell Carr bequest, for example, not only contained an important example of the Venetian High Renaissance in *Saint George and the Dragon* (Plate 155) by Tintoretto (1518–94),[9] but also contributed to the collection's genre painting with *A Woman bathing in a Stream* (Plate 156) by the Dutch artist Rembrandt (1606–69).

Plate 153 Peter Paul Rubens, *An Autumn Landscape with a View of Het Steen in the Early Morning*, probably 1636, oil on panel, 131 x 229 cm, National Gallery, London. Reproduced by courtesy of The Trustees, The National Gallery, London.

[8] Genre is understood here to mean everyday scenes of domestic and public life.

[9] As we saw in Case Study 3, the Venetian school of painting was held to place dazzling colour and texture above the more 'intellectual' aspects of line and composition associated with the Florentine school which influenced artists like Raphael and Michelangelo.

Plate 154 Giovanni Antonio Canal (known as Canaletto), *Venice: Campo S. Vidal and Santa Maria della Carità* (also known as *The Stonemason's Yard*), 1726–30, oil (identified) on canvas, 124 x 163 cm, National Gallery, London. Reproduced by courtesy of The Trustees, The National Gallery, London.

Plate 155 Jacopo Tintoretto, *Saint George and the Dragon*, probably 1560–80, oil on canvas, 158 x 100 cm, National Gallery, London. Reproduced by courtesy of The Trustees, The National Gallery, London.

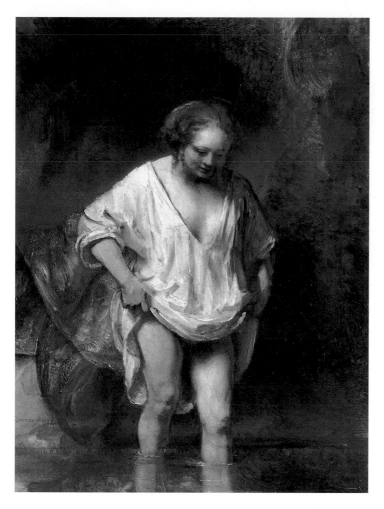

Plate 156 Rembrandt van Rijn, *A Woman bathing in a Stream (Hendrickje Stoffels?)*, 1654, oil (identified) on panel, 62 x 47 cm, National Gallery, London. Reproduced by courtesy of The Trustees, The National Gallery, London.

Looking British

Among the many bequests were an increasing number of British works. One such donation was Constable's (1776–1837) *The Cornfield* (Plate 157), which entered the collection in 1837. By the 1850s British art was firmly established within the collection. In 1847 Robert Vernon left his entire collection of British art to the nation, and a few years later, in 1856, an important addition was made when J.M.W. Turner bequeathed his paintings to the nation. The mere fact that such work was displayed upon the walls of the new gallery gave it an acceptability that influenced the reactions of the visiting public. Thus, despite Constable's initial fears, native artists retained their pedestals and an increasing number of pure landscape views and natural scenes were displayed, encouraging an appreciation of varying qualities of light and broken patches of colour, and preparing the public taste for the dramatic developments of later nineteenth-century French painting.

Plate 157 John Constable, *The Cornfield*, 1826, oil on canvas, 143 x 123 cm, National Gallery, London. Reproduced by courtesy of The Trustees, The National Gallery, London.

Looking Italian

Purchases and acquisitions during the second half of the 1850s also revealed a trend towards the Italian primitives[10] and early Renaissance artists. Paintings from the High Renaissance period had clearly been regarded as of canonical significance from the outset. Angerstein's own collection contained a portrait of Pope Julius by Raphael. And as early as 1835 statements in favour of the purchase of works by Raphael were presented to a Select Committee on 'Arts and their Connexion with Manufactures'. Dr Gustave Waagen, Director of the Berlin Gallery, argued that such works could have 'a great influence in forming the taste in the best manner, and in inculcating the best principles of art' (*Report of the Select Committee on Arts*). A few years later, what is now regarded as a supreme example of the Renaissance – Raphael's *Saint Catherine of Alexandria* (Plate 158) – was acquired for the nation.

[10] The term 'primitive' was commonly used during the nineteenth century for all those works produced in Italy during the fifteenth century or earlier. Renaissance was the term more commonly used for works from the sixteenth century.

Plate 158 Raphael, *Saint Catherine of Alexandria*, *c.*1507–8, oil on panel, 72 x 56 cm, National Gallery, London. Reproduced by courtesy of The Trustees, The National Gallery, London.

However, haphazard and piecemeal development attracted increasing public criticism until finally, in 1853, a Select Committee of the House of Commons was set up to review the whole situation. Art critics such as John Ruskin voiced particular dissatisfaction with acquisition policy. Ruskin had already criticized the gallery in a letter to *The Times* in January 1847 in which he expressed concern at the number of canvases by the Bolognese painter Guido Reni (1575–1642) acquired between 1840 and 1844. Ruskin had a complete disregard for the Bolognese school, which he described as a 'feeble and fallen school', and in particular Guido Reni, who in his view was a 'bad master' (quoted in Holmes and Baker, *Making of the National Gallery*, pp.16–20). Ruskin also questioned the attribution and quality of many of the paintings selected for the national collection, describing the National Gallery as 'an European jest, her art a shadow and her connoisseurship an hypocrisy'. There may have also been a sexual subtext. Ruskin was obviously shocked by Reni's overt depiction of the aged Lot's impending seduction by his two daughters (Plate 159) and the underlying sexual blackmail in *Susannah and the Elders* (Plate 160). For Ruskin, neither of these two stories offered any kind of edifying education either for the male or the female. They had 'no single virtue, no colour, no drawing, no character, no history, no thought'. Victorian propriety clearly underlines such sentiments.

Plate 159 Guido Reni, *Lot and his Daughters leaving Sodom*, *c.*1615–16, oil on canvas, 111 x 149 cm, National Gallery, London. Reproduced by courtesy of The Trustees, The National Gallery, London.

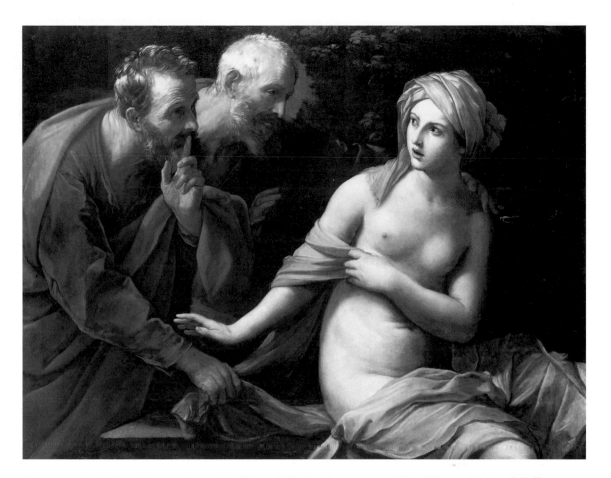

Plate 160 Guido Reni, *Susannah and the Elders*, 1620–5, oil on canvas, 117 x 151 cm, National Gallery, London. Reproduced by courtesy of The Trustees, The National Gallery, London.

But Ruskin not only rejected the prevailing taste for Guido Reni and other members of the Bolognese school of painting; he was also concerned about the balance and quality of the collection itself. What was the point of adding yet another Rubens when already there was a room full of his work? And why make such purchases when so many works by the early Italian artists remained to be bought?

The return of the primitives

One of the main criticisms voiced at the 1853 Select Committee concerned the absence of Italian primitives. This was to profoundly affect the development and nature of the national collection. Some of what are now considered to be the most beautiful and valuable paintings on display would not have entered the collection had this shift in artistic taste not occurred. Ironically such acquisitions were once again influenced more by finance than artistic expectations. Italian primitives were particularly 'easy' to acquire at that time: both easy to find and comparatively cheap to buy. Indeed, Ruskin claimed that such paintings were perishing as a result of their 'invisibility and ill-treatment' (quoted in Holmes and Baker, *Making of the National Gallery*, p.20).

When Charles Eastlake became first Keeper and then Director in 1855, he was given clear instructions to acquire only the best works (in other words, technically of the highest quality and in addition reliably attributed). Preference was to be given to 'fine pictures for sale abroad' and good specimens of the Italian school, including those of the earlier masters. Sir Charles Eastlake is now remembered for the central role he played in expanding the canon to include the early Renaissance. From 1855 onwards, he and his overseas agent Otto Mündler were responsible for seeking out such works, negotiating their purchase, and finally presenting them as new acquisitions. During Eastlake's period as Director, some of the finest examples of early Italian Renaissance painting from the fifteenth century were acquired for the nation. Among these were Piero della Francesca's (*c*.1415–92) *Baptism of Christ* (Plate 161) and the collection of early paintings bought from the Lombardi-Baldi collection,[11] including *The Adoration of the Kings* (Plate 162) by Sandro Botticelli (1446–1510) and Paolo Uccello's (1397–1475) *Battle of San Romano* (Plate 163).

Plate 161 Piero della Francesca, *The Baptism of Christ*, 1450s, 167 x 116 cm, tempera (identified) on panel, National Gallery, London. Reproduced by courtesy of The Trustees, The National Gallery, London.

11 The Lombardi-Baldi collection was a private collection in Florence.

Plate 162 Sandro Botticelli, *The Adoration of the Kings*, *c*.1470, tempera on panel, 50 x 136 cm, National Gallery, London. Reproduced by courtesy of The Trustees, The National Gallery, London.

Plate 163 Paolo Uccello, *The Battle of San Romano*, probably *c*.1450–60, tempera on panel, 182 x 320 cm, National Gallery, London. Reproduced by courtesy of The Trustees, The National Gallery, London.

During these same years Eastlake made annual journeys to the Continent, travelling from country to country, from town to town, from public art gallery to public art gallery, from private collection to private collection and from church to church in search of high-quality works (in other words, paintings in good condition and by well-known artists) at reasonable prices. In each place he filled his travelling notebook with countless details, commenting on the technical expertise and condition of the works he saw and on the reliability of existing attributions, balancing one work against another in terms of its authenticity or artistic quality. At the same time, he noted the particular characteristics of individual artists as an aid in verifying future attributions. Clearly he was operating both as a connoisseur and as an art-historical researcher. A new era of order was in the making.

The northern European acquisitions

Eastlake was just in time to catch the European market in early fifteenth-century Italian painting. But he found it increasingly difficult to stay within the budget set by Parliament. By the mid-1850s collectors elsewhere were also looking out for good examples from the 'primitive Italian school'. Competition for purchases abroad became increasingly fierce: Eastlake frequently referred to his 'luck' in finding a particular work to add to the collection. Inevitably such competition influenced the ever-shifting canon. Having established the credentials of Italian primitives, collectors began to look elsewhere when such paintings became scarce. There is an indication of this in the purchase of the Edmond Beaucousin collection in 1860. Beaucousin's collection reflected a new interest in early Flemish painting. Later artists from this school were already present in Angerstein's collection (which contained four Van Dycks and one Rubens). What is now regarded a key work was acquired when Sir George Beaumont donated Rubens's *Autumn Landscape with a View of Het Steen* (Plate 153). But these works all belonged to the sixteenth and seventeenth centuries. Neither Beaumont nor Angerstein had apparently felt drawn to works of the fifteenth century.

Although early Flemish painting played little part in the formation of the British canon during the first half of the nineteenth century, there was a growing interest in such works throughout the 1860s, possibly, as already suggested, because other works were becoming more scarce. But it is also possible that royal or aristocratic taste played a part in this shift. In 1863 Queen Victoria bequeathed to the nation a number of Flemish paintings which had been purchased by Prince Albert, and which were at his express command to be displayed in the national collection. Among these were three religious works attributed to Dieric Bouts (1400?–75) (Plates 164–166).

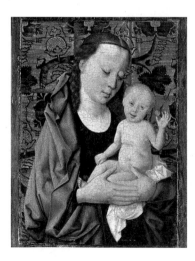

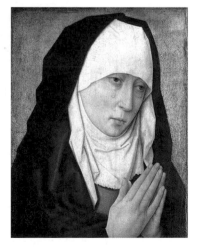

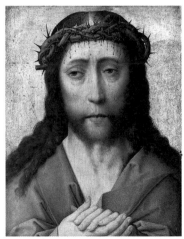

Plate 164 Dieric Bouts, *The Virgin and Child*, c.1460, oil on panel, 20 x 15 cm, National Gallery, London. Reproduced by courtesy of The Trustees, The National Gallery, London.

Plate 165 Workshop of Dieric Bouts, *Mater Dolorosa*, probably 1475–1500, oil on panel, 37 x 27 cm, National Gallery, London. Reproduced by courtesy of The Trustees, The National Gallery, London.

Plate 166 Workshop of Dieric Bouts, *Christ Crowned with Thorns*, probably 1475–1500, oil on panel, 37 x 27 cm, National Gallery, London. Reproduced by courtesy of The Trustees, The National Gallery, London.

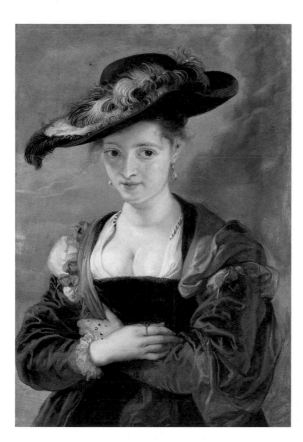

Plate 167 Peter Paul Rubens, *Portrait of Susanna Lunden (?)* (also known as *Le Chapeau de Paille*), probably 1622–5, oil on panel, 79 x 55 cm, National Gallery, London. Reproduced by courtesy of The Trustees, The National Gallery, London.

All three works had been purchased by Albert from the German collection of Prince Ludwig Kraft Ernst von Oettingen-Wallerstein as early as 1851. And Prince Ludwig had himself acquired them over 30 years previously. Before that all three works had been in the collections of aristocrats. Clearly, early Flemish art had been popular in private aristocratic collections on the Continent well before the formation of Angerstein's collection in England at the end of the eighteenth century.

Once having turned their attention to northern art of the fifteenth century, the British establishment began also to look with a new eye at seventeenth-century paintings of the Dutch and Flemish schools. An interest in later Dutch art was particularly noticeable under William Boxall, who succeeded Eastlake as Director in 1866. The purchase of Sir Robert Peel's collection in 1871, for example, revealed the first consistent desire for seventeenth-century Netherlandish art, since all 77 pictures had been painted by northern artists. Among Peel's pictures were Rubens's *Chapeau de Paille* (Plate 167) and *The Avenue at Middelharnis* (Plate 168) by Meindert Hobbema (1638–1709).

Seventeenth-century Dutch painting had, in fact, been fashionable in private collections since the mid-eighteenth century, and many other acquisitions after the purchase of the Peel paintings show similar tastes. An example of this was the Wynn Ellis collection, which was bequeathed to the gallery in 1876. This collection consisted of over 400 paintings, many of which were by Dutch artists.

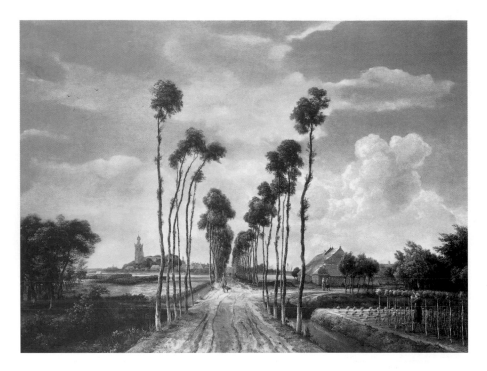

Plate 168 Meindert Hobbema, *The Avenue at Middelharnis*, 1689, oil (identified) on canvas, 104 x 141 cm, National Gallery, London. Reproduced by courtesy of The Trustees, The National Gallery, London.

Conscious order or contained chaos?

With each new acquisition there was increasing pressure on the existing display space. Lack of space was a problem throughout the gallery's early history. A constant refrain was that the Pall Mall premises were suitable only for small or moderately sized works. Sebastiano del Piombo's *Raising of Lazarus* already took up a disproportionately large amount of space, and it was argued that there was not enough room to display any other works of that size. Ten years after the opening of Angerstein's house to the public, the newly established gallery was moved to new – but once again rather small – premises at 105 Pall Mall, since it was clear by that time that 100 was far too small to house the ever-expanding collection. But 105 was little improvement: the space was again cramped and there was widespread anxiety about insufficient fire protection. There was a growing realization that the nation's pictures needed a new exhibiting space where they could be attractively displayed and comfortably viewed. The obvious answer was a purpose-built gallery. A new building was discussed with the architect William Wilkins in 1831, but work did not start on the project until 1833. Four years later the new Wilkins building was complete, and in December 1837 the nation's paintings were finally moved to Trafalgar Square. The building at that time was only one room deep. It was also divided into two halves, one end being occupied by the Royal Academy. An uneasy relationship existed between these two institutions until 1868 when the Royal Academy moved out, voicing dissatisfaction about the lack of space and establishing itself instead at Burlington House in Piccadilly. Even after expanding into the space left empty

by the Royal Academy, the Trustees were arguing that the Wilkins building could not accommodate all the newly acquired paintings. Thus plans were eventually put forward for an entirely new building, and this project was offered to the architect E.M. Barry.

Although Barry was initially asked to rebuild the Trafalgar Square site, he subsequently only designed a new east wing. This extension, which was built between 1872 and 1876, includes the domed hall (room 36 in Plate 150) and the four adjoining spaces to the north-east of the Wilkins building (rooms 35, 37–40 in Plate 150). This new space was to have a radical effect on the display of the nation's pictures. Despite earlier resistance to what became known as the art-historical[12] method of museum display, the departure of the Royal Academy in 1868 and Barry's additions to the Wilkins building the following decade opened the way for reform from 'chaos' to 'order'.

Before the eighteenth century, paintings were often crowded together on walls in a tapestry or mosaic-like effect, their arrangement governed by size, colour and subject-matter rather than according to any specifically historical context. But a new interest in the history of art governed the display of collections from the 1750s onwards. When the Viennese royal collection was reinstalled in the Belvedere Palace in Vienna in 1776, paintings were chronologically divided into national schools. Similar arrangements already existed in Florence and Dusseldorf. By the nineteenth century the art-historical method of display was well established on the Continent and was indeed discussed by both the 1853 and 1857 Select Committees on the National Gallery. But display in Britain remained obstinately ahistorical. When the national collection first opened, its pictures were traditionally hung in a completely haphazard manner. Moreover, classification of the collection during the early years emphasized its development in terms of its physical growth rather than any art-historical profile.

Attempts at classification and display

One of the earliest catalogues (published in 1832) divided the collection into four discrete parts: the works acquired from Angerstein's executors, the collection presented by the late Sir George Beaumont, additional pictures whether presented by individuals or purchased by the government, and the collection bequeathed by Rev. William Holwell Carr. The 107 paintings owned by the gallery in 1832 were listed in numerical order according to the numbers which were attached to the pictures themselves. Thus Richard Wilson's *Landscape with the story of Niobe* headed the list, followed by paintings by David Wilkie and William Hogarth; Titian's *Bacchus and Ariadne* (currently number 35) is listed last as number 107. Sebastiano del Piombo's *Raising of Lazarus* is listed as number 102 (this was subsequently changed in the late 1830s to its present number 1).

The numbering system adopted in the early 1830s obscured both the provenance[13] of the paintings and the order in which they entered the

[12] A method of display where paintings are arranged by school and in chronological order.

[13] The provenance of a work concerns the circumstances surrounding its original production and its subsequent history of ownership.

collection. Since *The Raising of Lazarus* is listed together with Van Dyck's *Emperor Theodosius* and Claude's *Embarkation of Saint Ursula* – as they in fact appear in Mackenzie's view of about the same date (see Plate 148) – we can assume that the 1832 list reflects the order in which the paintings were arranged on the walls. From this it seems that there were some extraordinary juxtapositions. The eighteenth-century English Sir Joshua Reynolds's *Lord Heathfield* was hung next to a *View of Venice* by the seventeenth-century Italian Canaletto; the sixteenth-century Italian Titian's *Adoration of the Shepherds* was flanked by the seventeenth-century Flemish Rubens's *Peace and War*. Apparently neither period, national school, subject-matter, size, provenance nor year of entry into the collection governed the display. Yet when Eastlake drew up a list of 'Observations on the unfitness of the present building for its purpose' in 1845, he noted that the first two rooms, which were far too small, were always crowded partly because they were 'the first of the suite' and also because 'popular pictures such as the works of Hogarth, Wilkie, Lawrence and others' were displayed there (National Gallery Archives, Eastlake, 'Observations', p.4). These rooms always suffered congestion because their doors opened on to the corridor leading from the main entrance staircase where the public both entered and left the gallery.

Eastlake was also acutely aware of the lack of balance of the collection with its emphasis on foreign paintings. His hope was that if the display space was expanded, particular attention could also be paid to 'the best works of the British school'. A year later Verax[14] (the pseudonym of the artist Morris Moore) publicly criticized the display of the national collection in a letter to *The Times*. Verax complained that the finest picture, Sebastiano del Piombo's *Raising of Lazarus*, was hung in the 'very worst light' while a 'poor' but 'expensive' one was hung in the best. Verax complained that elsewhere in the gallery an entire wall was reserved for some inferior works from a recent bequest while masterpieces such as Titian's *Rape of Ganymede* (now attributed to Damiano Mazza) and *A Concert* (now attributed to a follower of Titian) were 'thrust into dark corners' or hung impossibly high. How long, Verax asked, were the Lawrences and the Wests to remain 'as monuments to our ignorance and conceit, whilst so many good pictures require their room' (quoted in Holmes and Baker, *Making of the National Gallery*, p.16)?

To do him justice Eastlake had himself complained about displaying paintings above eye level, at the same time observing that it was not desirable to cover every blank space and at any height 'merely for the sake of clothing the walls, and without reference to the size and quality of the picture' (National Gallery Archives, Eastlake, 'Observations', p.7). Although he made no overt reference to school or period, Eastlake clearly favoured a hang[15] which allowed comparison of style, technical merit and scale. He was also in favour of large paintings or paintings with large figures being placed in large rooms, with perhaps smaller paintings by the 'Italianate masters' being clustered together beneath. He also distinguished national styles sufficiently to advise against placing small Dutch or Flemish paintings too far away from the source of

14 Meaning truth of speech in Latin.

15 A 'hang' is shorthand for the positioning of paintings on exhibition walls.

light. Cabinet pictures,[16] he argued, required 'a strong light to exhibit their delicate gradations of chiaroscuro,[17] and the beauties of their execution'. This suggests a very sensitive response to individual works within the collection.

Critics of the art-historical display argued that this method prevented the viewer from engaging in any meaningful response with the works themselves. A visitor to the Belvedere collection in Vienna in 1785 claimed that this arrangement attracted only those intent on seeing a display of the history of art. The more discerning or 'sensitive' viewer should, in his view, keep away. Art-historical display at that time demanded an array of paintings attributed to key figures and arranged in chronological order. But, according to this viewer, such biographical constraints did not necessarily result in the acquisition or display of works of the finest technical expertise or best condition. A mediocre Raphael (in other words, a workshop product[18] or a less well-preserved example of that master's *oeuvre*) was deemed more desirable than the finest product from a less famous or unknown hand. Evidence presented to the Committees of 1853 and 1857 indicates that many critics in England had similar reservations. James Dennistoun's advice was that the National Gallery should 'omit no favourable opportunity of obtaining any monument illustrative of the progress of art in any school, such as pictures authenticated by signature or date' (*Report of the Select Committee on the National Gallery*, para.5901), adding that it was most desirable in the first place to bestow their attention on and dedicate their funds to 'more particularly interesting and valuable examples' (in his opinion, examples from the Italian school of painting).

Although there was an initial resistance to the ordered methodology of art-historical display (prompted in many cases by piecemeal acquisitions and sheer lack of space), the nation's pictures were clearly arranged according to national schools by the end of the nineteenth century. A catalogue of 1904 lists the various schools, and also includes further subdivisions reflecting the chronological development of each school, with subsections concerning particular genres such as portraits, landscapes, animal painters and genre painters. The English school headed the list, followed by the Italians, Flemish, Dutch, German and French. This arrangement reflected national pride rather than the actual strengths of the collection. Angerstein would have been surprised to see his beloved Claudes listed at the end, although he may well have been pleased to see that one of his artistic advisers, Thomas Lawrence (1769–1830), and his six paintings by Hogarth were given prominence at the beginning. This would surely have vindicated his decision to buy the entire series of Hogarth's *Marriage à la Mode* (see Plates 110–11).

The 1995 *Complete Illustrated Catalogue* reflects another trend in classification, that of listing paintings in alphabetical order according to artists' names. The visual experience of trawling through this catalogue is thus in many ways reminiscent of the original display in Pall Mall. Although many other

16 Small easel paintings principally painted by minor Dutch artists during the seventeenth century.

17 The balance of light and shadow.

18 Works of art were commonly produced by small collectives in workshops under a master.

associated catalogues deal with specific schools and periods, the official catalogue in fact reflects traditional methods of display rather than the art-historical sequence introduced with such enthusiasm on the Continent during the second half of the eighteenth century.

Conclusion

In analysing the origins and establishment of the national collection of paintings in London between 1824 and the 1870s, this case study has focused on acquisition and display policies. We have learnt that there was a considerable amount of contained chaos throughout the collection's early history. We have also seen how at this time attention was focused on individual artists and on particular schools of painting, but restrictions on funds and space consistently exercised a negative influence on the purchase of historically significant or over-large paintings. It is worth reflecting on the haphazard nature of this collection's early development given its continuing canonical status.

I would like to conclude with a reference to Cecil Gould's *Failure and Success: 150 Years at the National Gallery 1824–1974* (written in 1974 during his employment as Keeper), which I think encapsulates the problems of the first 50 years. Gould observes that the gallery had the chance to buy *The Dormition of the Virgin* by Giotto (the fourteenth-century Italian artist who is often described as the 'father' of the Italian Renaissance) when it came up for sale in London in 1863. When the painting came under the hammer, Sir Charles Eastlake had already bought four paintings from the same sale (including the Venetian High Renaissance painter Bellini's *Agony in the Garden* and the fifteenth-century Italian Pesellino's *Trinity*). The Pesellino had cost £2,100 – a considerable portion of Eastlake's available funds. Bidding for the Giotto went up to £997 10s., but Eastlake's purse was empty. There was no more cloth to cut. The Giotto was bought in (it did not meet its reserve price at the auction so was not sold) but finally went to the Dahlem Museum in Berlin in 1914. Although the British national collection is now regarded as providing an effective survey of Western European painting from the thirteenth century to the present day, it still possesses only one predella[19] panel attributed to Giotto. Such 'failures' (in the sense of the collection's failing to purchase and thus represent adequately the western canon) illustrate the extent to which the gallery's development was piecemeal and largely determined by chance and restrictions on space and funds. Eastlake's empty purse left one more gap to plug during later years.

[19] A small painting usually containing a narrative scene which is placed together with others below the main panel of an altarpiece.

References

Baker, C. and Henry, T. (1995) *The National Gallery Complete Illustrated Catalogue*, London, National Gallery Publications.

Edwards, S. (ed.) (1999) *Art and its Histories: A Reader*, New Haven and London, Yale University Press.

Gould, C. (1974) *Failure and Success: 150 Years at the National Gallery 1824–1974, a Picture Book*, London, National Gallery Publications.

Holmes, Sir Charles and Baker, C.H. (1924) *The Making of the National Gallery 1824–1924: An Historical Sketch*, London, National Gallery.

Langmuir, Erika (1994) *The National Gallery Companion Guide*, London, National Gallery Publications.

National Gallery Archives, Indexes and Minute Books 1828–1856, 'Observations on the unfitness of the present building for its purpose' in Notebooks and Miscellaneous Notes by Sir Charles Eastlake, London, National Gallery.

Ottley, William Young (1832) *A Descriptive Catalogue of the Pictures in the National Gallery with Critical Remarks on their Merits*, London.

Report of the National Gallery Site Commission, 1857 (1971) Irish University Press series of British Parliamentary Papers, Shannon, Irish University Press.

Report of the Select Committee on Arts and their Connexion with Manufactures, 1835 (1968) Irish University Press series of Industrial Revolution Design, Shannon, Irish University Press.

Report of the Select Committee on the National Gallery with Minutes of Evidence, Appendix and Index, 1852–3 (1970) Irish University Press series of British Parliamentary Papers, Shannon, Irish University Press.

Art in the provinces

EMMA BARKER AND COLIN CUNNINGHAM

Introduction

In this case study we will be concerned with the 'consumption' of art in Britain during the second half of the nineteenth century. A key aspect of this phenomenon was the foundation of art institutions in the 'provinces' which made works of art accessible to many people who would never have the chance to visit the National Gallery in London (or its counterpart in Edinburgh, established in 1850). We will focus here on the example of Manchester, examining a number of different ventures that made works of art available to public view. In particular, we will be concerned with the motivation that lay behind them and the extent to which the choice of works of art did not simply reflect the prevailing canon of European high art (exemplified by the National Gallery) but also took account of local conditions.

First, we need to review the historical background for this growing public access to art. The establishment of public museums and galleries in cities such as Paris and London during the late eighteenth and early nineteenth centuries had already made works of art more widely accessible than they would have been in a royal or aristocratic collection. At the same time, as we saw in the previous case study, it became customary to display art within an overarching system of classification by national school and period. As a result, paintings and sculptures were transformed from being the objects of private delectation to being the means by which the public could be educated in the history of art. Prince Albert, for example, stated in 1853 that the National Gallery in London should 'afford the best possible means of instruction and education in the art to those who wish to study it scientifically in its history and its progress' (quoted in Trodd, 'Culture, class, city', p.40). The fundamental assumption underlying government reports on the gallery was that the study of art could have a civilizing effect on a mass audience.

However, major obstacles existed towards museums and galleries having such an effect. In an age when the working classes had only Sunday free and hours were long, access was effectively restricted to the wealthier sections of society. Although the National Gallery recorded 500,000 visitors in 1841, it was only open to the general public four days a week and never at weekends. Its location in the West End of London also made it increasingly inaccessible to working people as the city expanded to the south and east over the course of the century.[1] The notion that the working classes might benefit from contact with works of art was also in conflict with profound distrust of the poor, who were traditionally believed to be incapable of becoming civilized. Such

[1] It was for this reason that the South London Art Gallery (see p.182) and the Whitechapel Picture Exhibitions (mentioned later in this case study) were founded in other parts of London in the last three decades of the nineteenth century.

fears explain why the British Museum for many years imposed restrictions on access. Its trustees and curators were apprehensive that the unruliness of the mob would distract from the displays. However, attitudes underwent a significant shift after 1850.

A key role was played by the Great Exhibition, staged in a specially constructed iron and glass structure, the Crystal Palace, in London's Hyde Park in 1851. The over 100,000 objects on display were divided into four categories: raw materials, machines, manufactures and fine arts. The exhibition's purpose was to encourage good design and raise the general level of taste in Britain. Over the course of five months it attracted some six million visitors, proving that people were willing to travel long distances to view such displays. More fundamentally, the orderliness of the crowds at the exhibition provided reassurance that the people could be trusted to behave themselves. The Great Exhibition provided the impetus (and funds) for the establishment by the government of the South Kensington Museum in 1857 (later to be called the Victoria and Albert Museum) as part of the Department of Science and Art. It was conceived as a teaching institution, providing examples of good design (mostly in the decorative arts) for the instruction of its visitors. To ensure that the artisans for whom the museum was intended could gain access, it was decided that it should not only have free admission (unlike the Great Exhibition) but also open in the evenings. It was the first museum in Britain to do so and the experiment proved a great success, with evening visitors out-numbering daytime ones five to one.

Although the wide range of objects housed at South Kensington made it a rather different sort of museum from those already mentioned, it can be said to represent a more coherent application of existing aims. As we saw in the previous case study, it had been argued that the National Gallery would not only improve the minds of visitors but also foster advances in industrial design and thus promote exports. Given that the vast majority of the manufacturing in Britain went on outside London, it was only to be expected that the ruling classes should have been anxious to see a geographical widening of access to works of art. The impetus to establish art institutions in the later nineteenth century also needs to be set in the context of a more general concern to educate and moralize the working classes. The sociologist Tony Bennett, for example, views museums as part of an 'exhibitionary complex' which, in ordering objects on display on rational principles (such as the chronological order of art history), simultaneously ordered the people who came to look at them (Bennett, 'The exhibitionary complex'). From this perspective, museums functioned as an instrument of social control, helping to transform a disorderly populace into a self-aware, well-behaved citizenry.

Spreading the net

In 1845 the first Museums Act allowed towns of over 10,000 inhabitants to devote money from the rates to museums, but it was only after 1870, as part of the general expansion of educational provision, that museums and art galleries were founded in large numbers. Until this date, the only examples outside London and Edinburgh were a small group of university museums and private institutions. Many of the early municipal museums started off

without an art collection, mounting temporary exhibitions of contemporary art (as, for example, at Liverpool City Art Gallery, opened 1877). Several showed exhibitions sent by the Department of Science and Art that were intended to educate local craftsmen. At Birmingham Museum and Art Gallery (founded 1867), for example, displays of metalwork were presented in its early years. From the 1880s, museums and galleries were being established all over the country but especially in the wealthy towns and cities of Yorkshire and Lancashire. They were also extremely popular. Giles Waterfield has pointed out that the Birmingham Museum and Art Gallery was attracting 1,300,000 visitors in 1886, when the city numbered less than 500,000 people, while Leeds City Art Gallery (opened 1888), with a population about 400,000, regularly attracted over 250,000 visitors in the 1890s. According to Waterfield, 'the visitors to these new museums appear to have been drawn from the whole population, excepting only the poorest members of society' (Waterfield, *Art for the People*, p.35).

Manchester, our focus in this case study, was one of the great industrial and commercial cities of nineteenth-century Britain. It was the centre of the cotton trade and a major transport nexus. Its population grew from 80,000 in 1801 to 180,000 in 1831, 300,000 in 1851 and over half a million in 1891. In the middle of the century, Manchester became renowned both for its manufacturing wealth and for the terrible deprivation of the working-class population. The affluent middle classes were often depicted as ruthless materialists, indifferent to the plight of the poor and lacking in culture. Ruskin, for example, rebuked them in his Manchester lectures of 1857 for the harshness of their *laissez-faire*[2] economics and insisted that they should try to eradicate poverty. In 1877 he wrote that 'Manchester can produce no good art and no good literature, it is falling off even in the quality of its cotton' (quoted in Rose, 'Culture, philanthropy', p.102).[3]

Over the course of the century, Manchester strove to improve its cultural status. In 1867, for example, it commissioned the building (in the Gothic Revival style) of what was to be the most expensive town hall of the century from the architect Alfred Waterhouse (1830–1905). An ambitious scheme of decoration for the central hall of the new building was subsequently commissioned from the Pre-Raphaelite painter Ford Madox Brown (1821–93), consisting of twelve large murals depicting the history and achievements of the city (we will return to the Pre-Raphaelites later in this case study).[4] The cultural life of Manchester in the later nineteenth century reflected not only the civic pride of its prosperous citizens but also, as we will see below, the concern of at least some of them to bridge the gap between rich and poor. Philanthropy and the various ventures discussed in this case study represent parallel responses to fears that the problems of the urban poor threatened the city's social stability and economic progress.

[2] French for 'let do', *laissez-faire* means the principle of state non-interference with individual action, especially in the economy.

[3] The stereotype of Manchester's philistinism has recently been challenged by a number of scholars, one of whom goes so far as to claim that 'Art was everywhere in Manchester by the mid-nineteenth century' (Seed, '"Commerce and the liberal arts"', p.63).

[4] Although the Pre-Raphaelites are central to the canon of nineteenth-century British art, Brown's Manchester murals are not generally regarded to be among his more successful works. Recently, however, an attempt has been made to reassess them (Barlow, 'Local disturbances').

The Royal Manchester Institution

One of the most important cultural organizations in Manchester through which the newly wealthy citizenry legitimated their status as members of a social élite was the Royal Manchester Institution, founded in 1823. At the inaugural meeting it was resolved:

> That the diffusion of a taste for the Fine Arts in this populous and opulent district by establishing a collection of the best models that can be obtained in Painting and Sculpture, and by opening a channel through which the works of meritorious Artists may be brought before the public, and the encouragement of Literary and Scientific pursuits by facilitating the delivery of popular courses of public lectures, are objects highly desirable and important.
>
> (Quoted in Macdonald, 'The Royal Manchester Institution', p.31)

The architect Charles Barry (1795–1860) was commissioned to design a handsome classical building in the centre of the city to house the Institution's activities and the art collection that it proposed to acquire.[5] The decoration – complete with casts of the Parthenon marbles presented by King George IV (Plate 169) – conformed to the contemporary canon of sculpture, as did a collection of casts and antique marbles given in 1825. The Institution was funded by members' subscriptions and succeeded in attracting support from many of Manchester's wealthy citizens.

From the first, an annual art exhibition figured prominently among the Institution's plans. The first one was held in 1827, before the new building was completed, with tickets available to the public at 1 shilling (equivalent to 5p). Given that the average weekly wage was less than £1 a week, this meant that only the well-off and respectable could afford to attend. The Institution built up a modest collection through purchases from the exhibition; in 1832, for example, it bought a painting entitled *The Storm* (Plate 170) by the prominent British artist William Etty (1787–1849). Its educational activities also developed during this decade, with the establishment of a School of Design in the building. In the 1840s the charge was reduced at times in order to encourage working-class attendance. In doing so, the Institution was responding to attacks on its exclusiveness and belatedly following the example of the Mechanics' Institution which, from 1837, provided a venue for a series of exhibitions open to the working class of Manchester. From 1846 the collection was open to the public on a regular basis with an admission charge of sixpence. By 1882, however, it had become clear that the Institution would never have sufficient funds to acquire a major art collection. Financial problems resulted in the building and collection being handed over to Manchester Corporation in 1882. The deal required the city to make £2,000 a year available for the purchase of works of art, making Manchester City Art Gallery (as it became) one of the best funded municipal galleries in the country (Plate 171).

[5] Sir Charles Barry, as he became, later designed the Houses of Parliament with Pugin. He was the father of the architect of the first National Gallery extension.

Plate 169 Manchester City Art Gallery (previously Royal Manchester Institution), entrance hall, with Westmacott's casts of the Parthenon marbles. Copyright Manchester City Art Galleries.

Plate 170 William Etty, *The Storm*, 1829–30, oil on canvas, 91 x 105 cm, Manchester City Art Gallery. Copyright Manchester City Art Galleries.

Plate 171 H.E. Tidmarsh, *Interior of Manchester City Art Gallery*, c.1893–4, wash drawing, 25 x 36 cm, Manchester City Art Gallery. Copyright Manchester City Art Galleries.

The Manchester Art Treasures exhibition of 1857

Art Treasures of the United Kingdom, a massive exhibition held in Manchester in 1857, can be seen in many respects as a successor to the Great Exhibition of 1851. It was housed in a temporary iron and glass structure similar to the Crystal Palace (Plate 172). One of the aims of the organizers of the Manchester exhibition was to improve taste and design in manufactures. However, unlike its predecessor, it did not actually include manufactures but was a more specialized, art-based venture. Its purpose was set out in *The Art-Treasures Examiner*:

> Several of the influential merchants and manufacturers of Manchester, strongly impressed by the happy results of the Paris Exhibition of the previous summer [1855], as well as those of the Dublin Exhibition of 1853, – forcibly struck, above all, with the important claims and uses of the fine arts, and calling to mind the remark made by Dr Waagen[6] in his valuable work, that the art-treasures in the United Kingdom were of a character, in amount and interest, to surpass those contained in the collections upon the continent, bethought themselves of the grand idea of bringing the *élite* of these works into view under one roof, for the edification of their fellow men.

(*The Art-Treasures Examiner*, p.1)

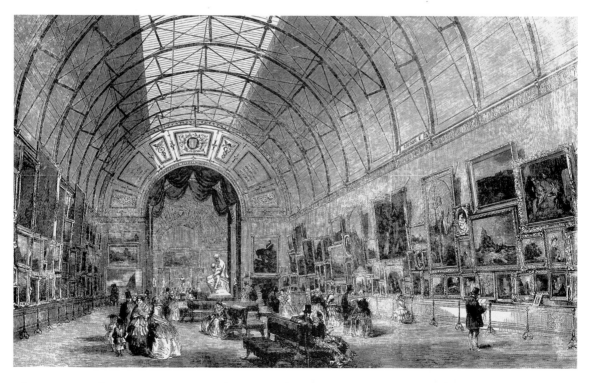

Plate 172 Manchester Art Treasures exhibition, the gallery of modern painters, wood-engraving, *Illustrated London News*, 4 July 1857.

[6] Gustave Friedrich Waagen, Director of the Royal Picture Gallery in Berlin, was a leading art historian and one of the first of the 'scientific' school of historians who based their writings on empirical and documentary research. The 'valuable work' referred to was Waagen's *Treasures of Art in Great Britain* (3 vols, 1854).

On the one hand, therefore, the exhibition expressed national pride in the great art collections of Britain (though some of the aristocrats who owned them refused to lend). On the other, it functioned as a statement of local pride, asserting that Manchester was anything but the cultural desert that it was so often supposed to be. The organizers also appear to have taken for granted that works of art could have an improving effect on spectators. Typically, it was the working class who was believed to be most in need of such moralization.[7]

The exhibition brought together some 16,000 works organized in ten sections, such as Old Masters, photography and ornamental art. Besides paintings and engravings, there were tapestries, ivories and architectural drawings, as well as a collection of armour and the Soulages collection.[8] The educational concerns of the organizers are evident in the arrangment of the works of art in chronological order in accordance with the art-historical approach of experts such as Waagen and of Prince Albert, who wrote to the organizers as follows:

> If the collection you propose to form were made to illustrate the history of Art in a chronological and systematic arrangement, it would speak powerfully to the public mind, and enable, in a practical way, the most uneducated eye to gather the lessons which ages of thought and scientific research have attempted to abstract.
>
> (Quoted in Finke, 'The Art Treasures exhibition', p.110)

The Old Master paintings, for example, were intended to present a comprehensive history of art from its earliest origins to the present day. George Scharf, the curator of this section, not only arranged them in chronological order but also hung Italian and Northern works on facing walls so as to indicate the co-existence of different national schools. Thus, Italian 'primitives' were complemented by Northern European works of the fourteenth and fifteenth centuries (including the Wilton Diptych[9]). Scharf commented: 'the taste for studying the history of early Italian art is not a recent development in our country alone; it is a novelty even in Italy itself' (*Handbook to the Paintings by Ancient Masters*, 1857, quoted in Finke, 'The Art Treasures exhibition', p.119). However, the centrality of the Italian Renaissance to the traditional canon was also underlined with the inclusion of works such as Raphael's *Three Graces*. Other national schools were represented both by well-established names (such as the Flemish Rubens) and also by some who had barely achieved canonical status (such as the Spanish Velasquez and the Dutch Frans Hals).

British art was also well represented in the Manchester exhibition. 'The British Portrait Gallery' was intended to illustrate the glorious history of the kingdom. It began with a portrait of Henry VIII by Holbein and ended with one of the

[7] The *Art-Treasures Examiner* also stated that 'a taste for the fine arts has an immediate bearing on the moral elevation of the working class' (quoted in McLeod, *Art and the Victorian Middle Class*, p.104).

[8] This collection of decorative art and smaller works by important artists was amassed in the 1830s and 1840s by a French lawyer, Jules Soulages, and was subsequently bought by the South Kensington Museum.

[9] The Wilton Diptych is an exceptional late medieval panel painting, depicting King Richard II being presented by three saints to the Virgin and Child and the heavenly host. Dated betweed 1395 and 1399, it is now in the National Gallery.

poet John Keats. The section of 'Modern Masters' (which was not arranged in chronological order) contained works by the most admired British artists of the past, such as Reynolds and Hogarth, and many by nineteenth-century artists. The selection began with Gainsborough's *Blue Boy*[10] and concluded with Leighton's *Cimabue's Celebrated Madonna is Carried in Procession through the Streets of Florence* (see Plate 126). This section also included works by members of the Pre-Raphaelite group such as William Holman Hunt (1827– 1910) and John Everett Millais (1829–1896), who represented what was then a recent and controversial development in British painting. The moving force behind the exhibition, Thomas Fairbairn, owner of an engineering firm, lent Hunt's *Awakening Conscience*, first exhibited at the Royal Academy in 1854.[11]

In terms of defining and redefining the canon, the exhibition was immensely significant. Above all, it marked the triumph of the 'primitives' over the traditional canon of high art – at least so far as the connoisseurs were concerned.[12] In terms of creating a new mass public for art, its implications are not quite so clear cut. Over the course of five months, it attracted well over a million visitors. The entrance fee of *2s. 6d.* was reduced to *6d.* on Saturday afternoons in order to encourage working-class people to visit. Employers in the North and the Midlands arranged excursions to the exhibition for their workers. A major problem, however, was the decision not to label the art works or give free lectures on the grounds that this would limit catalogue sales. Visitors were forbidden to draw or take notes. Numerous observers felt that the exhibition failed in its pedagogic goals. According to Scharf, 'the lower and uneducated classes did not go to the Art Treasures willingly. Many went because they were told they ought to go ... Had educational information been at the same time afforded to these helpless children and factory people, a more direct benefit might have resulted' (quoted in Finke, 'The Art Treasures exhibition', p.125).

The Manchester Art Museum

It was only in the latter part of the century that more systematic attempts were made to bring art to a working-class audience. The founder of the Manchester Art Museum, T.C. Horsfall, believed that the middle classes had a duty to provide guidance to the poor. The inspiration for the project, which he first put forward in 1877, came from Ruskin, who had proposed that educational museums should be set up in cities for the benefit of the working classes, who bore the brunt of the physical and moral ugliness of modern industrial society. Ruskin's influence is evident in Horsfall's vision of a

[10] The famous *Blue Boy*, lent by the Duke of Westminster from his collection at Eaton Hall near Manchester, is now in the Huntington Library in California.

[11] Hunt's *Awakening Conscience* is reproduced in Case Study 6 of Perry, *Gender and Art* (Book 3 in this series).

[12] The most popular painting with the general public at the exhibition was apparently not one of the austere, unfamiliar 'primitive' paintings admired by the connoisseurs, but a celebrated and intensely emotional depiction of the dead Christ mourned, known as *The Three Maries*, by the Bolognese painter Annibale Carracci (1560–1609); however, 'as it was the élite who won the day, it was about a hundred years before extensive coverage was to be given again to the Bolognese master of the seventeenth century' (Haskell, *Rediscoveries in Art*, pp.159–60).

museum 'giving to them the power and wish to discriminate between beauty and ugliness, in order that they may give beauty to their work, and that they may get much of the pleasure and happiness which beautiful things can give' (Horsfall, 'Art in large towns', p.1). He secured support from members of Manchester's philanthropic and cultural élite as well as from Ruskin himself and another notable commentator on art and social issues, William Morris.[13] The museum eventually found a home in Ancoats Hall in one of the city's most deprived working-class districts; it opened in 1886 and operated until 1918, when its art collection too was transferred to the city council as an addition to the Manchester City Art Gallery's collection.

The Art Museum contained works of art in a range of media: paintings, watercolours, engravings, photographs, sculptures and casts. The latter included casts of admired works of classical sculpture, such as the Parthenon frieze and the *Apollo Belvedere* (Plate 4). However, the aim was less to provide visitors with instruction in the history of art (though many of the exhibits were arranged in chronological order to this end) than to use works of art for didactic purposes. The corridors of the ground floor, for example, were hung with improving depictions of scenes from history and literature. Other rooms in the museum were variously devoted to depictions of 'Birds, Flowers and Fruit', 'Animals' and 'Trees and Wild Flowers'; here we can discern the influence of Ruskin, who laid great stress on the spiritual and moral benefits of contemplating the beauties of nature as well as works of art. Part of the museum was devoted to the industrial and decorative arts. A model room, with furnishings designed by Morris, was intended to show workers how they might introduce order and beauty into their own homes. This too was in accordance with the way in which Ruskin had envisaged museums helping to transform the blighted lives of the urban poor. In fact, however, the goods would have been too expensive for most Ancoats residents.

The orderly arrangement of the museum in distinct categories was intended to help the working-class visitor. For the same reason, the objects were labelled and guidebooks were provided, including one written by Horsfall called *What to look for in Pictures*. The museum succeeded in attracting over 2,000 visitors per week in its first year of opening. Many local people attended the entertainments that the museum put on. It was conceived not merely as an art gallery but as a centre of 'rational recreation', which would counteract the lure of the pub and other supposedly immoral attractions. Much of the museum's efforts were directed towards children, who seemed to offer the best hope for the future. The Mothers' Room, containing depictions of children and illustrations of nursery tales by artists such as Walter Crane (1845–1915), was intended for them. Horsfall also wanted to have loan collections for circulation to schools that would parallel the works in the main collection. Thus, just as the museum displayed paintings of rural scenes in the Manchester area, so the loan collections should include pictures of 'such pretty places as town children see when they are taken out of town, – country lanes, woods, fields, farmyards, shipping and coast scenery' (Horsfall, 'Art in large

13 However, it should be noted that whereas Horsfall (like Ruskin and Leighton) wanted to promote social harmony without fundamentally changing the existing order of society, Morris was a socialist who believed that real change would only be brought about through class conflict.

towns', p.3).[14] In practice, however, the museum's perennial shortage of funds (it relied on a relatively small circle of donors in Manchester) restricted the operation of the system.

The exhibits in the Manchester Art Museum included a print after Hunt's *Triumph of the Innocents* in a decorative frame designed by C.R. Ashbee, founder of the Guild of Handicraft, which provided people in the East End of London with a training in craftsmanship (Plate 173). Ruskin had proclaimed the original picture by Hunt to be 'the greatest religious painting of our time' (*The Lamp of Beauty*, p.162); his text – which explains how Hunt has enriched the biblical subject of the Flight into Egypt by depicting not only the holy family but also spirits of the children of Bethlehem whom King Herod had murdered in a vain attempt to kill the infant Jesus – was set into the frame of the print. The Guild chose this image on being asked by Horsfall in 1888 to frame a copy of some edifying picture; it had been voted one of the three most popular pictures by visitors to that year's Whitechapel Picture Exhibition, which aimed to bring the uplifting effects of art to the slums of London's East End.[15] As Alan Crawford has put it:

> It is hard to imagine an object more strongly associated with the vanished late Victorian ideal of social reform through art than this with its reproduction from Holman Hunt, its quotation from Ruskin, made in London's East End by reformed craftsmen to bring light and culture to the poor of Manchester.

(Quoted in Harrison, 'Art and philanthropy', p.129)

Plate 173 After William Holman Hunt, *The Triumph of the Innocents*, 1883–4, photogravure plate produced by Goupil & Co., 51 x 83 cm, in a decorative frame designed by C.R. Ashbee, 1888–9, probably birch with gilding, 99 x 132 cm, Manchester City Art Gallery. Copyright Manchester City Art Galleries.

[14] Horsfall shared the concern of late nineteenth-century philanthopists that the urban poor should visit the countryside, which also underlay the founding of the National Trust in 1895.

[15] Like Brown's Manchester murals, Hunt's later religious paintings (such as *The Triumph of the Innocents* and *The Shadow of the Cross*) are not much liked today. In the later nineteenth century, however, they were enormously esteemed for their moral and spiritual qualities. Prints after them were ubiquitous, especially in schools. Frances Borzello has observed that the vote in favour of *The Triumph of the Innocents* did not really express the genuine preferences of East Londoners since the picture had been given a place of honour by the organizers; see Koven, 'The Whitechapel Picture Exhibitions', pp.36, 45.

Compare the three institutions we have discussed in terms of the ways in which they tried to use art for educational ends, the status of the works of art exhibited and how they were classified (if known), and the support they received from the wealthy citizens of Manchester.

Discussion

While all three institutions did have educational goals, only the Royal Manchester Institution provided formal instruction that related to the broad aim of improving Britain's manufactures. In the case of the Art Treasures exhibition, the paucity of educational provision suggests that these aims came a poor second to the prestige element of the whole venture. We can also discern a shift over time from the practical approach embodied in the Institution to the primarily moral concerns of Manchester Art Museum. Whereas the exhibition displayed loans of precious objects and famous paintings, neither the Institition nor the Art Museum had the money to buy such works. For the latter especially, prints and casts could be just as useful as originals. The Art Museum also applied a quite different, more down-to-earth set of principles for classifying works of art than the exhibition: instead of the usual art-historical divisions by period or national school or media, we find works of art shown in different rooms in accordance with subject-matter and function. All three projects initially received support from the local élite, but the financial difficulties subsequently faced by the Institution and the Art Museum indicate that this kind of voluntary assistance was not sufficient in the long term.

◆◆

Regional collections, regional canons?

Once established as a municipal museum in 1883, Manchester City Art Gallery began to build up its collection. As we saw above, the core of the collection was formed by paintings taken over from the Royal Manchester Institution. They included a number of works by now obscure foreign artists such as Alphonse Legros (1837–1911), who had become a professor at the Slade School of Art in London. Works by British artists dominated the collection. They included two paintings by Etty, including the above-mentioned *Storm*, both of which reveal this artist's preoccupation with the nude. One of the most notable paintings and certainly the largest was *The Birth of Pandora* (Plate 174) by James Barry (1741–1806). Barry had been the most ambitious exponent of history painting in late eighteenth-century Britain but without much success. *The Birth of Pandora*, which is based on Raphael's *Council of the Gods* and depicts the first woman being created by Jupiter and the other gods as a punishment to men, failed to sell in his lifetime. It was eventually bought by the Royal Manchester Institution in 1856.

One of the gallery's earliest purchases was Brown's *Work* (Plate 175), which entered the collection in 1885. The minute detail and vivid colour of this picture are typical of the early work of the Pre-Raphaelites, who deliberately broke with the aesthetic conventions prevailing in Britain during the first half of the nineteenth century. (The sombre, old masterish tones and broad handling of paint that they deplored are apparent in Etty's *Storm*). They were praised for doing so by Ruskin, for whom their work embodied that truth to

Plate 174 James Barry, *The Birth of Pandora* (also known as *Pandora or the Heathen Eve*), 1804, oil on canvas, 279 x 520 cm, Manchester City Art Gallery. Copyright Manchester City Art Galleries.

nature to which he attributed a spiritual and moral value. Brown's painting also recalls Hogarth in the way that it depicts a scene of contemporary life and presents a moral commentary on the state of British society.[16] The composition, which rivals history painting in its scale and elaboration, centres on a group of workers who are mostly being ignored by the rich people whom Brown also depicts. *Work*, which was originally commissioned by a Leeds stockbroker, Thomas Plint, now forms the centrepiece of Manchester City Art Gallery's almost unrivalled holdings of Pre-Raphaelite painting. It hangs there alongside works such as Hunt's *Hireling Shepherd* (Plate 176) and Millais's *Autumn Leaves* (Plate 177), which were bought (in 1896 and 1893 respectively) from the collection of a Newcastle industrialist, James Leathart.

The collection was also enriched by gifts. In 1883, for example, it received Hunt's *Shadow of Death* as a gift from William and Thomas Agnew. The latter, founder of a firm of art dealers, had played an important part in encouraging the manufacturers and merchants of Manchester and other cities of the region to invest in contemporary British art. In 1896 the gallery was given a version of *Derby Day* (Plate 178) by William Powell Frith (1819–1909). The original had been the great hit of the Royal Academy show in 1858. Its appeal lay in its lively and detailed depiction of contemporary social types. Being well funded, the gallery could also afford to buy successful paintings from current Royal Academy exhibitions. In the same year, for example, it acquired *Hylas and the Nymphs* (Plate 179) by John William Waterhouse (1849–1914), which had proved a popular success at the Royal Academy. In 1894 the gallery

[16] In 1858 Brown and other members of the Pre-Raphaelite group founded the Hogarth Club as an alternative exhibition space to the Royal Academy.

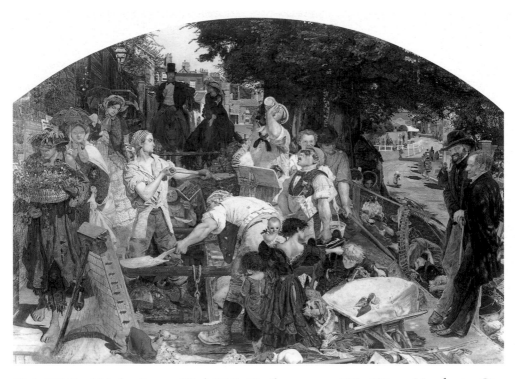

Plate 175 Ford Madox Brown, *Work*, 1852–65, oil on canvas, 137 x 197 cm, Manchester City Art Gallery. Copyright Manchester City Art Galleries.

Plate 176 William Holman Hunt, *The Hireling Shepherd*, 1851, oil on canvas, 76 x 110 cm, Manchester City Art Gallery. Copyright Manchester City Art Galleries.

Plate 177 John Everett Millais, *Autumn Leaves*, 1856, oil on canvas, 104 x 74 cm, Manchester City Art Gallery. Copyright Manchester City Art Galleries.

proudly issued a lavishly illustrated catalogue which shows that the collection included history paintings such as Leighton's *Captive Andromache* (Plate 119), genre scenes and a large number of landscapes.[17] Most of the artists are British, with a few exceptions such as Henri Fantin-Latour (1836–1904). Curiously, the catalogue contains no mention of Barry's *Birth of Pandora* but does record several pictures on loan from the National Gallery, including Turner's *Decline of Carthage*.

[17] Among the works illustrated (other than those already mentioned in this case study) are Hubert von Herkomer, *Hard Times* (1885), a 'social realist' painting concerned with rural unemployment; W.F. Yeames, *Prince Arthur and Hubert* (1883), a sentimental subject from British history; Marcus Stone, *The Lost Bird* (1884), a depiction of a pretty girl; Stanhope Forbes, *The Lighthouse* (1893), a work of the 'Newlyn school'. (The dates refer to their acquisition: see *Catalogue*, Nos 4, 37, 50 and 151.) Although all more or less successful in their lifetimes, none of these artists are now canonical in the way that the Pre-Raphaelite group is.

Plate 178 William Powell Frith, *Derby Day*, 1856, oil on canvas, 102 x 234 cm, Manchester City Art Gallery. Copyright Manchester City Art Galleries.

Plate 179 John William Waterhouse, *Hylas and the Nymphs*, 1896, oil on canvas, 98 x 163 cm, Manchester City Art Gallery. Copyright Manchester City Art Galleries.

Does the evidence presented in this case study suggest that a regional canon developed during the nineteenth century? How do the artists and subjects represented in Manchester City Art gallery compare to those of the standard canon of high art? Can it be said that Manchester helped to establish the canonical status of Pre-Raphaelite painting?

Discussion

Most obviously, the Manchester collection differs from (say) the National Gallery in its dominance by recent British art rather than Old Masters. This is something that characterizes all the ventures that we have discussed in this case study with the partial exception of the Art Treasures exhibition, which drew on collections from all over the country. The collection's bias towards this kind of art seems to relate to the existing preferences of local collectors, evidenced in Fairbairn's loan to the exhibition and Agnew's activities as an art dealer. While history painting in the classical tradition is represented by Barry and Leighton, it is possible to discern a preference for contemporary themes (for example, with *Work* and *Derby Day*). Overall, we can identify a concern with popular appeal and accessibility – whether in the moral earnestness of Hunt's religious paintings or in the gentle eroticism of Waterhouse's nymphs – which presumably related to the need to cater to a not very sophisticated regional audience. However, the fact that numerous works in the collection had first been seen at the Royal Academy in London might seem to suggest that there was nothing specifically 'regional' about it. Clearly the entry of Pre-Raphaelite painting into a public gallery during the nineteenth century can be seen as significant in terms of their canonization. Nevertheless, there is no evidence here that Manchester's private collectors played any special role in supporting Pre-Raphaelite painting in its early controversial years – given that that the most important examples in the gallery came from Leeds and Newcastle collections.

◆◆

The Manchester collection parallels that of many other regional galleries, which are typically dominated by nineteenth-century British painting.[18] The limited presence of Old Master and European art generally can partly be explained on grounds of restriction of funds and availability of works. However, the patriotic and moral concerns that we have discussed meant that British painting might be positively preferred. Municipal collections gave lasting form to the promotion of a national tradition of naturalistic and implicitly virtuous art that could be traced back to Hogarth. Established by the 1830s,[19] this position subsequently found a new and persuasive spokesman in Ruskin. Since the drastic fall from critical favour of Victorian painting after 1914, most municipal collections have been the very reverse of canonical. Manchester presents something of an exception on account of the strength of its Pre-Raphaelite holdings.[20] However, the status of all British painting of this period remains doubtful when viewed in the context of the European

[18] However, it should be emphasized that regional collections today are certainly not restricted to British art; for a survey of their holdings, see *Art Treasures of England*.

[19] The first major statement of this conception of the British canon was Allan Cunningham, *The Lives of the Most Eminent British Painters, Sculptors and Architects*, first published 1829–33 and much reprinted; for an account of this work, see Vaughan, 'The Englishness of British art', pp.15–17. It ultimately gave rise to the opening of the National Gallery of British Art (better known as the Tate Gallery) in London in 1897.

[20] Although the Pre-Raphaelites were included in the modernist execration of the realism and sentimentality of Victorian painting, they were not quite so vilified and returned to critical favour much earlier (around the middle of the twentieth century).

tradition of high art. It may be noted, for example, that the National Gallery only covers British painting up to the early nineteenth century, ending with Constable and Turner. The collection continues up to the end of the century, but the later works represented are all by French and other European artists. Victorian painting is excluded from this supremely canonical collection.

As we saw earlier, municipal museums and galleries drew immense audiences in the late nineteenth century. The universal principle of free admission played a crucial role here, as did the growing leisure enjoyed by working people. Their popularity declined after 1900 with the growth of alternative forms of entertainment, notably the cinema. By this date, their educational and civilizing role had been acknowledged by the central government; from 1894 time spent by children in museums and art galleries could count as time spent in school. The continuing aim was that museums should function to bring rich and poor together and help to forge a common national identity. While it must be acknowledged that this basically meant incorporating the working classes into the dominant culture, it can also be argued (following Waterfield and Koven) that ventures like the Manchester Art Museum and the Whitechapel Picture Exhibitions were not simply instruments of social control. Condescending and unrealistic as their founders appear by the standards of today, they nevertheless did try to open up the exclusive world of visual art to a mass audience in ways that are not wholly irrelevant to the present.

References

Art Treasures of England: The Regional Collections (1998) London, Royal Academy.

The Art-Treasures Examiner: A Pictorial, Critical and Historical Record of the Art Treasures Exhibition, at Manchester in 1857 (1857) Manchester.

Barlow, Paul (1996) 'Local disturbances: Ford Madox Brown and the problem of the Manchester murals', in Ellen Harding (ed.), *Reframing the Pre-Raphaelites: Historical and Theoretical Essays*, London, Scolar Press.

Bennett, Tony (1988) 'The exhibitionary complex', *New Formations*, 4, Spring, pp.73–102; reprinted in Bennett, Tony (1995) *The Birth of the Museum: History, Theory, Politics*, London, Routledge.

Catalogue of the Permanent Collection of Pictures (1894) City of Manchester Art Gallery.

Finke, Ulrich (1985) 'The Art Treasures exhibition', in J.H.G. Archer (ed.) *Art and Architecture in Nineteenth-Century Manchester*, Manchester University Press.

Harrison, M. (1985) 'Art and philanthropy: T.C. Horsfall and the Manchester Art Museum', in Alan J. Kidd and K.W. Roberts (eds) *City, Class and Culture: Studies of Social Policy and Cultural Production in Victorian Manchester*, Manchester University Press.

Haskell, Francis (1980) *Rediscoveries in Art: Some Aspects of Taste, Fashion and Collecting in England and France*, 2nd edn, London, Phaidon.

Horsfall, T.C. (1882) 'Art in large towns: in what way can the influence of art be best brought to bear on the masses of the population in large towns', paper read at the Nottingham Congress of the National Association for the Promotion of Social Science, September.

Koven, Seth (1994) 'The Whitechapel Picture Exhibitions and the politics of seeing', in Daniel J. Sherman and Irit Rogoff (eds) *Museum/Culture: Histories, Discourses, Spectacles*, London, Routledge.

Macdonald, Stuart (1985) 'The Royal Manchester Institution', in J.H.G. Archer (ed.) *Art and Architecture in Nineteenth-Century Manchester*, Manchester University Press.

McLeod, Dianne Sachko (1996) *Art and the Victorian Middle Class: Money and the Making of Cultural Identity*, Cambridge University Press.

Perry, G. (ed.) (1999) *Gender and Art*, New Haven and London, Yale University Press.

Rose, Michael E. (1985) 'Culture, philanthropy and the Manchester middle classes', in Alan J. Kidd and K.W. Roberts (eds) *City, Class and Culture: Studies of Social Policy and Cultural Production in Victorian Manchester*, Manchester University Press.

Ruskin, John (1959) *The Lamp of Beauty: Writings on Art*, ed. Joan Evans, Oxford, Phaidon.

Seed, John (1988) '"Commerce and the liberal arts": the political economy of art in Manchester, 1775–1860', in Janet Wolff and John Seed (eds) *The Culture of Capital: Art, Power and the Nineteenth-Century Middle Class*, Manchester University Press.

Trodd, Colin (1994) 'Culture, class, city: the National Gallery, London and spaces of education, 1822–57', in Marcia Pointon (ed.) *Art Apart: Art Institutions and Ideology across England and North America*, Manchester University Press.

Waterfield, Giles (1994) *Art for the People: Culture in the Slums of Late Victorian Britain*, London, Dulwich Picture Gallery.

Vaughan, William (1990) 'The Englishness of British art', *Oxford Art Journal*, vol.13, no.2.

Conclusion

GILL PERRY

The different case studies in this book have attempted to show how a western canon of art is rooted in constantly evolving and contested values. We have seen that these values are often shaped by forces beyond the specific practices of painting, sculpture and architecture, by notions of cultural authority and status. Historical, political, philosophical and educational issues are involved, ideas which are often expressed and formalized through the institutional structures of art academies, art galleries, museums and the historical narratives produced by curators, art historians and art theorists. The ways in which works are presented to the public – through the organization of museums and exhibitions, systems of categorization, and the ways in which histories of art have been written – are important forces in the construction of both canonical and broader political and cultural values. We've seen, for example, how the classicism of the Parthenon marbles was identified by the Victorians as confirming an idea of Britain as a civilizing imperial power. We've also seen that even within some of the most institutionalized contexts, such as the Royal Academy in the eighteenth century, attempts to assert a superior category of art works may be resisted or affected by market forces and the shifting tastes of those who purchase and commission works of art. It seems that 'academic' canons of art are not always sustained through history, and may be in competition with other popular or highly valued forms of art. As we saw in the case studies in Part 1, similar shifts have affected the status which has been attached to classical values. The idea of the western artistic canon is not a simple one: hence the use of 'canons' in the plural in the title of this book.

It has also been suggested that the growth of print culture and the wide-spread reproduction of works may affect their supposedly canonical status. As we saw in the study of Hogarth, this can have both positive and negative effects on the value which art works are seen to possess. Although this book has been concerned largely with ideas of the canon from the seventeenth to the nineteenth centuries, it is worth noting here that the development of what we now loosely label the 'modern canon' of the late nineteenth and twentieth centuries has been directly affected by the powers of the media and the growth of wide-ranging techniques of mass reproduction in the public presentation of art. And these very same techniques have helped to sustain or challenge some of the canonical views which we have inherited from art history by making widely available (in magazines, newspapers, advertisements, through television, the internet, etc.) reproductions and images of well-known or lesser known works from earlier historical periods.

We have also demonstrated the shifting and elusive nature of a canon by focusing on artists whose work has held a contradictory or marginal relationship with official codes of artistic value (such as Hogarth) or whose work has successively held and lost canonical status (such as Leighton). In the study of the Albert Memorial we have considered the problem of a multi-

authored sculptural monument which seems to have moved in and out of public favour in ways which could be seen to relate to changing political and nationalist ideologies within British culture. Moreover, the studies on the National Gallery and art in the provinces have revealed the extent to which (seemingly) relatively arbitrary factors, such as the tastes of private individuals, may help to determine the core works of important public collections.

The Preface mapped out some of the developments in recent art history which have questioned the idea of a western canon by examining some of the aesthetic, cultural and political beliefs which underpin canonical values. Through our look at some of the different art forms and structures through which ideas of a canon of art have been established, disseminated and developed, we hope that this book has opened up some problematic issues in art history and contributed to the on-going debate about how and why certain forms of art are deemed to be of superior quality.

Recommended reading

The following list includes books of general interest that are relevant to the overall themes of this book:

Blunt, Anthony (1998) *Art and Architecture in France*, 5th edn, New Haven and London, Yale University Press.

Boardman, John (1993) *The Oxford History of Classical Art*, Oxford University Press.

Craske, Matthew (1997) *Art in Europe 1700–1830*, Oxford University Press.

Duncan, Carol (1995) *Civilizing Rituals: Inside Public Art Museums*, London, Routledge (see especially Chapter 2 on the Louvre and the National Gallery).

Goldstein, Carl (1996) *Teaching Art: Academies and Schools from Vasari to Albers*, Cambridge University Press.

Haskell, Francis (1980) *Rediscoveries in Art: Some Aspects of Taste, Fashion and Collecting in England and France*, 2nd edn, London, Phaidon.

Hauser, Arnold (1951) *The Social History of Art*, 4 vols, London, Routledge & Kegan Paul. (Volume 2 is particularly relevant to Case Study 3 on Le Brun.)

Pevsner, Sir Nikolaus (1973) *Academies of Art, Past and Present*, New York, Da Capo Press (first published 1940).

Waterfield, Giles (ed.) (1991) *Palaces of Art: Art Galleries in Britain 1790–1990*, exhibition catalogue, London, Dulwich Picture Gallery.

The following list includes works that relate to specific case studies in this book:

Case Study 1

Blunt, Anthony (1967) *Nicolas Poussin*, London, Phaidon (reissued 1995, London, Pallas Athene).

Mérot, Alain (1990) *Nicolas Poussin*, London, Thames and Hudson.

Case Study 2

Cook, B.F. (1984) *The Elgin Marbles*, London, British Museum Press.

Jenkins, Ian (1992) *Archaeologists and Aesthetes in the Sculpture Galleries of the British Museum, 1800–1939*, London, British Museum Press.

Case Study 3

Crow, Thomas E. (1985) *Painters and Public Life in Eighteenth-Century Paris*, New Haven and London, Yale University Press. (Chapter 1 on the early history of the Académie royale is particularly helpful in relation to this case study, while the rest of the book – on the the Académie in the eighteenth century – is more generally useful for comparing with the account of the Royal Academy in London in the next case study.)

Gareau, Michel (1992) *Charles Le Brun: First Painter to King Louis XIV*, New York, Harry N. Abrams, Inc.

Montagu, Jennifer (1994) *The Expression of the Passions: The Origin and Influence of Charles Le Brun's Conférence sur l'expression générale et particulière*, New Haven and London, Yale University Press. (This contains an English translation of the complete text of Le Brun's *Lecture on Expression*.)

Case Study 4

Bindman, David (1997) *Hogarth and his Times*, London, British Museum Press.

Paulson, Ronald (1991) *Hogarth*, revised edn, 3 vols, New Brunswick, Rutgers University Press.

Pointon, Marcia (1993) *Hanging the Head: Portraiture and Social Formation in Eighteenth-Century England*, New Haven and London, Yale University Press.

Solkin, David (1992) *Painting for Money: The Visual Arts and the Public Sphere in Eighteenth-Century England*, New Haven and London, Yale University Press.

Case Study 5

Gage, John (1987) *J.M.W. Turner: 'A Wonderful Range of Mind'*, New Haven and London, Yale University Press.

Treuherz, Julian (1993) *Victorian Painting*, London, Thames and Hudson.

Case Study 6

Bailey, Stephen (1981) *The Albert Memorial*, London, Scolar Press.

Brooks, Christopher (ed.) (1999) *The Albert Memorial*, New Haven and London, Yale University Press.

Read, Benedict (1983) *Victorian Sculpture*, New Haven and London, Yale University Press.

Case Study 7

Lloyd, Christopher (1966) 'John Julius Angerstein 1732–1823, founder of Lloyds and of the National Gallery', *History Today*, June, pp.373–9.

Martin, G. (1974) 'The founding of the National Gallery', Parts 1–9 in *The Connoisseur*, April–December.

Potterton, H. (1977) *The National Gallery*, London, Thames and Hudson.

Case Study 8

Archer, J.H.G. (ed.) (1985) *Art and Architecture in Nineteenth-Century Manchester*, Manchester University Press.

Art Treasures of England: The Regional Collections (1998) exhibition catalogue, London, Royal Academy.

Kidd, A. and Roberts, K. (eds) (1985) *City, Class and Culture*, Manchester University Press.

Index

Page numbers in *italics* refer to illustrations. Works of art are listed under the artist where known; if the artist is not known, they are listed under their title.